TREASURES OF FLORENCE

THE MEDICI COLLECTION 1400–1700

Treasures of Florence

The Medici Collection 1400–1700

Edited by
Cristina Acidini Luchinat

With contributions by
Cristina Acidini Luchinat
Mariarita Casarosa Guadagni
Annamaria Giusti
Anna Maria Massinelli
Mario Scalini
Maria Sframeli

Prestel
Munich · New York

© 1997, by Prestel-Verlag, Munich · New York
© of the original Italian edition:
1997, by Octavo, Franco Cantini Editore, Florence

Translated by Eve Leckey
Edited by Kate Garratt

Photo Credits see p. *228*

Front cover: Flemish goldsmith, *Mermaid pendant,*
1570-80 (see page 204).
Back cover: Grand ducal workshops, *Table with
semi-precious stone inlay*, late 16th century (see page 123).

Die Deutsche Bibliothek – CIP-Einheitsaufnahme
Treasures of Florence : the Medici Collection 1400–1700 /
ed. by Cristina Acidini Luchinat. With contributions by Cri-
stina Acidini Luchinat ... [Transl. By Eve Leckey]. –
Munich ; New York : Prestel, 1997
Ger. ed.: Die Schätze der Medici
ISBN 3-7913-1867-5

Library of Congress Cataloging-in-Publication
data is available.

Prestel books are available worldwide. Please contact your
nearest bookseller or write to either of the following
addresses for information concerning your local distributor:

Prestel Verlag, Mandlstrasse 26, D-80802 Munich, Germany
Phone (89) 38 17 09-0, Fax (89) 38 17 09-35

and 16 West 22nd Street, New York, N.Y. 10010, USA
Phone (212) 627 81 99, Fax (212) 627 98 66

Designed by Auro Lecci
Produced by Matthias Hauer
Offset lithography by Fotolito Star
Printed and bound by Grafedit, Bergamo

Printed in Italy on acid-free paper

ISBN 3-7913-1867-5 (English edition)
ISBN 3-7913-1845-4 (German edition)

Contents

INTRODUCTION

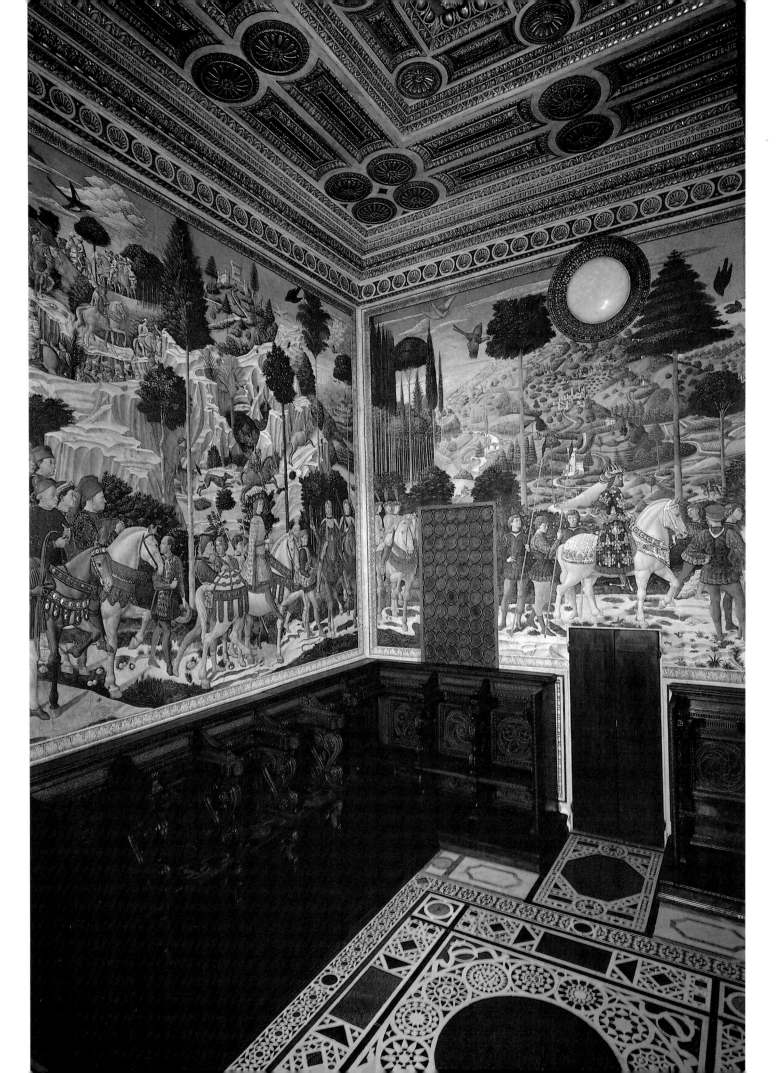

Since the earliest times, rare materials have wielded a powerful influence over man's ambitions and imagination; using whatever tools were available to him, whether rudimentary or refined, he has turned them into objects – ornaments, decorations, jewels – which are coveted not only for the rarity and durability of the primary material and their skilled craftsmanship, but also and especially for their eternal significance as symbols of wealth and power.

Until quite recent times the appropriation, by modelling and handling, of the precious materials yielded by earth and sea has had the aura of an almost magical transformation as these materials, both organic and inorganic, were seen as offering a privileged means of access to the interior, secret relationships within the realm of

The Treasures of the Medici: from Objects of Wonder to the Organization of Knowledge

Cristina Acidini Luchinat

nature. In the system of material affinities established by scholastic philosophy during the Middle Ages, every rare substance was influenced by a planet, regulated a part of the body, controlled one of the humours, harmonised with a character, was paired with a colour, and so on. A faded semblance of such beliefs is still found in the tradition which identifies each sign of the zodiac with a precious or semi-precious stone, or ascribes to them some therapeutic virtue, as in alternative medicine.

Many tales are told of spirits trapped in rings who, on being released when the setting of the stone is imprudently opened, wreak the most dreadful havoc. Various medicinal cures consisted of swallowing powdered precious stones, and they were even used to counteract poisons. It is no coincidence, for example, as Annamaria Giusti mentions in this book, that Anselm Boetius de Boodt, private doctor to the Emperor Rudolf II, was also the author of a treatise on gems and rare minerals. Lastly, it is well known that, with changes of ownership and the passage of time, certain stones have acquired their own name and seem to have developed their own personality. A Chinese poet, believed by some to be Confucius, attributed numerous moral qualities to jade.

And yet, perhaps more than any other aspect of the history of collecting in Europe, the concept of a single 'precious object', and collectively of 'a treasury', is in need of proper and considered historical analysis. While we quite clearly attribute a (particularly monetary) value to noble metals, precious gems, semi-precious stones, organic forms and substances which are attractive to look at and may be enhanced by skilful craftsmanship, such as coral, ivory, amber and pearls, all of which have been held in esteem since the earliest of times, it is more difficult for the post-Enlightenment mind to understand the value associated in the past with natural

Opposite page: View of the Capella dei Magi with frescoes by Benozzo Gozzoli, mid 15th-century. Florence, Palazzo Medici Riccardi

curiosities and artificial creations which had little or no material worth yet were highly regarded items in all the most illustrious collections. A wide range of objects, natural ones in particular, were considered interesting and desirable almost entirely for their arcane rarity, their presumed magical and therapeutic properties or simply because they were difficult to come by. Some marbles, for example, were greatly appreciated not only for their beauty but also because only small quantities were known to exist, while the hardness of porphyry led to its assuming a sacred quality. Exotic or even local shells, the legendary unicorn's horn (in fact, the tusk of a narwhal), whale's ribs and coconuts were all displayed alongside exhibits such as stones, fossils, roots, archaeological finds, oriental porcelain, desiccated snakes, and so on, to make up the fascinating and varied collection of an Italian Renaissance *studiolo* or a northern *Wunderkammer.*

Behind the collecting and patronage of the fifteenth and sixteenth centuries lay the formidable history of the classical period, the vestiges of which, after countless losses and dispersions, had been gathered together throughout the Middle Ages in the extremely heterogeneous collections belonging to the more important churches or monasteries. With their relics of an imperial past, impressive evidence of a concrete reality, the treasuries collected and conserved by the popes, as well as by the great rulers Charlemagne and Frederick II, are supreme examples of the continuity of a political ideal which, thanks to occasional, convenient sanctification, coexisted alternately in harmony or conflict with the Christian religion. From classical authors we learn that it was quite normal for invading barbarian warriors to devote themselves to the destruction of rare and costly vases and bowls of semi-precious stone which they had looted, hurling them violently against the wall. Along with the precious item, they were destroying the image of the power and authority which had acquired the material and had taught the craftsman. Reset in the crowns, sceptres, crosses and caskets of the Holy Roman Empire, the gems and cameos of imperial Rome continue, despite the passing of time, to convey their symbolic message of authority and magnificence which, even today, has lost nothing of its fascination and vigour. No less evocative are the inevitable forgeries, those jewels and cameos made by latter day craftsmen, considerably less expert than the classical engravers, who nevertheless had the sincere desire to revive this fascinating technique. Paradoxically, I am quite convinced that the notion of Europe is stronger and clearer in the smallest cameo of a Carolingian crown in the cathedral of Aachen than in many of the treatises and directives of Community politics today.

The Renaissance and Humanist periods saw a flowering of the arts which affected jewellery and ornament just as much as other skills. The important and wealthy families of the Italian peninsula competed with each other to acquire classical items found in excavations – vases and glyptics, coins and medals, exotic artefacts – as well as commissioning the best craftsmen to make costly decorations, jewellery and sophisticated mounts for their personal adornment, a practice common to both men and women until the last century.

In Florence, as they increased their power in the city during the fifteenth century, the Medici distinguished themselves in this, as in all other areas of collecting and patronage. The earliest known acquisitions of antique glyptics date from the time of Cosimo il Vecchio, who was able to call on the skills of a jeweller as outstanding as Lorenzo Ghiberti to create a gold mount in the shape of a dragon for the renowned cornelian engraved with Apollo and Marsyas. However it was with his son, Piero il Gottoso (the Gouty), and his grandsons Lorenzo and Giuliano, that the Medici collection of large and small antiquities, bronzes, numismatics and gems began to compete with those of the major northern Italian courts and the popes. The nucleus of this select collection of costly and refined pieces – a library for rare volumes, a treasury, a Schatzkammer – was housed in the family palace in Via Larga, close to the family sanctuary of the *Capella dei Magi*, completed in 1459. Here, the *Reliquario del 'Libretto'* glowed on the altar amidst the paintings of Filippo Lippi and Benozzo Gozzoli, the gleam of the gold and silver newly applied to walls and furnishings, and the magnificent colours of the *commesso* flooring made from antique and modern marbles with a disc of porphyry in the centre, most probably found during excavations and a miniature of the majestic imperial porphyry circle in Byzantium.

Almost all the jewels and luxury items have, however, been completely and irretrievably lost. Only the inventories remain to describe them, yet even their dry, official language allows us to imagine the splendour of the gold, the silver, the gems with their mounts, the enamel and niello work in designs and colours which recall the Medici heraldry (the red spheres or bezants, with a single blue one studded with fleurs-de-lys) and the family emblems: rings with a diamond and three feathers; branches of laurel, some aflame. Further symbols – beacons, roses, parrots – formed a galaxy of cryptic images (which could only be interpreted by a close circle of friends and intellectuals, but was immediately recognisable to all the townspeople) which today can only be glimpsed on the richly-illuminated borders and some of the sumptuous bindings of the Medici manuscripts housed in the Biblioteca Medicea Laurenziana, and only a few other places in the world.

For Lorenzo, pride and hope of the family after the death of Piero in 1469, Agnolo Poliziano composed this laudatory hendecasyllable, *Questo è il diamante, anzi il piropo ardente* ("This is the diamond, or rather the fiery pyrope"), thus identifying the young Medici with two gems: the first, the most frequently found in Medici emblems and a symbol of endurance favoured by God (*deo amante*), the second a flame-red garnet. On his deathbed, according to Poliziano, Lorenzo kissed a silver crucifix studded with pearls and precious gems, thus touching a precious object for the last time ("Postremo sigillum crucifixi argenteum, margaritis gemmisque munifice adornatum defixis usquequaque oculis intuens, identidemque deosculans expiravit"). In the streets of Florence it was said that the disastrous storm which preceded his death was the work of demons released from one of his rings.

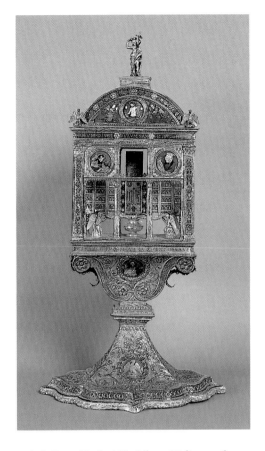

Paolo di Giovanni Sogliani, The 'Libretto' Reliquary, silver gilt and enamel, French workmanship of the 14th century, Florence, Museo dell'Opera del Duomo.

11

Workshop of the Sarachi brothers (?), Jasper flask, Milan c. 1575. Florence, Museo degli Argenti.

Giovanni dei Bernardi, Plate with Noah's ark, rock crystal, early 16th century. Florence, Museo degli Argenti.

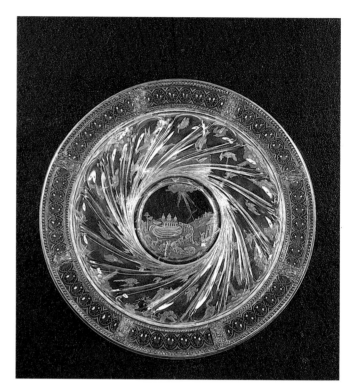

Opposite page: Jacopo Bilivert (designed by Bernardo Buontalenti), Lapis lazuli vase, 1583. Florence, Museo degli Argenti.

Lorenzo's famous collection of semi-precious stone vases (which also included pieces owned by his father, such as the rock crystal chalice, cut and faceted and probably of French origin), like all the other rare items housed in the Medici palace, was plundered and dispersed in 1494 when, on the arrival of the French troops led by King Charles VIII, his son Piero fled to Venice. The surviving items of the collection, many of which are engraved with the initials LAV.R.MED (the R has often been interpreted as 'Rex' and, more recently, as representing Horace's title for Maecenas, »Rex paterque«) are divided between the Museo degli Argenti in Palazzo Pitti, now the Schatzkammer of the Florentine museums, the university's Museo di Mineralogia, where items made of semi-precious stone without their mounts were housed for their scientific interest, and the Treasury of the church of San Lorenzo which the Medici popes, Leo X (1513–21) and Clement VII (1523–34), endowed with vast donations of vases to be used as reliquaries.

Other misfortunes befell the Medici collections of gems, begun by Cosimo il Vecchio and increased by quite sensational acquisitions made by Lorenzo in competition

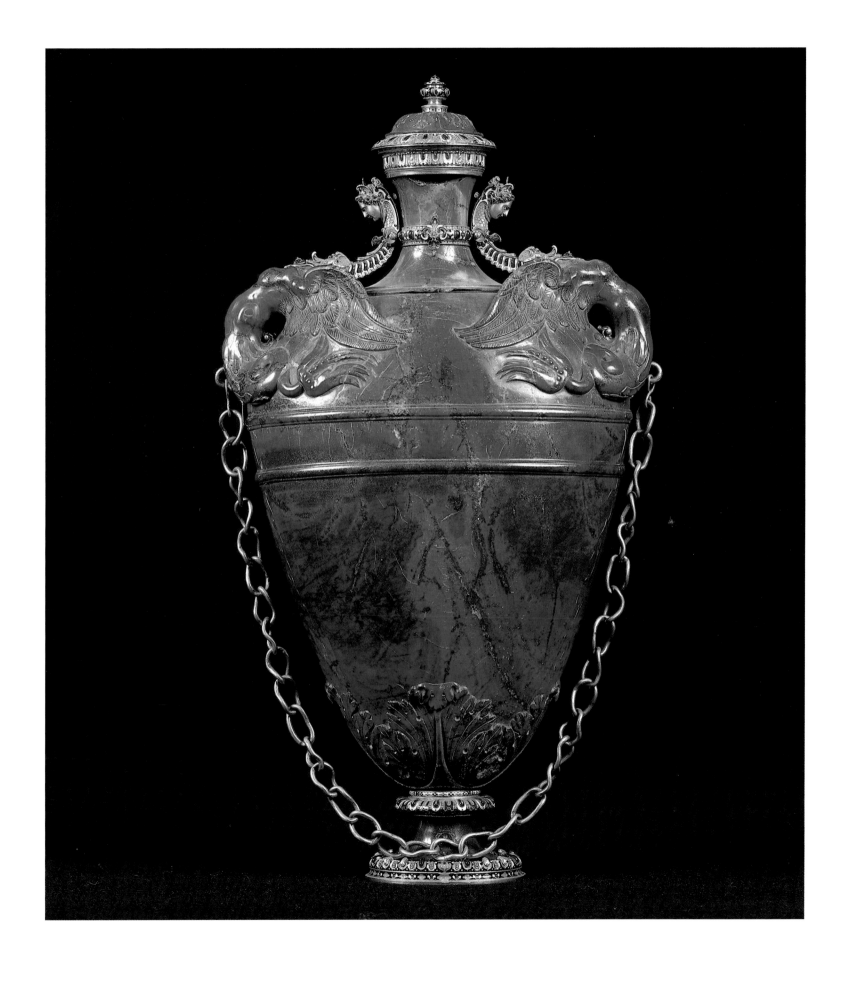

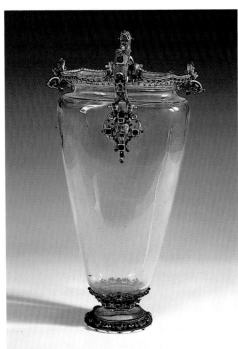

Rock crystal ewer, *Milan c. 1560. Florence, Museo degli Argenti.*

Rock crystal ewer, *Milan prior to 1619. Florence, Museo degli Argenti.*

with the glyptic collections of the most important Italian courts. Both classical and modern *intagli* and cameos profoundly influenced those Florentine artists closest to the Medici. Given access to study the jewels in the Treasury, they transposed the iconographic elements, compositional features and recognisable stylistic forms to painting and sculpture throughout the second half of the fifteenth and first half of the sixteenth centuries. Accurate impressions, or even only distant echoes and reverberations from that formal universe of gems and jewels, were all useful propaganda for the fame and renown of the Medici Treasury far beyond the private, protected rooms where only a few could enter.

The most valuable set of jewellery, despite having remained in the hands of the Medici throughout the dramatic period of expulsions and returns, left Florence for ever when it became part of the dowry of Margaret of Austria, the young widow of Duke Alessandro, in 1537. The gems became the property of the Farnese family when Margaret married Ottavio and were subsequently taken to Naples where they are now in the Museo di Capodimonte. Among them was the legendary Ptolemy cameo – now known, in fact, as the Farnese Bowl – of which Poliziano recounted the following anecdote: "King Alfonso [of Aragon], having bought the bowl of chalcedony, now used by Lorenzo de' Medici, from a merchant for the price of one thousand ducats, said he would never either sell it nor give it away as a present."

Like the rulers of classical times, Cosimo de' Medici, elected Duke of Florence in 1537, considered glyptics to be an attribute of magnificence and closely related to the exercise of political power.

With the help of his wife, Eleonora di Toledo, Cosimo made various acquisitions and commissions and thus restored both the nature and content of the family treasury. In 1559–60 he moved it to the private inner chamber known as the *Scrittoio di Calliope*, located in the well-protected depths of Palazzo Vecchio. The rich and heterogeneous collections housed in Cosimo's *scrittoio* represent a most interesting phase in the history of the fifteenth- and sixteenth-century 'chambers' or 'studies'; with increasing certainty, contemporary museum studies now consider these to represent the origin of the modern museum. For long overshadowed by his son Francesco's vast and skilful activity as a collector, Cosimo's collection was more satisfactorily taken into consideration by the Medici exhibitions and the related studies in 1980, and has now benefited from the detailed research, based on documentary sources, carried out by Anna Maria Massinelli. The *scrittoio* already had several features in common with modern (though certainly not contemporary) museums: firstly, the variety of the collections, ranging from natural and carved stones to numismatics and glyptics, from ancient bronzes (many of which were Etruscan, found during excavations) to modern figures, from the miniatures of Clovius to Cellini's jewellery, from small copies of the greatest classical statues to Mesoamerican artefacts; secondly, the attention to the arrangement, which sought to establish harmony within a general category; lastly, the careful lighting, which was diffused and indirect.

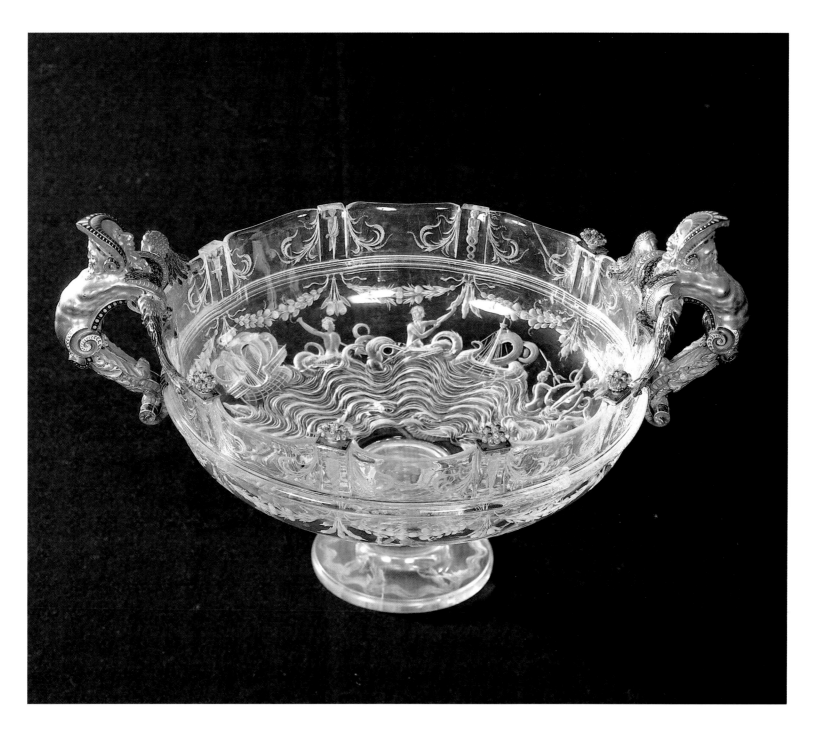

Rock crystal bowl, *Milan c. 1600. Florence, Museo degli Argenti.*

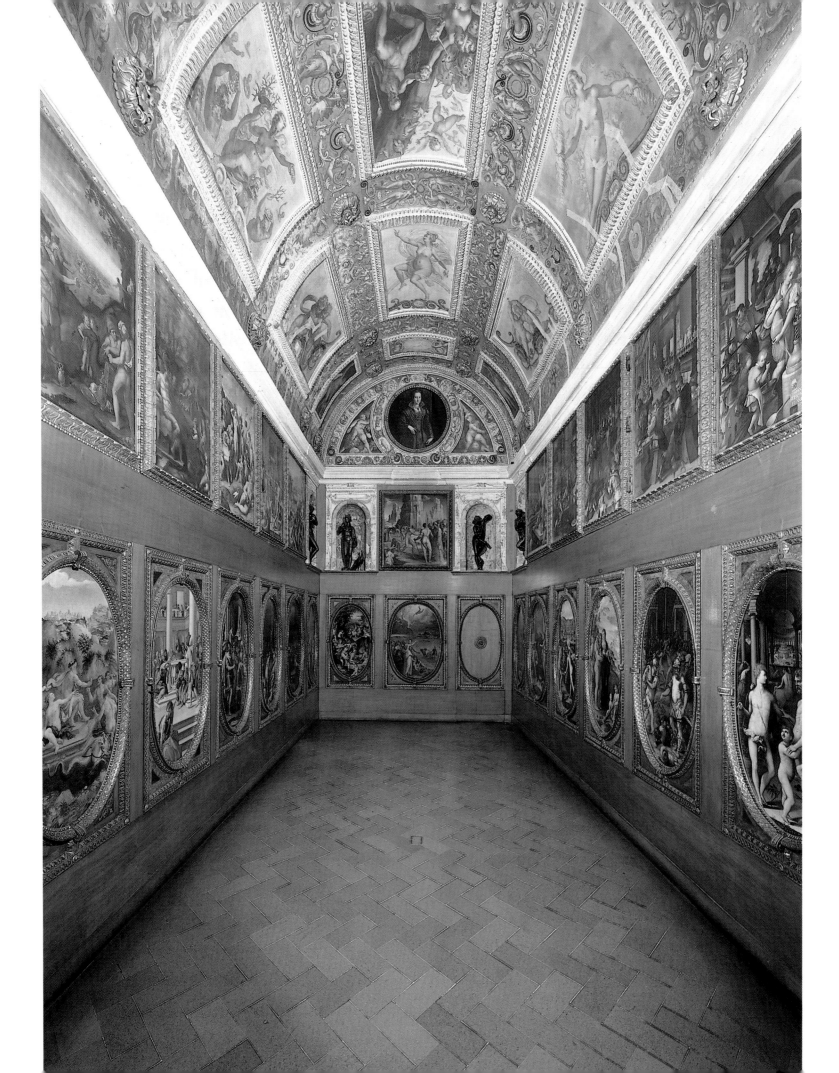

The extraordinary potential for collecting and commissioning rare treasures represented *in nuce* by the *Scrittoio di Calliope* developed into a dizzying and brilliant burst of activity under Francesco I, from 1564 regent for his father and, following Cosimo's death ten years later, grand duke. The *Casino* of San Marco, the *studiolo* in Palazzo Vecchio and the Tribune of the future Uffizi Gallery, were the three shrines to Francesco's inexhaustible collecting and experimentation with rare and precious materials. However more peripheral sites should not be forgotten, such as the villa at Pratolino, with its fantastic grottos where a continual sequence of natural and mechanical wonders excited the admiration of visitors, and the even more mysterious *casino* which documents dating from Francesco's time mention as being located in Boboli.

Francesco's inexhaustible curiosity about the realms of nature heavily influenced his inclinations as a collector. In a flurry of activity and correspondence scholars, gentlemen of the court and agents sought out bulbs from Flanders, shells from tropical seas or snow-white incrustations from various parts of Tuscany. Jacopo Ligozzi produced the most memorable series ever of drawings of naturalistic subjects. While his father Cosimo was to be remembered for having revived the skill of cutting porphyry, one of the hardest stones in existence, with a special 'water' for tempering the tools, it was Francesco who finally succeeded in emulating a long-envied oriental technique, thus producing the first European porcelain with a brilliant blue decoration on a pure white background.

His Schatzkammern were also planned according to harmonies and affinities, both obvious and cryptic, by which the universal organisation of knowledge was synthetically expressed in the secret language of materials and images. Indeed, they may represent one of the links – perhaps the most fascinating – between medieval scholastic philosophy and the empiricism of the Enlightenment. This systematic concept of things was interpreted for the prince by the prelate and scholar Don Vincenzo Borghini, who planned the iconography of the *studiolo,* emphasising the relationship of the world to the principles which govern it, the elements which give life to it, the materials which form it and the properties which these possess. The unrealised design made by Borghini in the 1560s for the wall paintings in the 'Garden Room' of the *Casino* of San Marco was a result of this orderly organisation of ideas, which bears several similarities to contemporary mnemonics based on the 'theatres' of the memory. According to the inventories, this gallery was to house stone vases, shells with decorative mounts and exotic rarities and Borghini's design, inspired by the theme of the 'quarries of the earth', was intended to create a link between the cycle of paintings and the processing of stones and metals in the workshops of the *Casino*. As Borghini himself stated, the liberal interpretation of the subject evolved, however, into a 'mirror of human life' where the inclinations stimulated in every individual by the stars were reflected in aptitudes, virtues, characters, trades, geographic locations and historic events. Appropriately placed in the series of images, the stone and metal

Opposite page: The 'Studiolo' of Francesco I de' Medici. Florence, Palazzo Vecchio.

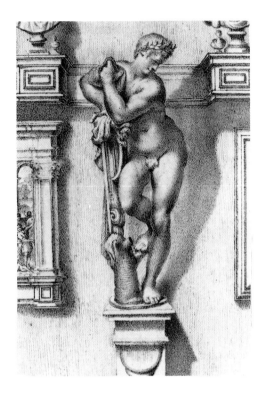

Giambologna, Apollo, *from the 'Studiolo' of Francesco I de' Medici. As seen in an 18th-century illustration of the Tribune by Benedetto De Greyss.*

17

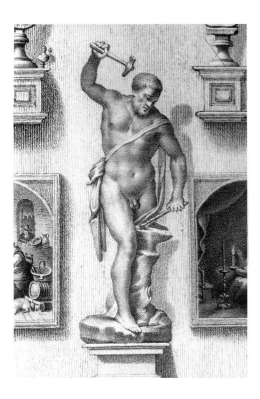

Vincenzo de' Rossi, Vulcan, *from the 'Studiolo' of*
Francesco I de' Medici. As seen in an 18th-century
illustration of the Tribune *by Benedetto De Greyss.*

of the mines thus become the physical representation of a complex celestial and terrestrial network of symmetries into which all matter is fitted, and are the symbolic and material catalysts of action, reaction and destiny. Evidence of the popularity of such a theme in Francesco's time were the pieces, now lost but described in the inventories as the "monti di miniera" (mineral mountains), consisting of an arrangement of rough stones, preciously set and decorated, displayed on the shelves of the Tribune. Perhaps the only remaining vestige of the "monti di miniera", or at least closely related to them, are the piles of coloured stones at the corners of the third chamber of Buontalenti's *Grotta Grande* in the Boboli gardens.

It was, I believe, to this method of placing knowledge into neat mnemonic compartments to which access was provided by a convenient series of images that Galileo Galilei intended to react in a passage in the *Considerazione al Tasso* (c. 1589), frequently quoted as a criticism of the *studioli* created by *qualche ometto curioso*, ("some inquisitive little dabbler") to house odd and unusual bits and pieces. The organising of knowledge and learning as if it were a finite and controllable entity, closed therefore to discoveries and progress, must have seemed to him intolerably restrictive.

Symbolic, with its transient lavishness, of Francesco I's collections was the ebony cabinet encrusted with semi-precious stones, designed by Bernardo Buontalenti to hold coins and medals and situated in the centre of the Tribune. The vogue for semi-precious stones, which Francesco indulged with his acquisitions of vases (most of which are now in the Museo degli Argenti), had begun in Rome though it was later adopted by Florence and extended to the decoration of furniture. Not only table tops but also grandiose cabinets were produced using techniques for *commesso* inlay which became increasingly sophisticated. As early as the 1570s the chapel of the cavalier Niccolò Gaddi in Santa Maria Novella, designed by Giovanni Antonio Dosio, a Tuscan architect who had trained and worked in Rome, had shown the possibilities of adapting coloured *commesso* to the context of ecclesiastical architecture. Although Francesco, who died in 1587, placed a magnificent *tempietto*, or cabinet, in the centre of the Tribune in the Uffizi, it was abandoned by his brother, the third Medici grand duke, Ferdinando I, who replaced it with yet another spectacular and grand piece, also designed by Buontalenti, to house the jewels and gems. The Tribune had not therefore lost any of its importance as a Schatzkammer of the cosmos as well as a shrine for masterpieces of painting and sculpture. Later alterations to the Tribune and the adjacent rooms, which now make it so difficult to determine their arrangement within the context of the museum, progressively weakened its significance as a synthesis of the arts, assembled here for non-competitive appreciation, the realms of nature and, represented by exotic artefacts, different parts of the world.

While not in any way undermining the traditional 'decorative arts' in precious metals and other valuable materials, under Ferdinando I semi-precious stone *commesso* became the pre-eminent art of Florence. From the time when he had lived at the Villa Medici in Rome as a cardinal, Ferdinando had always admired Roman marble inlay. As

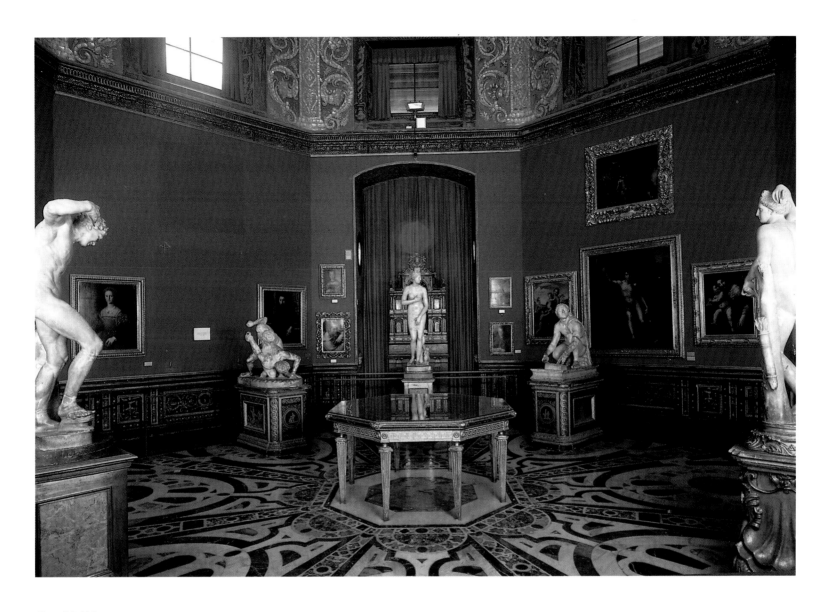

View of the Tribune.
Florence, Uffizi Gallery.

Opposite page: View of the Tribune. *Florence, Uffizi Gallery.*

grand duke he lost no time reorganising the activities begun by his brother which, although experimentally valid, very often lacked focus given their various different locations and branches of research and technology. With the establishment of the *Galleria dei Lavori* in the Uffizi, the Grand Duke effectively created a genuine court workshop for semi-precious stone inlay which soon produced table tops and furniture of the finest workmanship to be sent as diplomatic gifts to other courts, or to grace the Medici residences. Developing beyond the decoration of altars and chapels such as those of the Gaddi and the Niccolini, the sophisticated skill of *commesso* expanded in spatial and dimensional terms to become monumental in scale, reaching a climax in the Chapel of the Princes, preceded only briefly by Michelozzi's altar in Santo Spirito. In order to prevent a shortage of the coloured marble and semi-precious stones required to adorn the vast interior of the Medici mausoleum, proclamations were issued (one wonders with how much success) forbidding ordinary citizens to extract, work and export these rare materials from the grand duchy. Successor to the *Galleria dei Lavori* some two centuries later was the *Opificio delle Pietre Dure*, founded by the Lorraine and transformed into an institute of restoration by the Ministry of Arts during this century. One of the areas of restoration still actively and creatively practised there today is that of stone, and the cutting and working of semi-precious stones is still taught according to the traditional methods of Florentine *commesso*.

During the late sixteenth and early seventeenth centuries, the artist Iacopo Ligozzi, exploiting the experience he had gathered as a naturalist and artist in the service of Francesco I, played a vital role in the development of *commesso* from purely geometric to floral. Marble *commesso* work at the end of the sixteenth century, more than any other visual medium, combines the style and characteristics of Tuscan and Florentine art by simplifying as much as possible the elements involved: reliance on the drawing, which here must be as clear and precise as possible, being both an intellectual and practical guide to production; the use of brilliant contrasting colours, often stark or frigid, enlivened by transformations which flow from one brush stroke to another and correspond to the translucent shadings of the minerals; the profane luxury of the decorations, especially those by artists closest to the court.

Throughout the Baroque period, in the field of the applied arts the supremacy of semi-precious stone heavily influenced Florentine artistic production and was rivalled only by the extraordinary success of silverwork. As a result of developments which had taken place during the early seventeenth century, such as the statues of the Apostles made for the ciborium in San Lorenzo (never completed or put in place) and the ex-voto portrait of Cosimo II (which never reached its destination on the altar of Saint Charles Borromeo in Milan cathedral), the range of forms of semi-precious stone extended into three-dimensional high relief or sculpture, thus adapting itself in an intellectual and entirely Florentine way to the naturalistic trend of the century. Marble *commesso* even succeeded in responding to the fashion for landscape painting, and highly detailed and realistic scenes were made for the panels of the increasingly

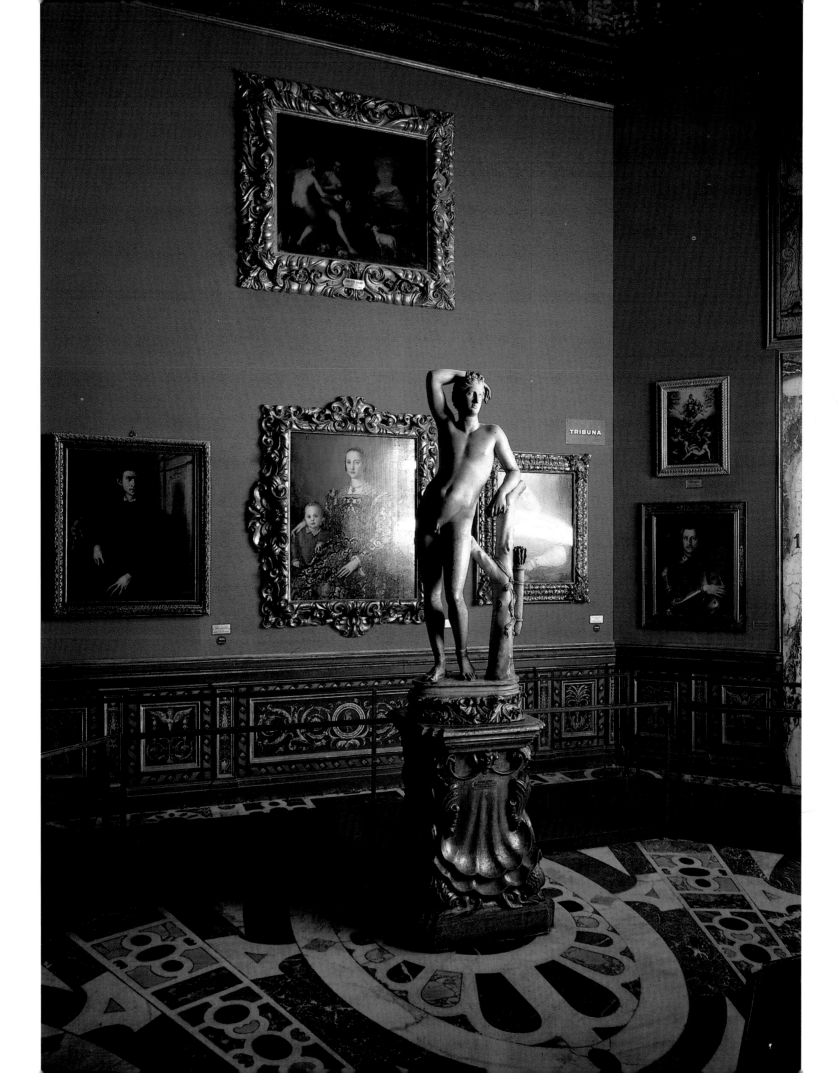

fanciful and grandiose cabinets. At the beginning of the century a fantastic, visionary style (known as 'painting on stone') developed – landscapes made of *pietra paesina* (landscape stone), evoking archaic scenes with the apocalyptic appearance of a geological disaster.

Always enthusiastic collectors, the grand dukes, their heirs and younger sons continually increased their range of interests with the expansion of their international political relationships, their dynastic marriages, travel, commerce and, indeed, the extension of the known world. While they continued to enjoy and appreciate the existing groups of collections, such as antique and modern jewels, ceramics and porcelain, exotic artefacts and natural curiosities, items and materials which, although more common in the courts of northern Europe, were relatively 'new' in terms of Florentine taste began to interest the Medici court. Made in Augsburg, the amazing *Stipo di Alemagna*, a complex, mechanical wonder concealed behind lavish religious iconography, arrived to grace the Florentine palace in 1628.

Other collections of northern origin, still well represented today in the Museo degli Argenti, consisted of turned ivories and carved amber. The twenty-seven ivory vases which Prince Mattias brought back from Coburg, with their eccentric and varied shapes combining geometric purity and free complexity, were well suited to the reserved Florentine interpretation of the Baroque, more inhibited than effusive, more intellectual than emotional.

Just as masterly was the craftsmanship of the celebrated collection of amber, a material found on the Baltic and carved by northern artists. Recently restored under the direction of Kirsten Aschengreen Piacenti, the deep, warm tones have been revealed and are attractively highlighted by the surprising contrast with the purple silk which, now as originally, lines the *scarabattoli* (showcases with the flowing, curvaceous lines of the Baroque) where they are displayed in the Museo degli Argenti.

It would be impossible to over-emphasise the contribution made to the arts by Anna Maria Ludovica, or Luisa, de' Medici, daughter of Cosimo III and last of a dynasty without heirs, which came to an end with her death in 1743. Even if Anna Maria Luisa, the Electress Palatine, had not been a distinguished patron and collector of the arts, her memory would still be cherished and respected for the drafting of the "Family Pact" in 1737. With relentless precision this laid down the terms of the succession from the Medici to the Habsburg-Lorraine family, and established that all items of value belonging to the Medici estate, including the "jewels and other precious things", would never leave Florence and the grand duchy of Tuscany. However, she too was a patron and collector like all her family, and like them had added to the Florentine Treasury. On the death of her husband she returned from the Palatine state, bringing with her an incomparable collection of personal jewels and costly ornaments known as the *galanterie gioiellate* ("jewelled favours"), which also included older, antique gems. Anna Maria Luisa's entirely feminine tendency to acquire and hoard jewels also, therefore, led to the preservation of rare jewellery

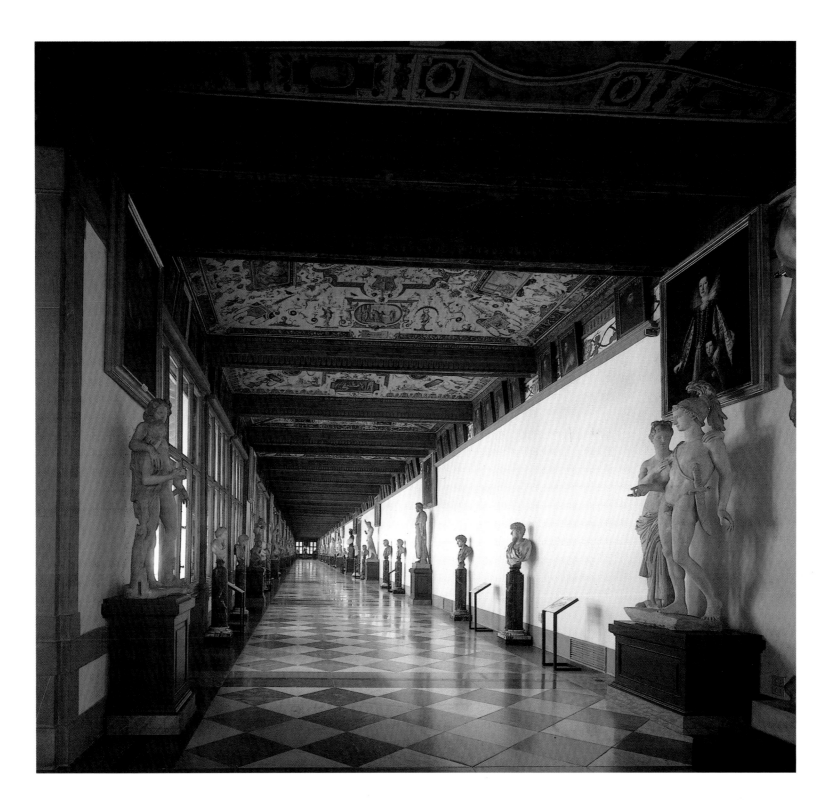

Florence, Uffizi Gallery, first corridor.

which, had it not been for such jealous protection, would probably have been lost. The remaining pieces of this collection, which must have been quite breathtaking, are almost all in the Museo degli Argenti. The Electress' treasures, however, could not avoid continual appropriation by Francis Stephen of Lorraine, and on her death he had many jewels and *galanterie* sent to Vienna, or dismantled and sold on the international market.

At the same time, the state jewels – most significantly the crown – were removed, effectively confirming the end of the Medici dynasty. This crown, the third, had been made at the time of Cosimo III, the first having belonged to Cosimo I, and the second to Francesco I. With its diamonds, rubies, emeralds and enamels, the last crown boldly proclaimed the Medici colours of white, red and green used in the family livery since the fifteenth century and symbolising, according to Paolo Giovio, the three theological virtues of Faith, Hope and Charity. Also removed from the Treasury was the *Fiorentino*, the enormous diamond which, before being lost (most probably cut down), was to be seen on top of the Habsburg imperial crown.

Always associated with the seats of Medici power – the Uffizi, Palazzo Pitti – the Medici treasures have for a long time been considered a minor 'genre' of artistic production, which could be moved around and re-grouped with ease. During the period of the Enlightenment, 'scientific' principles were applied to their reorganisation: classic and antique jewels (or those believed to be so) were placed with archaeological items; arms, ceramics and porcelain with the applied arts; natural curiosities with collections of fauna; cut and worked stone in the mineralogy section; exotic artefacts in the ethnographic collections, and so on. The collections (still amazingly extensive) which remained in the Florentine galleries after dispersal are now exhibited together in the Museo degli Argenti, the Schatzkammer of Palazzo Pitti. Fittingly housed in the Summer Apartment on the ground floor, they fill the imposing series of rooms decorated with frescoes by Giovanni da San Giovanni and many other seventeenth-century Florentine artists, as well as Mitelli and Colonna, artists from Bologna who introduced the technique of *trompe-l'oeil* to Florence.

In the last few decades, exhaustive and careful studies of the Treasury, based on a thorough analysis of archival documents, have succeeded in providing an ever more complete overview of specific aspects, identifying on the one hand patrons and clients, and, on the other, craftsmen, workshops, methods and origins. An extremely important opportunity for specialised study and an incentive to the general public to reconsider these areas of artistic expression, previously little appreciated, was without doubt provided by the series of exhibitions entitled 'Firenze e la Toscana dei Medici nell'Europa del Cinquecento', sponsored by the Council of Europe in 1980.

As is obvious from the bibliography, many specialists are involved in the various sectors of the collections which form the extensive and varied Medici Treasury; one need only mention names such as Kirsten Aschengreen Piacenti, Paola Barocchi, Lionello Giorgio Boccia, Enrico Colle, Willemijn Fock, Detlef Heikamp, Giovanna

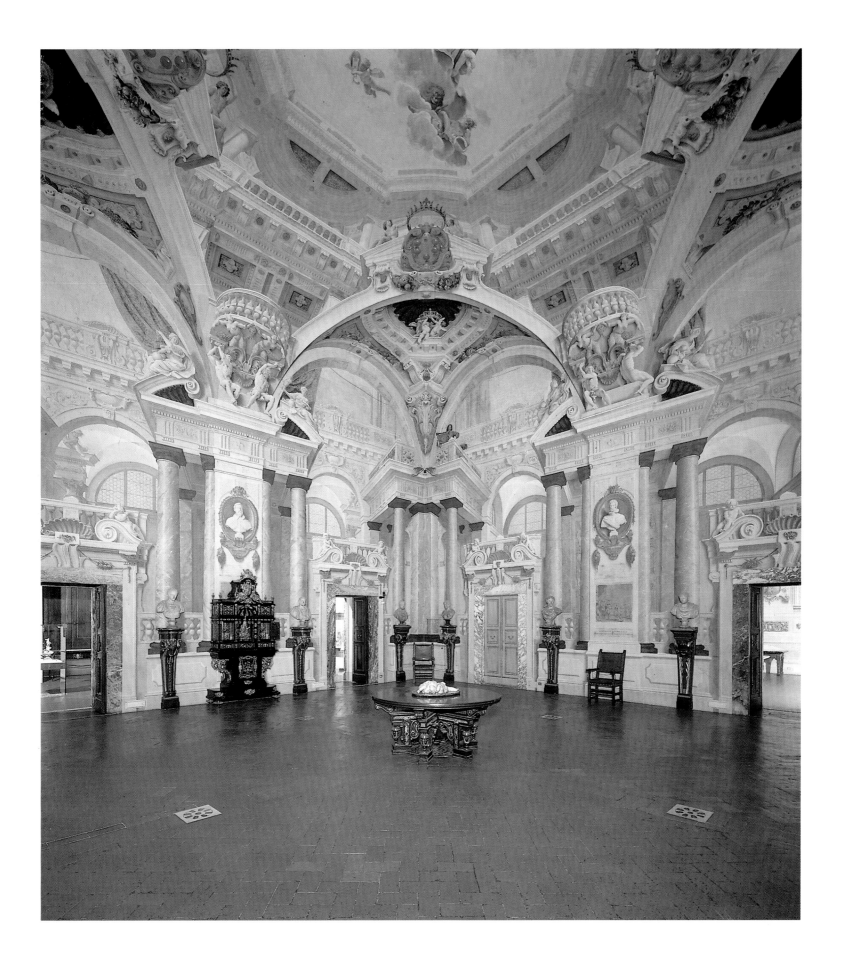

Gaeta Bertelà, Alvar Gonzáles-Palacios, Yvonne Hackenbroch, Adalgisa Lugli, Martha McCrory and Marco Spallanzani. It is thanks to their studies and those of many other experts, including the authors of this book, that an enhanced understanding of the Treasury and its nature has evolved, not least from information concerning lost and missing items. Thus it may now be seen in its proper historical perspective, reflecting the preferences of the Medici – influential private citizens in the fifteenth century, dukes and grand dukes from the sixteenth century on – and, as examples of excellence, influencing the tastes of the Florentines.

Yet that is not all. The evolution of museum studies has brought deserved attention to historic displays – the case of the Tribune in the Uffizi is exemplary – and has emphasised the role of rare and precious items within a systematic arrangement weighted with complexities and subtleties and much more sophisticated than the more usual exhibits to be found in a gallery of paintings or statues. Although on the whole the reconstruction of such settings is impracticable, an awareness of them helps us to envisage works of art and paintings in their composite context, reflecting that elusive and indefinable element known as period feel, or 'taste'. Moreover, should there still be any need, it might also help to break down that old barrier of preconceptions which, particularly in Italian art history, has led to the exclusion of the decorative arts from the Olympus of fine arts, still dominated by painting and sculpture.

THE MEDICI COLLECTIONS FROM
THEIR CREATION TO THEIR DISPERSION

ॐ

The political and economic power wielded during the fifteenth century by the Medici, beginning with Averardo *detto* Bicci (1360–1428), was based mainly on the patron-client network and the inter-family bonds they had so skilfully created within the structure of the republican state. The Medici could, and perforce did, make use of various resources in order to gain supremacy in the republic, and their rise[1] was most certainly facilitated by the alliances they made with brilliant and creative men as a result of their ability to offer much more enticing opportunities than their political competitors[2].

Many today, therefore, may not be aware of the considerable importance attributed to some apparently secondary aspects of the family's patronage and collecting.

The Formation of the Fifteenth-Century Collection, its Dispersion and the Return to Florence of the Medici Treasures

In fact, Cosimo il Vecchio (1389–1464) had gradually accrued in his palace wealth and possessions of every possible kind, and these were intended to present a quite unique image of himself and his family. As regards personal tastes in jewels and rarities we know very little of the fifteenth-century founder of the dynasty. We only know, from a description in Lorenzo Ghiberti's *Commentarii,* that he owned the precious "cornelian as large as a nut with the shell on" portraying Apollo and Marsyas (now in the Archaeological Museum of Naples) which the artist mounted as follows in 1428: "As a clasp I made a dragon with its wings a little open, its head low, and its neck arched and the wings formed the handle of the seal. The dragon, or serpent as we call it, was placed among ivy leaves. Around the figures were antique letters giving the name of Nero which I carved with great care. The figures in the cornelian were certainly from the hand of Pyrgoteles or Polycletes: they were as perfect as anything I have ever seen in intaglio"[3].

Since art historians have generally maintained that Cosimo had an ascetic character which might appear incompatible with a taste for opulent possessions, and given the lack of information concerning his personal tastes as an art collector and patron, it is therefore rather interesting to note that, in a eulogy dedicated to him, Giovanni Avogadro describes, albeit in symbolic fashion, his princely residence as having a roof of shining alabaster, with red porphyry covering the right side and green serpentine the left[4]. These materials, especially the last two with their imperial connotations, were, in fact, used for inlays in the Old Sacristy and to mark Cosimo's tomb in the crossing of San Lorenzo. The floor here contains large discs of these rare stones enclosed by curved marble surrounds which extend outwards and, in their turn, enclose a large circle in the centre. The design is similar to that of the floor, now

Mario Scalini

much worn and damaged, in Hagia Sophia in Istanbul, significantly the place where emperors were crowned.

Such an allusion may perhaps be justified in this specific context as a reference to the role played by the Medici on the occasion of the Council of Florence, of which they were not only the main advocates but also the chief financiers. But we are here mainly concerned with the creation, particularly in the palace in Via Larga built for the Florentine patron by Michelozzo, of a truly unique collection, consisting of rare vases in semi-precious stone, cameos and antique gems, cut and polished jewels, oriental antiquities and antique manuscripts, sophisticated objects made from unusual materials and believed at the time to have magical powers, fragments of classical statues and contemporary masterpieces. In short, the phenomenon we now refer to as 'collecting' began here and, as already mentioned, was motivated primarily by the full awareness that cultural patronage was an indispensable element in achieving stable power.

Unfortunately for us, it is not so easy to follow the sequence of events. Problems arise from both the lack of an inventory of Cosimo's possessions[5] and from the subsequent disappearance of many of the treasures following the 'misfortunes' which befell the dynasty after the death of Lorenzo il Magnifico. Such misfortunes were the result not only of the economic decline of the family, but also of the almost total inability shown by those who succeeded Lorenzo to maintain the general support of the public.

It should be stated, in order to better understand the events which we can only briefly describe here, that the origins of collecting certain types of object have been lost in the mists of time, and that, in general, possession of something already accepted as being of value for whatever reason has always enhanced the owner's reputation. For centuries elements of superstition, witchcraft, magic, cultural or historic mystique, religious devotion and intellectual curiosity have loosely inter-mingled in princely collections, and the history of the Medici treasures reflects all these aspects.

Although often ignored by art historians, the most important item in the collection belonging to Piero (1416–69), the son of Cosimo il Vecchio "Pater Patriae", was neither a rare curiosity nor a magnificent painting or sculpture, but was precious both for the material from which it was made and for its symbolic and devotional value. This was a reliquary known as the *Reliquiario del 'libretto'* which is now housed in the Museo dell'Opera del Duomo in Florence, partially concealed, despite its solemn magnificence, by the later container in which it is kept, a not unworthy piece by Paolo di Giovanni Sogliani (Florence 1455–1520)[6]. The relics it contains correspond to those which Baldwin II, Emperor of Constantinople, sent to Saint Louis in 1247 and for which the Sainte Chapelle was built. Charles V, King of France, then presented it to the Duke of Anjou as a gift around 1370, though probably more precisely in 1371, the year in which the king gave a fragment of the True Cross to his other brother, the Duke of Berry.

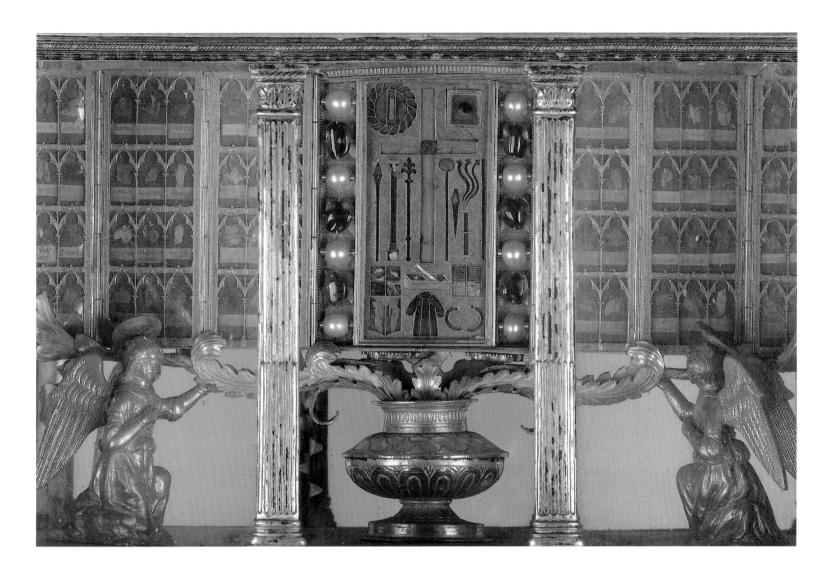

French workmanship, the Libretto
Reliquary *(detail) 1371. Florence, Museo
dell'Opera del Duomo.*

Following page: Franco-Burgundian, Reliquary of the Thorn,
*rock crystal with mounts of enamelled gold, precious stones and
pearls, first half of 15th century. Baroque support in silver and
amethyst. Florence, San Lorenzo.*

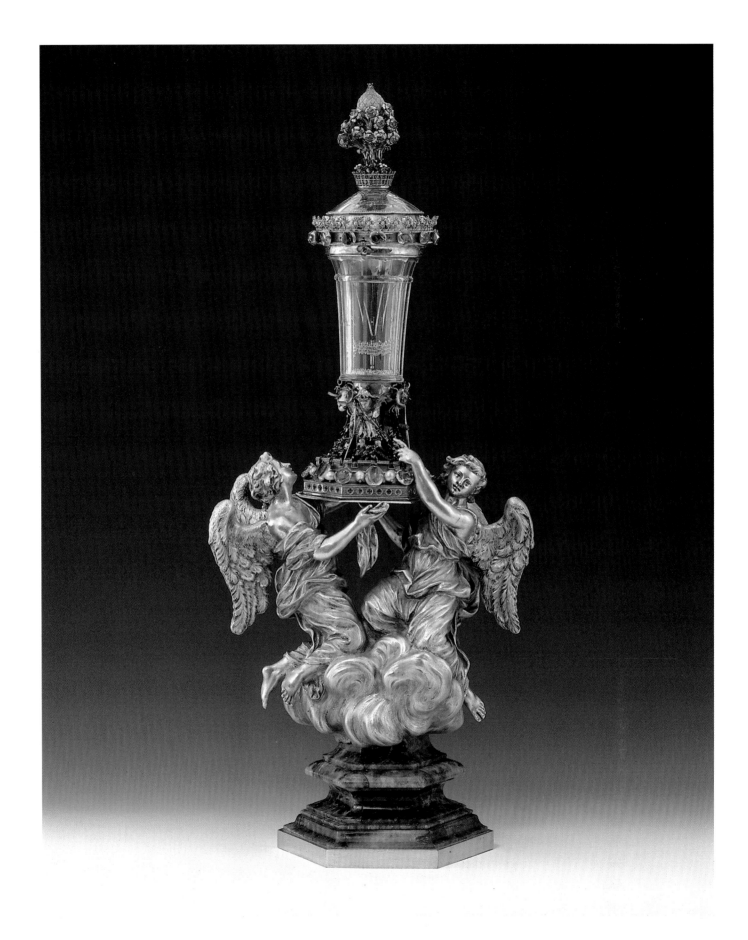

This splendid example of the goldsmith's skill is easily identified in the inventory of 1465[7], *Gioie et altri cose di valuta di Piero di Cosimo de' Medici* (Gems and other things of value of Piero di Cosimo de' Medici), and in the inventory compiled on the death of Lorenzo il Magnifico: "A gold reliquary in the form of a tabernacle with six doors in which are 8 pearls each of 32 ounces and 6 rubies, estimated weight altogether one pound and 6, and with a case fitted with locks and chains and hooks and gold keys, in all 1500 florins"[8].

The reliquary was handed over to Cardinal Francesco Piccolomini, who later became Pope Pius III, by the auditors of Lorenzo's legacy. He subsequently presented it to the Opera di San Giovanni by order of the Florentine Signoria itself.

One can already see from the history of this first, well-documented item of the Medici treasure that the family's collection of valuables consisted of objects which had come into their possession in various ways and for many different reasons. In this particular case we do not know if the piece was given to Piero as security against a loan which was never repaid, or if instead it was perhaps presented to him during the period in which he enjoyed the favour of Louis XI of France who granted the right to add to the Medici coat of arms a blue bezant (sphere) adorned with gold fleurs-de-lys, a heraldic symbol of regal benevolence[9].

The second hypothesis seems more probable as the reliquary still preserves the miniature representing its original owners as well as the inscription confirming the Anjou provenance, clear evidence that the item could not, in fact, have passed through many hands before reaching Cosimo's son.

In comparative studies of the semi-precious stone vases which once constituted the collection housed in the Medici's Via Larga palace, the existence or otherwise of the French bezant in the description of the heraldry, where present, has always provided a means of dating the addition of an item to the collection as either before or after the concession of the privilege in 1465, or at least of proposing a date for their mounts.

It is rather interesting to note that according to the inventories[10] three of the most prestigious pieces belonged to Piero "the Gouty". The most opulent of these is the large goblet made of rock crystal, now in the Treasury of San Lorenzo (Inv. 1945 no. 25)[11]. The stand on which it rests is decorated with three fantastic figures of hunters, one of whom is armed with a bow and quiver and holds a curved sword at his side. The technique of combining gold carving with enamel in colours ranging from white, blue, red, green and pale pink to purple was much favoured at the time in the courts of Burgundy and France. In 1492, when Lorenzo il Magnifico's inventory was drawn up, it was described as: "A crystal glass, with a lid also in crystal mounted in gold, and set in the base 6 sapphires, 6 balas rubies with, in between these, twelve large pearls with three more rubies and three pearls in each of the three enamelled figures; on the lid are 7 sapphires and 7 balas rubies, 14 large pearls and 27 rubies, between these rubies are 12 pearls and on the top is a pyramid-cut diamond, total weight 3 pounds and 4 ounces, value 800 florins"[12].

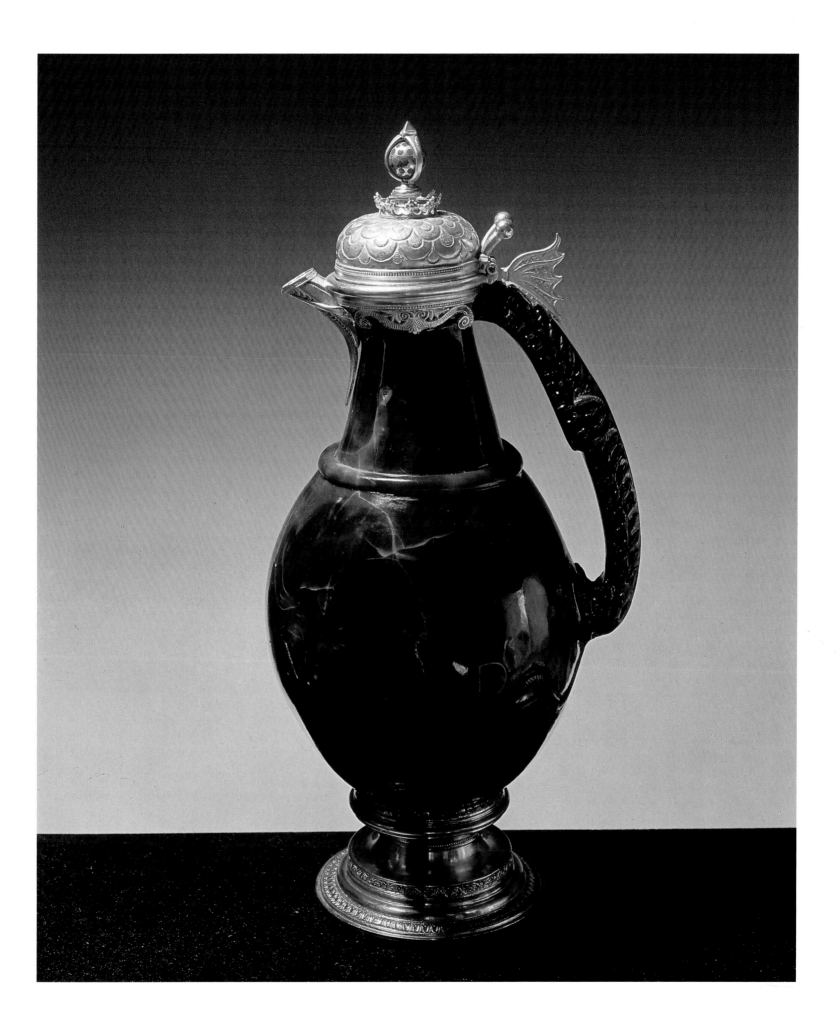

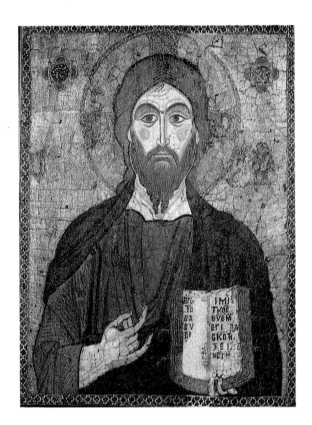

Frame in silver and enamel *with the Medici arms, Florence, 15th century. London, Victoria & Albert Museum.*

Byzantine art, Mosaic of Christ, 12th century. Florence, Museo Nazionale del Bargello.

This spectacular piece is one of the most assured examples of the French method of faceting rock crystal and can be compared with other precious works made in the early fifteenth century for the king of France and the Duke of Berry[13]. Moreover, its style and overall design are clearly very similar to those of the goblet belonging to Philip the Good, dated some time between 1453 and 1467, housed in Vienna's *Weltliche Schatzkammer*. It was customary to drink from such goblets during festivities to celebrate the beginning of the new year, and it is interesting to think that the Florentine glass may well have been made for this purpose and could even have been a goodwill gift to Piero de' Medici from the French court. Cosimo's son also possessed two sumptuous vases of red jasper with handles and mounts attributed to Giusto da Firenze[14], now in the Museo degli Argenti (Inv. *1921* nos. 638, 772). The first, a truncated cone shape, could perhaps be "a cooler" described in the 1492 account, or more probably "a goblet" valued at three hundred florins, assuming, however, that the compiler described it somewhat inaccurately. According to the sixteenth-century drawings of it when it was used as a reliquary in San Lorenzo, it had a ferrule like a ring set with a diamond, a feature frequently adopted by the Medici, containing a sphere bearing bezants. The other, also mentioned in the 1456 inventory, and later as belonging to Lorenzo il Magnifico, is described as "a goblet with handles and lid, in jasper decorated with silver gilt", weighing eight pounds and estimated at 600 florins. During the sixteenth century this splendid example of glyptic carving lost its ferrule and today it has a beautiful finial consisting of a slightly concave element rising from a gothic-style crown engraved with the motto SEMPER and a circle of tricolour feathers

which, following the account of Paolo Giovio[15], are traditionally considered to be Lorenzo's. At the top, the ring with the diamond encloses a sphere bearing, however, only red bezants, as in the oldest form of the Medici arms. Clearly all these objects were frequently altered in the past and it is therefore difficult to link the documentary evidence to the pieces as they are today; the vases which are inscribed Lau.r.Med, however, all belonged to Lorenzo il Magnifico[16]. It is equally difficult to determine precisely the origin of these faceted vases. Although the craft of stone engraving, or at least cutting, is known to have existed in Paris during the Middle Ages, and although it has often been suggested that the vases were of oriental manufacture, it seems increasingly likely that they were, in fact, of Venetian origin[17].

In Florence the art of cutting rare marbles, found mainly in excavations, was not unknown as can be seen from the floor decorated with Medici emblems in the chapel of the Via Larga palace, but the craft of engraving, turning or making semi-precious stone into bowls or cups was probably not yet one of the city's skills. In fact, in 1477 Piero di Neri Razzati was exempted from taxes on the condition that he taught apprentices the art of cutting precious stones[18]. Piero de' Medici even regarded the rock crystal pommel of a sword as a rare and unusual item in his collection[19].

The evaluation of the jewels and vases which belonged to Lorenzo is extremely interesting. Apart from the "bowl of sardonyx" worth ten thousand florins, now known as the 'Farnese Cup', and the "horn of a unicorn" which had belonged to Cosimo il Vecchio[20], the items of greatest value are a pendant with "a faceted diamond set in gold in the form of a serpent and a large pearl of about 38 carats of pure and perfect colour and texture, and a shoulder clasp with a pierced cabochon balas ruby, without a backing or a mount, fixed in a square frame and with two large pearls each in a clasp and of about 20 carats and a diamond mounted in four places inside the aforementioned flat setting", estimated respectively at 3,000 and 2,200 florins[21]. As we have already seen, the *Reliquario del 'libretto'* was valued at 1,500 florins, while the bronze chimney relief decorated by Bertoldo di Giovanni with a skirmish between horsemen and now attractively displayed in the Bargello museum, was worth barely 30 florins, more or less the same as a good jousting helmet. It is obvious, therefore, that great value or prestige was attached only to those items which were rare either for their material, antiquity or exotic origins. These factors may help to explain the estimated value of no less than 2,000 florins for the "sardonyx chalice" with silver gilt mount, now in the Museo degli Argenti (Inv. 1921 no. 777).

This is, without doubt, one of the most fascinating pieces to have survived and the quality of the material blends so harmoniously with the form chosen for the vase that the question of its origin is extremely puzzling. The shape of the vase is strongly classical in style. This has been seen as evidence of the influence of Byzantine art on the Sassanid culture to which many attribute the piece, though Heikamp has rightly pointed out that this was also found in other cultural contexts and over a considerable period of time. Nevertheless, the handle in the form of a panther (although the later

Timurid. Jade cup. *Central Asia, 15th century. Florence, Museo di Mineralogia.*

Opposite page: Franco-Burgundian, Cup in violet and ochre jasper, with mount of silver gilt and pearl, first half of the 15th century. *Florence, Museo degli Argenti.*

addition of a webbed wing embossed with a series of eyes on top of the head has transformed it into a sort of dragon) and the motif of small leaves at the base of the handle itself are indeed reminiscent of a Byzantine or Sassanid creation of the sixth to seventh centuries as Hahnloser suggested[22]. The mount is most unusual: the lower part of the band around the neck consists of a reversed double volute with palmettes, not unlike a design by Donatello[23] and most certainly of Florentine craftsmanship, similar in style perhaps, as Dora Liscia Bemporad has suggested, to some of Verocchio's work. Not only is the finial the same as that on the red jasper goblet but it should also be noted that the sphere inside the ring has a field with the Medici bezants. The presence of this early Medici coat of arms may suggest a very early date for the mount, which could well conform to Cosimo's tastes rather than to those of his son Piero. Such a hypothesis might be upheld on the basis of the heraldry found on the frame of an item not yet identified in the inventories and now kept in the Victoria and Albert Museum in London, consisting of an unusual shield shaped like a plaque and almost identical to those found in the Old Sacristy in San Lorenzo[24].

Another vase, this time in rock crystal and housed in San Lorenzo (Inv. 1945 no. 29), is comparable to Sassanid examples and is identified as being that "with a handle and lid and spout", weighing nine pounds and valued at no less than 800 florins in the 1492 inventory. To the modern eye it is just as attractive as the previous piece, but the faceting, which had been imitated in Venice for quite some time, and the more common material of quartz which is not even entirely pure, must have considerably diminished its value for the Renaissance connoisseur. In this case, too, the mount, which has been altered at the top, is clearly of Florentine craftsmanship as can been seen on comparison with various religious objects often made of gilded copper which are contemporary with it and which have recently been brought to the attention of historians[25]. Its dating, later than 1487 and certainly before 1492, has been suggested by the emblem of the Guild of Silk Makers which can be seen stamped on one of the lilies on the band around the lip of the vase[26]. This further confirms that the piece is Florentine and indirectly casts some doubt on the presumed Venetian origin of the rock crystal[27].

Unlike other materials such as jade, clearly a rarity at the time in the West since the only vase of this material in the collections today, unfortunately lacking its mount, is now believed to be of Timurid origin[28] (Museo di Mineralogia, Inv. 1947 no. 1336/565), rock crystal had always been worked in Europe. This has frequently been discussed by art historians as it is linked to the symbolic significance of the transparency of purest quartz, considered particularly suitable for displaying relics which had to be visible. During the Middle Ages, although precious and durable containers were required, they could not be made from engraved glass since the skill of working silica at high and at low temperatures had been partially lost with the fall of the Roman Empire. In the West the increase in production and use of rock crystal followed the discovery of veins of quartz in the Alps and Carpathians, whereas the

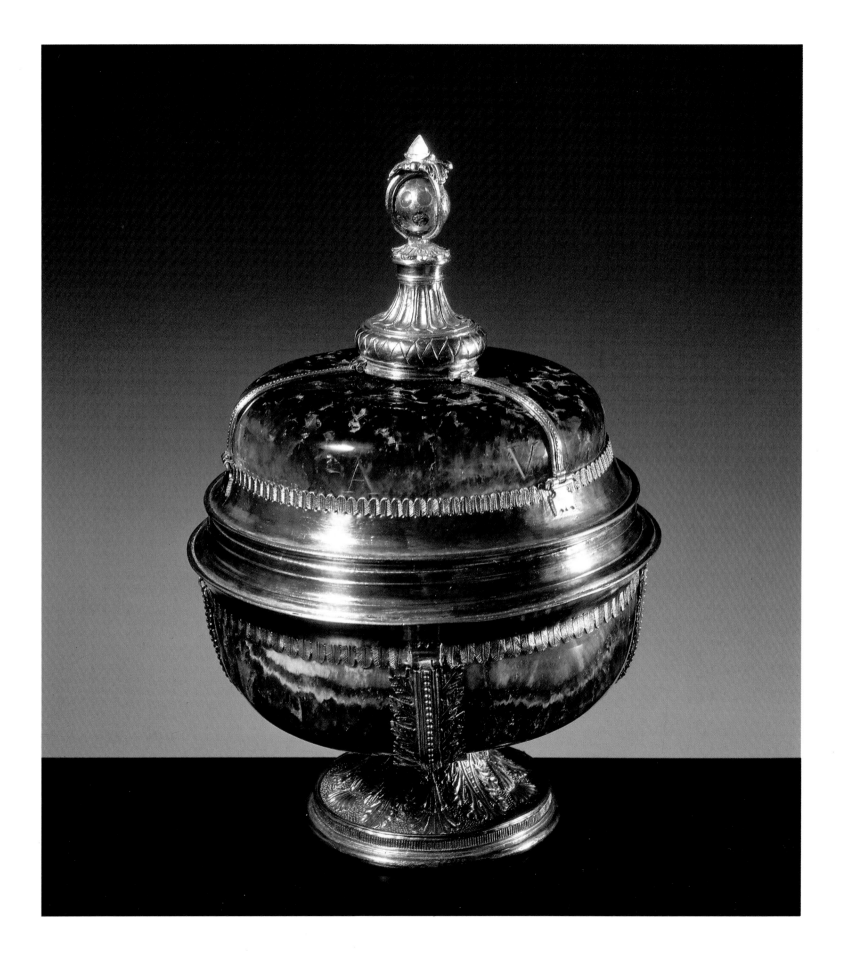

Fatimid caliphs used the deposits in the Red Sea already known in Pliny's day[29]. Indeed, its use was so frequent that in the statutes of Paris between 1258 and 1269 the cutting and polishing of rock crystal is referred to specifically alongside that of precious gems[30], and in 1281 a Guild of Crystal Workers was created in Venice. Items of French manufacture in the Laurentian collection still include "a cup of chalcedony and jasper flecked with yellow and with a lid and a band and base decorated with silver and gold and a pearl on the top of the lid, weight 2 pounds 3 ounces – f. 200" (Museo degli Argenti, Inv. 1921 no. 533). This has certainly been less tampered with than other pieces and is the best example of the French method of working coloured stone as well as of the crenellated style of mount with animal motifs already seen in the more prestigious rock crystal vase.

While it is obviously not possible to discuss every item, the gaudy amethyst vase in the Museo degli Argenti (Inv. 1921 no. 804) poses not a few problems despite its magnificence. The finial with the ring and diamond encloses the usual sphere with bezants, one of which has the French fleurs-de-lys, though this is not present in the sixteenth-century drawing which documents it. Despite this, it is perfectly clear from the initials engraved on the lid of the goblet that it belonged to Lorenzo il Magnifico; moreover, the decorative bands on the rim of the mount, with the motif of small feathers, are so similar to those on the lip of a brass horn described in the 1492 inventory that it seems probable that the same Florentine craftsman worked on both of these pieces[31].

A vase, also with a lid and also in amethyst, housed in the Museo degli Argenti (Inv. 1921 no. 685), seems to have been cut from the same stone. Indeed it is reasonable to suggest that both, including the mounts, were made in Florence around 1470 for Lorenzo at the time when Piero di Neri Razzati, referred to earlier, was active as a semi-precious stone cutter. Strangely it is not possible to identify these two pieces with any certainty in the inventory of 1492, although several amethyst »vases« are mentioned. On the other hand, also included among the sumptuous items which were clearly considered of great value was a twelfth-century Byzantine mosaic of Christ (Museo Nazionale del Bargello, Inv. mosaici no. 3)[32]. This cannot be excluded from the group of precious items in the Medici collection since, although it is not made of costly materials, from both a devotional and artistic point of view its value as a venerable rarity is equal to that of other items in the collections, including religious ones[33].

There is no certainty about the origin of many items which were very probably part of the Medici collection housed in Michelozzo's palace, and in fact the vicissitudes which befell the Medici jewels after the death of Lorenzo were so complex that any identification can now only be extremely tentative.

In 1494, when the palace in Via Larga was looted, many, if not all, of the valuables must already have been taken to a safe place, probably the monastery of San Marco which was closely identified with the Medici. Thus, when Charles VIII, King of

Opposite page: Double cup in amethyst *with silver-gilt mount, Florence, 15th century. Florence, Museo degli Argenti.*

Seal-mount, seal with Hercules *owned by Clement VII, Alessandro and Cosimo I de' Medici, silver gilt, precious gems and enamel. Florence, Museo degli Argenti.*

Domenico di Polo, Guilded cameo with profile of Duke Alessandro. *Florence, Museo degli Argenti.*

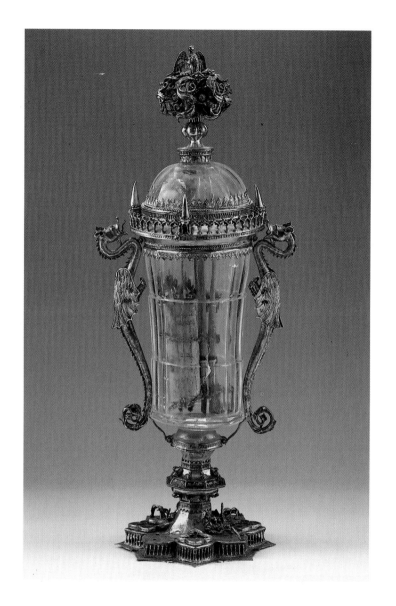

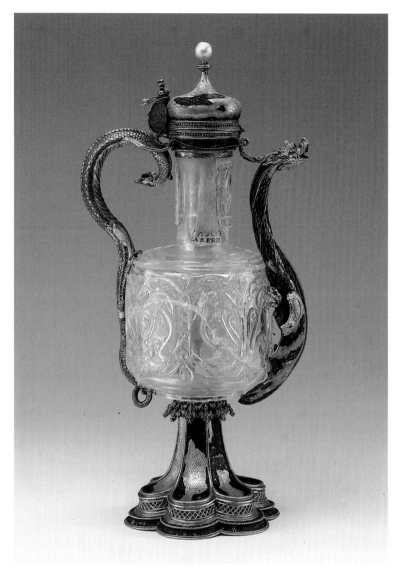

Venetian art, Reliquary of Saints Cosmas and Damian, *rock crystal and silver,
15th century. Florence, church of San Lorenzo.*

Reliquary of Saint Erina, *rock crystal with enamelled silver and pearl mount, Arabian art,
10th century and Venetian art, 15th century. Florence, church of San Lorenzo.*

Opposite page: Florentine goldsmith active in Rome, Reliquary of Saint Nicholas, *rock crystal
and silver gilt, early 16th century. Florence, church of San Lorenzo.*

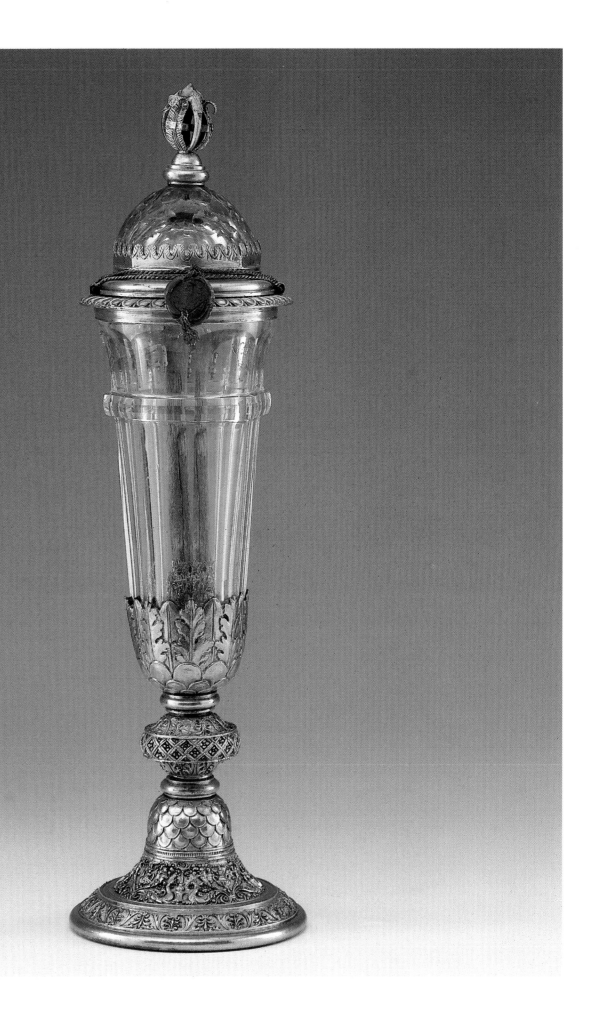

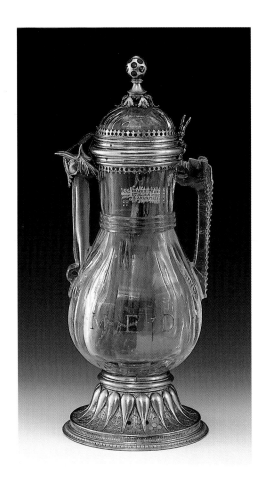

Reliquary of Saint Anastasia *rock crystal, silver and enamel, Persian art, 10th century and Florentine art, 1487–1492. Florence, church of San Lorenzo.*

France, entered Florence on 17 November of that year and asked to see "the medals, cameos and porcelain of Piero" his request was unfulfilled, according to the account of Mario Sanudo[34]. Nevertheless he may have been able to obtain some pieces of value for Lorenzo's son, Piero *lo Sfortunato* (1472–1503), who had gone to Venice after being banished from the city. Historians described him as having more than adequate means and possessions during his stay in the city which, however, ended tragically in a skirmish near Garigliano while in the service of the French.

In Florence the possessions which had passed to the Signoria were, on the whole, pledged "contro valuta" (for cash) in order to compensate the French king. It was during this difficult period that a mosaic representing the Saviour, probably forming a pair with the mosaic in the Bargello, was sent to Naples as a gift for Charles VIII, crediting the Medici with only ten florins. The special group of "auditors and officials for the goods and possessions of Piero di Lorenzo de' Medici" subsequently decided to pay non-Florentine creditors by raising money from an auction which was held in Orsanmichele in 1495[35].

Twenty-seven of the Medici vases, in point of fact the same number as those recorded in Lorenzo's *scrittoio* inventory[36], were sold to Lorenzo Tornabuoni who appears again shortly afterwards as the main client for the jewels and precious gems which the Signoria had recovered from San Marco, the Murate[37] and San Lorenzo, religious houses which had in the past enjoyed Medici patronage. How this had been achieved is of little importance since the fact that such items were handed over for a value far below their actual worth has no relevance for historical purposes. In fact, in late 1495 many of the Medici valuables, including at least twenty-two vases, were already quite legally in Rome, while another four were with the Nerli family in Florence. Both Ludovico il Moro, Duke of Milan and Isabella d'Este, Duchess of Mantua, were interested in acquiring some of these rarities, and Isabella even called on Leonardo da Vinci's expert advice in 1502 when considering the acquisition of one of the Nerli vases. The Duchess was undecided between a rock crystal vase which appealed strongly to her and a jasper vase favoured by her consultant.

In 1515 we hear of another precious vase, this time a gift from the Medici Pope Leo X to the church of San Lorenzo to be used for the *Corpus Christi*[38]. It is quite probable, at least according to the papal edict of 16 November 1532 in which Clement VII bequeathed about forty reliquaries to the church, that already in 1520 other precious receptacles in the treasury of San Lorenzo contained important relics, but it was not until 1525 that plans were made for the famous *Tribuna delle reliquie*. Designed by Michelangelo, this structure was eventually built on the inner façade[39], although it was originally planned to locate it over the main altar, in the form of a ciborium with porphyry columns. These plans were altered once again after the sack of Rome but it was finally completed to house the rare relics put on display once a year when intercession was made for the sins of the 'penitent' who went to see them. In 1530, heavily escorted by a company of imperial lancers, Alessandro de' Medici (1511–37)

became Duke of Florence. The son of Clement VII, he was accepted only reluctantly by the citizens and, like his predecessors, he too was a lover of art and luxury. It is known that in his Palazzo Vecchio residence he kept a rare pontiff's rapier, a sword presented to him by his father-in-law Charles V, and a golden rose, all unfortunately later destroyed[40]. A seal portraying Hercules also belonged without a doubt to Alessandro, later passing to Cosimo I. It, or at least part of its attractive mounting, may perhaps be identified as the seal now in the Museo degli Argenti (Inv. Bg. oreficeria civile 30)[41]. If the ducal coat of arms in silver leaf was applied some time after the handle of the gem had been made, as it surely must have been[42], then it most probably dates from the period of Alessandro's ownership. The same is true of the beautiful fifteenth-century reliquary, also in the Museo degli Argenti (Inv. A. s. e. no. 263), on which the same coat of arms obscures those of the Signoria although two Florentine seated lions on either side of the shield were left visible. Such an alteration as this seems an act of arrogance and condemnation of the Republic scarcely imaginable on the part of a ruler as shrewd as Cosimo I. By reconstituting the nature and contents of the collection of the first Florentine duke, which also included some gems engraved with his portrait attributed to Domenico di Polo (post 1480–c. 1547)[43] and therefore most probably made at court (Museo degli Argenti, Inv. 1921 nos. 112, 172), we can also perceive the ambition which led to his commissioning coins and medals with his own profile from the great Cellini[44].

Five years before Duke Alessandro was assassinated, Clement VII issued an edict bequeathing to the church of San Lorenzo most of the "antique vases" housed there, many of which came from sources other than the original Medici collection. Some of these have fantastically inventive mounts representing creeping dragons, such as those on the reliquary of Saint Erina (Inv. 1945 no. 3). It is not known how this splendid tenth-century Fatimid vase arrived in Europe[45], but it has an extremely unusual fifteenth-century Venetian mount. The container of the relics of Saints Cosmas and Damian (Inv. 1945 no. 95) is also Venetian, decorated on top with a tangle of flowers above which an eagle rises majestically. The same craftsman was probably responsible for the reliquary of Saints Theodosia and Bartholomew (Inv. 1945 no. 148), also decorated with dragons which, on both the vessel itself and on the lid, are facing each other as if to diffuse outwards the effect of the crystal's reflections.

These are now unanimously considered to be entirely fifteenth-century pieces[46]; however, the mount and the rock crystal body of the Saint Nicholas reliquary (Inv. 1945 no. 147) are still generally considered to be of different periods. The most recent suggestion[47] is that the hyalite quartz is of fifteenth-century Venetian manufacture, while the mount was most probably commissioned by Pope Leo X from a Florentine jeweller active in Rome at the beginning of the sixteenth century. This theory is partially confirmed by the decorative repertory seen in late works by Donatello and perhaps Verocchio, later codified in a book of designs by Vittore Ghiberti (now in the Biblioteca Nazionale in Florence), containing motifs such as the facing wingless

Pier Maria Serbaldi, Venus and Eros, porphyry, 1st quarter of 16th century. Florence, Museo degli Argenti.

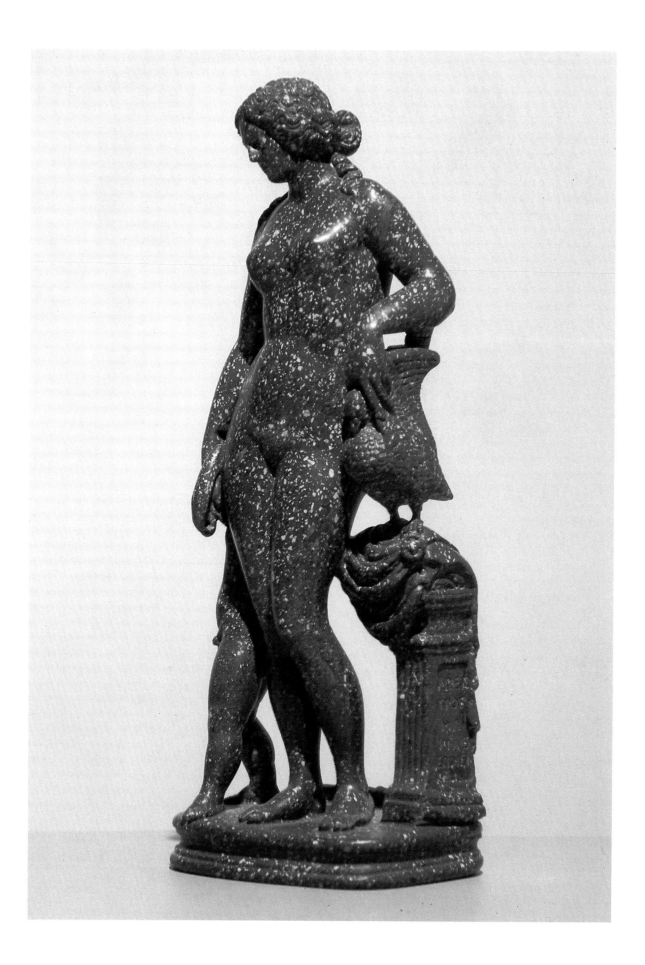

griffins on the base, the palmettes, alternately seen frontally and in reverse, and other forms of decoration. If this is, in fact, the vase which once contained the wood of the cross, donated by the Pope in 1515–16, or at the latest in 1520, as indeed it seems to be, then it could perhaps be similar to the container for the *Corpus Christi* which was destroyed in 1799.

One of the most striking, and also one of the most problematical, items in San Lorenzo is the reliquary of Saint John the Almsgiver, Bishop of Alexandria (Inv. 1945 no. 87). A cylindrical vase with handles, it has an elaborate mount of partially enamelled silver, and putti holding scrolls inscribed M.L.M [48].

Unfortunately no full explanation has yet been found for the symbols[49] stamped on the piece, nor are we helped by the fact that it is generally believed to be the work of Francesco d'Antonio, a Sienese craftsman known to have been active between 1440 and 1480, and renowned for his reliquaries containing the arm of John the Baptist in the Opera del Duomo and the robe of Saint Bernardino in the church of the Osservanza in Siena[50]. Given the complex sequence of gifts and donations to the church of San Lorenzo, we should be particularly cautious in this case since the only date of which we can be certain is that of 1532 when it was listed in the papal edict.

As we have seen, many uncertainties and hypotheses remain in reconstructing the fate of the secular items in the Medici collection, but the rare little porphyry figure of Venus and Cupid in the Museo degli Argenti (Inv. sculture 1914 no. 1067)[51] must date from some time during the first twenty years of the sixteenth century. Signed in Greek by Pier Maria Serbaldi da Pescia (*c.* 1455 – *c.* 1520), a sculptor who lived in Rome from 1499 and worked for Leo X, the statuette does not appear in the Medici inventories until 1704, when it is recorded in the Tribune of the Uffizi. There is nothing to indicate that it was commissioned by or belonged to any of the Medici before Alessandro's death. Nevertheless, it is clearly part of the revival of interest in rare, symbolic and unusual materials that early Renaissance patronage had created in Italy[52].

An engraved bas-relief portrait of Leo X in the Museo degli Argenti (Inv. 1921 gemme no. 325) may almost certainly be attributed to Serbaldi[53] and, given the subject's own cultural and artistic preferences, it is not unlikely that he may himself have commissioned this unusual work of art which, like so many other of his rare and precious possessions, subsequently found its way to the city of Florence.

Notes and references

1 Alberto Tenenti summarises the problem in his book, *Firenze, dal comune a Lorenzo il Magnifico 1350–1494*, Milan 1970, first ed. Paris 1968; see especially pp. 90–102, and at p. 95: "…it should not be thought that during this period Florentine humanism was ever politically 'popular' or had ever proposed, even implicitly, true solidarity among all citizens. The frequent opposition to the hereditary nobility was intended, above all, to emphasise the worth of the bourgeoise 'nobility' in comparison…".

2 For information of a general nature and of mainly literary and philosophical content, see Eugenio Garin, *L'educazione in Europa*, Bari 1957, and *L'umanesimo italiano*, Bari 1952. Also E. H. Gombrich, "The early Medici as patrons of art: a survey of primary sources", in *Italian Renaissance Studies*, London 1960, pp. 279–311.

3 L. Ghiberti, *I Commentarii*, II. 20, edited by J. von Schlosser, Berlin 1912, II, p. 47.

4 Gombrich 1960, p. 294.

5 See *Gli inventari medicei 1417–1465, Giovanni di Bicci, Cosimo e Lorenzo di Giovanni, Piero di Cosimo*, edited by M. Spallanzani, Florence 1996; the text Archivio di Stato di Firenze, Mediceo Avanti Principato [hereafter ASF MAP] no. 83, insert no. 30, cc. 166–169b records at least the more opulent items inherited by Cosimo from Giovanni di Bicci (1360–1429), notably c. 167b: "…A goblet of cut crystal with a stem of silver gilt /…/ A horn decorated with silver gilt and with precious stones and a dragon's tongue…" described in the paternal inventory as for placing on a table.

6 G. Brunetti, entry no. 21 in *Il Museo dell'Opera del Duomo a Firenze*, II, Milan, 1969, pp. 250–52. It is described by Brunetti in detail thus: "The reliquary of this name, of French manufacture dating from the second half of the 14th century, is a small gold polyptych, enamelled and decorated with eight pearls and six balas rubies with an application above the central section; when the reliquary is closed, a miniature on parchment is revealed, portraying on the recto a Crucifixion with the Virgin, Saint John and Mary Magdalen, and on the verso the Holy Trinity and portraits of Charles V, King of France and his wife, Jeanne de Bourbon, kneeling. On the verso of the central section there is an inscription in enamel [see below]; the verso of the two lateral sections has an enamel decoration of French lilies in a diamond shaped frame, visible on the front when the reliquary is closed. On the front the six lateral sections are subdivided into four by three pillars and each compartment thus obtained (seventy-two altogether) contains a relic, named in a tiny scroll. However, the most important relics, almost all the tools of the Passion, are placed in the central section. On the frontal there is an enamelled image of the instruments; the inscription in French on the verso states that King Charles V [1364–1380] gave to his older brother, Louis, the first Duke of Anjou, this reliquary and the relics taken by him from the Sainte Chapelle of the palace: the blood of our Lord; the blood of the miracle [from an image of Christ bleeding after being struck by an infidel]; the crown of thorns; the true cross; the iron of the lance; the cloth [the cloth which covered the supper table ?]; the seamless tunic; the vermilion cape; the cloth He wore at the supper; the swaddling bands; the shroud from the tomb; Moses' tablets; the sponge; Moses' staff; the chains which bound [Christ] to the stake; the nail found at Saint Denis; the pillar; the whips…"

7 A. Grote, "La formazione e le vicende del tesoro medicео nel Quattro-cento", in *Il tesoro di Lorenzo il Magnifico*, edited by N. Dacos, A. Grote, M. Giuliano, D. Heikamp, U. Pannuti, Florence 1980 (which brings together the catalogues of the exhibitions on the jewels, 1973, and the vases, 1974), pp. 125–44. Grote mentions the first inventory of Piero's possessions (ASF MAP no. 162) from 1456 to 1463.

8 Cf. E. Müntz, *Les collections des Médicis au XV siècle*, Paris 1888, pp. 40 and 73; the description is taken from the manuscript in the ASF MAP no. 165. The description was identified as the item in question by G. Poggi, "Il reliquario del 'libretto' nel battistero fiorentino", in *Rivista d'arte*, IX, 1916–18, p. 247.

9 The original document, or certification of nobility, is still kept in the Archivio di Stato di Firenze, Diplomatico Mediceo, May 1465.

10 See the research carried out by Andreas Grote and Detlef Heikamp at the time of the exhibition in 1974, bibliography at note 7.

11 Cf. E. Nardinocchi in *I Tesori di San Lorenzo*, exh. cat. Florence 1995, p. 28.

12 ASF MAP no. 165, c. 17v. The three pearls between the figures, the fourteen around the base of the lid and the twelve on the finial (now shaped like a pine cone) have all been lost. The discrepancy is probably due to a mistake on the part of the compiler of the inventory, influenced by the mountings of other vases. In 1532 when it was brought to its present location, it contained a relic of Saint Catherine; today it contains a thorn from Christ's crown. This relic was probably brought to Florence in 1709 by Cardinal Ottoboni in a gold reliquary "of most excellent craft". Evidently the precious container, rightly believed to be the most sumptous of all those in rock crystal, had previously been sent to Rome to hold this exceptional object of veneration. The present amethyst base with two silver angels, made by Cosimo Merlini to a design of Giovan Battista Foggini (1696), as Nardinocchi tells us, came from the dismembered reliquary of San Fiacre.

13 The Reliquary of the Thorn, which was brought from Constantinople by Louis XI (1239) and belonged to the Duke of Berry, is now in the Rothschild Bequest in the British Museum; for a discussion of the group see R. Eikelmann, "Goldemail um 1400", in *Das Goldene Rössl*, exh. cat. München 1995, p. 130. For analogies between the mountings of the stones and the colours of the enamel work and the famous Hohenlohe necklace, first documented in 1511, see the entry by R. Kahsnitz, ibid. pp. 246–8.

14 See also G. Cantelli, "Storia dell'oreficeria e dell'arte tessile" in *Toscana dal Medioevo all'età moderna*, Florence 1996, p. 97, figs. 62–3, for an excellent reproduction of the Vannucci reliquary in Cortona, undoubtedly one of Giusto's works.

15 Cf. Heikamp (1974) in *Il tesoro* 1980, p. 247 and the relevant references.

16 The two goblets in the Museo degli Argenti (Inv. 1921 nos. 428, 436) are clearly the two jasper coolers without handles, weighing five pounds and four and a half pounds, estimated at five hundred florins each; ASF Mediceo Dopo Principato [hereafter MDP] no. 165, c. 17.

17 See, for example, the article by Marco Collareta in M. Collareta, A. Capitano, *Oreficeria sacra italiana*, Florence 1990. The discussion of a fine "phial-shaped" reliquary in rock crystal in the Ressman collection provides some interesting information on Sienese precious stone work, including the famous jasper cross of Siena cathedral which Jacopo del Tonghio completed in 1406 with silver mounts. An analysis of the material has shown that the cross and the goblet in the Museo degli Argenti (Inv. 1921 no. 772) are from the same piece of stone. The style of the cross is typically Venetian, cf. H. R. Hahnloser, "Opere di intagliatori veneziani di cristallo di rocca e di pietre dure del Medioevo in Toscana", in *Atti del convegno sulle arti minori in Toscana*, Arezzo 11–15 May 1971, Florence 1973, pp. 155–9, for the pieces mentioned pls. 100–101.

18 Gombrich 1960, p. 309, referring to E. Kris, *Meister und Meisterwerke der Steinschneidekunst in der italienischen Renaissance*, Wien 1929. For all the pieces discussed above see also H. R. Hahnloser, S. Brugger-Koch, *Corpus der Hartsteinschliffe des 12.–15. Jahrhunderts*, Berlin 1985.

19 ASF MAP no. 162 (1465), c. 5.

20 Also mentioned by Tuena in F. Tuena, A. Massinelli, *Il tesoro dei Medici*, Milan 1992, p. 20; more precise is Grote in *Il tesoro* (1974) 1980, p. 125.

21 ASF MAP no. 165, c. 29 and c. 29b.

22 H.R. Hahnloser in *Tesoro di San Marco*, II, edited by Hahnloser, Florence 1971, p. 4.

23 The Byzantine chalice in light grey onyx in the Museo degli Argenti (Inv. 1921 no. 751) has a silver band around the rim made to the same design, see K. Aschengreen Piacenti, *Il Museo degli Argenti*, Milan 1967, p. 140. no. 220; given the similarities to the mounting under examination, it must also be dated during the last quarter of the fifteenth century.

24 The same person is responsible for at least the design, if not the making, of this frame and the surround of a similar plaque in gilded and enamelled silver, probably dating from before 1460 and now in the Louvre, Départment des Objets d'Art, showing Christ casting out the devil. M. Kemp, entry on p. 240 in *Circa 1492. Art in the Age of Exploration*, exh. cat. edited by J.A. Levinson, Washington – New Haven 1991, suggested that this latter item, the central scene of which is often attributed to Filippo Brunelleschi, could have been commissioned by Piero de' Medici. As Dora Liscia Bemporad comments, entry no. 24, in *Piero e Urbino, Piero e le corti rinascimentali*, exh. cat. edited by P. Dal Poggetto, Venice 1992, pp. 122–3, there is no documentary evidence at the moment; however, since it is an interesting theory, I feel it is worth pursuing.

25 D. Liscia Bemporad, entry 3.4 in *San Lorenzo i documenti e i tesori nascosti*, exh. cat., Florence 1993, pp. 155–6, refers to the Saint Louis reliquary, datable to the last quarter of the fifteenth century. This has a decoration of drop-shaped pods, inverted compared to this vase, forerunners of the spiral-shaped motif found more frequently at the end of the century.

26 D. Liscia Bemporad, entry 3.7 in *San Lorenzo* 1993, pp. 159–60.

27 The design is very similar to the mount of the jasper chalice in the Museo degli Argenti (Inv. 1921 no. 800), probably by the same craftsman and possibly the "cup in green jasper and sardonyx with a lid, band and base in embossed silver gilt, weight 3 pounds 8 ounces – f. 150" documented in 1492, ASF MAP no. 165, c. 18.

28 Cf. E.J. Grabe, entry 217 in *Eredità dell'Islam*, exh. cat. by G. Curatola, Venice 1994, pp. 360–61; citing Heikamp's bibliography (1974) in *Il Tesoro* 1980. The piece is analysed by comparison with the shape of metal vases without, unfortunately, any conclusive evidence despite considerable detail. One can, however, concur with the reference at least provisionally, while excluding the Far East, despite the vague similarity to Chinese artefacts. It should be noted however, that the fact that jade is now found in Egypt, Italy, Switzerland and Silesia is of little importance, firstly because there is no evidence that these deposits were being worked at the time, and secondly because the material was not necessarily worked at the place of origin. We need only think of the excellent quality of the lapis lazuli worked in Florence at the time of Francesco I de' Medici, though the stone was not available locally, or even of the 230 pounds of ebony which Cosimo I had brought from Cologne in 1566 (ASF Depositeria Generale 773, c. 43, no. 277) when clearly the city was only a collection and distribution point for the exotic wood, much in demand at the time and which in this case was for a cabinet.

29 L. Dolcini, "La fortuna del cristallo di rocca nel Medioevo. Guida alla consultazione della bibliografia", in *Technologie et analyse des gemmes anciennes. Technology and Analysis of Ancient Gemstones*, conference proceedings, Ravello, 13–16 November 1987; PACT, 23, 1989, V.2, pp. 341–68.

30 *Livre des Métiers* by Etienne Boileau, in G.B. Depping, *Règlements sur les arts et métiers de Paris*, Paris 1837, pp. 71–2.

31 See M. Scalini , entry no. 89 in *Eredità del Magnifico*, exh. cat. edited by G. Gaeta Bertelà, B. Paolozzi Strozzi, M. Spallanzani, Florence 1992, p. 109, with an earlier bibliography, datable between 1465 and 1470; Museo Nazionale del Bargello, Ressman no. 250, the same decoration is found on a cup (modified vase) made of petrified wood in the Museo degli Argenti (Inv. 1921 no. 633).

32 M. Bacci, entry no. 117, in *Eredità* 1992, pp. 133–4, ASF MDP no. 165, c. 14.

33 See also, for example, the famous Byzantine mosaic with minute tesserae in the Museo dell'Opera del Duomo, Florence.

34 A. Grote in *Il tesoro* 1980, p. 132.

35 Information can be found in the ASF MDP no. 129, Inventario di robe finite per li sindaci de' Medici particolarmente a chi et quanto finite (Inventory of things in the hands of the Medici auditors especially what was sold to whom).

36 The famous small study, the ceiling of which is decorated with majolica representing the labours of the months by Luca della Robbia and now in the Victoria and Albert Museum, London.

37 Evidently well founded, the suggestion that this monastery represented one of Lorenzo's earliest acts of patronage is quite recent, see F. W. Kent, "Lorenzo de' Medici, Madonna Scolastica Rondinelli e la politica di mecenatismo architettonico nel convento delle Murate a Firenze (1471–72)", in *Arte, committenza ed economia a Roma e nelle corti del Rinascimento 1420–1530*, conference proceedings edited by A. Esch and C.L. Frommel, Rome 1990, Turin 1995, pp. 353–82.

38 Heikamp (1974) in *Il Tesoro* 1980, p. 157, no. 3, the vase was sequestered and the metal parts were melted down in 1799.

39 Heikamp (1974) in *Il Tesoro* 1980, pp. 147–58.

40 MS Riccardiano no. 1849, c. 158: "Inventory made of all the personal property in Palazzo della Signoria in Florence after the departure of the Most Illustrious Gonfalonier and Prior of the freedom of that Republic. Begun on the 26th day of April 1532 in the presence of Signor Antonio da Ricasoli… [c. 162, the chapel] A gold rose with branches in a copper candlestick, on which is a cut sapphire estimated at 6 scudi, the weight of gold valued about 25 scudi …A large silver seal with Hercules on a cornelian…/ [c. 162] 2 large swords with sheaths and large handles richly and completely made of gold and silver with the Medici coat of arms and belt and band with silver fitments. The Emperor's sword is lacking X silver roses…".

41 Cf. A. Muzzi, entry no. 249, in *Sigilli del Museo Nazionale del Bargello*, Florence 1990, pp. 115–6.

42 According to eighteenth-century historians, another seal with Hercules used by Cosimo I existed, made of cornelian instead of the emerald plasma seal still existing today. The fact that Leo X's emblem of the yoke is found on the mount, together with other emblems belonging to various members of the dynasty, suggests that the item was sent to Florence as a gift from Rome and therefore most probably from Clement VII to Alessandro. This is further confirmed by the style of the shield in silver leaf, which is very similar to Alessandro's majolica shield still visible on the left of the façade of the church of Ognissanti, and by the fact that Cosimo I normally used the oval shield even when he was only a duke. However, Middeldorf had already pointed out that there are discrepancies in the top and bottom sections of the handle of the seal; see U. Middeldorf, "Überraschungen im Palazzo Pitti", in *Pantheon* XXXII, 1974, p. 22.

43 M. A. McCrory, entry nos. 271 and 272, in *Committenza e collezionismo medicei, 1537–1610*, edited by P. Barocchi, Florence 1980, pp. 145–6; they came to Florence with Christine of Lorraine.

44 M. Scalini, *Benvenuto Cellini*, Florence 1995.

45 Conversely, in the Topkapi Saray there is a Venetian vase of rock crystal with a similar mount made of copper gilt.

46 Cf. F. Tuena in Tuena, Massinelli 1992, pp. 50–2; Nardinocchi, *Il Tesori* 1995, pp. 26–7.

47 D. Liscia Bemporad, entry 3.9 in *San Lorenzo* 1993, pp. 162–4, cited by Nardinocchi, *Il Tesori* 1995, pp. 36–7.

48 The initials are believed to stand for Magnus Laurentius Medices, though the name 'Leo', for Pope Leo X, is also valid.

49 A gothic O, a shield surmounted with a cross and the head and face of a lion with a crown, similar to later English silver hallmarks; moreover, despite the fact that according to the sixteenth-century drawings the container held relics of Saint Bridget and Saint Apollonia, the top is adorned with a small figure of Saint George in the act of killing the dragon. The matter is, at present, being studied by Tim Schroeder, but we may already report certain similarities to some designs of Hans Holbein the Younger, see D. Scarisbrick, *Tudor and Jacobean Jewellery*, London 1995, p. 35, though earlier works also exist.

50 The attribution is Ulrich Middeldorf's and has been accepted by Heikamp (1974) in *Il Tesoro* 1980, pp. 254–5 and Tuena in Tuena Massinelli 1992, pp. 50–1.

51 M. Sframeli, entry 1, in *Splendori di pietre dure*, exh. cat. edited by A. Giusti, Florence 1988, pp. 74–5.

52 Cf. S. B. Butters, *The Triumph of Vulcan: Sculptor's Tools, Porphyry and the Prince in Ducal Florence*, Florence 1996, especially pp. 41–65.

53 K. Aschengreen Piacenti, *Il Museo* 1967, p. 188, no. 1182.

THE 'NEW MEDICI' AS COLLECTORS AND PATRONS

In 1537, after the unexpected death of Duke Alessandro, the seventeen-year-old son of Maria Salviati and Giovanni Dalle Bande Nere arrived in Florence from the Mugello. The young man was named Cosimo and with his "shrewdly humble manner", he adroitly asserted his right to the succession, assuming the title of Duke of Florence within the year. From then on he seemed determined to establish a public image in keeping with the importance of his position. The Medici palace in Via Larga, designed by Michelozzi and traditionally the family residence, no longer satisfied the requirements of the new duke and he therefore decided that Palazzo Vecchio would provide more suitable accommodation. "Everything was turned quite upside down," wrote the historian Bernardo Segni[1], "so that the duke could live there in greater comfort."

The Medici Collections at the Time of Cosimo I and Francesco I

Anna Maria Massinelli

The inventory of the new residence, drawn up in 1553[2], provides valuable information on the furnishings and collections kept there and it is quite clear that Eleonora di Toledo, who arrived in Florence as Cosimo's bride in 1539, and her cortège, considerably influenced the magnificence and splendour of the Medici court.

As part of the extensions and alterations to Palazzo Vecchio carried out under Giorgio Vasari between 1555 and 1558, a small study[3] was made in the *Quartiere degli Elementi*, with access from both the *Sala di Cerere* and, via a secret room, the floor below. In an imaginary conversation with Prince Francesco in his *Ragionamento IV*[4], Vasari describes the iconography of the little study, known as the *Scrittoio di Calliope* after the painting of the muse Calliope with which he had decorated the ceiling. An analysis of the items removed from the *Guardaroba* and arranged in the study between 1559 and 1560[5] confirms that it was intended to be a private and personal museum, a development of the Renaissance concept of a 'chamber for antiques' where classical items, natural curiosities, medals, cameos, semi-precious stones and all kinds of rare objects were housed. The study was of primary importance in the progression of rooms devoted to the collections of the grand dukes and was a forerunner of the later and more sophisticated *Studiolo* of Francesco I, also in Palazzo Vecchio. This in turn was replaced, some twenty years later, when the Tribune in the Uffizi was created, a magnificent and elaborate interpretation of the sixteenth-century *Wunderkammer* more in keeping with Francesco's princely passion for collecting. The first in this sequence of 'cabinets', the *Scrittoio di Calliope* was in many ways a synthesis of both the humanist's private study, where a cultured prince would not only keep his personal valuables but would also retire to study or attend to his own correspondence, and the eclectic *Wunderkammer* where a whimsical collector could examine and enjoy

Athena, *Etruscan bronze, Hellenistic period. Florence, Museo Archeologico.*

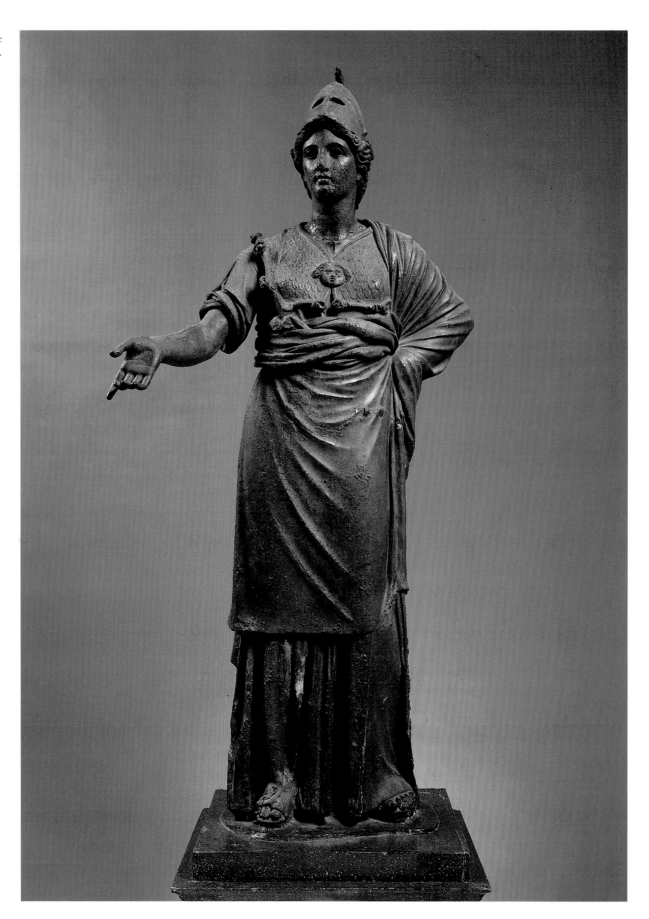

Chimera, *Etruscan bronze, late 5th century BC. Florence, Museo Archeologico.*

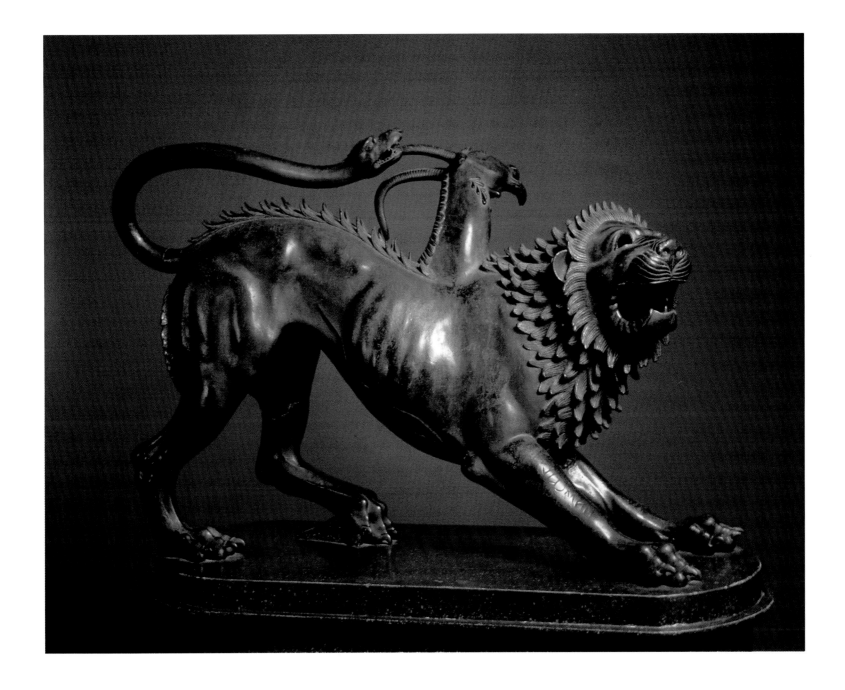

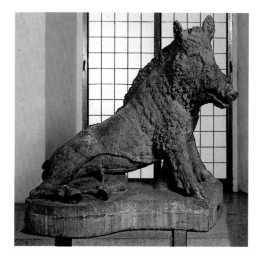

Wild boar, *marble, mid 1st century BC. Florence, Uffizi Gallery.*

Opposite page: Niccolò Tribolo and other Florentine sculptors, the Animal Grotto, *detail of the right side, mid 16th century. Granite, marble and coloured stone. Castello, Villa Medicea.*

his treasures. Vasari, in his *Ragionamento IV,* describes the more general features of the collections housed there, frequently mentioning various individual objects in more detail. [Vasari to the prince] "In this study, the duke wishes to use the rows of shelves around the walls, resting on a series of pilasters, to display small bronze statues of which, as Your Excellency can see, there are very many, all of which are antique and most beautiful; between the columns and the pilasters and in the cedarwood drawers he will keep all his medals so that they can be seen quite easily and kept in good order, because the Greek ones will be in one place, the copper ones in another, the silver ones will be in this other row, and the gold ones will also be separate from the rest. [Prince] What will be kept in this section between the columns? [Vasari] Here there will be the miniatures made by Don Giulio and other excellent master craftsmen as well as small paintings which are in themselves little gems; below the drawers, at the bottom of the whole structure, there will be treasures of all kinds, the bowls and vases in one place, those of stone in another, while in the cupboards beneath will be the large oriental crystal, the sardonyx and cornelian pieces and the cameos; in the larger one he will keep the antiques for, as Your Excellency knows, he has many and most rare examples. [Prince] I find it all most pleasing and it is all very well arranged; but will there be enough bronze figures to fill all this space, for the study has three tiers all the way round and you have made so many shelves to hold them all? [Vasari] Indeed there are quite enough and here I want only those statuettes and figures which were found near Arezzo, including the antique figure of the lion which has on its shoulders the neck and head of a goat[6] [or the Arezzo Chimera, Archaeological Museum, Florence]."

The fittings consisted only of a few simple and functional elements such as the supports and the containers themselves: supported by pilasters, three rows of shelves for sculptures ran around the walls, which were covered with scarlet velvet, while cedarwood drawers held precious gems, medals and various other items. There seem to have been no cupboards for books and documents, as these were kept in the *Tesoretto*, the secret study situated on the lower floor of the palace. The above description dates from 1557, when Vasari had composed all the *Ragionamenti* except for the last, dated 1563. The building and decoration of the *scrittoio* must have been almost finished at the time as, two years later, the records of the *Guardaroba* contain information concerning the arrangement of the valuables. Vasari, in his life of Agnolo Bronzino (1502-72)[7] mentions a set of twenty-four miniatures in tin plate, representing famous men of the House of Medici, which were also kept in the study, "all in order, behind the door", clearly the one which is now walled up and which leads to the secret staircase. Here too he speaks glowingly of the study where "there are many antique statues in bronze and marble, and small modern paintings, most rare miniatures and an infinity of gold, silver and bronze medals, most attractively arranged in good order".

Some of the most beautiful items in carved stone must surely have been the rare jasper and lapis lazuli vases displayed in two niches surrounded by the tentacles of a

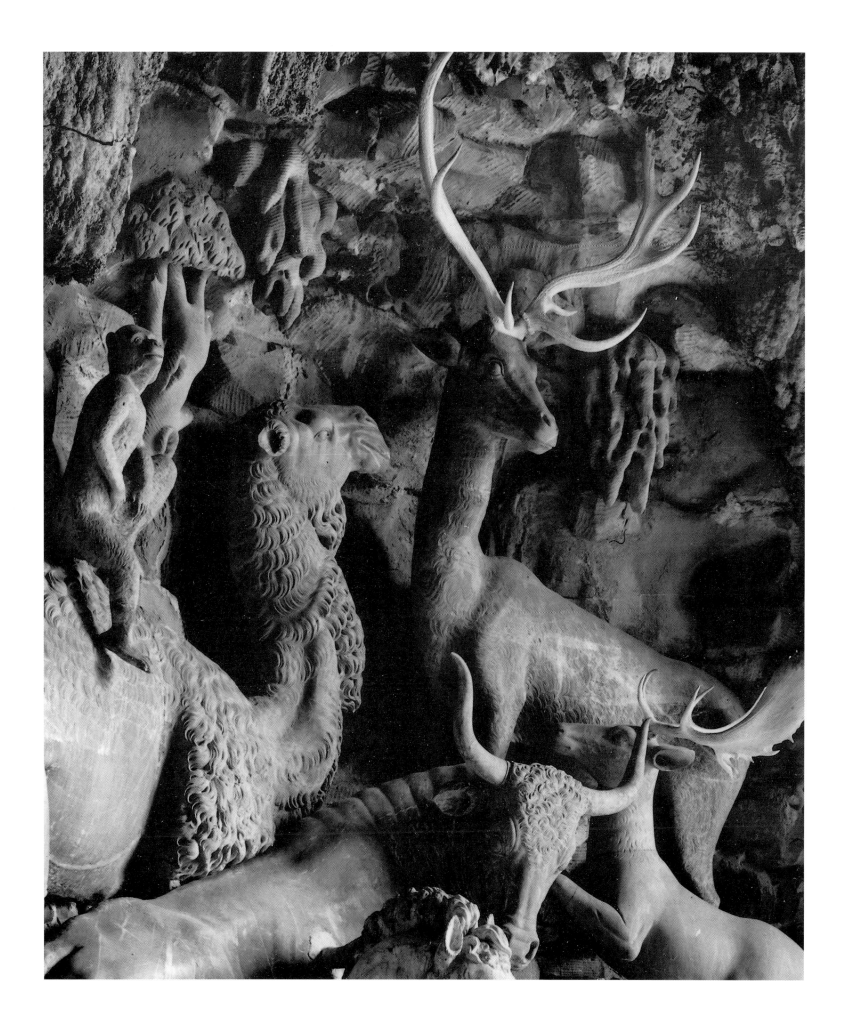

Willem Tetrode, scale reduction in bronze of the Belvedere Apollo, *c. 1560. Florence, Museo Nazionale del Bargello.*

monster which Cosimo had bought from the Milanese craftsman Gasparo Miseroni[8] (Florence, Museo degli Argenti and Museo di Mineralogia). More detailed information concerning the valuables housed in the study is found in the records of the *Guardaroba*. In the Journal for the period between 1559 and 1560[9] (ASF, GM 37, *c.* 13 v.), on 13 June 1559 we read that "His Excellency, to furnish the new rooms of his study, took from the antique cabinet of the *Guardaroba* all the antique and modern figures, all the torsos, animals and antique and modern things made of metal which were in the cabinet". The list goes on to describe a series of sculptures in various kinds of stone and other rare pieces such as the "eight heads of animals, the size of walnuts, made of various stones, and trinkets made by Benvenuto Cellini in a box covered with black leather".

It would appear from the arrangement of the display that Vasari intended the most privileged items to be the small bronzes, an art form particularly favoured by Duke Cosimo. In fact, in his conversation with Francesco who asks if the bronzes in the *Guardaroba* will be sufficient to fill all the rows of shelves, Vasari is in no doubt whatever, adding that the Etruscan bronzes found in Arezzo in 1553, including the Chimera, were particularly suitable for housing in the *Studiolo*. The importance of this most fortunate archaeological discovery, made halfway through Cosimo's period of rule, is also confirmed by a famous passage in the Life of Cellini[10]: "During those days some antiquities had been discovered in the country around Arezzo. Among them was the Chimaera, that bronze lion which is to be seen in the rooms adjacent to the great hall of the palace. Together with the Chimaera a number of little statuettes, likewise in bronze, had been brought to light; they were covered with earth and rust, and each of them lacked either head or hands or feet. The duke amused his leisure hours by cleaning up these statuettes himself with certain little chisels used by goldsmiths."

However, the Chimera was never placed in the study, remaining instead in the apartments of Leo X, beside the *Salone del Cinquecento*, until 1718. Doubtless many visitors to the palace admired it though they may not have fully appreciated the symbolic significance which Vasari attached to it, asserting that "fate had decided it should be discovered during the reign of duke Cosimo who has tamed all the wild beasts of our day". Montaigne[11], who visited Palazzo Vecchio in 1581, recounted that it was commonly believed that the Chimera had been found alive in a cave in the mountains. In fact, the only large Etruscan bronze from the area of Arezzo to be housed in the study was the Athena (Museo Archeologico), discovered in 1541 and acquired some ten years later. This figure is indicative, however, of Vasari's original intention which, judging by the ideas he expressed in the *Ragionamento IV*, was to create a kind of Etruscan cabinet. This idea was the natural consequence of contemporary court culture which tended to exalt Cosimo as being of royal Etruscan descent, thus creating an image perfectly in keeping with his claim to the title of Magnus Dux Etruriae which he obtained in 1569. The continuity between the old and

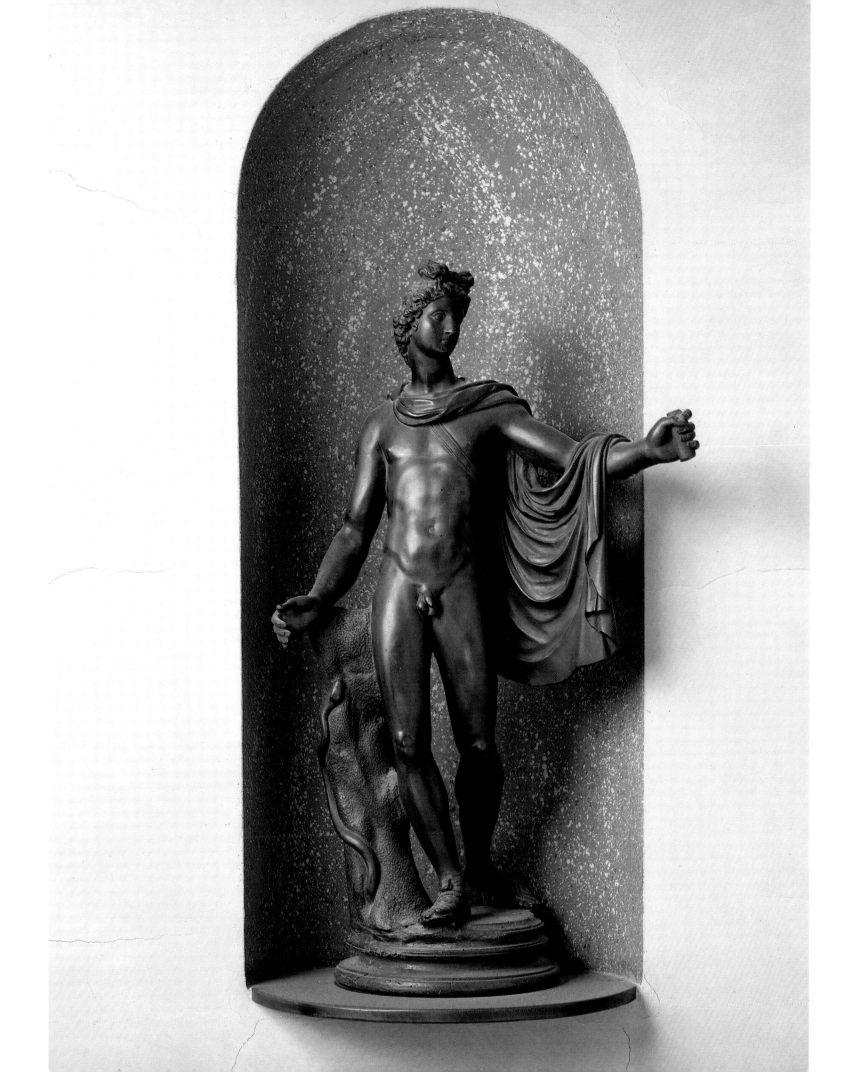

*Workshop of Agnolo Bronzino, Series of portraits
representing famous members of the Medici family, 1555-65.
Oil on copper plate. Florence, Uffizi Gallery.*

the new kingdom of Etruria, constantly referred to in the writings of intellectuals within Cosimo's circles, was most cleverly and attractively represented in the *Studiolo Calliope* where the bronzes discovered in the grand ducal territories were displayed as the first in a series of works arranged chronologically and intended to show the development of the arts in Tuscany from the time of the Etruscans until Cosimo's day. Objects believed to be Etruscan and medieval pieces (such as a small sculpted head removed from the cathedral of Pisa, mentioned in the records), were grouped together with fifteenth-century bronzes by Donatello and Pollaiolo and sixteenth-century bronze sculptures by Sansovino, Cellini and Bandinelli. Moreover, the miniature copies of the *Laocoon* and the *Belvedere Apollo*, the two works of classical art most renowned during the sixteenth century, and the copy of Michelangelo's *River*[12], suggest comparisons and references to the classical period which only a Tuscan genius of the day could have defended.

The sculptures were arranged on the shelves and lit by the soft, golden light which filtered through the painted glass window representing the Three Graces attending Venus by Gualtieri D'Anversa; beneath, the drawers and cupboards held a vast and comprehensive range of all manner of items and materials from the most magnificent paintings to small Aztec figures of animals, gold, silver and bronze medals, rough and polished gems and minerals and even an assortment of antique curiosities. This first selection of rare and valuable items collected and housed in the *scrittoio* by Cosimo I was later relocated to the gallery of the Casino di San Marco and the Tribune of the Uffizi, both of which came into being as a result of Francesco I's (1541–87) multifarious interests as a collector. The quantity and the quality of the pieces which were displayed in the gallery of the Casino di San Marco are quite evident from the inventory compiled in the year of Francesco's death[13], which lists not only a vast number of small marble, bronze and silver sculptures, but also many objects clearly considered to be of value for the rarity of the material, their unusual shape or formation, or their exotic nature or origin. Indeed, the list describes a series of objects much more suited for housing in the cases and cabinets of a study, such as the vases carved from semi-precious stone, or the nautili with precious mounts. Francesco, however, had much grander ideas and planned to bring all the masterpieces of his family's collections together in one place – the gallery of the Uffizi. The focal point of the gallery was to be the Tribune, the octagonal chamber designed by Bernardo Buontalenti and completed in 1584 as a kind of inner sanctuary to house the most valuable items. Francesco died suddenly in October 1587 and therefore never saw his collection fully arranged in its magnificent setting. The general inventory of the Tribune was, in fact, compiled some two years later in 1589[14], during the second year of his brother Francesco's reign.

Although portraying an arrangement which had already been altered since 1589, the eighteenth-century representations of the Tribune of the Uffizi, such as Zoffany's famous painting (in the Collection of Queen Elizabeth II) dated 1773, or the drawings

Giovanni Antonio Maggiore, Turned sphere of ebony and ivory *containing miniatures, c. 1580. German artist. Florence, Museo degli Argenti.*

Grand ducal workshops and Giovanni Battista Cervi, Lapis lazuli bowl in the shape of a shell with a handle of enamelled gold shaped like a snake, 1576. Florence, Museo degli Argenti.

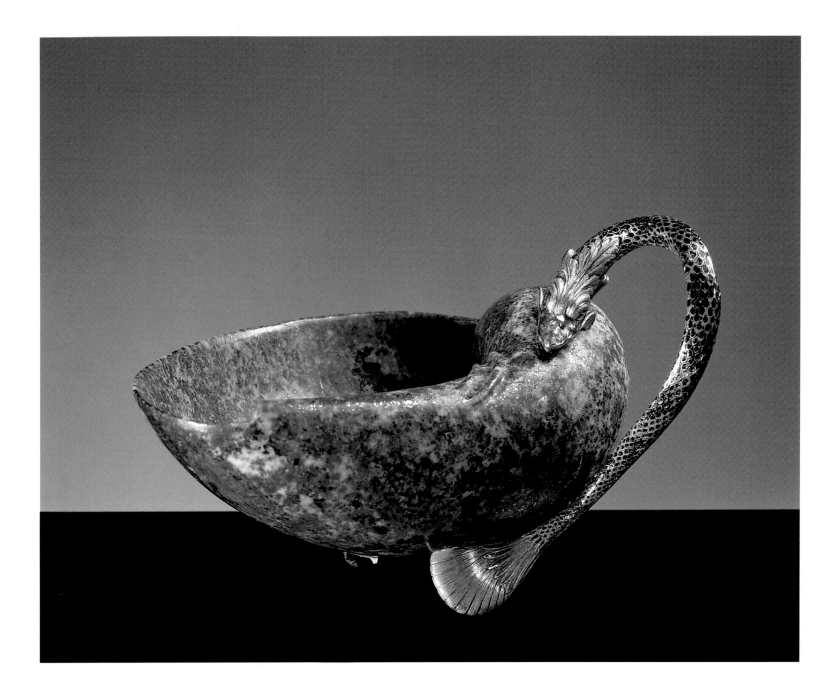

Opposite page: Giovan Battista Metellino, Bowl with dolphin base, rock crystal and silver gilt. Milan, late 16th century. Florence, Museo degli Argenti.

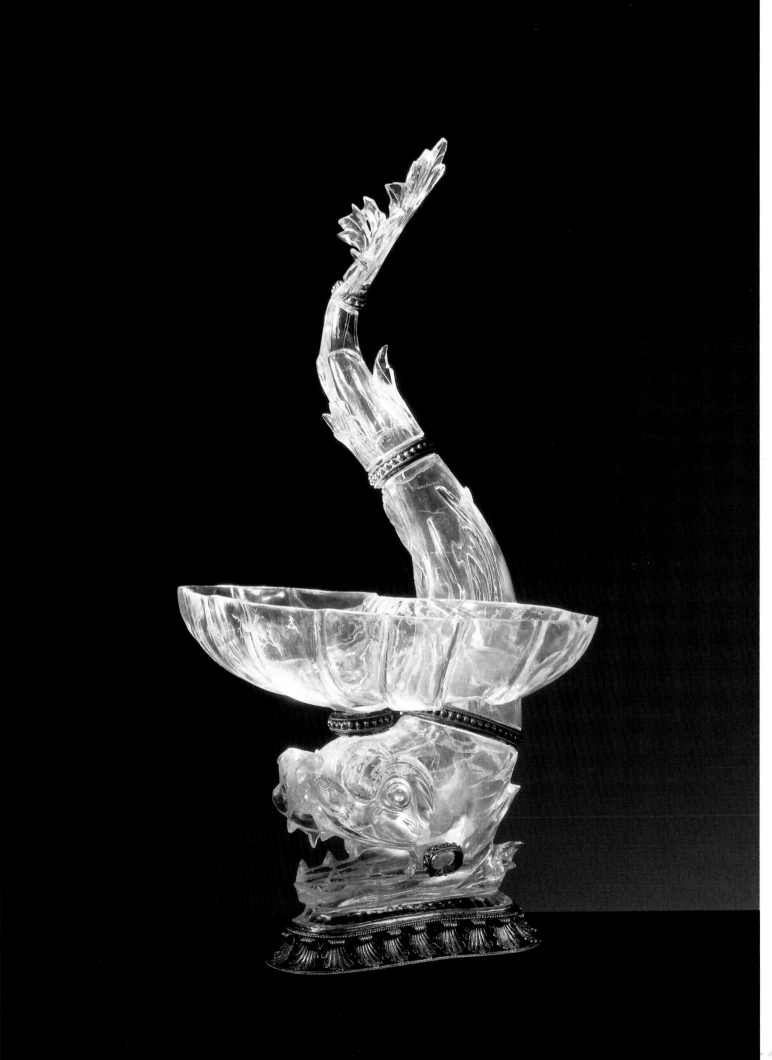

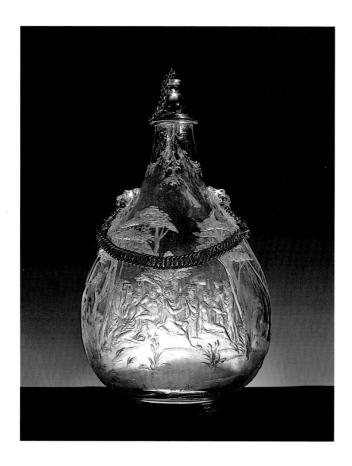

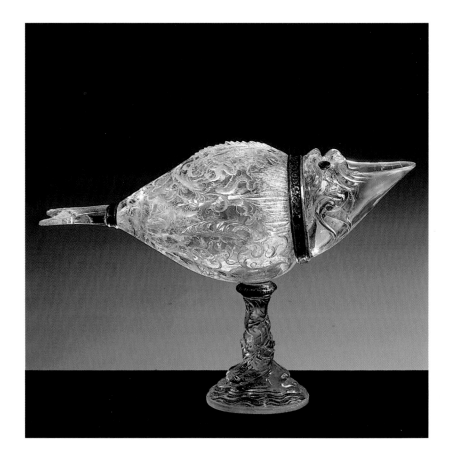

Milanese artist, Flask engraved with Orpheus with the Muses and the Judgement of Midas, *rock crystal with gold mounts, c. 1580. Florence, Museo degli Argenti.*

Milanese artist, Flask shaped like a fish, *rock crystal and enamelled gold, c. 1580. Florence, Museo degli Argenti.*

Opposite page: Sarachi workshop, Chalice in the form of a bird, *engraved with scenes of boar and wolf hunting, rock crystal with enamelled gold mounts, c. 1580. Florence, Museo degli Argenti.*

made by Benedetto de Greyss[15], still provide a good impression of the original organisation of the chamber. The shelves around the walls at shoulder height are still in place in these representations. Busts and statuettes of marble, semi-precious stone and bronze are seen apparently casually placed in an order which is, however, confirmed by the 1589 inventory. According to the original arrangement of the items housed within the Tribune, most of the semi-precious stone vases, especially the larger ones with precious mounts, were kept in two cupboards – 64 in the first one and 77 in the second. All manner of other, smaller items, as well as the medals, were kept in the drawers of the cabinets while, according to the descriptions of visitors, the octagonal ebony structure encrusted with semi-precious stones and made to a design by Bernardo Buontalenti for Francesco I was brimming with gold and silver medals. It was not long, however, before this was removed and replaced by a larger structure, also made by Buontalenti for his brother Ferdinando. In the drawers of this second, monumental *studiolo* were vases, cut and polished rubies, sapphires, topazes, emeralds and opals[16]. At the beginning of the eighteenth century the structure was still used as a "case for gems" and Grand Duke Cosimo III used to enjoy dipping his hands into the drawers of the cabinet, drawing them out filled with gems, to the undisguised

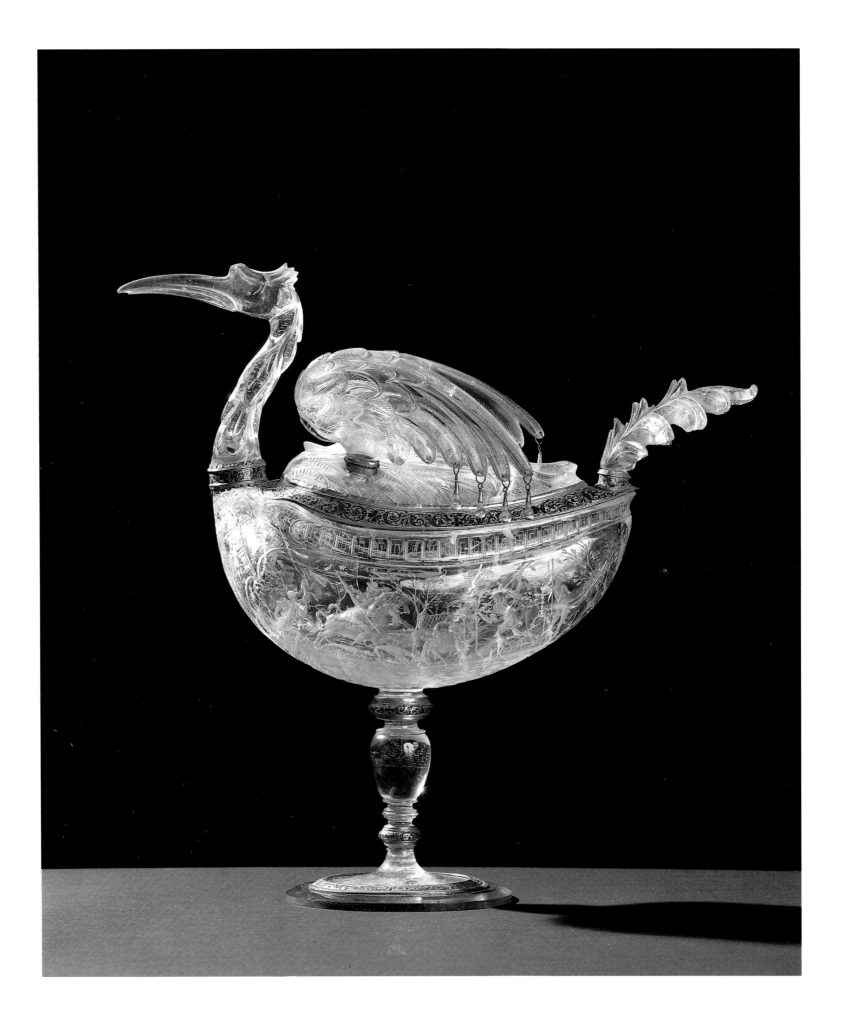

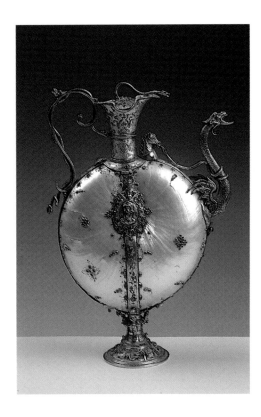

Flemish artist. Double nautilus pitcher with a mount of silver gilt, rubies and turquoise, second half of 16th century. Florence, Museo degli Argenti.

Opposite page: Double nautilus pitcher *(detail).*

admiration of the King of Denmark who visited Florence in 1708: "And one could not pass by without comment for here they wanted to show a sample of the great quantity of precious gems which the grand duke had had laid out on a table covered with a green velvet cloth. The diamonds, emeralds and rubies were arranged in three rows of increasing size and were more than two hundred in all. The collection of onyx, topaz and chalcedony was quite fabulous … diamonds of various sizes were arranged here and there in cases and since the grand duke was particularly knowledgeable about topazes he had collected many different kinds of these stones and had them carved and set by the most skilled craftsmen[17]."

Among the assortment of valuables kept in the drawers of the cabinet were some small animal heads carved in semi-precious stone, which had belonged to Cosimo I. These included the heads of two dogs, one in onyx, the other in amethyst, and of a bear and a boar (Museo degli Argenti, Museo di Mineralogia). More pieces were arranged on top of the shelves still seen in the eighteenth-century paintings of the Tribune, while it is most likely that a continuous row of small drawers was concealed in the depth of the shelves. It would seem from the descriptions of the 1589 inventory that these contained miniature paintings as well as small wax models, bronzes, busts made of semi-precious stone, various small vases, many ornamental knives and daggers in precious metals and studded with gems, most of which are recorded as being of German (*germani*) or Islamic (*domaschino*) origin. The contents of the fourteenth shelf, for example, are described as follows: "An antique silver figure of Jupiter with a torch in one hand and a lance in the other. A small agate vase with base and lid of silver gilt / A miniature scene of silver on ebony, portraying the *Torre di Nembrotte* in silver filigree inside a tondo, made by Giorgio (…) / A German or Islamic knife with a handle of local crystal and silver gilt ferrule decorated with enamel, and its case of black Turkish leather with silver gilt tip and ferrule, also enamelled, and a silver chain / Half of an ebony box with a fillet of brass framing a portrait of the Most Serene Grand Duchess Christina, made of silver mail by Costantino de' Servi …".

The arrangement of the objects on the shelves which ran around the walls was particularly significant. These were the first to catch the visitor's eye and were intended therefore to create an immediate impression of the vast range of materials, techniques and types of item housed there. It was, perhaps, Bernardo Buontalenti himself who invented the elements made of wood and decorated with gold, shaped like small turrets, with pedestals and niches where statuettes and rare little vases were placed. Each of the eighteen pedestals was crowned by a bronze sculpture of considerable size. The series of pedestals was separated by six arches, also of gilded wood, with various shelves where the smaller pieces were arranged. Above the arches were small silver sculptures of the Labours of Hercules by Giambologna.

The turrets, taking the eleventh as an example, appeared as follows: "a little turret made of wood and inlaid with gold, with pedestals and niches which contained four small antique bronze figures, two vases of agate and jasper with handles, lids and

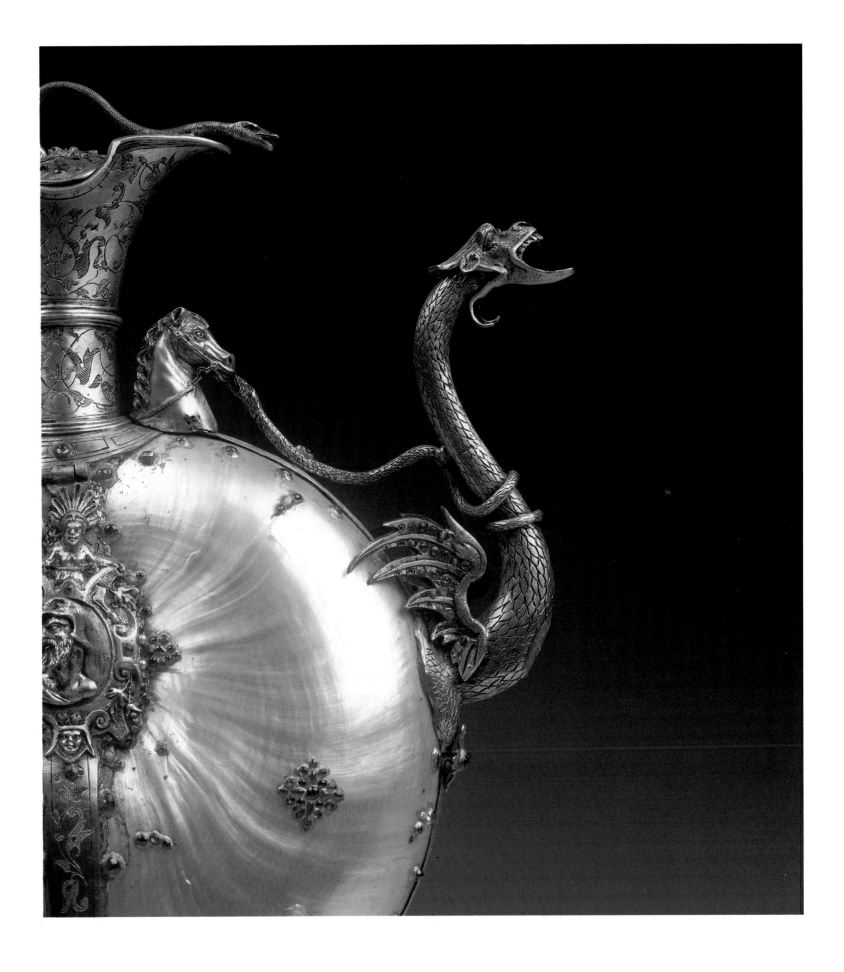

Flemish artist. Double nautilus pitcher *with a mount of silver gilt, second half of 16th century. Florence, Museo degli Argenti.*

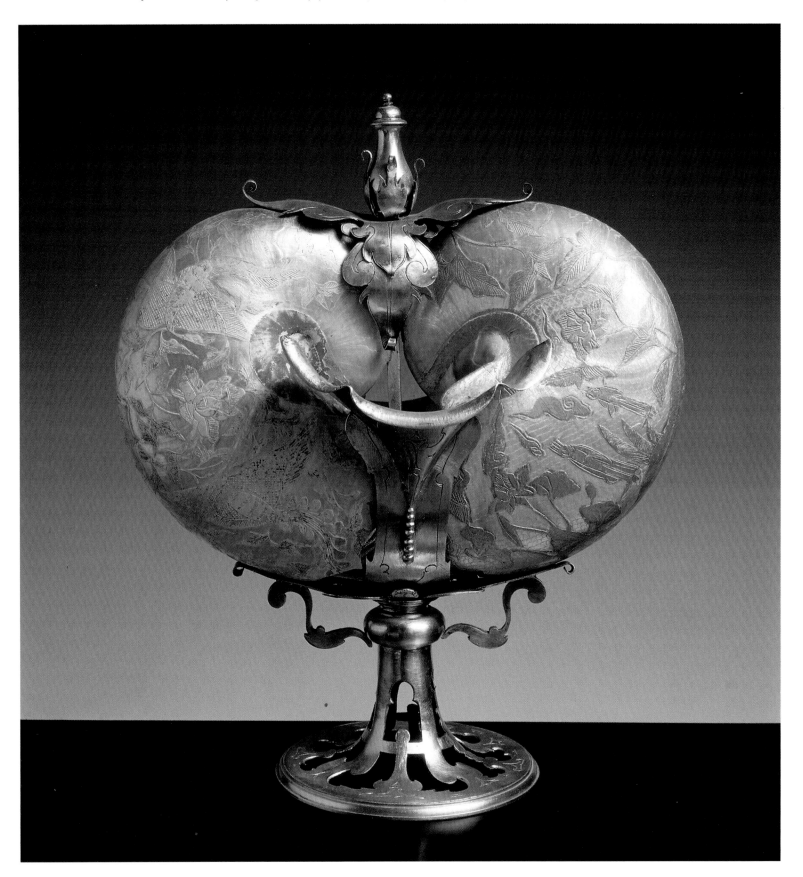

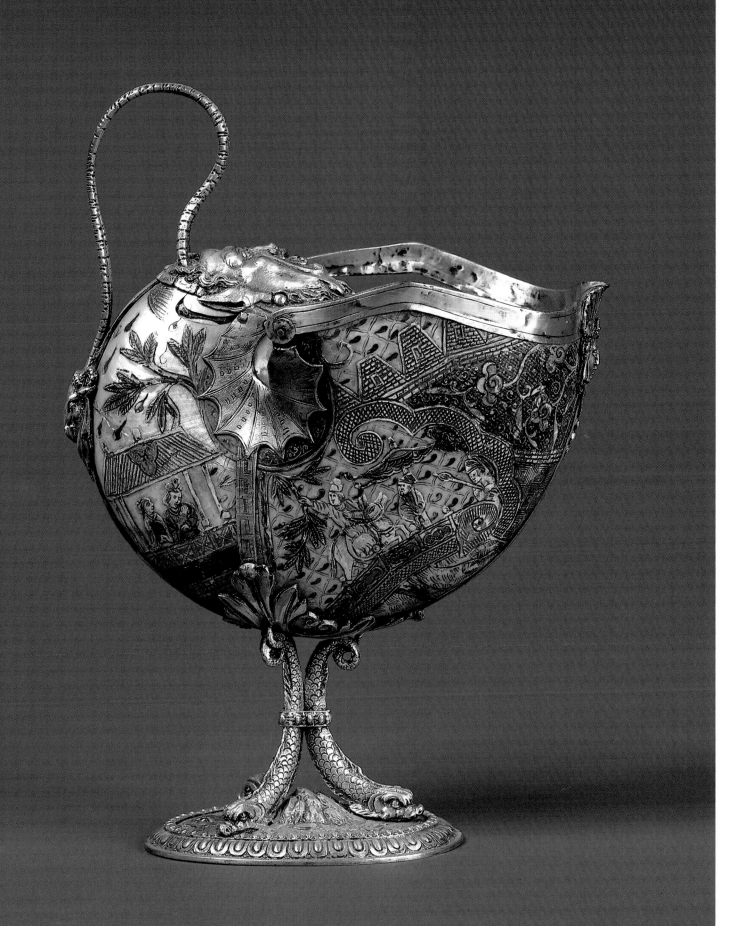

Previous page: Engraved double nautilus cup with silver-gilt mounts, *China, 16th century. Florence, Museo degli Argenti.*

Properzia de' Rossi (attr.) Engraved cherry nut *with silver-gilt mount, mid 16th century. Florence, Museo degli Argenti.*

bases of silver gilt / a small antique bronze figure of a nude woman with one hand on her hip and a bunch of flowers in the other, about ⅔ of a *braccia* high, stood on the top of this turret." The fourth of the six arches contained a heterogeneous collection of objects: "an arch with wooden steps inside, all gilded and inlaid, containing the following figures: four classical bronze figures / a small antique head of Bacchus made of bronze with a cloth of silver gilt around it, set on a pedestal of various stones / a small antique domestic cat, made of chalcedony, sitting on a block of wood / a dolphin made of chalcedony, with a little putto of the same material on its back, set on a pedestal of black bone (Museo degli Argenti, inv. Gemme no. 811) / a silver Hercules with a boar and a club over his shoulder wearing a cloak, made by Giambologna, ¾ of a *braccia* high / Two small antique figures in bronze are on the shelf beneath the arch / A small chalcedony head with an alabaster torso and silver gilt cloak resting on a pedestal of black wood / A vase made from half an ostrich's egg and engraved with grotesques by the German Marchionni, with silver gilt mounting, terminals, and a base in the form of a crab / a small bronze figurine of a baboon, dressed in a cloak, on a wooden base / a bronze figure of a Capitoline Jupiter, clothed and with a hand raised, standing on a base of the same material, ½ *braccia* high". Thus each of these structures provided some visual and conceptual coherence between groups of pieces which were of various periods, materials and subjects, and gave a coherent appearance to the overall arrangement. To the observer the effect was that of a kind of compendium of both artistic creativity and the variety of material provided by nature.

Other groupings seem to have had the same underlying concept. The pieces known as the "monti de miniera" (mineral mountains), for example, consisted of blocks of raw mineral set on silver stands and crowned with little silver or bronze figurines, usually of a religious nature, with the exception of one which represented a bronze Hercules with the lion. Perhaps the piece which best illustrates the style and manner of these decorative pieces is the one described in the 1589 inventory as "A mineral mountain of silver and other materials with several small figures which are working the mines, resting on a silver gilt stand, about 1 & ⅔ of a *braccia* high with a glass cover".

The Tribune of the Uffizi continued to be the *Sala del Tesoro* until the second half of the eighteenth century, and the collection of vases and other gems and ornaments was added to on various occasions until the 1770s, just a few years before the dispersal of the Treasury. The room, no longer conceived as a *Wunderkammer*, was then transformed into the *Sala di Venere* (the Venus Room), where the famous antique statue known as the Medici Venus formed the centrepiece to the collection of classical objects now displayed there.

Anthropomorphical pendant in jade, *Mayan, 600-900 AD. Florence, Museo degli Argenti.*

Small jade statue of a forefather, *Central Mexico, post-classic period (900–1520?). Florence, Museo degli Argenti.*

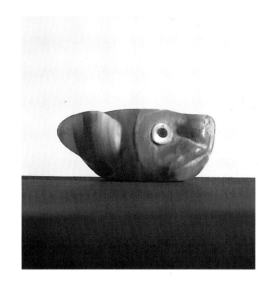

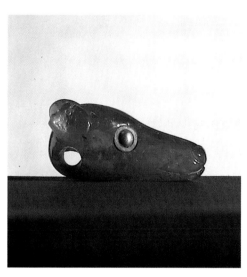

Head of a dog in onyx, *Aztec, late post-classic period (1430–1520). Florence, Museo di Mineralogia.*

Head of a dog in amethyst, *Aztec, late post-classic period (1430–1520). Florence, Museo di Mineralogia.*

Notes

1 B. Segni, *Storie fiorentine dall'anno 1527 al 1555*, Augsburg 1723, p. 148.

2 C. Conti, *La prima regia di Cosimo I de' Medici*, Florence 1893.

3 E. Allegri, A. Cecchi, *Palazzo Vecchio e i Medici*, Florence 1980, pp. 80-82.

4 G. Vasari, *Le vite de' più eccellenti Pittori, Scultori, Architettori italiani*, Florence 1568, ed. G. Milanesi 1878-1885, vol. VIII, pp. 58-60.

5 Florence, Archivio di Stato, Guardaroba Medicea 37, c. 13 v.

6 See note 4.

7 E. Baccheschi, *L'opera completa del Bronzino*, Milan 1973, p. 106.

8 See *Splendori di Pietre Dure*, Florence 1988, p. 80.

9 See note 5.

10 B. Cellini, *La vita*, ed. P. D'Ancona, Milan 1912, p. 454.

11 M. de Montaigne, *Journal de Voyage en Italie*, ed. M. Rat; Paris 1955, p. 88.

12 A. M. Massinelli, *Bronzetti e anticaglie nela Guardaroba di Cosimo I de' Medici*, exh. cat., Florence 1991, pp. 9-24.

13 Florence, Archivio di Stato, Guardaroba Medicea 136, cc. 154-168.

14 Florence, Biblioteca degli Uffizi, Ms. 70, cc. 10, 22, 25-26.

15 Florence, Uffizi, Gabinetto dei Disegni e delle Stampe 4584F-4587F

16 See A. M. Massinelli, *Magnificenze Medicee: gli stipi della Tribuna degli Uffizi*, in: "Antologia di Belle Arti" nn. 35/38, 1990, pp. 11-134, with preceding bibliography.

17 P. F. Covoni, *Visita del Re di Danimarca a Firenze nel 1708*, Florence 1886.

Of all the rare and precious items so avidly collected by the Medici, the engraved stones were considered to be particularly important. The gems (meaning all the stones either engraved or in relief, usually known as *intaglio* or cameo) reflected the family's need to establish its refined and scholarly interests in pursuit of its determination to achieve and maintain absolute supremacy in the cultural as well as the political life of the city.

For many centuries the jewels (whether genuinely antique or simply presumed to be so) were associated both physically and symbolically with the collection of medals and antique coins as they provided visual evidence and cultural information concerning the classical world, the ethical, historical and artistic values of which were continuously cited as models.

The Medici Collection of Gems during the Fifteenth and Sixteenth Centuries

In addition to coins and antique glyptics the Medici also collected contemporary gems and medallions, not simply for the purpose of augmenting their possessions, but also to patronise and encourage the arts, an interest which was common to many members of the family. Thus modern jewels were juxtaposed with classical items in a single and informal arrangement which emphasised the cultural prestige and power that the possession of such rarities had represented since the earliest times.

In the stimulating and prolific humanist circles of the mid-fifteenth century, antique jewels were assiduously sought, purchased at great cost, admired by artists for their superb technical skill (*intaglio,* especially, involved a slow and extremely difficult technique) and studied by scholars for their iconography which was often obscure and difficult to understand.

It would even be true to say that the Medici's obvious historical interest in these objects is quite clearly evident in the building which symbolised their rise to power – Palazzo Medici in the Via Larga in Florence.

The eight marble tondi set into the spandrels of the arches around the internal courtyard of the Medici family's palace (today Palazzo Medici Riccardi) depict motifs taken from antique cameos and intagli. Indeed, one of them reproduces a relief from one of the most famous of the Medici jewels – the chalcedony engraved with an image of Diomedes and the Palladium which belonged to Lorenzo and is now believed lost.

This engraved stone had been bought by pure chance by the humanist Niccolò Niccoli, who spotted it around the neck of a boy in the street. In 1457 it was acquired by Pope Paul II, a renowned collector of jewels (documents show he also owned two other stones with the same subject), and then subsequently by Lorenzo il Magnifico[1].

Mariarita Casarosa Guadagni

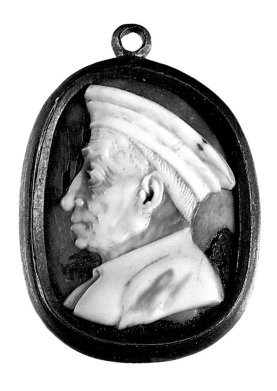

Cameo, shell, Portrait of Cosimo the Elder.
Florence, Museo degli Argenti.

The marble medallions in the courtyard were made in 1452 by Maso di Bartolomeo and payment was made on 2 July of that year. Three of the medallions reproduce scenes from engraved gemstones (Daedalus and Icarus, Athena and Poseidon, Dionysus and the Satyr) which were not added to the Medici collection until 1462; two (the Chariot of Dionysus, and Diomedes and the Palladium) were acquired by the Medici from the collection of Paul II in 1471; one (the Centaur) was added in 1492. The final medallion – Ariadne in Naxos – belonged to the Gonzaga family.

The original nucleus of the Medici collection was created by Piero de' Medici (1416–69), son of Cosimo il Vecchio and father of Lorenzo il Magnifico, himself portrayed in an attractive cameo in the Medici collection (Museo degli Argenti). According to the entries in the 1456 and the 1465 inventories, however, it consisted of only about thirty pieces – few indeed if compared to the 821 gems collected by Pope Paul II in the same period[2]. According to the memoirs of Cardinal Francesco Gonzaga and Filarete, Piero was a cultured and discerning man with a particular fondness for carved stones. His interest in antique cameos is obvious from the inventories which list, for example, one representing Athena and Poseidon, attributed to Pyrgoteles and valued at 180 florins at the time (Naples, Museo Archeologico), and a medieval cameo with the "Entry into the Ark", estimated, at some 300 florins, to be the most valuable of all[3].

It was not until some twenty years later, following the purchases and gifts presented to Lorenzo il Magnifico in Rome in 1471, that the collection of gems reached princely proportions[4].

Lorenzo travelled to Rome that year as ambassador to the papal court for the coronation of Pope Sixtus IV and returned laden with antique and classical items. In his account of the objects brought back to Florence, Lorenzo mentions in particular "our bowl" (*la scudella nostra*) as though it were a familiar family possession. Now known as the Farnese Bowl and housed in the Museo Archeologico in Naples, this exceptional piece of chalcedony, about 30 cm in diameter, was made in Alexandria in Egypt some time between 180 and 150 BC. It is exquisitely engraved on the inner and outer sides; on the concave side numerous figures are represented in a complex, allusive allegory celebrating the power and wealth of the Ptolemaic rulers of Egypt; on the convex side the head of a Medusa is probably an indication of the sacred funtion of the item. After its arrival in Europe, and before passing to Lorenzo, the cup had been in the possession of Pope Paul II, Alfonso d'Aragona of Naples and Friedrich I, Duke of Swabia[5].

In the inventory dated 1512, compiled after Lorenzo's death, the cup is valued at the astronomical figure of 10 000 florins, about a quarter of the total cost of a gentleman's palace!

Besides the bowl of chalcedony, Lorenzo also acquired antique cameos and engraved stones. Among these was, for example, the lovely classical cameo, signed by Sostratos, with Nike driving her chargers at a gallop (Museo Archeologico, Naples).

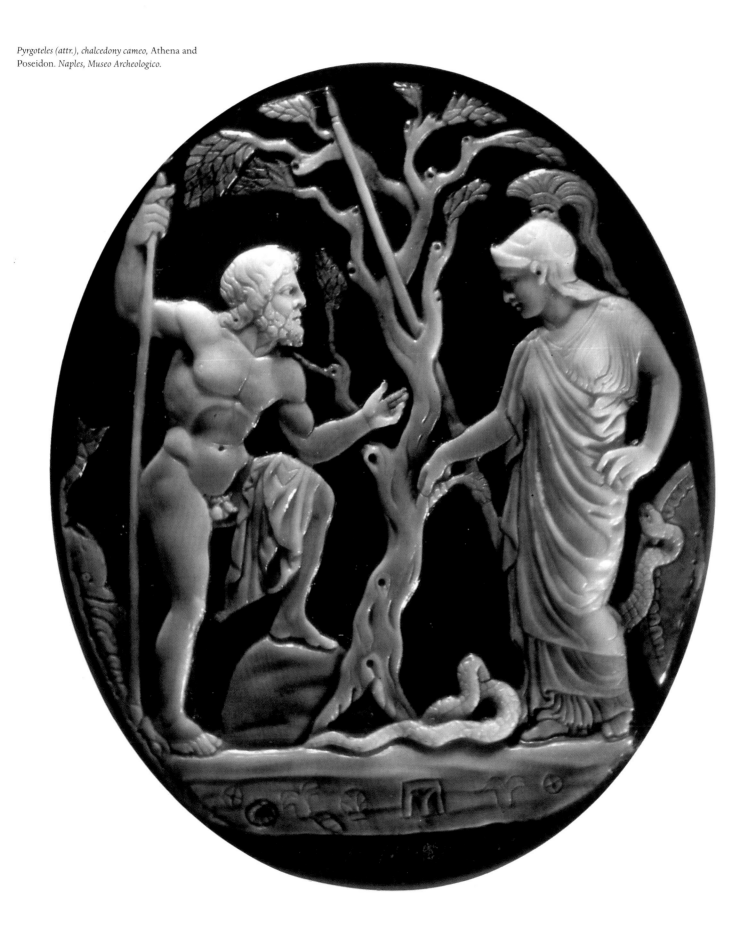

Pyrgoteles (attr.), chalcedony cameo, Athena and Poseidon. *Naples, Museo Archeologico.*

The Farnese Bowl, *chalcedony cameo.*
Naples, Museo Archeologico.

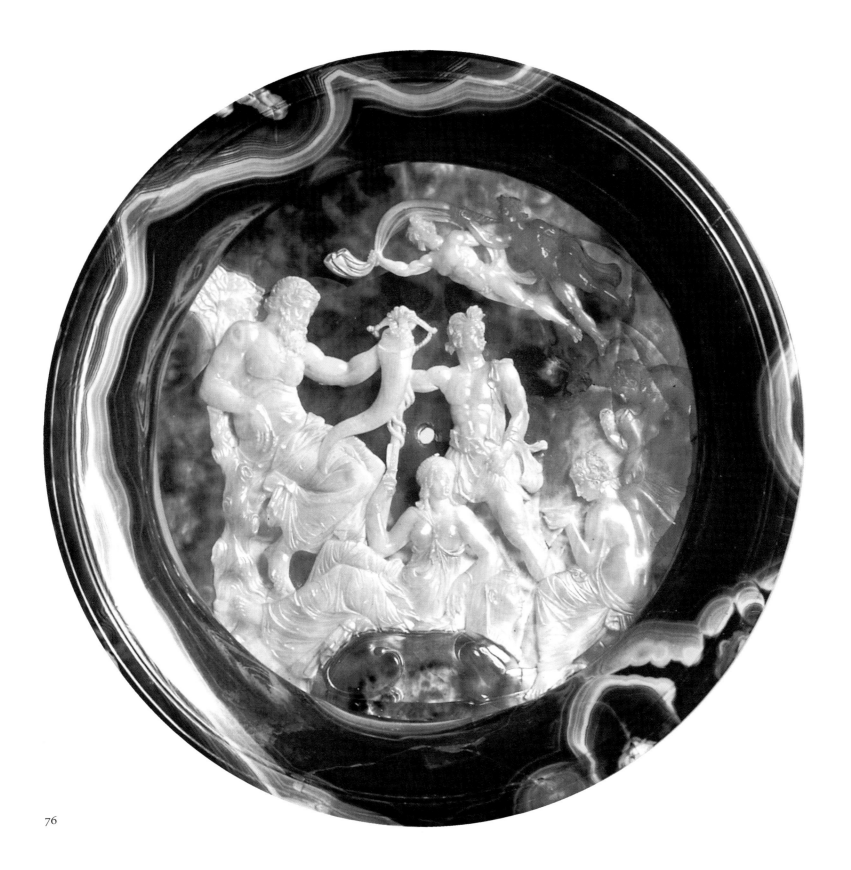

Engraving, cornelian, Apollo, Marsyas
and Olympus, *or* 'Nero's seal'.
Naples, Museo Archeologico.

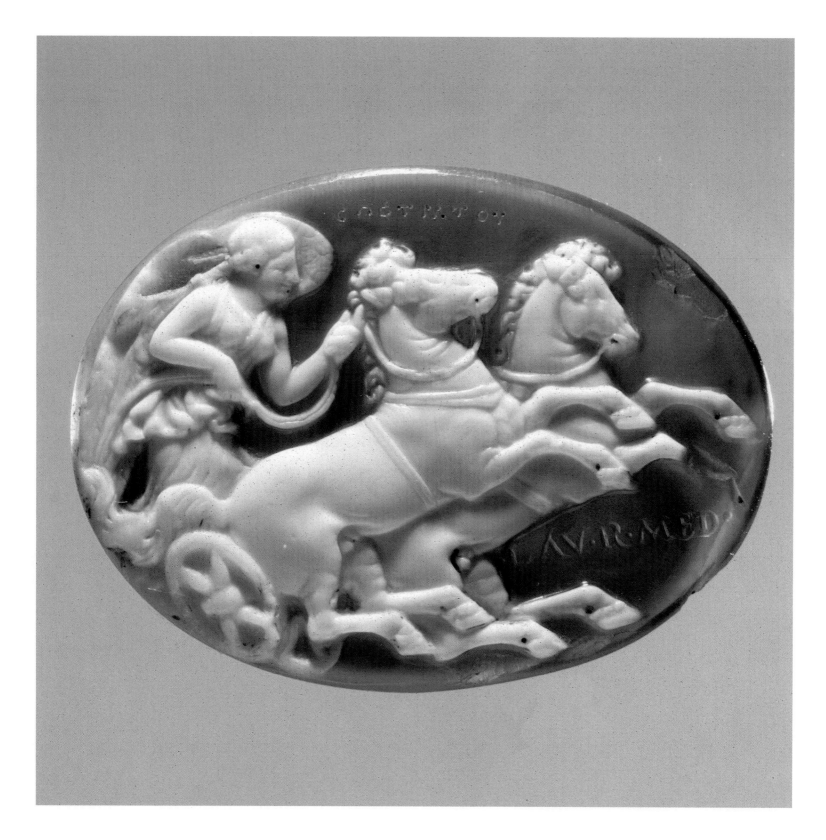

Sostratos, chalcedony cameo, Nike with two galloping horses. *Naples, Museo Archeologico.*

The iconography of this piece inspired various suitably-adapted versions by fifteenth-century artists, who often made use of it as an allegorical representation of the immortality of the soul according to Neoplatonic doctrine.

Forty-three cameos, many of which came from Paul II's collection, are engraved with the initials LAV.R.MED almost as though Lorenzo wished to assert his ownership of them. In February 1495, barely a year after the death of Lorenzo il Magnifico, Caradosso, a renowned jeweller from Milan, visited the Medici collections and, in a letter to Ludovico Sforza, described the most famous gems in their possession, as well as the Farnese Bowl. These included the famous chalcedony *intaglio,* engraved with Diomedes and the Palladium, already mentioned with reference to the medallions in the courtyard, and two other *intagli:* – 'Nero's' seal and Phaeton's Chariot ("That day I saw the bowl, and on another occasion they showed it to me together with other things which are quite matchless, that is Nero's seal, Phaeton's chariot, the chalcedony"). In fact, when Charles VIII entered Florence in 1494 and Piero, Lorenzo's son, was forced to leave the city, these three engraved stones and the Farnese Bowl were the first items to be removed to a place of safety.

'Nero's' seal consisted of an engraved cornelian representing Apollo, Marsyas and Olympus. This Medici piece is believed to be the cornelian now in the Museo Nazionale Archeologico, Naples. The engraving is attributed to Dioscorides, a Greek craftsman who worked in Rome for the Emperor Augustus. The letters LAV.R.MED. carved on the stone confirm that it belonged to Lorenzo il Magnifico. The unusual association of the cornelian with a seal which may have belonged to Nero derived from an inscription found in the precious gold mount in the form of a dragon made by Lorenzo Ghiberti. On the ring which enclosed the stone was a Latin inscription referring to the Roman emperor. Some rare bronze reliefs which reproduce the cornelian may be considered faithful copies of the stone when it still had the inscription around the border mentioned by Ghiberti (NERO. CLAVDIVS.CAESAR. AVGVSTVS.GERMANICVS.P.MAX.TR.P.IMP.P.P.) [6].

The last gem, representing the Chariot of Phaeton, may perhaps be identified with an engraved cornelian also in the Museo Archeologico, Naples, which, like the seal, also has Lorenzo's well-known inscription on the base. It is tempting to believe that this is the cornelian over which Lorenzo had to haggle with Luigi Lotti da Barberino in 1487, eventually obtaining it through Giovanni Ciampolini, a Roman merchant and collector, for a price of 150 ducats [7]. It would appear that in the same year Caradosso, or another jeweller, judged the cornelian to be modern and not antique. This shows that Lorenzo readily accepted the numerous gifts offered to him, even when they were modern pieces and occasionally even presented as being antique. Whatever their artistic value, he was clearly fascinated by the subjects portrayed and their inspiring interpretations.

In fact, Lorenzo also bought modern cameos and *intagli* made by the jewellers employed to repair or reset his gems and whom he encouraged to learn the ancient and

Giovanni delle Opere, known as 'Delle Corniole', engraving on cornelian, Portrait of Girolamo Savonarola. Florence, Museo degli Argenti.

Domenico di Polo, engraving on emerald plasma, Hercules. Florence, Museo degli Argenti.

Domenico di Polo, chalcedony cameo, Portrait of Alessandro dei Medici. Florence, Museo degli Argenti.

Opposite page: Chalcedony cameo, Sacrificial scene. Gold frame with coloured enamel, late 16th century. Florence, Museo degli Argenti.

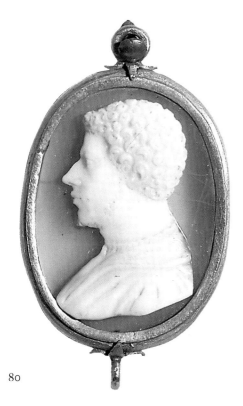

difficult art of engraving semi-precious stones. Lorenzo brought many engravers to Florence, including Antonio da Pisa and Piero di Neri Razanti or Razzanti. The latter was the *maestro* who taught Giovanni delle Opere, nicknamed Giovanni delle Corniole for his renowned skill in cutting that particular stone (cornelian). Giovanni was born around 1470 and is documented in Florence in 1498. When Lorenzo died, Giovanni would have been only about 22 years old, perhaps too young to have engraved one of the best portraits of Lorenzo (himself young in the image) on an attractive small cornelian housed in the Museo degli Argenti in Florence (Museo degli Argenti). His excellence as an artist is attested, however, by the portrait of Savonarola attributed to him by Vasari, which was added to the Florentine collections only towards the middle of the following century (Museo degli Argenti)[8]. His confident style and clean line earned him fame and repute as a portraitist of famous men of the day.

In 1513 Giovanni delle Corniole, who had already valued the Medici jewels for the Florentine republic, received another important commission from its representatives; requested to engrave a cornelian with a figure of Hercules *ad usum sigilli* (to be used as a seal), he portrayed the hero walking slowly with his club over one shoulder and the skin of the lion he had killed over the other. Hercules is here intended to represent the mythical founder of Florence, symbolically embodying the human and civic virtues of the city[9].

Unfortunately the cornelian engraved by Giovanni has been lost, but another *intaglio* of an only slightly later date, which belonged to Cosimo I, has survived and is still in the Medici collections[10]. In emerald plasma, it reproduces an image of Hercules with the traditional iconography and is presumably similar to Giovanni's seal. The later engraving was commissioned in 1532 from Domenico di Polo whom Vasari recalls primarily as "an excellent master of engraving" and a student of Giovanni delle Corniole. Another cameo may certainly be dated to the time of Lorenzo from its splendid solid mounting of gold and coloured enamels; representing a flourishing laurel tree, the Greek inscription is the equivalent of the Latin motto *semper viret*[11].

The death of Lorenzo il Magnifico finally led to a political crisis and in 1494 the Medici were forced to flee from Florence, returning to the city only in 1512 on 14 September. They were able to take the collection of gemstones with them, but his difficult financial situation forced Piero de' Medici, Lorenzo's son, to pawn some of them to Agostino Chigi for the sum of 3,000 ducats. From 1496–1512, therefore, the collection was kept in the Chigi bank in Rome, creating considerable interest in Roman artistic circles.

The events of the following years were to affect the fate of the Medici collections dramatically, and the collection of gems which had been created by the early Medici was widely dispersed. After the sack of Rome in 1527 and the arrival of Charles V's imperial forces in Italy, the Medici were once again forced to leave Florence, entrusting their jewels and other valuables to Baccio Bandinelli. The definitive return of the Medici dynasty to Tuscany's first city did not occur until 1532 when Clement VII, with

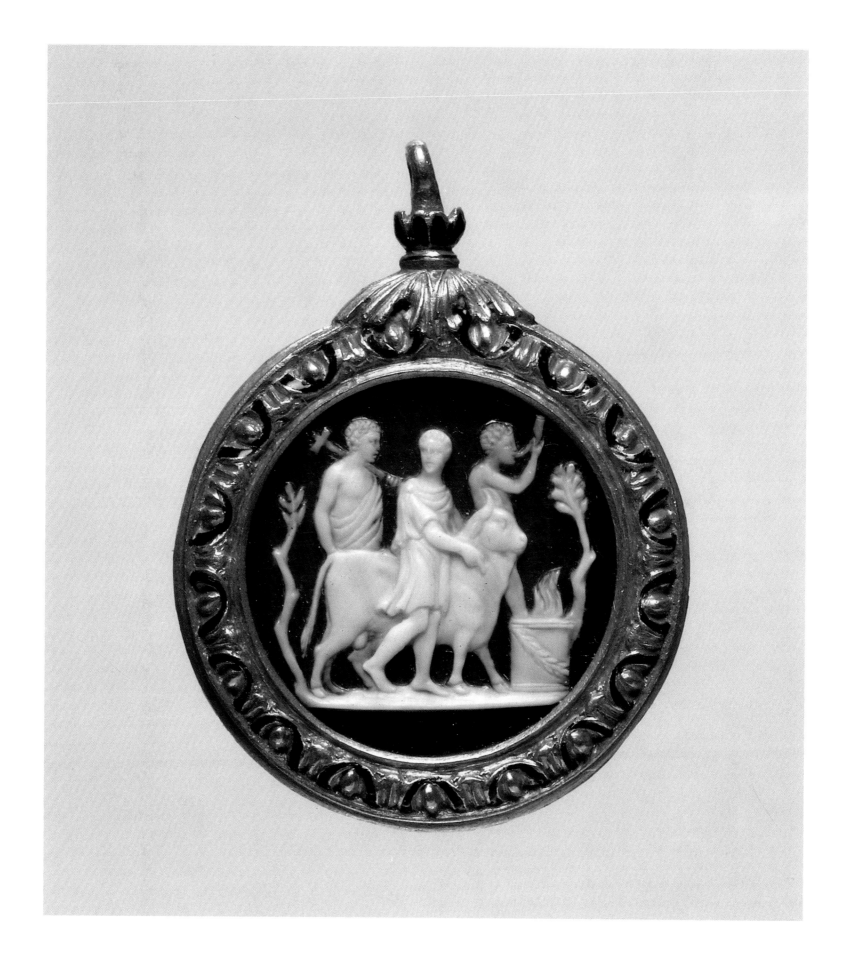

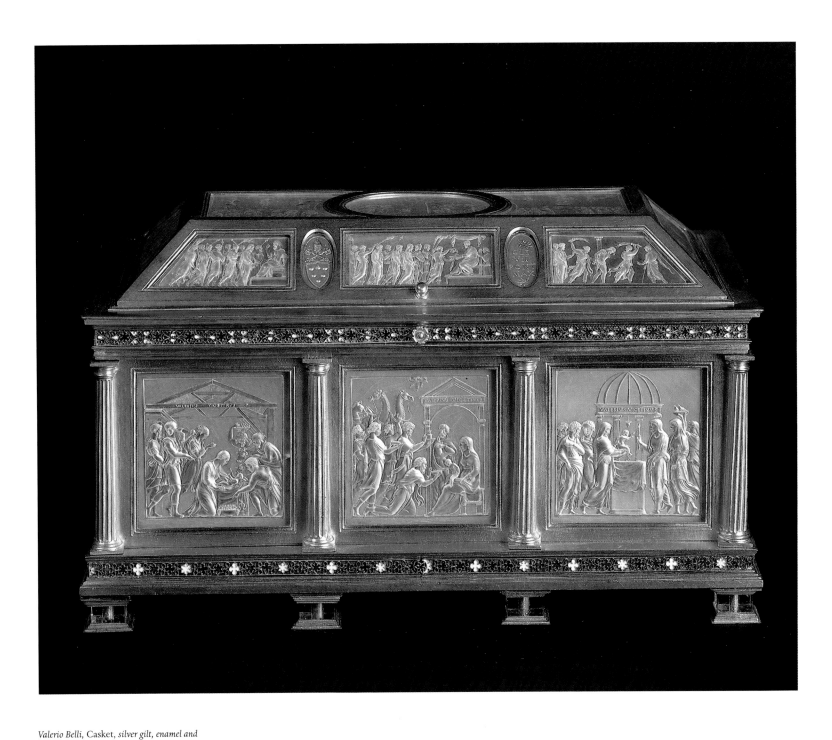

Valerio Belli, Casket, silver gilt, enamel and rock crystal engraved with scenes from the Passion, 1532. Florence, Museo degli Argenti.

the support of Charles V, imposed the young Alessandro as the supreme authority in the city, and on 27 April of that year the Medici were declared the hereditary rulers of Florence.

The new duke ordered that all symbols of the previous republic should be removed and obliterated, and even had the bronze bell in the tower of the Signoria melted down and the metal used to make commemorative medals of himself. These bear a striking resemblance to the splendid cameo with his image made by Domenico di Polo in white chalcedony with a creamy background (Museo degli Argenti)[12].

In 1537 Alessandro was stabbed and murdered by his cousin Lorenzino. This event brought about an abrupt division of the collection of gems. The majority, including the most valuable items, was taken by the imperial ambassador, guardian of Charles V's illegitimate daughter, Margaret of Austria, the fifteen-year-old widow of Duke Alessandro. Margaret took most of the gems which had once belonged to Piero and Lorenzo il Magnifico to Rome when she took up residence there in Palazzo Madama, a Medici property, on 10 July 1537. The following year she was married to Ottavio Farnese and consequently the famous Hellenist chalcedony bowl, Lorenzo il Magnifico's forty-three gems and numerous other engraved stones passed from the Medici to the Farnese. When the Farnese moved to Naples in 1735, to continue the succession of the dynasty, they took the collection with them and the Medici jewels have remained there with other valuable possessions of the Farnese ever since[13].

During the first half of the sixteenthth century, one of the most important pieces in the collection was the silver-gilt enamelled casket with engraved rock crystal panels made by Valerio Belli, one of the most famous engravers of the century. It is signed and dated 1532 (Museo degli Argenti).

Pope Clement VII was, as already mentioned, responsible for the consolidation of Medici power not only in Florence, with the installation of Alessandro as the city's duke, but also in Europe. On the one hand he succeeded in obtaining recognition of his dynasty by Charles V, while on the other he confirmed his alliance with France by marrying his kinswoman, Catherine de' Medici, daughter of Lorenzo Duke of Urbino, to Henry II. The marriage took place in 1532 and Clement's present to his niece, whom we see portrayed as a young girl in a pure white chalcedony cameo (Museo degli Argenti), was this splendid classical casket of rock crystal engraved with episodes from the Life of Christ[14].

When Cosimo was elected Duke of Florence in January 1537, the collection of jewels barely existed. Despite his youth (the new duke was only eighteen years old), Cosimo was strong-willed and decisive as we can see from a portrait of him engraved in rock crystal (Museo degli Argenti). He immediately asserted his position and confirmed the Medici's power by renewing the city's institutions and initiating important urban and architectural projects, as well as recreating the dispersed collections.

Chalcedony cameo, Portrait of Catherine dei Medici. Frame set with rubies. Florence, Museo degli Argenti.

Engraving on rock crystal, Portrait of Cosimo I dei Medici. Florence, Museo degli Argenti.

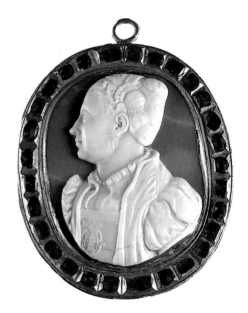

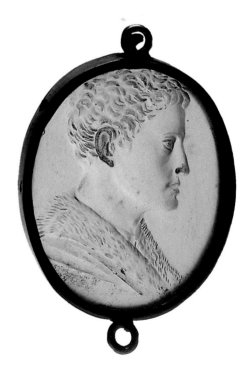

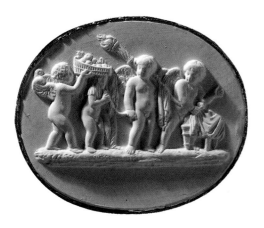

Tryphon, cameo, The marriage of Cupid and Psyche.
Boston, Museum of Fine Arts.

Opposite page: Giovanni Antonio de' Rossi, chalcedony cameo,
Portrait of Cosimo I dei Medici, Eleonora di Toledo and
their children. *Florence, Museo degli Argenti.*

FROM COSIMO I TO FERDINANDO

Cosimo, who in 1537 had been endowed by Charles V with the title *Caput et Primarius* of the duchy of the Florentine Republic, received two other important titles: in 1554 the emperor made him a member of the *Ordine del Toson d'Oro* (Order of the Golden Fleece) and in 1569 Pope Pius V nominated him Grand Duke.

To assert the stability of this newly-acquired power and prestige, Cosimo ordered a large cameo from Giovanni Antonio de' Rossi (1517–75), a famous engraver and maker of medallions. The cameo imitated the style of large antique cameos by presenting the grand ducal family in an 'official' pose; it was in fact symbolically placed, representing the Medici's power, in the cabinet which the Grand Duke had made for the Tribune of the Uffizi Gallery, to house the most prestigious items of the Medici collections. Vasari mentions the cameo in his 1568 edition of his *Lives of the Artists*, though his description is imprecise and he makes no reference to the ornate gold frame which is reputed to have surrounded it[15].

Eleonora di Toledo, Cosimo's wife, also bought valuable cameos and *intagli*, thus supplementing those few which remained of the original collection. In 1556, through Luigi Maiolo in Rome, she acquired a large amethyst with a pastoral scene (Museo Archeologico) and a cameo with a head of Socrates (Museo degli Argenti). In 1562 she bought from Giovanmaria di Jacopo Veneziano a "large amethyst of wonderful colour engraved with ancient Hercules and set in gold..." (Museo Archeologico)[16]. On 7 October of that year, she succeeded in procuring for 40 scudi, through Gaspare Miseroni, the beautiful cameo with a double portrait of Philip II and Don Carlos, traditionally attributed to Jacopo da Trezzo (Museo degli Argenti). During the same period a beautiful antique cameo portraying the marriage of Cupid and Psyche, signed by Triphon, a Greek engraver at the court of Augustus, was bought for some 506 ducats. Now in Boston, the cameo was originally found in an archaeological excavation at Sentinum some time before 1572, and was sold to a Venetian merchant; from here it passed into the collection of the Tuscan grand dukes, though only for a brief period since it is documented in the collection of P. P. Rubens early in the seventeenth century[17].

Cosimo was succeeded by Francesco I in 1574. Interested in the occult sciences and alchemy, the new prince was particularly fascinated by the infinite variegations and colourings of semi-precious stones, which he had made into refined and elegant objects in keeping with his tastes and preferences as a shrewd collector. Francesco considerably increased not only the collection of semi-precious stone vases, of which he was particularly fond, but also that of gems. His brother Ferdinando, while still a cardinal in Rome, kept him constantly informed of sales of antiquities, gems and valuables as they took place on the Roman antiquarian market and was always ready with advice on which items were worth buying. Francesco also commissioned Roman craftsmen to work for him; in 1574 for example, he ordered a cameo with posthumous

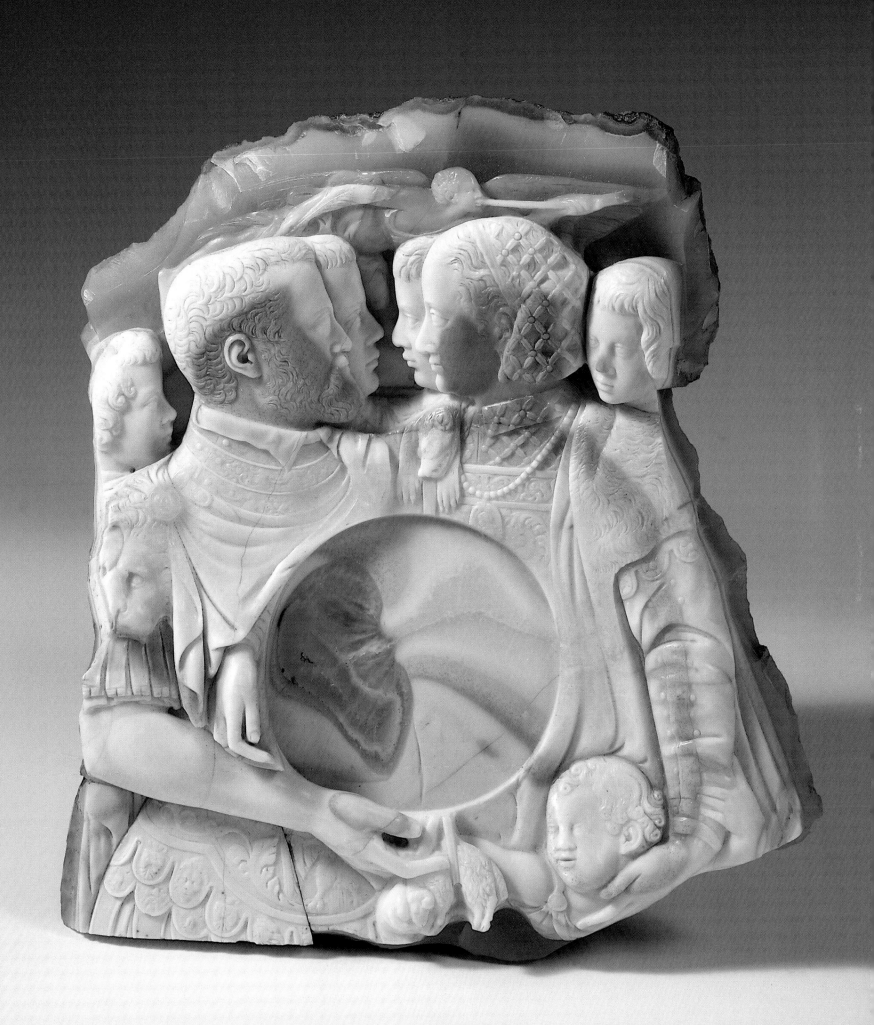

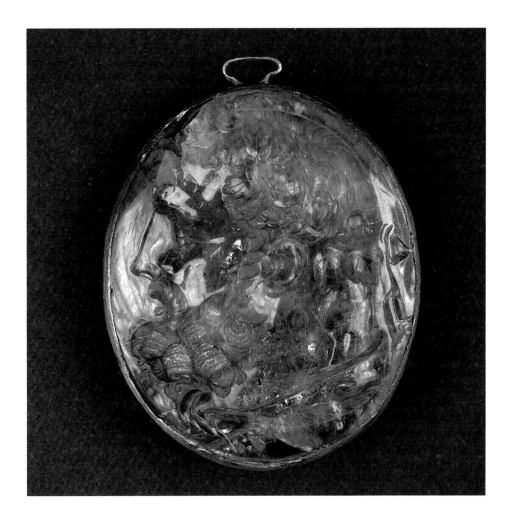

Engraving on amethyst, Hercules.
Florence, Museo Archeologico.

portraits of his parents from Domenico Compagni, an engraver working in Rome (Museo degli Argenti)[18].

In 1575 Cardinal Ferdinando informed his brother Francesco of the sale of a collection of antiquities which included many antique and modern cameos. The sale was ordered by Giulio Gualtiero, heir of the Bishop of Viterbo, Sebastiano Gualtiero. Among the jewels bought by the grand duke was a cameo of particular importance both for its size and the scene portrayed: the *Triumph of Philip II*, with no less than 13 figures and 4 horses, still in the Medici collections. Unusually for the time, the piece is signed by the engraver DNICVS ROMANVS, most probably an engraver working in Rome and known as Domenico dei Cammei, though we do not know if this is the Domenico Compagni already mentioned. The cameo had most probably been given to Bishop Gualtiero in recognition of his diplomacy between Spain and France in 1556[19], and when it became his property Francesco I decided to modify it. Somewhat oddly, the grand duke wished to transform the image of Philip II into that of his father, Cosimo, and asked the engraver to make this alteration. Although this was never done, the information itself reveals the rather casual and frequent practice of

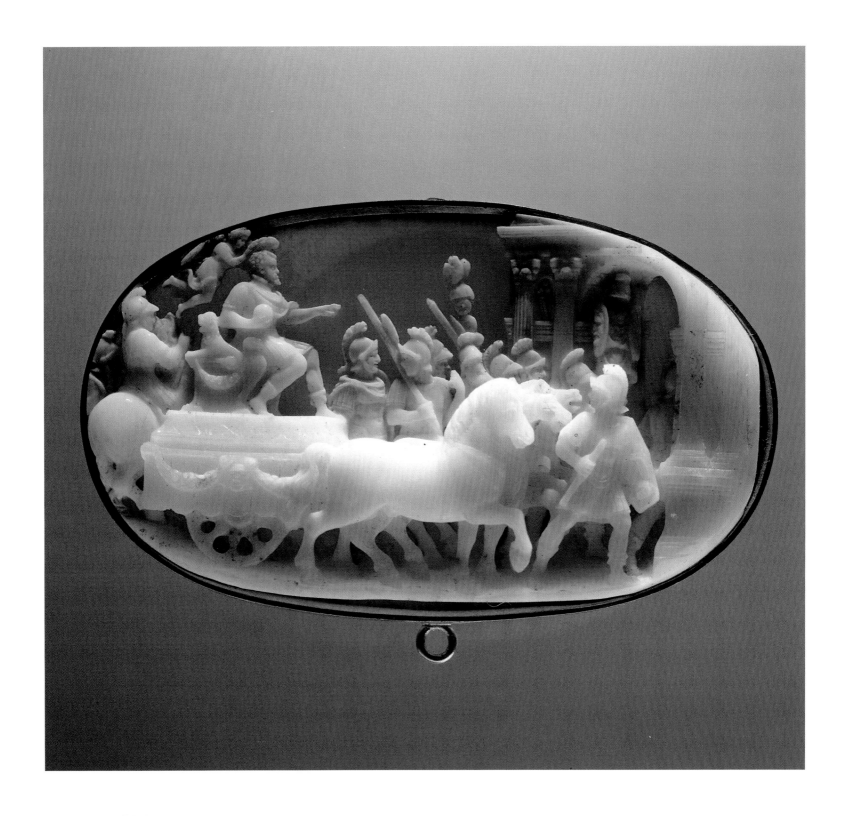

Domenico Romano, chalcedony cameo,
Triumph of Philip II of Spain,
c. 1550. Florence, Museo degli Argenti.

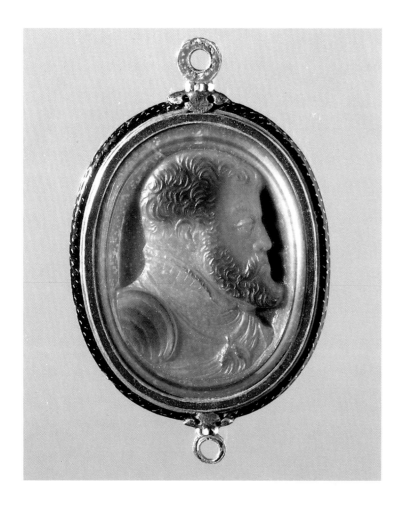

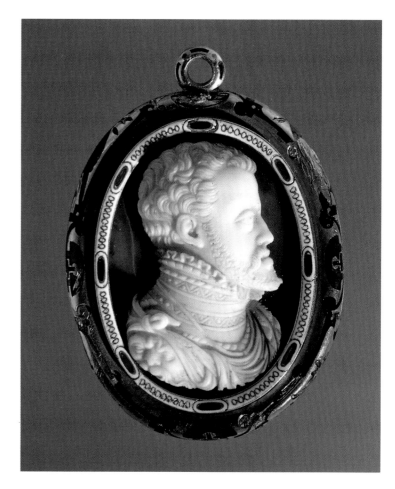

Cameo in 'sapphire' chalcedony,
Portrait of Philip II. *Gold frame with coloured enamel.*
Florence, Museo degli Argenti.

Gaspare Miseroni, chalcedony cameo,
Portrait of Philip II. *Gold frame with coloured enamel.*
Florence, Museo degli Argenti.

altering existing cameos and *intagli,* with the result that it is difficult both to date and to attribute the engraved stones with any certainty.

Lengthy negotiations took place in 1574 to obtain a cameo found during excavations, which Stefano Alli, a member of a noble Roman family, had brought to the attention of Francesco I . The cameo portrays Jupiter, Ganymede, Venus and the eagle and was priced at 50 scudi (Museo Archeologico)[20]. The vendor, at first willing to send the cameo to Florence, subsequently changed his mind and even refused permission to make a wax impression of it. He later agreed that it could be sent to the grand duke for approval but on very strict conditions. The confidential nature of the deal and the vendor's terms emphasise the special attention reserved for certain items considered to be extremely rare.

Around 1583, Francesco commissioned Bernardo Buontalenti to make an ebony cabinet in the form of an octagonal temple to house both the Medici's numismatic collection and the gems, thus replacing the existing receptacle. The cabinet, which took some three years to make, was of ebony with semi-precious stone inlay, with columns of oriental alabaster, pillars of veined alabaster and a dome covered with

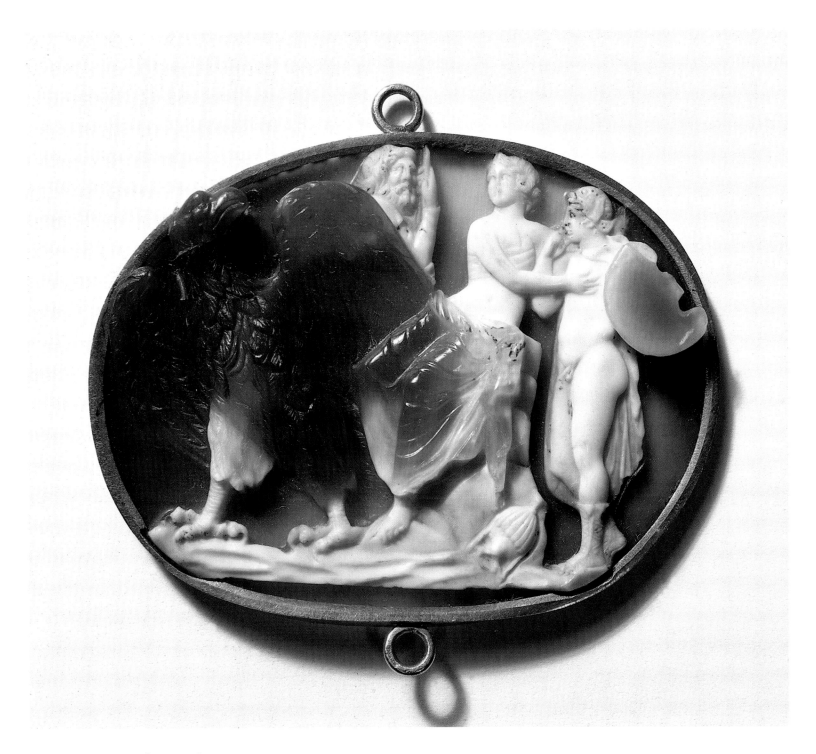

Agate cameo. Jupiter, Ganymede, Venus and
the Eagle. *Florence, Museo Archeologico.*

gilded scales. It had the same form as the Tribune in the Uffizi Gallery, where it stood in the centre on a table. Suitably arranged in the 54 large drawers and the 120 small ones were gold, silver and bronze medals, together with "agates, sapphires, amethysts and all the jewels which were engraved or made in relief; if we consider their value they are priceless; if their craftsmanship, they are incomparable".

Francesco died in 1587 and was succeeded by his brother, Ferdinando, who left Rome and the office of cardinal behind and returned to rule over the Tuscan grand duchy. In April 1589 Christine of Lorraine (Museo degli Argenti), Catherine de' Medici's favourite niece, arrived in Florence as Ferdinando's bride. Madame, or Madama, as the Tuscans affectionately called their new grand duchess, brought a number of jewels to Florence as part of her dowry. These included many engraved gemstones which her aunt Catherine had originally taken with her to France. As well as the famous casket of engraved rock crystal made by Belli, the inventory includes many rare cameos[21].

Ferdinando I, who had lived in Rome from 1571 to 1587, also brought many quite excellent items with him. His, for example, was the antique head of Augustus in turquoise (Museo degli Argenti) which he had mounted on a gold bust made by the goldsmith Antonio Gentili da Faenza. He probably also owned a cameo of Philip II of Spain (Museo degli Argenti) framed in gold with an eagle and grotesque mask made by the goldsmith Lionardo Fiammingo. However, the most important item added to the family collection by Ferdinando was a cameo worthy of the Roman emperors themselves: an agate measuring 14.2 cm in diameter, portraying the Emperor Antoninus making a sacrifice to Hope[22].

With the help of the Medici agent in Rome, Alfonso del Testa, Ferdinando and Christina acquired some cameos in 1587[23], including one with the head of Vespasian, possibly the beautiful cameo now in the Museo Archeologico)[24]. Giovanni Antonio and Domenico dei Cammei (di buona memoria, indicating that Domenico was probably already dead in 1587) also obtained for them a series of twelve cameos with portraits of Roman emperors which had been intended, however, as a gift for Philip II ("...they are the first twelve emperors, which were made as a gift for King Philip and they are all in order in an ebony box with little windows covered with scarlet velvet"). The grand dukes' intermediary concluded the deal for 60 scudi, and the set, mentioned in the 1576 inventory of the Guardaroba, was added, complementing the other which already belonged to the Medici collection of gems[25].

At the end of the sixteenth century the Medici collection was one of the largest and most valuable in Italy and so it remained, unlike many others, unchanged for another two centuries.

Notes and references

1 On the meaning of the tondi in the courtyard of Palazzo Medici Riccardi, see Dacos in *Il Tesoro di Lorenzo il Magnifico. Le Gemme,* exh. cat. Florence 1972, p. 147 and note 36. The choice of iconography seen in the decorative carved medallions around the courtyard of the palace may be explained as not only representing a sophisticated 'exercise in ancient history' but also as demonstrating the symbolic and cultural importance the Medici attached to the most admired and recognised stones of the time.

2 In the Medici collection housed in the Museo degli Argenti (Inv. Gemme 1921 no. 323) is a large cornelian engraved by Giuliano di Scipione Amici with a portrait of Pope Paul II for the declaration of the Jubilee decreed in a papal edict of 19 April 1470. The cornelian has been linked to some bas-reliefs identical in form and iconography to the original. The frame consists of a wide raised and decorated border, with a motif of volutes at the top, most probably a copy of the original frame of the engraving, now lost. *L'arte degli Anni Santi,* Roma 1300-1875. Milan 1984, no. VIII. 7; no. VIII. 8.

3 *Il Tesoro* ibid. 1972, p.119; for the cameo of Athena and Poseidon, p. 42, no. 6; the Entry into the Ark, p.64 no. 37. For the memoirs of Cardinal Francesco Gonzaga who was received by Piero in 1462, see *Il Giardino di San Marco maestri e compagni del giovane Michelangelo,* ex. cat Florence 1992, p.29, note 12; for Filarete, writing around 1464, see De Benedictis *Per la storia del collezionismo* Florence 1992, pp. 154–5.

4 *Il Tesoro* ibid. Florence 1972; Giuliano *Ancora il tesoro di Lorenzo il Magnifico* in *Prospettiva* 1975 N. 2, P. 39 ; Giuliano *I cammei della collezione medicea del Museo Arceologico di Firenze* Rome 1989; Tondo Vanni *Le gemme dei Medici e dei Lorena nel Museo Archeologico di Firenze* Florence 1990; *Il Giardino di San Marco ibid.* 1992 etc.

5 On the famous Medici chalcedony cup see *Il Tesoro* ibid 1972, doc. XI p. 120 and p. 69 no. 43; more recently Gasparri in *I Farnese,arte e collezionismo Colonna (Parma)* 1995, Milan 1995 pp.134–5 and bibliography. Federico II's ownership dates, as deduced by Ulrico Pannuti, from 1239 when he bought it from two Provençal merchants for 1,230 gold ounces (*Il Giardino di San Marco* ibid 1992, p. 25, note 16).

6 See *Il Tesoro* ibid. 1972, pp. 55–7. The difference of size between the stone and the remaining bronze reliefs has been pointed out (*Piccoli bronzi e plácchette del Museo Nazionale di Ravenna* Faenza 1985, no. 12). Of the numerous copies with variations, a cornelian of high quality in the Bibliothèque Nationale in Paris is believed to be fifteenth-century (*Il Tesoro* ibid 1972, no. 41; Giuliano ibid. 1975, no. 41, fig. 5).

7 *Il giardino di San Marco* ibid 1994, pp. 22 ff. Letter dated 2 February 1487.

8 The cornelian with the portrait of Savonarola by Giovanni delle Corniole, bought by Grand Duke Cosimo I in 1565 and set in a gold frame, now missing (Gaye *Carteggio inedito d' artisti sec. XIV-XV-XVI* 1840, III, p. 196) is recorded for the first time in the journal of the Guardaroba in 1566 (ASF Medicei no. 643, post 2 July 1566; see also Giuliano *I cammei della collezione medicea del Museo Archeologico di Firenze.* 1989, p. 299). At number 302 there is also "A large gold ring engraved with two harpies around the arms of Toledo with Mazzocchio, in chalcedony" (Museo Argenti, Inv. Gemme 1921 no. 350), and at no. 310: "a stellaria stone with a small serpent engraved on it" (ibid. no. 1162).

9 Collareta ibid. 1986, p. 292, note 5. An amethyst seal with a Greek inscription and attributed to Marco Tassini, an engraver of gemstones buried in Santa Maria Novella in 1496 (Giulianelli *Memorie degli intagliatori moderni di pietre dure, cammei e gioe dal sec. XV al XVIII* Livorno 1753, p. 125), was in the possession of Abbot Andrea Andreini in the early eighteenth century. Engravers active at the end of the fifteenth and beginning of the sixteenth centuries included a certain Michelino, Domenico di Francesco Delfini "a cutter of cornelians" and Pier Maria Serbaldi da Pescia (c. 1455–1550), recorded as a carver in relief and imitator of antique items. He was Domenico di Polo's maestro and his name is signed on both a porphyry statuette of Venus (Museo degli Argenti in *Splendori in Pietri Dure L' arte di corte nella Firenze dei Granduchi* 1988, no. 1) and a portrait engraving of Leo X (Museo degli Argenti, no. 325).

10 The seal is now in Palazzo Pitti (Museo degli Argenti, Inv. Bargello no. 30; McCrory in *Palazzo Vecchio e collecionismo mediceo. Firenze e la Toscana dei Medici nell' Europa dell Cinquecento* exh. cat. Florence 1980, no. 280; Collareta *Il sigillo con l' Ercole del Museo degli Argenti* in *Rivista d'Arte* 1986 XXXVIII, pp. 291–3).

11 Museo degli Argenti, Inv. Gemme 1921 no. 92; Gori *Monumentum colombarium* Florence 1727, II p.75 no. 5; Vasari Milanesi *Le Vite de piu eccellenti pittori scultori e architettori scritte da Giorgio Vasari 1568,* Florence 1880, vol. V p. 370; other gems with the same mounting have been found, see Hackenbroch *Renaissance Jewellery* London 1979 fig. 165; Babelon *Catalogue des carnees antiques et modernes de la Bibliotheque National* Paris 1897 no. 464 fig. LV; the emblem is not one of those normally associated with Lorenzo, see Dillon-Fantoni in *All'ombra* 1994, pp. 135 ff.

12 A detailed study of Domenico di Polo's medallions can be found in Fox *Medaglie medicee di Domenico di Polo* in *Boletine numismatica,* 1989 NO. IO, PP. 189-212, which also includes the cameos attributed to him.

13 In *Il Tesoro, ibid* 1972, p. 7, Pannuti gives a detailed account of the history of the Medici-Farnese collection. More recent are Gasparri 1994 and C. Gasparri in *I Farnese* ibid. 1995, pp. 132–51; a bibliographical summary is given on p. 138.

14 Catherine took the casket to France, but it returned to Florence as part of the dowry of Christine of Lorraine in 1589. ASF Guardaroba Mediceo no.152. See C. Furlan on the casket in *Atti, ori e tesori* 1992, pp. 323–37 and bibliography.

15 Vasari Milanesi ibid. *1880* vol. V, p. 387; Foggi *Rivista d'Arte* 1916-18, IX pp. 41–8; McCrory in *Palazzo Vecchio* ibid. Florence 1980 no. 279 ; *Splendori in Pietre Dure* 1988, no. 2.

16 Pastoral scene engraved in amethyst, Museo Archeologico, Florence, Inv. no. 14789, see McCrory 'Some gems from the Medici Cabinett of the Cinquecento', *Burlington Magazine* 1979; Tondo Vanni *Le gemme dei Medici e dei Lorena nel Museo Archeologico di Firenze* Florence 1990, no. 35. Cameo of Socrates, Museo degli Argenti, Florence, Gemme 1921, no. 60. Hercules in amethyst, Museo Archeologico, Inv. no. 14856, see McCrory ibid. 1979.

17 It may have belonged to Pirro Ligorio before passing to Rubens and subsequently to the Duke of Marlborough, G. Nonni 'Le nozze mistiche di Amore e Psiche : storia di una gemma ellenistica ritrovata a Sentinum nel xvi secolo' in *Studi umanistici Piceni* 1995, pp. 169–78.

18 Museo degli Argenti, inv. Gemme 1921 no. 11; Palazzo Vecchio 1980, p. 154 no. 287 and McCrory 'Domenico Compagni: Roman Medallistand antiquities dealer of the Cinquecento' in *Studies in the History of Art . Italian Medals ,* 1987 PP. 21, 115-29 .

19 Tuena 'Un episodio del collezionismo artistico del Cinquecento. La dispersione della raccolta del Vescovo Gualtiero *Mitt. Kunst. Inst.* 1989 N.33, PP.85-104. One is tempted to identify Domenico Romano, the artist who made the cameo, with Domenico dei Cammei, or Domenico Compagni; for the latter see McCrory 1982; Palazzo Vecchio *ibid* 1980 p. 154, no. 287 and McCrory *ibid.* 1987.

20 Museo Archeologico, Florence,Inv. no. 14436; McCrory 'An antique cameo of Francesco I de Medici; an episode from the Grand Ducal Cabinet of anticaglie in *Le Arti del Principato Medico ,* 1980, p. 312 doc. I: ASF Carteggio Artisti I ins. 24; Giuliano *ibid.* 1989, no. 1. A later letter contains a sketch of the stone (ASF Carteggio Artisti I ins. 37) including a description, which has enabled us to identify the cameo.

21 Bequest of Christine of Lorraine, ASF Guardaroba Mediceo no. 152.

22 In the eighteenth century the emperor was identified as Julian, in the nineteenth as Antoninus and today (Tondo Vanni 1990, no. 270) as either Julian or Claudius Gothicus (third century AD), making a sacrifice to Hope (McCrory 1979, p. 513; Giuliano 1989, no. 183). As well as furnishings and valuable jewels, numerous rings with stones engraved by Domenico Compagni are included in the inventory of the Guardaroba made listing the items which became Ferdinando's property when he was elected grand duke (ASF Guardaroba Mediceo no. 79, 1571–1588).

23 Among the engraved stones mentioned by Minucci del Rosso 1885, pp. 319–20, is "A gold ring with a most lovely precious stone, with the head of Brutus" and a sardonyx with "Olympia, the mother of Alexander".

24 Museo Archeologico, Florence, Inv. no. 14544, Giuliano 1989, no. 175; Tondo Vanni 1990, no. 248.

25 ASF Guardaroba Mediceo no. 79, signed "A", (1571–1588), c. 25v.

In 1588 Ferdinando I created a grand ducal workshop in Florence specialising in the cutting and working of semi-precious stones. This *opificio* employed the best cutters in the city to work on the decoration of the monumental Medici chapel in San Lorenzo, an immense task which was to last for many decades. The work of the craftsmen was not limited to this decoration alone, however; many other pieces, such as *commesso* table tops, bas-reliefs and small sculptures frequently used to decorate certain pieces of furniture (small altars, prie-dieux, reliquaries, cabinets), were ordered not only by the Tuscan but also by foreign courts.

Previously the art of the semi-precious stone engraver had been of a highly individualistic nature but it was now applied to various different productions

The Medici Collection of Gems from the Seventeenth Century until the End of the Dynasty (1743)

Mariarita Casarosa Guadagni

combining several specialisations in a single project which was often both complex and grandiose.

The creation and early formation of the Medici collection of gems had been strongly influenced by the classical tradition, but from the end of the seventeenth century onwards the acquisitions made were more heterogeneous, intended to represent various qualities and kinds of stones and gems, different techniques, materials and origins.

In fact, semi-precious stones had been considered in this light since the second quarter of the sixteenth century and consequently, as examples of the utilisation, exploitation and transformation of minerals (*naturalia*) into artistic products (*artificialia*), they were selected not only for their antiquity or the expertise of the engraving, but also for the unusual appearance of the stone, which was admired for its specifically natural and mineralogical qualities as well as for the originality of the subject depicted or technique used (*mirabilia*).

An example of the new technique of Florentine "commesso" can be seen in an attractive portrait of the young Grand Duke Cosimo II (1590–1621) (Museo degli Argenti) made from various semi-precious stones, while a cornelian engraved in very low relief with portraits of the two grand dukes, Cosimo II and Maria Maddalena of Austria is clear evidence of the high degree of technical expertise which the grand ducal workshops had achieved (Museo degli Argenti). A select number of the collection of gems was kept in the cabinet of the Tribune in the Uffizi Gallery, while most of the items were hidden in secret wall cupboards on either side of the entrance to the room. Towards the end of the 1630s, the collection was enriched by the legacy of Maria Maddalena, who died in 1629, and later by that of Christine of Lorraine, who died in 1637.

Commesso *cameo, various semi-precious stones*, Portrait of Cosimo II. *Florence, Museo degli Argenti.*

93

Cornelian cameo, Portrait of Cosimo II and
Maria Maddalena of Austria. *Gold frame with coloured
enamel and drop pearl. Florence, Museo degli Argenti.*

Francesco Gaetano Ghinghi, chalcedony cameo,
Portrait of Cosimo III. *Florence,
Museo degli Argenti.*

During the second half of the century the collection was again enlarged when
Marguerite Louise d'Orléans, niece of King Louis XVI, came to Florence as the bride
of Cosimo III, bringing various gems as part of her dowry. Among the jewels added
to the collection at this time was the magnificent fourteenth-century cameo of Christ
borne by an angel (the *angelpietas*), an extremely rare example of semi-precious stone
work from the court of Paris. This quite large piece, first documented in the French
royal collections during the Renaissance period, once formed the central part of a
reliquary with sunbeams made of gold radiating from it. When it was acquired by the
Medici collection, it was embellished with a frame of enamelled floral decoration.
(Museo degli Argenti)[1]. Towards the end of the century, the collection was again
increased by the addition of 911 antique and modern pieces bequeathed by Leopoldo
de' Medici (1617–75), brother of Grand Duke Ferdinando II, who had been made
cardinal in 1667 and was a renowned and enthusiastic art collector[2]. The
correspondence he maintained with his numerous agents and friends has been closely
examined by scholars, giving us a good insight into his many interests revealing that
they were not limited to *anticaglie* (including the antique gems) but also extended to

any modern or contemporary works worthy of belonging to the princely collection of which he was so proud.

The cardinal's collection of gems had been created over a period of about ten years and must already have been of a considerable size in 1670, the year in which he commissioned two expert antiquarians, Ottavio Falconieri and Francesco Cameli, to compile a catalogue of its contents and supervise the making of a cupboard "like a cabinet for jewels", designed by Marco Gamberucci, to house them all.

The archival documents regarding the negotiations which took place between the cardinal and his agents in Rome and other cities give us quite a good idea of the rather frenetic activity within the antiques market at the time, as well as an understanding of his tastes and preferences. On the one hand he sought to acquire original, antique pieces of exceptional beauty while on the other he added quite modern pieces to his collection on account of their unusual size, the rare or strange characteristics of the stone or of the engraving. He competed fiercely with Cardinal de' Massimi to acquire the cameo with Tiberius and Livia, one of the finest in the Medici collection, now in the Museo Archeologico, Florence, and succeeded in obtaining it for the sum of 130 scudi[3] although it was broken and in need of restoration. The intermediary in this deal was Paolo Falconieri, one of Cosimo III's chamberlains and cousin of Ottavio Falconieri, an antiquarian in the service of Cardinal Leopoldo in Rome. He not only informed the cardinal of the cameo but, aware of its value, strongly advised its acquisition, writing: "We must of course try to obtain it for as little as possible, but we simply must get hold of it in any case because pieces as large as this and in this state of preservation are no longer to be found…".

At the suggestion of Ottavio Falconieri, who also proposed "curiosities which I happened to come across", the cardinal bought a clearly 'modern' cameo of Hercules (Museo Archeologico). Quite a large piece, it was made from a stone known as *stellaria*, from the unusual star-shaped markings which characterise the surface. The gem was accepted despite its modernity: "although it is a modern piece, I thought it worth sending to Your Highness, both for the curious stone and for the style, which is not at all bad[4]."

In 1673, through Abbot Andrea Andreini, an antiquarian and collector of gems, Leopoldo bought a set of twenty-eight modern cameos of German origin. These can nearly all be identified in the Medici collection in the Museo degli Argenti, and are particularly interesting for the unusual variegations in the engraved stones and for the originality and inventiveness of some of the subjects.

Between 1669 and 1670, again at the suggestion of Ottavio Falconieri, the cardinal bought a substantial part, if not the entire collection, of the gems belonging to Leonardo Agostini which included some antique pieces of quite superb beauty[5]. Leonardo Agostini was an important figure in the cultural circles of seventeenth-century Rome. A friend of Cassiano dal Pozzo, Pietro Bellori and the painter Andrea Sacchi, he was curator of the library of Queen Christina of Sweden. Originally in the

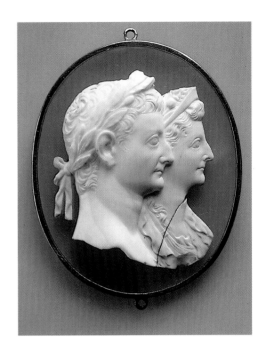

Chalcedony cameo, Portraits of Tiberius and Livia. *Florence, Museo Archeologico.*

Engraving on amethyst, Head of the 'Massinissa'. *Florence, Museo Archeologico.*

Opposite page: Parisian workshop, chalcedony cameo, 'Angelpietas', c. 1400. Gold frame with coloured enamel, 17th century. Florence, Museo degli Argenti.

service of Cardinal Spada and later of Francesco Barberini, in 1655 Alessandro VII nominated him commissioner responsible for the antiquities of Rome and Lazio, an appointment which enjoyed great power and prestige.

In 1657 Agostini published a work on cameos and *intagli* which had considerable success. The treatise is based on the description of 214 gems chosen from the most beautiful and interesting pieces kept in the main collections of the day. This publication, which ran to several successful editions, enables us to examine drawings of the gems selected, to study the suggested meaning of the iconography, containing many erudite references, and even to identify the owners. Unfortunately, although the smallest details of the engravings are often reproduced, they are far from being faithful stylistically. Several gems belonging to Agostini himself are described in the publication and are now to be found in the Medici collection, such as the cameo with the Hermaphrodite (Museo Archeologico), the Apollo attributed to Allione (Museo degli Argenti) and the amethyst engraved with the head of the warrior known as the *Massinissa* (Museo Archeologico)[6].

Other gems which the Medici added to their collection and whose previous owners are identifiable are the rock crystal 'Sacrifice of the Vestals to the Goddess of Health', attributed to Valerio Vicentino, which had belonged to Leone Strozzi (Museo degli Argenti), and a cameo with the Young Bacchus, most probably the lovely piece now in Palazzo Pitti (Museo degli Argenti), which was previously owned by Cardinal Mario Piccolomini. More superb examples of antique engraving were added to the Medici collection with the acquisition of the gems of Abbot Pietro Andrea Andreini, another important figure in the Roman antiquarian world who procured gems and antiquities for Cardinal Leopoldo and frequented the same cultural circles as Agostini. A friend of Pietro Bellori, Christina of Sweden, Prince Odescalchi, Pier Leone Ghezzi and numerous Roman scholars and collectors, he was defined by his contemporaries as "a learned and most diligent collector of gems", capable of recognising unhesitatingly their authenticity and perfection. His collection consisted of genuine archaeological treasures which he had found in his periods of residence in Naples, Venice and Rome and included some of the most prestigious examples of antique glyptic carving. Most significantly, many of the antique gems were signed, thus increasing their prestige and renown; indeed, it seems that this is precisely why so many were stolen.

In 1731, some years after Andreini's death, Gian Gastone de' Medici bought some 300 gems from his collection; however, some pieces had certainly come into the possession of the Medici prior to that date. The famous cameo representing Eros Riding a Lion, signed by Protarcos had, for example, belonged to Andreini (Museo Archeologico). According to Stosch (1724), the abbot had given it to the grand duke as a gift, though others claimed that it had been stolen from him and then resold. Also from Andreini's collection were an engraving of a Muse in yellow plasma, signed by Onesa (Museo Archeologico); a cornelian with Hercules, also signed by Onesa

Protarcos, chalcedony cameo, Eros on a lion.
Gold frame. 17th century. Florence, Museo Archeologico.

(Museo Archeologico); a splendid aquamarine with a portrait of Pompeius Sextus signed by Agathopus (Museo Archeologico) which had belonged to Marcantonio Sabatini; an amethyst with Hercules and Iole, signed by Teucer (Museo Archeologico); and a sculpted head in 51-carat aquamarine portraying Matidia (Museo Archeologico).[7]

At the beginning of the eighteenth century 1,300 gems were displayed in the cabinet located in the Tribune, arranged on 32 trays covered with velvet. Many others were hidden in two secret cupboards in the walls of the Tribune and even more were kept "in different places around the gallery, in boxes and drawers, all in confusion". In 1710 therefore, Grand Duke Cosimo III (1642–1723) commissioned Abbot Andreini and Senator Filippo Buonarroti to carry out a thorough reorganisation of the entire collection; as a result the items were arranged, with their respective casts, in the medal room together with the immense numismatic collection.

During the late seventeenth and early eighteenth centuries, some stones engraved by contemporary artists were added to the Medici collection. Andrea Borgognone (or

Borgognoni or Bergognoni and probably of French origin) was an engraver in the pay of the Grand Duchess Vittoria della Rovere[8] and had worked with Orazio Mochi on the two statues of evangelists for the ciborium in San Lorenzo[9]. He is responsible for the engraving on an octagonal topaz (once set as a ring) of the combined Medici-Rovere arms (Museo degli Argenti) and perhaps also for a bust in lapis lazuli (Museo degli Argenti). However, a jasper engraved on both sides for the grand dukes of Florence has been lost; on one side was the Medici coat of arms, and on the other a ship with five stars alluding to Galileo's discoveries.

Andrea's son, Francesco Gaetano Ghinghi (1680–1762) worked with several of his brothers as an apprentice of Foggini in the grand ducal workshops[10]. We still have a cameo portrait of Cosimo III made by him in oriental chalcedony (probably the portrait in the Museo degli Argenti)[11], a piece which so pleased the grand duke that he gave the artist six *zecchini* and Ghinghi was commissioned to make further portraits of the grand dukes[12]. It would seem that Ghinghi was responsible for reintroducing cameo engraving on semi-precious stones to the Florentine workshops, as we are told that "he began cutting cameos hesitantly and with some difficulty, as there was no teacher of that art in the gallery; only his father could give him some guidance, having seen Maestro Stefano Mochi work on small heads in bas-relief".

In 1737 Ghinghi decided to leave Florence to go to Naples and the court of Charles of Bourbon, who had invited him to share his skills and experience with the Neapolitan semi-precious stone workshops. Probably the death of Cosimo III, the last Medici grand duke, was decisive in this move for, as he himself wrote with regret, "the lack of teachers in the fine art of working semi-precious stones has caused such a decline in the practice of the skill that the teachers were reduced to almost complete despair".

The Medici collection also contains some cameos by Gaetano Torricelli such as Pyrrhus with a Shield (Museo degli Argenti), a Cleopatra in sardonyx agate (Museo degli Argenti) and a Minerva in yellow agate (Museo degli Argenti). These show his preference for working in quite high relief on cameos which are larger than usual and with stones in a rich variety of shades and striations. Giuseppe Antonio Torricelli (1662–1719) was a skilful inventor of the grand ducal "fogginerie" so fashionable around the end of the century. One of the most important Florentine baroque cameos, inspired by a medallion of Massimiliano Soldani Benzi and now in the Museo dell' Opificio delle Pietre Dure[13] is attributed to him, though it may be by his "rival" Francesco Ghinghi. He also wrote a volume dated 1714 entitled *On the jewels used ...*[14], which includes drawings of the tools used in working semi-precious stones "in the Milanese manner, in the service of the most Serene Grand Duke of Tuscany". The treatise provides a wealth of technical information concerning the instruments and even on the cost and origins of the materials used.

Finally, the Medici collection contains some engravings by Carlo Costanzi (1705–81), an excellent craftsman who, according to contemporaries, surpassed even

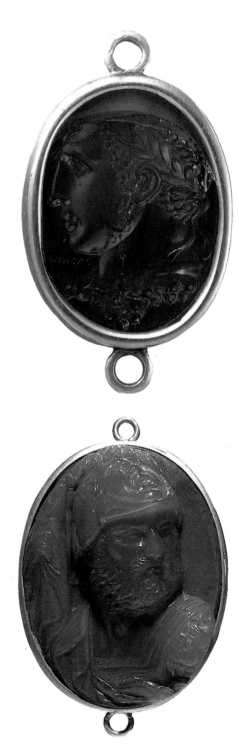

Onesa, engraving on cornelian, Hercules. Florence, Museo Archeologico.

Gaetano Torricelli, agate cameo, Pyrrhus with a shield. Florence, Museo degli Argenti.

Cameos, white onyx on a sardonyx ground, Portraits of
Maria Luisa de' Medici and Johann Wilhelm, Elector
Palatine, crowned. *Bronze gilt frames. Florence,
Museo degli Argenti.*

his father Giovanni (1664–1734)[15] and was particularly expert in copying antiques. Such
was his renown that in 1731 Prince Gian Gastone bought a set of 23 gems from him for
the gallery. Two of Costanzi's engravings have been identified with gems in the
collection: the first is a portrait of Baron Filippo Stosch on a white sapphire (Museo
degli Argenti), and the second a signed portrait of Pope Benedict XIII in topaz (Museo
degli Argenti).

Giovanni Hamerani (1649–1705), a member of the famous family of engravers and
medal makers in Rome, most probably made the attractive cameo portrait on black
onyx taken from a medallion portraying Cardinal Ludovico Emanuele Portocarrero,
who died in 1709 (Museo degli Argenti).

Without doubt, during the first half of the eighteenth century many engravers
came to Florence seeking an introduction to the grand dukes. Lorenz Natter, for
example, came to Florence between 1732 and 1735 and was introduced to Baron Filippo
Stosch who encouraged him to specialise in the art of copying antique gems. Two of
his engravings are in the Medici collection. One, signed by him, shows a head of

Pompeius Sextus (Museo degli Argenti), the other, attributed to him, depicts a male portrait in the classical style (Museo degli Argenti).[16] Unfortunately a topaz with three facets by him has never been traced. Representing a portrait of Gian Gastone, his initials and the Medici coat of arms, it was specifically made for the last grand duke.

In 1716, with the addition of the gems belonging to the Electress Palatine, Maria Luisa de' Medici, widow of Johann Wilhelm, as well as those of Prince Ferdinando, a precise inventory and catalogue of the Medici collection was required. Both the interests of antiquarians and the Florentine cultural climate favoured the compilation and dissemination of a complete and detailed work describing the grand ducal collections.

Agostini's successful catalogue was revised and enlarged several times. It was followed by another by Stosch describing several splendid signed gems selected from the most prestigious collections of the day[17]. Anton Francesco Gori, a Florentine scholar and provost at the cathedral of Santa Maria del Fiore, compiled and published a monumental work illustrating the Florentine collections and in particular those of the Medici. The first two volumes were devoted to the gallery's gems[18].

Gori's publication allows us to identify the nucleus of Maria Luisa's collection of gems, including the outstanding cameo of gold on sardonyx which had previously belonged to Cardinal Piccolomini (Museo Archeologico).

This brief history of the Medici collection of gems closes with the portraits of the Electress Palatine and her husband, as a tribute to Maria Luisa, who ensured that the collection would remain, despite later events, one of the largest still intact in the world.

Notes and references

1 Kahsnitz in *Das Goldene Rössl. Ein Meisterwerk der Pariser Hofkunst um 1400*, Munich 1995, p. 214, no. 14.

2 Numerous studies on Cardinal Leopoldo and his collections have been published. In particular the publication of several volumes of the *Carteggio di Artisti*, kept in the State Archives, Florence, edited by the University of Florence and the Scuola Normale Superiore, Pisa, has provided much useful information on the cardinal's interests as a collector. Giovannini 'Notizie sulle medaglie della collezione Agostini aquisitate dal Cardinale Leopoldo de' Medici' in *Rivista italiana numismatica* 1979; Giovannini 'Lettere di Ottavio Falconieri a Leopoldo de' Medici' in *Carteggio di Artisti dell' Archivio di Stato di Firenze*, Florence 1984; Fileti Mazza, *Il Cardinale Leopoldo de' Medici* , Florence 1989, vols. I-II.

3 On this splendid cameo, see Casarosa 'Collezioni di gemme e il Cardinale Leopoldo de' Medici' 1976, p. 61; Giuliano *I cammei della collezione medicea del Museo Archeologico di Firenze* Rome 1989, pp. 234–5 no. 159 and relevant bibliography. Paolo Falconieri who discovered the piece and chose to sell it to Cardinal Leopoldo rather than Cardinal de' Massimi, requested that he might be given an official permit authorising him to acquire and sell antique and classical items as, despite the fact that numerous regulations controlled the market, a thriving black market for works of art existed in Rome.

4 For the cameo, probably sixteenth-century and now in the Museo Archeologico, Florence, see *Carteggio XI* 1670, no. 282; Casarosa *ibid, * 1976, p. 56; Giuliano *ibid* 1989, no. 80.

5 On Agostini, see Giovannini *ibid.* 1984, p.202 ff.

6 On the Massinissa, see Casarosa 'Variazioni su Massinissa' *Prospettiva* 1989–90, N. 57-60, PP. 358-62. Concerning the stolen pieces, see Gori, *Monumentum Colombarium* 1727, p. 115.

7 On collections in general and Andreini's collection of gems in particular, see Battista 'La collezione di gemme dell' Abate Andreini' in *Anticita' viva* 1993, xxxii,n.1, pp. 53–60; on the collecting of Etruscan antiquities, see *L'Accademia Etrusca* 1985, p. 110 and p. 140, note 34. For Protarcus' cameo of Eros and the Lion see Giuliano *ibid.* 1989, no. 34 and relevant bibliography. For the cornelian with Hercules signed by Onesa, see Tondo Vanni *Le gemme de' Medici e de' lorena nel Museo Archeologico di Firenze*, Florence 1990, no. 129. The amethyst engraving of Hercules and Iole, signed by Teucer (Tondo Vanni *ibid.* 1990, no. 29), was stolen from Andreini and sold to Andrew Fauntaine, though subsequently returned to its owner (Battista ibid. 1993, pp. 56–57). The Maecenas signed by Solon (once owned by Fulvio Orsini, now lost), see the item in the Martinetti collection, *Il tesoro di Via Alessandrina. Il tesoro di Francesco Matinetti 1863-1895*, ed. L. Pirzio Brioli, Cinisello Balsamo, Milan 1990, p. 61, no. 36. Hercules with the Club in amethyst, signed by Gnaios, originally belonged to Fulvio Orsini, subsequently passed to Leone Strozzi and is now in the British Museum, London. All of these are splendid antique pieces. According to Stosch *Gemmae antiquae caelatae, sculptorum nominibus insignitae; ad ipsas gemmas aut earum ectypos delineatae et aerei incisae par B. Picart. Ex Ex percipuis*

Europae museis selegit et commentariis illustravit Ph. De Stosch Amsterdam 1774. Andreini's collection also included a cornelian with Diomedes and the Palladium signed by Polycletes, and an amethyst with Hercules, very similar to the one seen on the seals of the Florentine republic.

8 Giulianelli *Memorie degli intagliatori moderni di pietre dure, cammei e gioie dal sec. XV al XVIII*. Livorno 1753, p. 59 and pp. 138–139; Borgognoni wrote a volume entitled *Adversaria, sive Adparatus pro Historia Glyptographica* containing all the documents regarding commissions and payments made from the time of Grand Duke Cosimo I onwards. Aldini *Institutioni Glittografiche*. Cesena 1785, p. 110 mentions that many of his pieces are kept in the grand dukes' gallery. For the Grand Duchess Vittoria della Rovere he engraved two skulls on a ruby; she was a keen collector of religious pieces and he also made for her the "Virgin Mary, and an Angel in various stones" which could be the two medallions set into the holy water stoup in the Museo dell'Opificio delle Pietre Dure (Inv. 1905, no. 515).

9 Giulianelli *ibid.* 1753, pp. 138–140; *Splendori di pietre dure. L' arte di corte nella Firenze de' Granduchi*, Florence 1988, no. 25.

10 On Ghinghi, see Giulianelli, *ibid.* p. 146; on his autobiography, see González-Palacios 'Un autobiografia di Francesco Ghinghi' in *Antologia di Belle Arti* 1977, N. 3, PP. 271-81.

11 On the cameo which is similar to Massimiliano Soldani Benzi's medallion dated c. 1684, see Palacios *ibid.* 1977, pp.273–4; Langedijk *The portraits of the Medici* Florence 1981, I no. 124. Gonzáles attributes another portrait to Ghinghi (Museo degli Argenti, Inv. Gemme 1921 no. 1166), also representing the grand duke, though considerably older (Palacios *ibid.* 1977 pp. 273–4; Langedijk *ibid.* 1981 no. 125). The artist also wrote that he made two portraits in emerald for Maria Luisa, one of her father Cosimo III (Langedjik *ibid.* I, p. 207) and one of her husband the Elector Palatine.

12 One of Ghinghi's engravings made around 1720, a portrait of the grand duke "79 years of age", was identified by a cast kept in the Biblioteca Marucelliana, Florence: Marucelliana Ms. A. 51 c. 6 in Langedjik *ibid.* 1981, I no. 129.

13 *Splendori ibid.* 1988, no. 45. Although unconfirmed, the cameo is traditionally attributed to Torricelli. Giulianelli *ibid.* 1753, pp. 147–8, attributes a head of Solon in topaz to him, as well as the head of a faun in agate and a Cleopatra; a head of Antinious in cornelian and a "small faun". Aldini *ibid.* 1785 also lists his clients, one of whom was Baron Stosch for whom he made a Bacchus in a niche with a black background; for Horace Mann he made a head of Antinous taken from a medallion.

14 The manuscript is kept in the Kunsthistorisches Institut of Florence,V. 825 d.

15 On Carlo and Giovanni Costanzi, see Giulianelli *ibid* 1753 pp. 62–3, p. 144 and p. 162, who refers to various contemporary sources; more recently see Pirzio Biroli *ibid.* 1984. On the portrait of Baron Stosch and Benedict XIII, see Casarosa 1973.

16 On Natter (who made three portraits of Baron Stosch, two of which are in the Hermitage Museum), see Nau *Lorenz Natter.* Siberach 1966.

17 Picart Stosch 1724.

18 Gori, *Museum Florentinum* 1731-32.

The magnificent ceiling of the *Salone dei Cinquecento* is dominated by an allegory of Florence crowning Cosimo de' Medici with a wreath of laurel leaves, while two putti bear his golden, bejewelled crown, the cross of the Knights of Saint Stephen and the emblem of the Order of the Golden Fleece. Thus the glorification of Florence becomes also the Apotheosis of Cosimo, lord of the state of Tuscany, his authority asserted by the symbols of political power and confirmed by the recognition of the Catholic church. The fresco was painted between 1563 and 1565 and the crown which Cosimo was at the time entitled to present to the Florentines from the lofty heights of the *Salone* was described in an inventory of 1566, where it was named as the *mazzocchio*. It consisted of a circlet of gold set with precious gems, above which was a row of lilies also set with stones and

The Symbols of Power: Dukes and Grand Dukes

alternating with large drop-shaped pearls; two lilies, more elaborately decorated with gems than the rest, represented the cities of Florence and Siena as, after the defeat of Siena in 1557, Cosimo had become the ruler of both states. Crowning the arched bands was an impressive large diamond surrounded by four rubies [1].

Maria Sframeli

In 1558, on the death of Charles V, Cosimo had been in favour of the election of Philip II in Spain and of Ferdinand I as Holy Roman Emperor in Vienna. In 1564, when Vasari was painting the ceiling of the *Salone* in the Palazzo Vecchio, Cosimo obtained the consent of Maximilian II, Ferdinand's son, to the marriage of Joanna of Austria to his son, Francesco. The event was celebrated in Florence with great pomp and splendour.

The Duke of Florence had also been favourable to the election of the Medici Pope Pius IV in 1559, and although the pope was always grateful and most generous with his help and support, he never rewarded Cosimo with the coveted title of Grand Duke which would have placed him in a position of superiority in relation to other lords of Italian states. Only some years later, on 27 August 1569, was Cosimo to receive from Pope Pius V the title to which he had for so long aspired. On 13 December of that year the papal edict sanctioning his new position arrived in Florence and was read in the *Salone* of Palazzo Vecchio.

With the edict the pope sent a drawing of the approved design for the new crown, specifying that it should not be in the usual and traditional style but in the form of a corona, similar to that used by the kings of ancient times, and that a red lily should be placed at the front. The coronation took place in Rome on 5 March 1570, four years before Cosimo's death. The solemn and long-awaited ceremony is recorded both in a painting by Jacopo Ligozzi in the *Salone dei Cinquecento* and in a series of drawings by

Scipione Pulzone, Christine of Lorraine, *detail, 1590. Florence, Uffizi Gallery.*

Opposite page: Alessandro Fei del Barbera, The Goldsmith's workshop, *from the 'Studiolo' of Francesco I de' Medici, Florence, Palazzo Vecchio.*

Stradano, which Giambologna later used as a model for one of the bas-reliefs around the base of the equestrian statue of Cosimo in Piazza della Signoria, erected by his son Francesco. The crown which the pope is seen placing on Cosimo's head is the first crown of the grand dukes of Tuscany. "His Holiness stood, and he too read aloud once more. Then, having seated himself, as Grand Duke Cosimo bowed before him, he placed on his head the royal crown which the duke had had made here in Florence and brought with him." Thus Agostini Lapini, the diarist, described the scene, continuing, "and it is said that it was worth two hundred thousand *scudi,* for it has seventy-five precious gems of all kinds, all large and of great value, with a garland of most beautiful large pearls above"[2].

An engraving published by Galluzzi in the *Istoria del Granducato di Toscana* in 1781 provides us with the design of the crown sent with the papal edict. However, the theme of the painting portraying the goldsmith's workshop in Francesco I's *studiolo* had already been suggested to Vasari by Vincenzo Borghini in a letter dated 15 October 1570, and indeed Alessandro Fei's representation of the scene gives pride of place to the grand duke's crown. The goldsmith is seen copying the design, pinned beside his workbench together with two other models, which corresponds exactly to the engraving later published by Galluzzi. The inscription dictated by the pope and faithfully recorded by Lapini is clearly visible: "The words which were written around the crown were, and are, as follows, PIUS V PONTIFEX MAXIMUS, OB EXIMIAM DILECTIONEM AC CATOLICAE RELIGIONIS ZELUM PRAECIPUUMQUE JUSTITIAE STUDIUM DONAVIT." The crown was used for over a century until 1691, when Cosimo III was elevated to the level of royalty and thus acquired the right to a crown adorned with arches. However, research carried out by C.W. Fock[3] in the Florentine state archives has shown that Cosimo I's crown was replaced by a new one after only a few years.

Cosimo died on 21 April 1574 and the emperor finally consented to sign the act already approved by the pope, elevating the lords of Tuscany to the rank of grand duke, on 2 November 1575. Francesco I considered this a good occasion to have a new crown made and, although no mention of it is made in official documents nor in the accounts of diarists, it is clearly documented in the account books of the goldsmith and jeweller Jacques Bylivelt of Delft who, between 1577 and 1583, recorded all the gold and precious stones acquired for the new grand ducal crown of Tuscany. The finished crown is recorded in the inventory of the *Guardaroba* on 30 June 1583.

A perfect and minutely-detailed description of the crown is provided in the inventory dated 1691. It consisted of a circlet, the lower part of which was decorated with alternating rubies and pearls. Beneath the large lily in the centre was an emerald and beneath this a triangular diamond; two small niches on either side of the emerald contained figures of enamelled gold, probably representing Justice and Prudence. The circlet was enhanced by a row of large gems, each separated by two smaller stones one above the other, and above this, on the band beneath the points, was a commemorative inscription of the title of grand duke received from Pius V. The seventeen points were

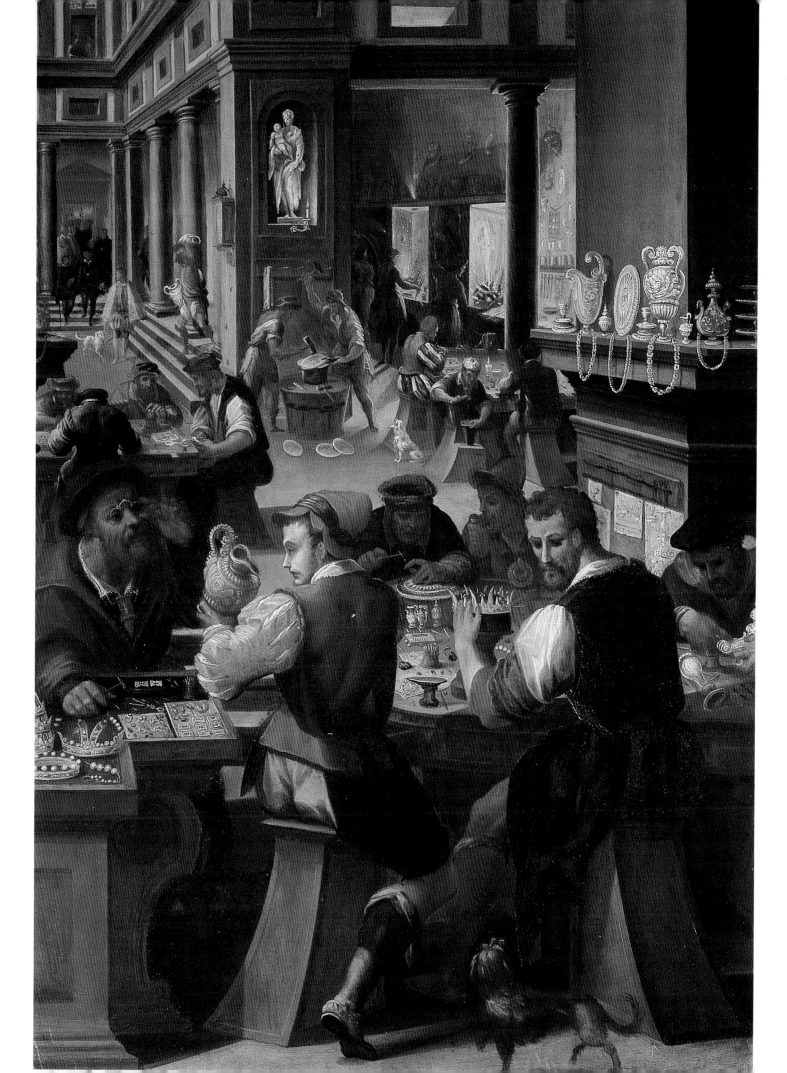

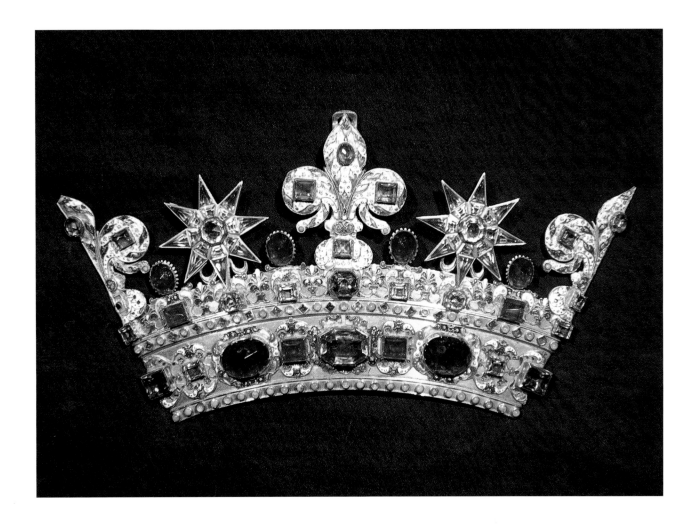

Grand ducal workshops, The Crown of the Virgin, *1608. Monsummano Terme, Pistoia, Church of Santa Maria della Fontenuova.*

each set with three stones, a ruby, an emerald and a diamond, and every alternate one was decorated with a small lily. The large lily of Florence in the centre was studded with rubies, and linking the settings of all the gems were shoots and fronds of plants decorated with flowers, grotesques and masks in red, green and black enamel[4].

Like so many of the jewels which formed the treasury of the grand dukes, the crown has been lost and is now only to be seen in some portraits of the Medici. It is, for example, clearly reproduced in the portrait of Ferdinando, still dressed as a cardinal, in the deposits of Palazzo Pitti, but this precious piece of regalia can be seen better in Suttermans portrait of Maria Maddalena of Austria with her son, Ferdinando, or in the large painting portraying the marriage of Francesco I to Joanna of Austria, completed by Jacopo Ligozzi in 1627 and now in Great Britain in the collection of Lord Elgin. There is, moreover, a drawing made during the first half of the eighteenth century and attributed to Giovanni Cassini in the Victoria and Albert Museum, London, as well as a rather free interpretation of the crown in copper gilt and precious and semi-precious stones, commissioned by Ferdinando de' Medici in 1608 for the altar panel of the Virgin in the church of Santa Maria della Fontenuove at Monsummano[5]. Although this is most

probably not an exact nor perhaps intentional copy of the grand ducal crown and was intended simply to adorn the sacred image of the Virgin, whose traditional iconographic symbols are the lily and the stars, the similarity is still relevant, as the piece was produced by the same grand ducal workshop which had made the Medici crown.

All the precious and semi-precious stones were meticulously recorded in the documents which also give the total cost as three thousand one hundred and sixty-six *scudi*, yet their description can offer only a pale impression of their splendour and of the admiration and wonder the magnificent Medici crown must have aroused. In 1671 the crown was restored by Giovanni Comparini, goldsmith to Vittoria della Rovere, but it was no longer used after Cosimo III's elevation to royalty in 1691. The crown is recorded in the Schatzkammer in Vienna in 1765, but a year later it was once again brought to Florence for the coronation of Pietro Leopoldo. It no longer appears in the inventory of 1805.

The sceptre, so imposingly borne in Vasari's fresco, is another symbol of power. In his account of the ceremony in Rome, Lapini describes it as follows: "He then placed in his right hand the sceptre, which was of silver with a red sphere crowned by a red lily; the Grand Duke received it with joy and then reverently kissed the feet and knee of His Holiness, upon which His Holiness embraced and kissed him on both cheeks"[6].

In a posthumous portrait painted by Cigoli between 1602 and 1603, Cosimo is represented in the full splendour of his grand ducal regalia, with his ermine cloak, crown, sceptre and the badge of the Knights of Saint Stephen. The majestic figure stands proudly beneath a ceiling decorated with grotesques, very simiilar to those in the courtyard of Palazzo Vecchio, and allegorical figures of Religion and Justice, two of Cosimo's attributed qualities to which the papal edict of 1569 referred, "ob zelum religionis praecipuumque iustitiae studium". The painting most probably provided the model for the effigy in semi-precious stone made for Cosimo's tomb in San Lorenzo, and documents show that Cigoli borrowed the ceremonial regalia from the *Guardaroba* in September 1602, apparently returning them not long afterwards since he presented his bill for the completed painting in April of the following year. The event was, however, highly prestigious for this is in fact, the first full-length portrait of a grand duke and it thereafter became the oft-repeated model for all official representations of the grand dukes[7].

The cross of the Knights of Saint Stephen also has a symbolic purpose in the Apotheosis of Cosimo portrayed in the *Salone dei Cinquecento*; Cosimo had created the illustrious company of military cavaliers after the defeat of the French on 2 August 1554, Saint Stephen's Day, and wished to commemorate the victorious battle. The ribbon of the decoration, worn on the left, was red, as was the forked cross, while the badge in the centre was of gold. Membership of the order was a hereditary privilege of the Medici family and the cross of Saint Stephen therefore appears on the verso of Ferdinando I's medal and is also seen in the portrait of Gian Gastone, the last grand

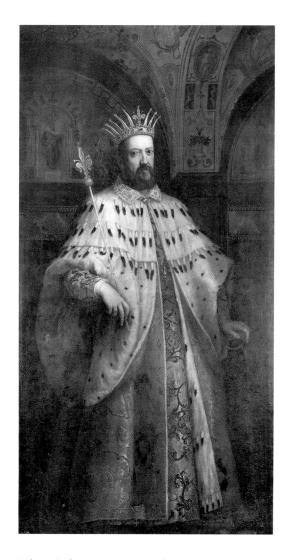

Ludovico Cigoli, Cosimo I, *1602-1603. Florence, Prefecture (deposit of the Florentine galleries).*

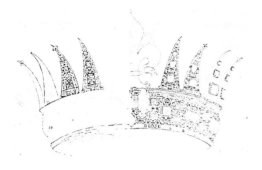

The grand ducal crown *worn by Cosimo I, etching, 1871.*
In R. Galluzzi's Istoria del Granducato di Toscana. *Florence.*

Giovanni Cassini (?), the grand ducal crown *made by Jacques*
Bylivelt for Francesco I, drawing, 18th century. London.
Victoria and Albert Museum.

duke, by Franz Ferdinand Richter now in the Palatine Gallery. The inventory of the state jewels compiled in 1741 describes it thus: "A cross of the Order of the Knights of Saint Stephen, with four pieces of Syrian garnet, divided by four large triangular, faceted diamonds, at the internal corners of which are four smaller, similar diamonds while at the outer tip of the large diamonds three smaller ones are arranged in the form of a lily. The cross hangs on a chain with eight diamonds all of the same size, above which is a stud or catch consisting of a large faceted diamond surrounded by twelve equal, smaller diamonds all mounted *à jour*"[8].

The Medici, like many of the important royal families of Europe, owned a large diamond. Known as the *Fiorentino*, it could also be classed with the Crown Jewels, and indeed it is even recorded as such in the inventory of state jewels dated 1741[9]. Various legends concerning the diamond have come into being over the centuries, the most fanciful perhaps being that the stone had been lost by Charles the Bold at the height of the Battle of Grandson in 1476. The negotiations to acquire the *Fiorentino* during the reign of Ferdinando I are, however, well documented. At the end of the sixteenth century the diamond belonged to Ludovico di Castro, the Portuguese count of Montesanto and his wife, Donna Mexia de Norohna, who had connections with India where it seems the diamond had belonged to the king of Narsingharh. The count and his wife decided to sell the stone, but the price of one hundred thousand *scudi* was apparently too high and, with no buyers forthcoming, the diamond remained in safekeeping with the Jesuits in Rome for almost twenty years. It was eventually Cardinal del Monte, Caravaggio's patron during his early years in Rome, who suggested the deal to Ferdinando and who handled the negotiations in Rome. A satisfactory agreement was reached and signed on behalf of Ferdinando by Orazio Rucellai, at a price of thirty-five thousand *scudi*, following an evaluation by Jacques Bylivelt, the Medici court goldsmith and jeweller, and a further bid by the Emperor Rudolf II.

It is uncertain whether the rough diamond, which was of a yellowish hue, weighed 139½ or 138 carats. In Florence the Venetian diamond-cutter, Pompeo Studentoli, was commissioned to cut it: "His Highness wished the stone to be facet cut in an almond form and contracted with a Venetian hunchback, known as Pompeo Studentoli, to pay him 50 ducats a month for cutting and setting the diamond and on completing the work, which was to be done in the Gallery, His Highness would make him a gift of 4,000 ducats. Today, 25 October 1615, the diamond is finished and is cut in facets in an almond shape; it weighs 23 *danari*, which is equal to 112 carats, and having been seen by many jewellers and gentlemen who are connoisseurs, it is estimated at a value of two hundred thousand ducats."

The diamond is later described in the inventory of 1741: "A slender serpent encrusted with small diamonds, holds the aforementioned diamond on high between dragon-like wings". After the death of Anna Maria Luisa de' Medici the stone was taken to Vienna by the Lorraine and was to be seen mounted on the top of Francesco

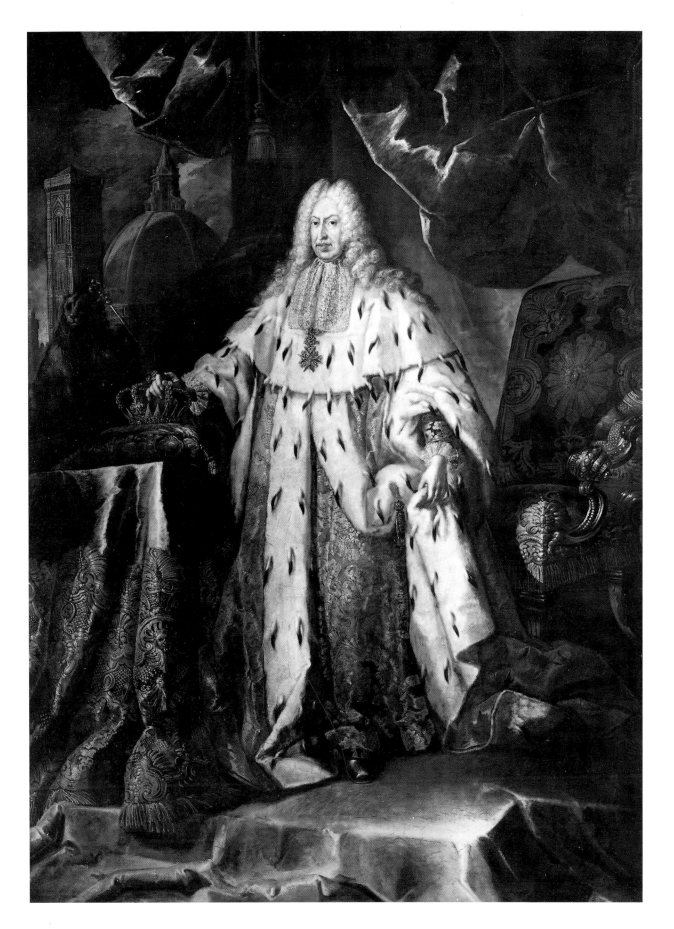

Franz Ferdinand Richter,
Gian Gastone de' Medici.
Florence, Palatine Gallery.

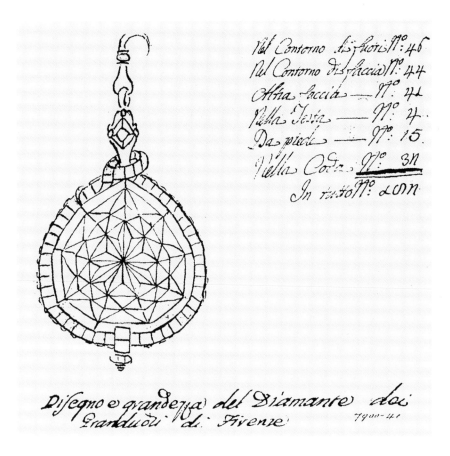

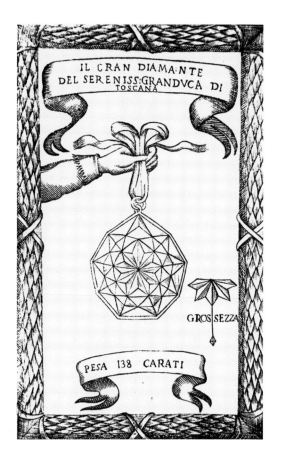

Drawing of the 'Fiorentino' diamond *with the setting described in 18th century inventories, before 1745. London, Victoria & Albert Museum.*

Engraving of the 'Fiorentino' diamond, *17th century. Florence, Biblioteca Marucelliana.*

Stefano's crown when he was proclaimed emperor and crowned in Frankfurt on 4 October 1745.

The diamond remained in the Schatzkammer in Vienna until the Austrian dynasty died out, and immediately before the Second World War it was still in the possession of the Hapsburgs. On 12 July 1938 the Florentine newspaper 'La Nazione' carried the news that Otto of Habsburg had decided to sell the stone and it is said to have been cut into three parts.

The original stone can be seen in an engraving in the Biblioteca Marucelliana in Florence and in a print in the Bibliothèque Nationale de Paris. Yet another image of it is found in *Les six voyages en Turquie, en Perse et aux Indes*, illustrating the travels of Jean Baptiste Tavernier, published in Paris in 1677. Only one drawing, dating from before 1745 and now in the Victoria and Albert Museum in London, shows the diamond with the setting described in the 1741 inventory. Many copies of it have also been made, such as the reproduction in pale yellow crystal in the 'Leonardo da Vinci' Science Museum in Milan. There is however, in a rather unusual and interesting context, a further example, now housed in the Museo dell'Opera del Duomo in Florence where it crowns the 'Cross of the Passion', a precious reliquary completed in 1618 in the same grand ducal workshops where, just a few years earlier, the Venetian diamond-cutter had finished setting the *Fiorentino*.

Notes

1 From an inventory published by C. Mazzi, Le gioie della corte medicea nel 1566, in 'Rivista delle biblioteche e degli archivi', XVIII, 1907, pp. 134-8.

2 A. Lapini, *Diario fiorentino dal 1552 al 1596*, edited by G.O. Corazzini, Florence 1900, p. 167.

3 C. W. Fock, "The Medici Crown: Work of the Delft Goldsmith Jacques Bylivelt", in *Oud Holland* LXXXV, 1970, pp. 197-209.

4 The relevant, unabbreviated document (ASF, Miscellanea medicea 29, ins. 3) was published by Fock, op. cit., pp. 208-9.

5 A. Paolucci, "Un capolavoro di gioielleria medicea del '600: la corona della vergine di Monsummano", in *Paragone* XXVII, 1976, no. 315, pp. 27-32.

6 A. Lapini, op. cit., p. 167.

7 K. Aschengreen Piacenti, "The Regalia of the Medici Grand Dukes", in *Symbols of Sovereignty*, conference organised by the Society for Court Studies, London, June 1996.

8 The inventory is published in Y. Hackenbroch, M. Sframeli, *I gioielli dell'Elettrice Palatina al Museo degli Argenti*, Florence 1988, pp. 158-159.

9 See the volume mentioned in the previous note for the inventory entry and historic references.

THE SPLENDOUR
OF SEMI-PRECIOUS STONES

The history of the Medici grand dukes' patronage and collecting from the early years of Cosimo I's reign to the decline of the dynasty almost two centuries later, which spanned an enormous variety of interests, was highlighted by one constant feature. The Medici's passion for semi-precious stones was an inheritance almost on a par with the throne of Tuscany, to such an extent that it became 'institutionalised' in the form of an artistic court workshop so well established and so productive that, like some enchanted relic of bygone glories, it survived both the Medici and the grand duchy, continuing into quite recent times[1].

With a decree dated 3 September 1588, Ferdinando I (1549–1609) created a stable and practical organisation for the artistic studios already working for the court[2], which

The Grand Ducal Workshops at the Time of Ferdinando I and Cosimo II

Annamaria Giusti

had begun to move into rooms in the Uffizi two years earlier. 'Government and Art' would now have been a suitable motto to attach to Vasari's building for it housed the *uffici*, or offices, which administered state business, the Tribune which was the showcase for the rarest of the Medici treasures, and the artistic workshops intended to add to such possessions. However, the same motto, perhaps elegantly translated by some court scholar, could well have been added to Ferdinando I's emblem, for he seemed to combine the temperament of his father, Cosimo I, as an able sovereign of the 'res publica' with his brother Francesco's impressive flair for the fine arts.

Ferdinando had moved to Rome in 1563 and lived there for more than twenty years, enjoying a privileged position as both cardinal and representative of the Medici. He was entirely at ease in the refined intellectual climate of the artistic capital, centre and stimulant for the antiquary's passion for antique marbles which had already seized Cosimo I. Original and lasting examples of this interest were the tables inlaid with rare stones, using the *opus sectile* technique described by Pliny, which became popular in Rome from the mid-sixteenth-century[3] and were destined gradually to replace the *pietra dura* vases as coveted status symbols for cultivated and wealthy collectors.

While Cosimo I and Francesco entered into frequent and often complicated deals with Rome to transfer materials, works and artists to Florence[4], Ferdinando was free to make use of the cosmopolitan artistic resources at hand. With these local craftsmen he magnificently fitted out the villa and garden of Trinità dei Monti, which he had bought in 1575, including amongst the furnishings some sumptuous inlaid tables. Of the rather large number of surviving sixteenth-century Roman examples, one is quite outstanding for its design and quality. Now in the villa of Poggio Imperiale, this square table has geometric divisions of rare marbles of the classical

period, between which, beneath slivers of alabaster, are monochromatic mythological subjects derived from the lively decorative repertory of Raphael's later followers[5]. The Medici cardinal clearly had excellent artistic connections and it is tempting to imagine that, as a connoisseur of beautiful tables, he cannot have failed to appreciate one made in Rome during this period, which has been somewhat overlooked by specialists until now. I refer to the majestic table in the Prado Museum, on which Turkish-style slaves yoked to war trophies appear, somewhat unusually, amidst the rich design of typically Roman motifs. Could this perhaps be the table which Pope Pius V gave to Don Giovanni of Austria in gratitude for the part he played in the victory of Lepanto[6]? The splendour, and especially the unusual iconography of the piece encourage one to think so, and if this were the case it would therefore follow that as early as the beginning of the 1570s Roman intarsia was capable of producing a complex series of designs and of handling scenes with figures, an aspect which was to meet with little success in Rome and became instead one of the most popular themes in Florentine *commesso* towards the end of the century.

In the frequent exchanges and close contacts which took place when the art of Roman intarsia was introduced to Florence[7], an important role was played by the architect Giovanni Antonio Dosio. Of Tuscan origin but educated in Rome, he designed the coloured marble decoration of the Gaddi chapel in Santa Maria Novella (1575–76) and the Niccolini chapel in Santa Croce (1579–89). In these two structures the austere style of Florentine architecture began to be influenced by the classical culture of Rome, again apparent in Giambologna's design for the Salviati chapel in San Marco, completed in 1589. It is no coincidence that Dosio was also responsible for the design of another inlaid table which Ferdinando de' Medici kept in the Villa Medici, his residence in Rome, clearly confirming the extremely close links which existed between architectural inlays and inlaid furnishings, at least in the early stages of the art. The Medici cardinal's large table, with an iridescent Spanish emerald oval in the centre[8], has the same solemnity and precision of design typical of architectural decoration, while the altar table in the Niccolini chapel, made between 1584 and 1585, is identical with many contemporary Roman or Roman-style table tops. The artist responsible for the inlay on the altar was a certain Giulio Balsimelli[9], probably the father or a relative of Alessandro and Giuliano Balsimelli who worked in the grand ducal workshops during the early 1600s on the coats of arms for the Chapel of the Princes[10], and, I believe, the "maestro Giulio of Florence who cannot be too highly praised". According to Agostino del Riccio[11], a contemporary and expert on the subject, this artist also made the inlaid tables owned by Giovanni Vittorio Soderini, who was the first to collect them in Florence.

Since no records have as yet been found linking "maestro Giulio" with the workshops in the service of the grand duke's court[12], one is inclined to believe that he most probably worked for a private clientele, which was overshadowed with the passing of time by the magnificence and supremacy of the Medici workshops but

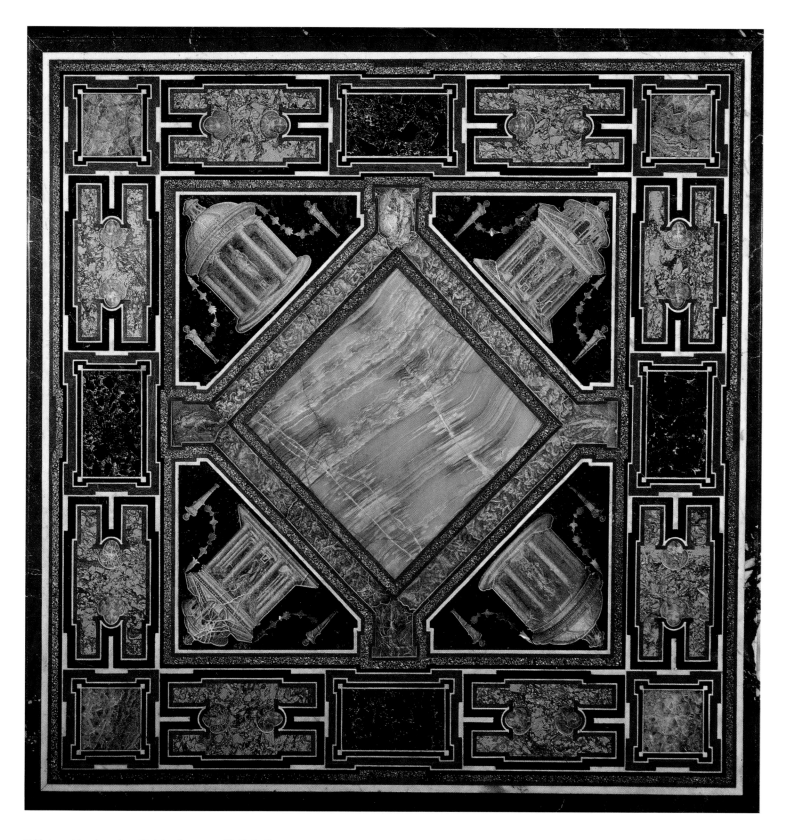

Table top with coloured marble inlay, *Rome, second half of 16th century.*
Florence, Villa of Poggio Imperiale.

Giulio Balsimelli, Altar shelf (detail), 1584-85.
Florence, Church of Santa Croce, Niccolini chapel.

Florentine workmanship, Ciborium (detail)
1599–1607. Florence, Church of Santo Spirito.

must have experienced flourishing and innovative activity when the art of working semi-precious stones was first introduced to Florence. The Gaddi and Niccolini chapels have already been mentioned and these were immediately followed by the Salviati chapel in San Marco, also frequently referred to by Del Riccio in his *Istoria delle Pietre*. However, the author died in 1597 and therefore never saw the high altar and ciborium in Santo Spirito which Giovan Battista Michelozzi made between 1599 and 1607. At the time, however, Ferdinando I's *Galleria dei Lavori*, as the workshops were known for centuries, had already established itself as the 'Parnassus' of the art of working semi-precious stones, the fount of all new ideas and craftsmen. The exuberant intarsia frontal, the vases of flowers in *commesso* above the altar table and in fact the entire structural design of the ciborium and altar are derived from the preparatory plans for the Medici Chapel of the Princes; moreover, the grand duke generously authorised Urbano di Simone Ferruzzi, one of the workshop's *maestri*, to work on the inlays of the Santo Spirito altar[13].

At approximately the same time, between 1593 and 1605, the high altar of the church of Ognissanti, commissioned by Pandolfo Bardi, was being made. It is most probable that the ornamentation and the inlays of the stories of Saint Francis were conceived by Iacopo Ligozzi[14], one of the painters who as a designer frequently supplied designs for the grand ducal workshops . Another artist who played a similarly

High altar, 1599–1607. Florence, Church of Santo Spirito.

Florentine workmanship, High altar *(detail), 1593–1605.*
Florence, Church of Ognissanti.

important role at the beginning of the seventeenth century was Ludovico Cigoli who, in 1603, designed the family chapel of Lorenzo Usimbardi, like Gaddi and Niccolini an important member of the Medici court. The decoration of the chapel, in the church of Santa Trìnita, comprised not only coloured marble panelling but also even more precious stones which by then had become a typically Florentine speciality.

Before the absolute supremacy of the workshops was established *de iure et de facto* under Ferdinando, others such as Soderini, whose early interest in inlaid tables has already been mentioned, also took important initiatives – at times even anticipating the Medici – in the field of marble and stone decoration. Vasari writes that he designed, for example, the decoration for a wooden table inlaid with ivory and jasper for Bindo Altoviti certainly before 1557, the year Altoviti died, which has only recently come to light[15]. Niccolò Gaddi too was not only an important client but also collaborated with Dosio on the design for the family chapel in Santa Maria Novella and was a consultant for that of the Niccolini. A trusted friend and agent to both Francesco I and Ferdinando, Gaddi, who had similar cultural interests, helped to create the Medici collections while becoming a discerning collector himself. He also experimented with artistic techniques and created an extensive gallery and well-equipped workshop with benches and tools for jewellery-making and engraving in his palace in Piazza Madonna. In this 'parallel workshop' of the San Marco Casino Mediceo, which was based on the philosophy of "artis et naturae coniugium", the rare antique marbles collected by Gaddi[16] and used to decorate tables and cabinets are

recorded both in the inventory of his possessions made at the time of his death in 1591 and in the frequent references praising them in the *Istoria delle pietre* by Del Riccio. As a connoisseur, Del Riccio was particularly impressed by a "most fine and beautiful small table inlaid with flowers and fruit, *a rare thing in this skill*"[17]. In fact, both the regular geometric patterns of the semi-precious stone tables associated with the time and tastes of Francesco I[18] and the classical compositions with scrolls and shields, Roman imitations or copies, reflect the preference for abstract decorative designs. The change from abstraction to imitation in Florentine *commesso* which took place under Ferdinando I resulted in a move away from the architectural type of inlay work from which it had derived, towards the expressive potential and illusory fascination of a 'painting in stone'.

Del Riccio's writings seem to confirm that this new tendency coincided with the beginning of Ferdinando I's reign and the organisation of the grand ducal workshops as a state manufacture. The new stylistic repertory which was being developed by Florentine craftsmen most probably reached its 'consecration' in the famous table[19] commissioned by Emperor Rudolf II of Habsburg, which the Milanese craftsman Stefano Caroni worked on between 1589 and 1597. Using Bohemian jaspers specifically sent from the emperor's territories, he composed an amazing 'puzzle' including the Habsburg coat of arms, trophies, landscapes, birds and vases of flowers. With the eye of an expert, Del Riccio also noted the technical innovation of the Emperor's table which "looks as if it is all of a piece and not inlaid in marble or bardiglio or in any other stone, the way tables are made in Florence and Rome". The technical and interpretative limits of the 'inlay' were now eliminated: there was no longer a background to delimit or outline the coloured composition which now became the principal element and which, thanks to the incredible precision of the joins between the individual pieces of stone, seemed to be 'all of a piece', exactly like a painting, and intended to surprise and deceive.

Although the emperor's table has sadly been lost, other table tops, most probably of the same period, remain to shed light on the development of Florentine mosaics at the time. A square table from the villa of Petraia, now in the Museo dell'Opificio, is decorated with military trophies, birds and flowers, which are very probably similar to those created for Rudolph II, against a black marble background which looks "all of a piece", but is, in fact, made of perfectly matched inlays. Some of the tables in the Museo degli Argenti, originally in the Medici collections, are perfect examples of the unusual combination of the abstract decorative style seen in Roman inlays and the pictorial and occasionally naturalistic style which became increasingly popular in Florentine mosaics at the time of Ferdinando I.

The antique marbles of Roman tradition are used, for example, to decorate a rectangular table with the Medici coat of arms surmounted by the grand ducal crown[20], a heraldic style often recorded in the documents relating to the early decades of the Galleria workshops. Here, the coat of arms is not part of a larger design, as in

Grand ducal workshops, Table with semi-precious stone inlay and Medici coat of arms, *late 16th century,* Florence, Museo degli Argenti.

Opposite page: Grand ducal workshops, Table with semi-precious stone inlay and Medici coat of arms *(detail), late 16th century. Florence, Museo degli Argenti.*

Rudolf II's table or as in another made later for the viceroy of Naples (finished in 1616 and now in the Prado[21]). Instead it dominates the white background, emerging with bold elegance from the frothy whorl of streaked alabaster surrounding it and consequently breaking with the Roman tradition of setting a particularly rare piece of stone or marble in the centre of the table.

This kind of composition appears again in another square table, also in the Museo degli Argenti, with a series of Roman-style motifs radiating out from a central octagonal piece of *occhiato* from Antioch. These, however, are arranged into the geometrical patterns which Florentine mosaics tended to favour at the time of Francesco I[22], and are interwoven with fronds of flowers, forerunners of Ligozzi's pure naturalism[23].

The combination of abstract decoration and botanical illustration, achieved with a harmonious use of design and colour, is also found in two rather similar tables which are not in Florence[24], showing a stylised flower pod identical to that on the frontal of the altar in Santo Spirito. Works of this kind, which are often difficult to place chronologically due to the lack of documentation, may therefore be dated to the late sixteenth or early seventeenth century.

While at the end of the century craftsmen were experimenting with this kind of mosaic composition, of a purely ornamental kind whatever the design, the grand ducal workshops began, rather ambitiously, to explore the possibilities of using the *commesso* technique on the rather difficult subject of the human figure, starting with the most challenging of all – the portrait.

The *"ingenious craft"* of this new type of mosaic is praised by Ferdinando I himself in a famous letter[25] which he wrote in 1601 to accompany the gift of a *commesso* portrait of Pope Clement VIII. This sumptuous and sparkling icon is made of chalcedony and mother-of-pearl, lending it a glacial luminosity which contrasts with the deep black of the Flanders jasper framing the bust of the Pope. Vasari wrote that "all manner of things can be engraved in semi-precious stones *and the antiquity and memory is preserved better in them"*[26]; in fact the eternal quality which these immutable materials were seen to represent must have seemed particularly appropriate to the grand duke for the commemorative purpose of the portrait, a genre which the Florentine workshops experimented with several times in the early years[27].

It was only natural that the grand duke should choose semi-precious stones for the Medici mausoleum being built at the time, both to defy the oblivion of death and to confirm for eternity the magnificence of the Tuscan dynasty in the splendour of a glittering setting. This had, in any case, been the intention behind the plans already made by Cosimo I, and later by Francesco, for a 'third sacristy' where the new tombs of the ruling family would remain in their traditional location within San Lorenzo, but it was Ferdinando who turned them into a commemorative and dynastic project, thus initiating a truly grandiose enterprise[28]. Determined to create the "most wonderful and

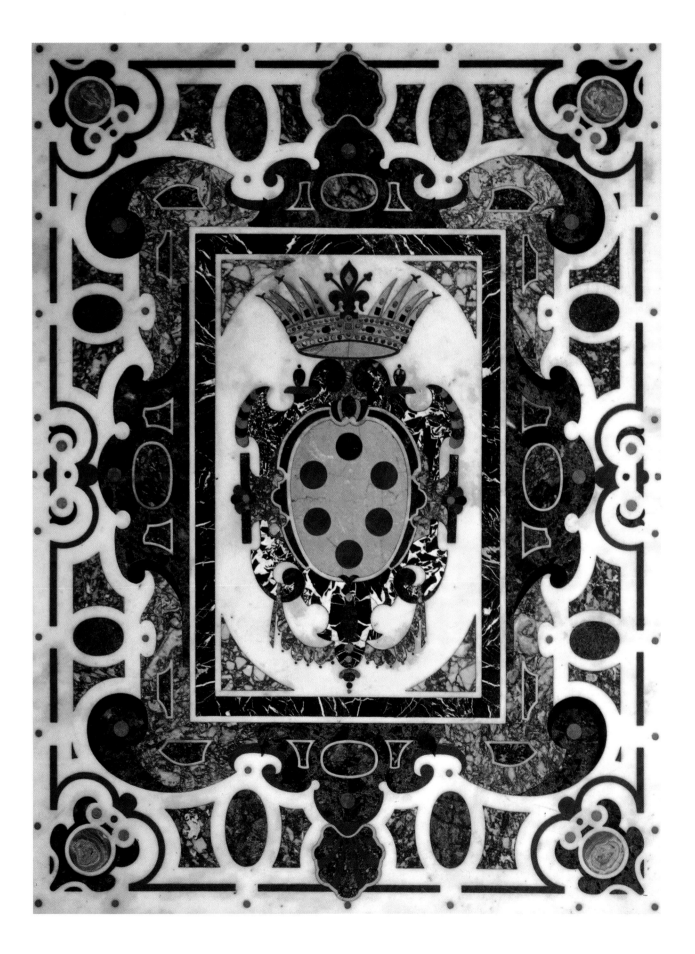

Grand ducal workshops, Table with geometric designs
and flowers, *late 16th – early 17th century. Florence,
Museo degli Argenti.*

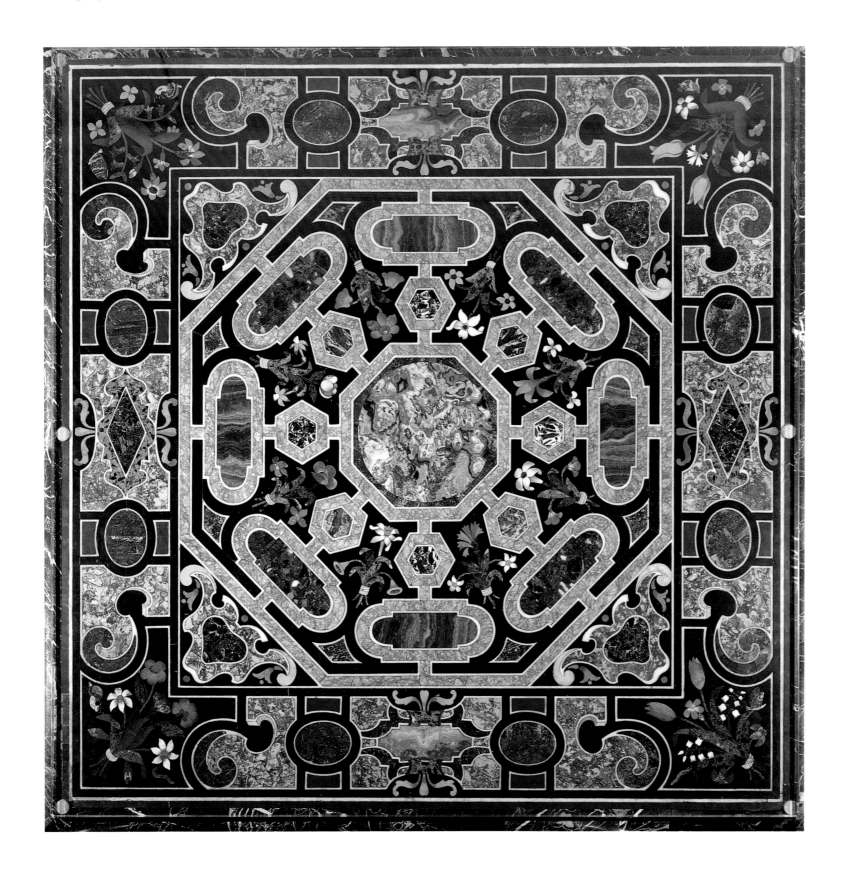

noble thing of its kind to be seen in all the world" (Baldinucci), the grand duke made the Chapel of the Princes the main occupation of the newly-created workshops. For the task they were supplied with a stock of semi-precious stones, in quantities and of a quality and variety which amazed, as did the rapidity with which the chapel was built.

While Cosimo's acquisitions had consisted mainly of antique marble of Roman origin, Francesco preferred to add to his collection by seeking out semi-precious stones which complemented his studies as a naturalist. At Barga he even opened quarries of jasper, with red and white markings "which give it great beauty", as Del Riccio wrote, also explaining that the grand duke had been informed of the presence of the stone by his herbalist, Francesco Mazzeranghi from Barga. It was during Francesco's reign that an incomparable and opulent stock, not entirely depleted even today[29], of jaspers, agates, chalcedony, quartz and lapis lazuli was gathered in Florence from places as near as Volterra and as far as exotic Goa, thanks to a network of commercial agents, ambassadors, naturalists, artists and influential friends whom the tireless duke efficiently managed and directed.

Chapel of the Princes, *interior. Florence., San Lorenzo*

Meanwhile, within the workshops, in order to cope with the immense task of revetting the interior of the Chapel with semi-precious stones and the making of the central ciborium, a gleaming gem set amidst such stern splendour, the number of craftsmen working on the stones grew considerably, as did their skills. Indeed we should not forget that even during Francesco's time Florence had few experts who knew how to cut semi-precious stones, and the entire workshops of the Caroni (1572) and Gaffurri (1575) families from Milan had to be transferred there. Originally specialists in the traditionally Milanese art of glyptics and most probably not experienced in *commesso* inlay, they were quick to learn the skill and produced excellent results, probably encouraged by the urgent, yet remunerative, demands of the Medici patrons[30].

The two techniques are combined in the famous tabernacle with Christ and the Samaritan Woman (Vienna, Kunsthistorisches Museum), a superb masterpiece of inlay, mosaic and goldsmith's work[31]. Made between 1591 and 1600, the piece represents a collaboration between Jacques Bylivelt who made the parts in gold and enamel, Giovanni Ambrogio Caroni who carved the adamantine crystal structure, Cristofano Gaffuri who made the two small coloured statues in semi-precious stone, and Bernardino Gaffurri who composed the mosaic landscape in the background, lending an atmosphere of medieval chivalry to the evangelical meeting.

During the same period a sophisticated combination of various techniques produced the oval with the view of Piazza della Signoria (Museo degli Argenti) which is unique both in the use of the materials and in its conception. It was made between 1599 and 1600 to crown the lost *studiolo grande* which Ferdinando I had made during the last decade of the century to place in the Tribune of the Uffizi, where the small temple-shaped cabinet commissioned by Francesco I was already housed[32]. The space of the oval contains, within an almost theatrical perspective setting, an entirely

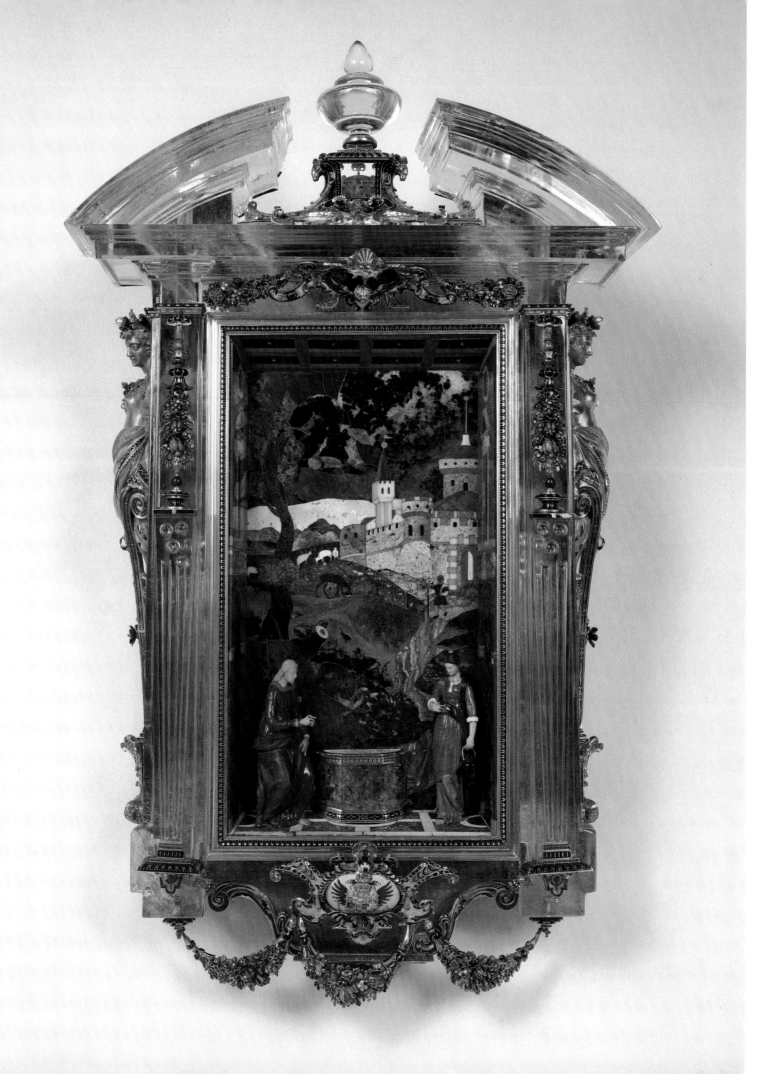

Opposite page: Jacques Bylivelt, Giovanni Ambrogio Caroni, Cristofano and Bernardino Gaffurri,
Aedicule with Christ and the Samaritan woman, *rock crystal, semi-precious stone and*
enamel, 1591–1600. Vienna, Kunsthistorisches Museum.

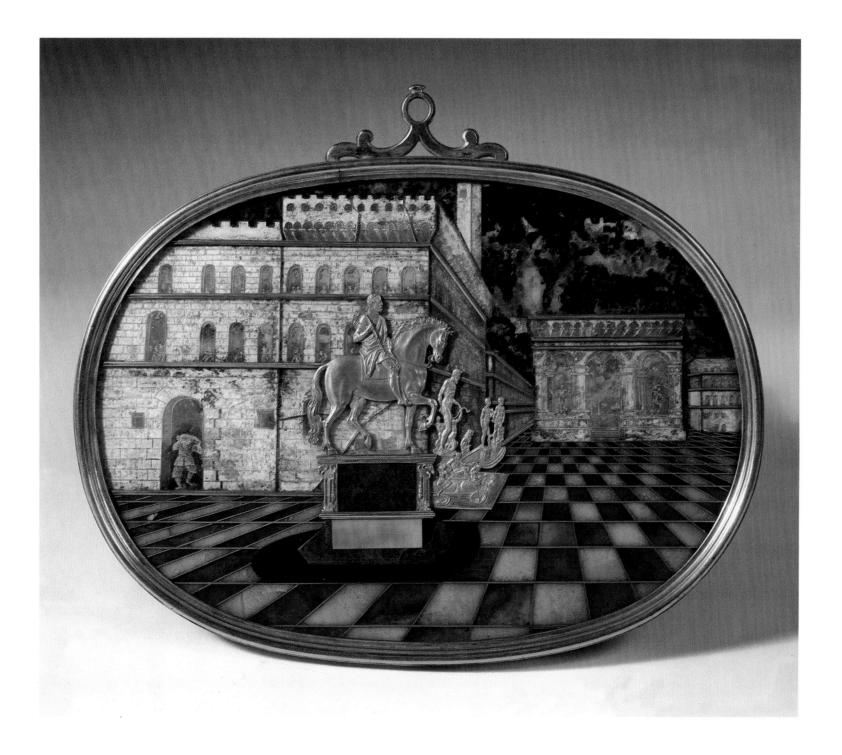

Jacques Bylivelt and Bernardino Gaffurri, Oval with a view of Piazza della Signoria,
semi-precious stone and gold, 1599-1600. Florence, Museo degli Argenti.

Cristofano Gaffurri (designed by Jacopo Ligozzi), Table with a view of the Port of Livorno, *1604. Florence, Uffizi Gallery.*

Opposite page: Giovan Battista Sassi (designed by Bernardino Poccetti), The manna from heaven, *semi-precious stone commesso, 1620. Florence, Church of San Lorenzo, high altar.*

Opposite page:
Camillo di Ottaviano (designed by Bernardino Poccetti),
Tuscan landscape, semi-precious stone commesso, 1608.
Florence, Museo dell'Opificio delle Pietre Dure.

Prague workmanship, Table with landscapes, semi-precious
stone commesso, silver and garnets, early 17th century.
Florence, Museo degli Argenti.

recognisable and quite enchanting view of the famous piazza; the buildings gleam with silver placed beneath slivers of rock crystal, the sculptures were moulded in gold leaf by Bilivelt, while the jaspers of the paving and the flecked lapis lazuli of the sky were inlaid by Bernardino Gaffurri. But Gaffurri was not the only one in the family workshop to have mastered the art of *commesso*. Indeed, the technique of these early pieces appears to be quite surpassed by the expertise of Cristoforo Gaffurri who completed a table top with a View of the Port of Livorno (Galleria degli Uffizi) in 1604 after three years of work based on a painting with which Iacopo Ligozzi[33] had provided him as a model. Landscape subjects, which had already appeared in the decoration of the table for Rudolf II and had provided the background for the meeting of Christ and the Samaritan woman, now developed to become the main feature of this table which the Grand Duke saw as both a celebration of the achievements of his favourite art and of the grand ducal port which he had considerably extended.

Although the Gaffurri and the Caroni were the most outstanding master craftsmen employed at this date to work on the Chapel of the Princes and the ciborium, many other craftsmen worked on the inlays, including relatives such as Giovan Battista Sassi, a nephew of the Gaffurri; the others were mostly Florentine, such as Ottavio di Bernardino di Porfirio, whose father had been an inlayer in the service of Cosimo and Francesco; but there were also artists of German origin including Iacopo di Gian Flach[34]. Even so, the intensity of the production during Ferdinando I's time was quite astounding and was never matched; looking ahead, he had ordered that work should begin on the coats of arms of the grand ducal cities destined for the walls of the Chapel of the Princes in 1589 and the ciborium was begun in 1599, while the building itself was only begun in 1604.

During the first decade of the seventeenth century an amazing number of masterpieces were made, or at least begun: to mention only a few, there were, for example, the magnificent panel of the Last Supper (now on the altar in the Palatine Chapel in Palazzo Pitti), made to a design by Cigoli and completed by Gaffurri almost at the same time as the table with the Port of Livorno; the scene of the Manna from Heaven and its frame, both in a refined mannerist style, designed by the elderly Poccetti and inlaid by Sassi, now on the high altar in the church of San Lorenzo; the fresh, bright scenes of the Tuscan countryside, also designed by Poccetti and indicative of the advent of landscape painting, made by Camillo di Ottaviano, an inlayer who exploited the tones and colours of the stones with creativity and imagination (Museo dell' Opificio delle Pietre Dure)[35].

However, the jewelled structure of the ciborium was not composed only of *commesso* work; the little temple forming part of the altar should have had a dome covered with scales of rock crystal, though this was never completed. Various elements of this dismantled treasure, now divided between several museums and collections, comprise columns of agate and rock crystal crowned with jewelled

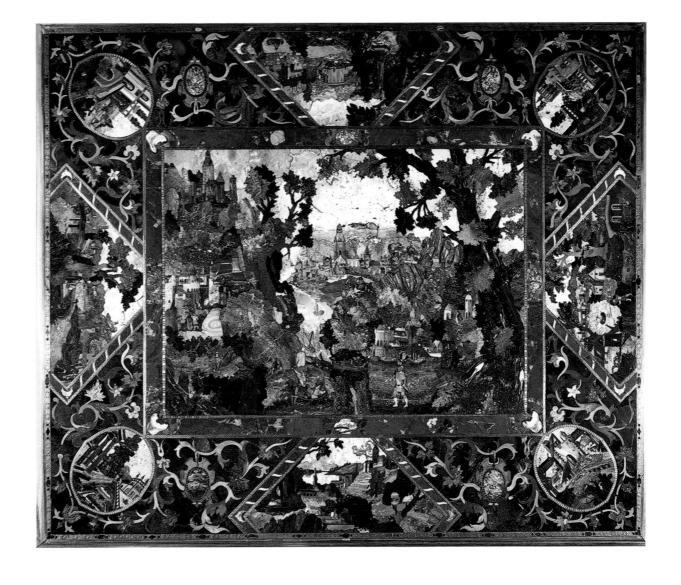

capitals, small aedicules of jasper and lapis lazuli with metal decorations and mounts, small sculptures of the Evangelists and an angel[36], bas-reliefs of the Virtues[37] and incomparable examples of "mosaic sculpture" made from several pieces of semi-precious stone individually carved and then assembled with a refined delicacy of form which defies the rigidity of such unyielding materials.

Despite the commitment to the Chapel, which would appear to have been almost total, other furnishings were, in fact, produced, in particular tables and cabinets with which Ferdinando furnished the many grand ducal residences, or sent as gifts to Italian and European courts where they were to be admired as examples of the splendour of the Medici. In 1602, for example, a *"studiolo* which is going to France"[38] was completed, probably for the court of Maria de' Medici and Henry IV, who had already been presented with a portrait in semi-precious stones of his Florentine bride on the occasion of their marriage in 1600. However the bed which "is to be inlaid with stones"[39] and which Marchionne and Tommaso Tedeschi were working on in 1606, most probably remained in Florence. This was the first of a series of such beds decorated with semi-precious stones, which astounded even the most sophisticated of visitors to Palazzo Pitti and Palazzo Vecchio and which we can now only imagine[40].

Between 1602 and 1603 German craftsmen also worked on a "small silver table inlaid with stones"[41]. The combination of silver and semi-precious stone mosaic is frequently referred to in documents and one specimen has survived despite the disappearance of many most beautiful pieces. Now in the Museo degli Argenti, this famous table top is believed to have been made in Prague sometime between 1620 and 1630[42]. The panels with landscapes made of jaspers from Bohemia are separated by bands of engraved silver, set with garnets. Dazzlingly opulent, the Bohemian table is similar to another in semi-precious stone, made in 1611 for Christine of Lorraine, by then the widow of Ferdinando, "where some *commesso* landscapes invented by Antonio Francesco Burchielli, known as 'il Rosso', are to be placed" and involving another three craftsmen "to set the stones, fillets and all the rest"[43].

During the rather brief reign (1609–21) of Ferdinando's son and heir, Cosimo II, the stable yet brilliant artistic reserve created by the workshop's founder continued to produce results, though this often involved the completion of work begun a decade earlier and mainly for the Chapel. The newly-commissioned secular furnishings which Cosimo, like his father before him, often presented to illustrious personages were increasingly characterised by naturalistic designs, a feature destined to influence the future development of Florentine *commesso* for a lengthy period, and based almost entirely on Jacopo Ligozzi's unique decorative style.

Defined by A. González Palacios[44] as a "narrator of sublime natural scenes", Ligozzi had already most splendidly revealed his ability as a meticulous yet lyrical observer of nature in his drawings for Francesco de' Medici of plants, flowers and insects, now in the Uffizi. His relationship with the Medici court, and the grand ducal workshops in particular, was never entirely interrupted, though it was probably not

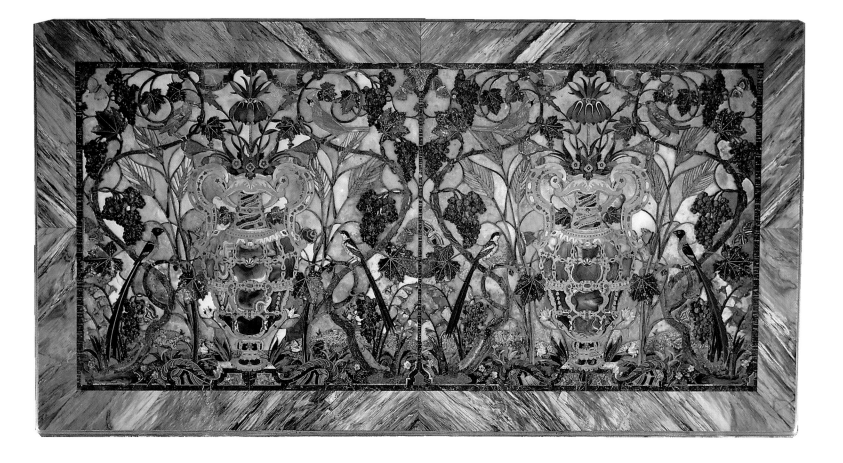

Grand ducal workshops (designed by Bernardino Poccetti and Jacopo Ligozzi), Table with vases and flowers, *1610. Florence, Palatine Gallery.*

always an easy one given his somewhat rancorous and exacting character which possibly only relaxed when he was absorbed in the study of nature.

On several occasions towards the end of the sixteenth century, however, the Grand Duke commissioned him, either alone or in collaboration with other painters, to make designs for *commesso* inlay. An example is the iridescent frontal for the altar in the Chapel, made between 1603 and 1610 and subsequently converted into a table top now exhibited in the Palatine Gallery; Ligozzi's style is illustrated in many of the exotic birds, insects and plants gleaming within their setting of silvery chalcedony like a vision of an earthly paradise[45].

It was during the period 1610–20, however, that Ligozzi's naturalistic designs of flowers, fruit, birds and insects, probably encouraged by the increasing popularity of the northern European genre of still life and landscape in Cosimo II's circles, became the main subjects of Florentine inlay, remaining their hallmark for a considerable period of time. Highlighted by the black background of Flanders jasper, the infinite colour ranges of the stones succeeded in avoiding any possible repetition in the constant variations on the naturalistic theme invented by Ligozzi, whether in a frame of flowers and butterflies around a chessboard made of jasper and lapis lazuli (Museo degli Argenti)[46], or panels with birds, flowers and branches of fruit in a particularly fine example of a table cabinet (Ottawa, National Gallery of Canada)[47], or again the birds of paradise in flight, probably seen in the aviaries of the Boboli gardens, amidst spreading branches of fruit and flowers in a table top in Rosenborg, possibly originally made for the Danish court[48].

This new style of table, dominated by floral decorations, met with immediate success and seems to have pleased many high-ranking personages. Records reveal that between 1615 and 1620 a table was made for "Madama Serenissima", in other words the dowager grand duchess, "full of flowers and butterflies of all kinds", with a base also inlaid with leaves and flowers[49]. During the same period a table was made for the Duke of Mantua, completed in 1619 by Giovan Battista Sassi, "with scrolls and flowers and other things in it, all surrounded with silver and with a frieze of amethyst"[50], while shortly before he died Cosimo sent to the Farnese cardinal a table with a black jasper top inlaid with flowers and a base, also in black jasper, mounted with bronze and inlaid with foliage and arabesques[51].

The conclusive masterpiece resulting from Ligozzi's collaboration with the workshops was the magnificent table of "scattered flowers" in the Uffizi which he worked on from 1614 to 1621, devoting special attention to it and choosing the shadings of the stones himself so that they would perfectly correspond with the masterly selection of flowers which covers the entire surface of black jasper in an explosive yet orderly luxuriance checked only by the laurel garland in the centre and the four thistles in the corners. Ligozzi's exceptional talents as a designer are also evident in the most original frame with pearl-shaped drops of translucent chalcedony, set into small shields of lapis lazuli and chalcedony outlined with gold[52].

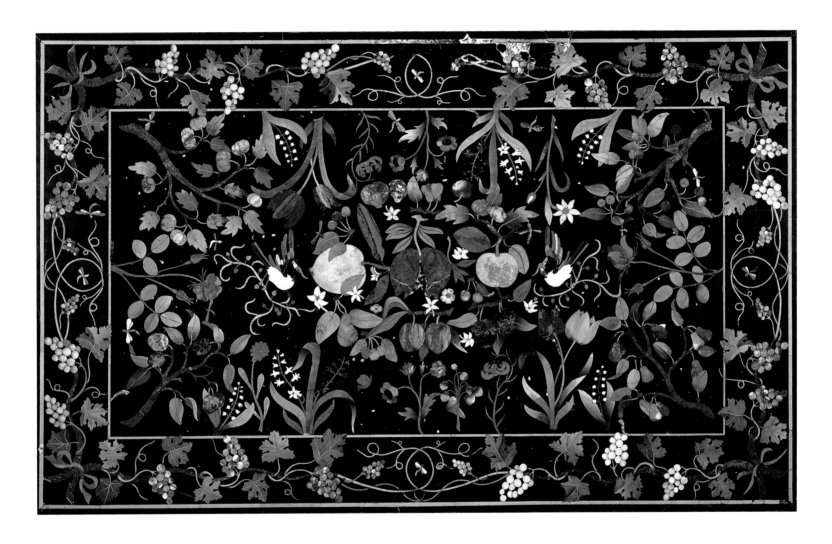

Grand ducal workshops, Table with fruit, flowers and birds, *semi-precious stone* commesso, *first quarter of 17th century. Castle of Rosenborg, Denmark.*

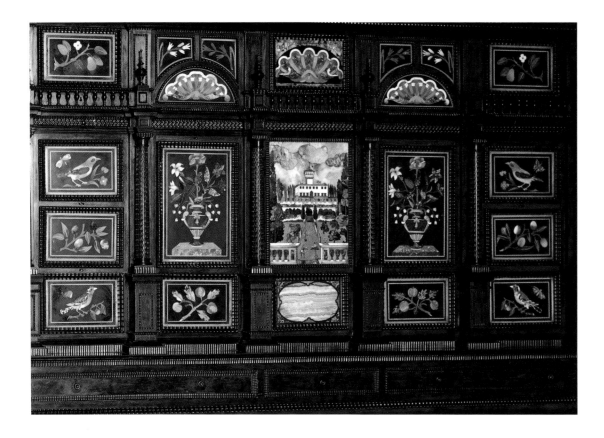

Grand ducal workshops and Giovanni Bilivert, Cabinet with a view of Villa La Petraia, *second decade of 17th century. Florence, Palazzo Vecchio.*

Not only the works which can be identified as by Ligozzi, but also the numerous surviving pieces belonging to that period and style, are evidence of the immediate and widespread popularity of this art, providing the best-known image of Florentine mosaics both in Italy and abroad. For over a century this kind of production was copied in craftsmen's workshops not only in Florence but also in Augsburg, northern Italy and other centres which have yet to be better identified by a closer study of this subject.

The decisive change to naturalistic subjects at the time of Cosimo II can also be seen in the increasing popularity of landscape scenes; as we have seen, however, these had already appeared in the mosaics made during the first twenty years of the workshop's activity – a particularly lively and inventive period. In the scenes of biblical stories then being made for the ciborium, such as Elias and the Angel and Jonah and the whale, both in the Museo dell'Opificio, the landscapes began to acquire depth, realism and harmony and were occasionally given particular prominence in works such as the cabinet which belonged to Don Lorenzo de' Medici (Palazzo Vecchio). Set amidst 'Ligozzian' panels of flowers, fruit and birds, the central door has an informal and spacious view of the nearby Villa La Petraia, where it was to be housed[53]. The model was most probably made by Giovanni Bilivert, who worked in the workshops in a period which coincided precisely with the years of Cosimo II's reign, and who

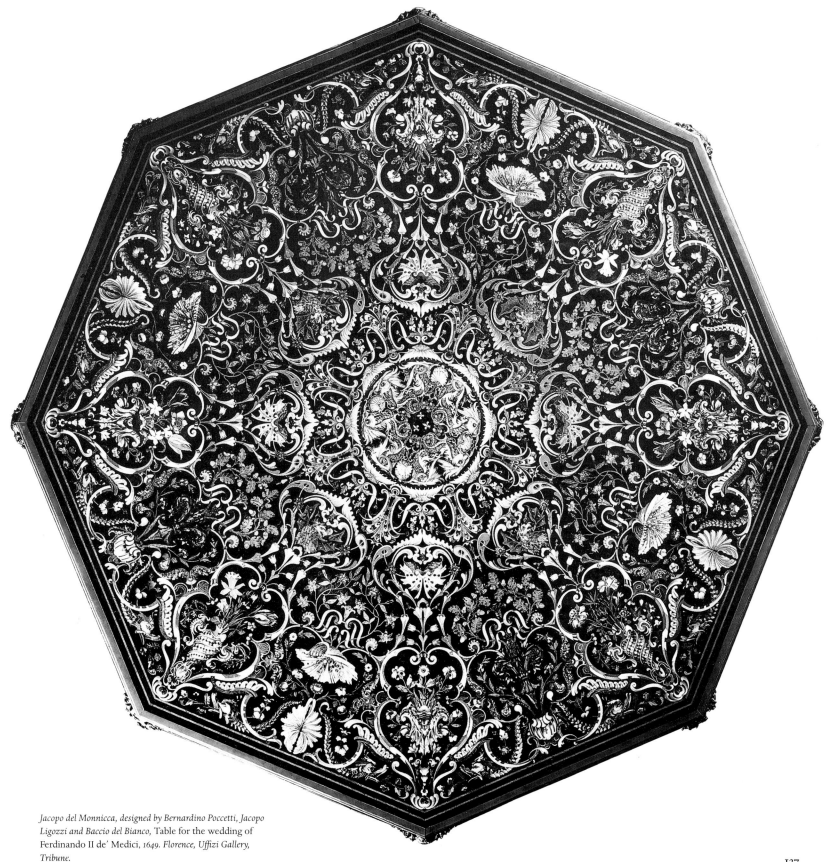

Jacopo del Monnicca, designed by Bernardino Poccetti, Jacopo Ligozzi and Baccio del Bianco, Table for the wedding of Ferdinando II de' Medici, *1649. Florence, Uffizi Gallery, Tribune.*

visited the various Medici villas on horseback to make "water-colour sketches" to be used for the mosaics.

Parallel to this interest in landscape 'in' stone, the Grand Duke developed an interest in landscape 'on' stone. He had assembled a heterogeneous collection of artists at his court and from those (generally from more northerly regions) who were skilled in landscape painting he commissioned various themes ranging from mythological to heroic biblical or devotional scenes, all set within landscapes adapted to the natural qualities of the stone which formed the background of these paintings "created by nature and enhanced by the paintbrush"[54]. The fashion for combining artistic invention with the *bizzarria* or eccentricity of nature was not exclusive to Florence at the time. Florentine pieces, however, are often identified by the use of *alberese* limestone for the background. This stone was found in the riverbed of the Arno in two forms, referred to as *lineato* (lined), which suggested undulating expanses of water, and *paesina* (rustic), which was ideal for rough and rocky settings. These particular types of *alberese* had not been ignored during the quest for natural curiosities at the end of the sixteenth century. Del Riccio mentions them, stating that "admirers of charming and pretty stones have begun to seek in the river Arno", and goes on to say that, in his day, these stones inlaid together made "attractive tables"[55]. Indeed, examples datable to the reign of Ferdinando I have survived, some of which use the stone as a background for inlays of painted alabaster (a table in the Museo della Specola, for example, or the high altar in Ognissanti) almost anticipating its later use as a base for oil painting.

The last creation of the workshops for Cosimo II was not, however, to be made in the local Arno stone, despite its charms; it was, on the contrary, to be a sumptuous array of dazzling and rare materials handled and worked with almost obsessive perfection – the ex-voto intended by the grand duke for the altar of Saint Carlo Borromeo in Milan and now in the Museo degli Argenti. The panel, which was originally set into a golden altar frontal, took seven years to make and involved many of the workshop's craftsmen, but it never reached its destination as the grand duke died three years before it was completed in 1624[56]. The two techniques of *commesso* and mosaic sculpture are again combined in this magnificent celebration, where the grand duke, in his regal apparel studded with rubies and diamonds and decorated with enamel, is seen kneeling haughtily against a most Florentine background which, in its intended Milanese setting, would have instantly identified the monarch, and left no doubt whatsoever as to his generous patronage, magnificence and the quality of the piece.

Cosimo II died relatively young in 1621, but the semi-precious stones which he had chosen to capture forever his fixed image would continue to represent the artistic culture of the Tuscan grand duchy for more than two centuries afterwards.

Grand ducal workshops, Ex-voto of Cosimo II, *semi-precious stone, enamel and diamonds, 1624. Florence, Museo degli Argenti.*

Notes and references

1 In fact, the original Medici workshop has never really ceased to exist. The present-day Opificio delle Pietre Dure has descended directly from it without interruption and indeed the museum's rather nineteenth-century title reflects its original purpose. From the end of the last century it has increasingly specialised in the restoration of works of art, now the main activity of this public institution.

2 The 'patent letter' by which Grand Duke Ferdinando created the Galleria dei Lavori is published by A. Zobi, *Notizie storiche sull'origine e progresso dei lavori in commesso di pietre dure che si eseguiscono nell I. e R. Stabilimento di Firenze*, 2nd ed. Florence 1853, pp. 162–4, the first exhaustive account of grand ducal workshops from their origins to the time of the Lorraine dukes, of which the author was a well-informed observer.

3 The oldest documentation on inlaid marble tables available at the moment dates from the 1550s; in a letter of 1555 Ammannati, writing of the furnishings in Julius III's villa, mentions large tables with marble bases, "with a frieze of various materials", meaning polychrome marbles. A year earlier Giovanni Colonna da Tivoli sketched, along with other furnishings and monuments in his notebook, an octagonal table with marble base and inlaid top.

4 With the cardinal of Montepulciano as intermediary, Francesco had unsuccessfully tried to persuade the "excelente maestro" of inlaid tables, Giovanni Minardi, known as il Franciosino, to move from Rome, where he was working, to Florence. He frequented Michelangelo's circles and several courts sought to employ him though he finally decided to move to France in 1579 where he died a few years later in the service of Caterina de' Medici. See F. Tuena, "Appunti per la storia del commesso romano: il 'Franciosino maestro di tavole' e il cardinale Giovanni Ricci", in *Antologia di Belle Arti*, n.s. nn. 33–4 1988, pp. 54–69.

5 The table was identified and published by the present author in *La Cappella dei Principi e le pietre dure a Firenze*, Milan 1979, cat. 105; later publications are by A. González Palacios, in *Splendori di pietre dure*, exh. cat. Florence 1988, cat. no. 7; A. Giusti, *Pietre Dure. L'arte europea del mosaico negli arredi e nelle decorazioni* London-Turin 1992, pp. 25–6; A. González Palacios, *Il Gusto dei Principi* 1994, pp. 383–4, who suggests that the artist who engraved the mythological subjects beneath the alabaster could have been close to Michele Lucchesi.

6 F. Tuena refers to the Pope's gift of a commesso table in "Ammannati virtuoso di marmi per Giulio II", in *Gazzetta Antiquaria*, 1987, pp. 63–6.

7 See A. Giusti, "Tra Roma e Firenze: inizi cinquecenteschi dell'intarsio di pietre pregiate", in *Pietre Dure* cit. pp. 9–33.

8 The table, now in the Galleria Palatina in Florence, was published, with information concerning its origins, by A. Giusti in *La Cappella* cit. 1979, cat. no. 56. The design for the table top is seen in a watercolour sketch discovered in the Gabinetto Disegni e Stampe in the Uffizi by A. Morrogh who attributes it to Dosio: see *Disegni di architetti fiorentini 1540–1640*, exh. cat. Florence 1985, pp. 116–7.

9 In December 1584 the engraver Giulio Balsimelli received a payment for the altar which would seem to have been completed in the spring of the following year; the sculptor Baccio Giani also worked on the piece. The relevant. documents have been traced and recorded by R. Spinelli in *Cappella Niccolini in Santa Croce*, in *Cappelle barocche a Firenze*, edited by M. Gregori, Cinisello Balsamo 1990, pp. 101–34.

10 Documents referring to the two Balsimelli who worked on the Chapel have been traced by C. Przyborowsky: see the entry by him in *Splendori* cit. 1988, p. 126. A Florentine, Francesco Balsimelli, is documented in 1617 as the craftsman who made the inlaid pulpit in Santa Maria la Nova in Naples; in 1619 he worked with Jacopo Lazzari, also Florentine, on the ciborium of Santa Patrizia. See also A. Giusti in *Pietre Dure* cit. 1992, p. 225.

11 In his *Istoria delle pietre*, written in 1597, Del Riccio only mentions "maestro Giulio" once, but in terms of quite glowing admiration. R. Gnoli, in his recent annotated edition of the *Istoria*, Turin 1996, identifies the maestro with Giulio Caccini whom Zobi mentions among those working in Ferdinando's Galleria. Caccini was, in fact, the famous musician and it is not unusual that he should appear as one of the members of the Galleria dei Lavori since, according to the statutes, it included "maestri di musica" at the time.

12 From Vasari and other sources we know that the inlayers employed by Cosimo I in Florence were Domenico di Polo and Bernardino di Porfirio da Leccio; after the arrival in Florence of the "virtuosi maestri milanesi", experts in the art of glyptics summoned by Francesco to the Medici 'Casino', the semi-precious stone inlay made for the dukes seems to have become, for quite some time, the monopoly of these craftsmen.

13 See A. Giusti, *Tesori di pietre dure,* Milan 1989, pp. 51–54.

14 Ibid. pp. 64–6.

15 *Le Vite*, 2nd ed. Florence 1568, ed. Club del Libro, Milan 1962–66, VIII, p. 37. Vasari adds that the *ottangolo* was made by the inlayer Bernardino di Porfirio da Leccio who, he recounts, worked mainly for Cosimo I. The piece has been identified as the octagonal wooden top with Moorish motifs in jaspers outlined with ivory, now in the collection of the Banco di Roma; see A. Giusti in *Splendori* cit. 1988, p. 22 note 13; A. González Palacios, ibid. p. 43; idem, in *Fasto Romano*, exh. cat. Rome 1991, pp. 145–6; A. Giusti, *Pietre Dure* cit. 1992, p. 26; A. González Palacios, *Il Gusto* cit. 1993, pp. 380–1.

16 See C. Acidini, "Niccolò Gaddi collezionista e dilettante del Cinquecento", in *Paragone*, XXI, 1980, nos. 359–60, pp. 141–75.

17 Del Riccio, who frequently refers to Gaddi's collection and his artistic initiatives, wrote: "Thus in his house you see a gallery worthy of a prince and he has filled his house with so many most beautiful stones that they could adorn another chapel …". The contemporary account of Scipione Ammirato adds that in Gaddi's house the craftsmen in his service "cut and polished the stones".

18 See *Splendori* cit. 1988 cat. 9 and 10, and A. Giusti, *Pietre Dure* cit. 1992, pp. 27–8.

19 As well as the numerous archive documents relative to the complex stages and processes on making the table top we also have Del Riccio's description; moreover, once the piece had arrived in Prague, it was greatly admired by Francesco Vendramin, the Venetian ambassador to the court of Rudolf II, and Anselm Boetius de Boodt, the Emperor's personal doctor and author of a treatise on gems and rare minerals. See A. Giusti, *Pietre Dure* cit. 1992, pp. 137–8 and relevant bibliography.

20 The crown is a faithful copy of the model made in 1583 by the goldsmith Jacques Bylivelt for Francesco I and used over a long period of time. The table is published by A. Giusti in *La Cappella* cit. 1979, cat. no. 8.

21 The table which still adopts, at a rather late date, a design and motifs that are late sixteenth-century in taste, was published by A. González Palacios in *Civiltà del Seicento a Napoli*, Naples 1984, II, p. 394. A payment made in April 1616 shows that the craftsman who made the central arms was Iacopo di Gian Flach, also mentioned with reference to the arms of the cities of the grand duchy inlaid around the skirting of the Chapel of the Princes. See also *Splendori* cit. 1988, cat 32.

22 I refer particularly to works such as the renowned table top in the Museo degli Argenti, with semi-precious stones on a white ground, arranged in a combination of octagons and squares (see the catalogue *Splendori* cit. 1988, p. 90 and bibliography), or the perspective compositions, made with antique marbles, on the table in Aston Hall, Birmingham (A. Giusti, *Pietre dure* cit. 1992, p. 27), similar to an unpublished table top in the Herzog Anton Ulrich Museum in Braunschweig.

23 The table, which is mentioned for the first time among the Medici furnishings in 1624, in the villa of Poggio Imperiale, was first published by A. Giusti in *La Cappella* cit. 1979, p. 258. Without wishing to make a too hasty identification, I believe it is, however, worth mentioning several coincidences which exist between this top and the one with flowers mentioned by Del Riccio in the collection of Niccolò Gaddi; among the various stones used were the Antioch *occhiato* and the *breccia quintilina*, both of which are antique materials rare even at the time and also, in fact, found in the Argenti tables.

24 A square table in the Villa Reale, Milan, described by A. González Palacios in *Mosaici e pietre dure*, Milan 1981, p. 16, and published by A. Giusti in *Pietre dure* cit. 1992, p.75, comparing it to a similar table in the collection of the Marquis of Salisbury in Hatfield House. Common to both these pieces is the use of coral which was not frequent and which, according to Del Riccio, was used in the table and cabinet sent by Francesco I as a gift to Philip II of Spain. Recently A. González Palacios, *Il Gusto* cit. 1993, pp. 386–7 has described a half table-top in a private collection, made from a square table, rightly relating it to the table in Milan.

25 First published by A. Zobi, cit., pp. 187–8.

26 G. Vasari, *Ragionamenti*, in *Le Opere di G. Vasari*, vol. VIII, Florence 1882, p. 39.

27 The oldest known portrait is of Cosimo I, now in the Museo dell'Opificio, made by the Florentine craftsman Francesco Ferrucci in 1598 to a design by Domenico Passignano. In 1601 the collaboration between Passignano and Ferrucci also produced a portrait of Ferdinando I, now lost, while in 1600 Maria de' Medici took a portrait, also by Ferrucci, to her husband Henry IV of France. The painting from which the latter was made, by Santi di Tito, is in the Opificio. The portrait of Clement VIII, which Zobi had seen in the Corsini collection in Rome before 1853, only recently reappeared on the art market and is now in the Getty Museum, Malibu. Documents show that it is also the work of Ferrucci and mention Ligozzi with reference to the original painting which had probably been sent to the grand ducal workshops from Rome: see A. González Palacios, "Iacopo Ligozzi in Galleria", in *Il Gusto dei Principi*, I, Milan 1993, pp. 193–6.

28 A vast bibliography exists on the Chapel of the Princes concerning both the numerous projects, the various changes made previous to the beginning of the work, and the building and decoration of the mausoleum which continued into the twentieth century. For more specific information on the period and subjects covered here, see in particular A. Przyborowsky, *Die Ausstattung der Fürstenkapelle an der Basilica von San Lorenzo in Florenz: Versuch einer Rekonstruktion*, degree thesis, 2 vols., Berlin 1982, and A. Giusti, *Pietre Dure* cit. 1992, for the bibliography.

29 Not only does the Museo dell'Opificio exhibit a collection of over 500 examples of various rare stones, but it also has in storage large quantities of semi-precious stones, ranging from large quarried blocks to pebbles and sheets already prepared for cutting, most of which date from the Medici period.

30 The change from one technique to another was neither easy nor frequent. Although in Prague Emperor Rudolf II had experts in the art of glyptics, such as the Miseroni from Milan, when he wished to start up a *commesso* workshop he asked for and obtained the transfer of Cosimo

Castrucci from Florence some time earlier than 1596. Moreover, at the end of the seventeenth century, the two methods of working semi-precious stones seem to have developed quite different roles in the Florentine workshops since documents distinguish between maestri *in piano* and those *di rilievo*, one of whom was, at the time of Cosimo III, Giovan Battista Torricelli.

31 The tabernacle was studied and published, with full documentation ,by C.W. Fock "Der Goldschmied Jacques Bylivelt aus Delft und sein Werk in der Mediceischen Hofwerkstatt in Florenz", in *Jahrbuch der Kunsthistorischen Sammlungen in Wien*, XXXIV, 1974, 70, pp. 89–178. A piece which was in preparation in 1628 may have been based on the tabernacle. An unpublished document (ASF, GM 432, c. 402) states that the sculptor Orazio Mochi delivered a wax model to Nigetti, at the time superintendent of the workshops, representing "Our Lord, when arisen, appearing to the woman, to be made in stone with a crystal frame".

32 On the oval and the *studiolo* see in particular the entry by Detlef Heikamp in *Splendori* cit. 1988, p. 104, and, by the same author, Lo "*Studiolo Grande*" *di Ferdinando I nella Tribuna degli Uffizi*, ibid. pp. 57–61.

33 Documents regarding the making of the table are published by A. Giusti in *La Cappella* cit. 1979, pp. 285–6.

34 An exhaustive list of the names of craftsmen working on the Chapel under Ferdinando I and in the grand ducal workshops in general, is in C. Przyborowsky cit., who has examined the relevant documents in detail.

35 For an extensive bibliography of these well known and documented pieces see A. Giusti, *Pietre Dure* cit. 1992.

36 See *Splendori* cit. 1988, cat. nos. 23, 24, 25.

37 Two reliefs portraying Faith and Charity were made in 1785 for the altar of the Palatine Chapel in Palazzo Pitti: see A. Giusti, *La Cappella*, cit. 1979, pp. 302–3. Another four reliefs of Virtues were sold by the Opificio in 1863 and have subsequently passed into private collections.

38 On 18th July of that year the "cartoon of the design of a *studiolo* which is going to France" (ASF, GM 236, c. 924) was made – in other words, as was normal for pieces which were completed and were to be sent outside Florence (as, for example, the table sent to Prague to the court of Rudolph II of Habsburg) a copy was made as a kind of record, to be kept in the workshops. Two payments made the same year might also refer to the same cabinet: one is to Jacopo Monnicca for a "perspective" with a pergola, made for a *studiolo,* and the other to the goldsmith Michelagnolo Palai, for having inserted "two pyramid-shaped pieces of copper, to go at the end of the pergola" (ASF, GM 245, c. 9r. and GM 236 c. 762). Possibly the design was supplied by Ligozzi in 1600, as he was paid that year for a "perspective with pergola, fountain, birds, vases and landscape" (ASF, GM 228, ins. 2, c. 53).

39 ASF, GM 245, c. 20v.

40 Almost always made partly of silver, the Medici beds inlaid with semi-precious stones have all disappeared. Recently in the deposits of the Opificio delle Pietre Dure four damaged polygons of lapis lazuli and red and yellow jaspers with bronze mounts have come to light which I believe could have been on the ends of a four-poster bed, possibly dating from the time of Ferdinando II. See A. Giusti, *Guida al Museo dell'Opificio delle Pietre Dure,* Venice 1995, pp. 45–6.

41 ASF, GM 245, cc. 9 and 11.

42 See A. Giusti *Pietre Dure* cit. 1992, and bibliography.

43 The 'fillets' would quite clearly have been bands of precious metal; the document, dated January 1611, is in ASF, GM 306, c.136. Burchielli was one of the craftsmen working on the coats of arms of the cities in the grand duchy for the walls of the Chapel of Princes, in the period between 1589 and 1609: see C. Przyborowsky in *Splendori* cit. 1988, p. 126.

44 "Iacopo Ligozzi in Galleria", in *Il Gusto dei Principi*, Milan 1993, I, pp. 389–9.

45 The extensive and complex documentation on the frontal and sides which must have formed the Chapel altar has been collected by C. Przyborowsky, see *Splendori* cit. 1988, p. 108.

46 Documents exist for the chessboard, designed by Ligozzi in 1617 and completed in 1619; see the entry by Enrico Colle in *Splendori* cit., 1988, p. 154, and bibliography. More information concerning Ligozzi's collaboration with the workshops is provided by L. Conigliello, "Alcune note su Iacopo Ligozzi e sui dipinti del 1594", in *Paragone*, 1990, 485, pp. 21–42; eadem, *Le vedute del Sacro Monte della Verna. I dipinti di Poppi e Bibbiena*, exh. cat. Poppi 1992. See also A. González Palacios, in *Il Gusto* cit. 1993, pp. 389–99.

47 Not yet documented, the Ottawa cabinet has been studied by A. González Palacios, *Mosaici e Pietre Dure*, Milan 1981, I, p. 33, and *Il Tempio* cit. 1986, I, pp. 64–6, where it is dated to 1615, or slightly earlier, and pointing out the Ligozzian style of the decorations.

48 As yet unpublished, I believe the top could be derived from a design by Ligozzi in a phase which, given the spacious nature of the composition and the rather large size of the sections of inlay, may have been during the first decade. I am most grateful to Jorgen Hein, the curator of furnishings at Rosenborg, who kindly sent a photograph of the top and provided the information that the table was recorded in Rosenborg in 1623.

49 A. González Palacios, *Il Gusto* cit., 1993, I, pp. 392–3.

50 ASF, GM 362, cc. 364 and 580.

51 ASF, GM 370, cc. 104 and 181. Work was done on the base during January 1621; Sassi was also involved, at least on the 'frieze' of the table. A design in oil on card in the Museo dell'Opificio, which I have recently concluded to be identifiable as a life-size model by Ligozzi for a table top, might be

related to one of these lost pieces. See A. Giusti in *Guida* cit. 1995, p. 51.

52 The documents relevant to the table, some of which were already known, have been collated more precisely by A. Giusti in *La Cappella* cit., 1979, pp. 286–7.

53 See *Splendori* cit., 1988, cat. nos. 15, 17, 31.

54 For the method of painting on stone at the time of Cosimo II see M. Chiarini, *La pittura su pietra*, exh. cat. Florence 1970; P. Dalla Pergola,

Opere in mosaico, intarsio e pietra paesina, exh. cat. Rome 1971; A. Cecchi, "La pêche des perles aux Indes: une peinture d'Antonio Tempesta", in *Revue du Louvre,* XXXVI, 1986, I, pp. 45–7.

55 *Istoria* cit. 1996, pp. 122–3.

56 An extensive bibliography and detailed documentation exist for this piece, and may be consulted in the entry by M. Sframeli in *Splendori* cit. 1988, pp. 158–60.

As early as the fifteenth century the Medici inventories included, with surprising frequency, descriptions of items made from natural materials and originating from distant lands, or of unusual hand-crafted articles from other continents which had no equivalent in western Europe. In Piero's inventory for example, we find, 'Three pairs of small Turkish knives, decorated with silver gilt',[1] and later on the inventory lists some thirty-two 'Turkish' items in metal, including round perfume burners, many of which were inlaid, pierced and embossed with silver and gold in pure Islamic style. In addition to such objects, which were made at least partially of precious materials and therefore fall within the scope of this volume, we also find listed Mameluk carpets, most of which were made in Alexandria. Even in the sixteenth century these were

Curios and Exotica in the Medici Collections

Mario Scalini

much admired for their geometric designs, so suited to the western, and particularly Florentine, mentality[2].

As well as Islamic metals and textiles, weapons too were brought from the east and indeed quite early on formed such an important part of the collections that Filarete, referring to Piero the Gouty's possessions, was surprised and impressed by this aspect of the Florentine patron's interests. Moreover, in the period when the Medici lived in the palace in Via Larga, they had already accumulated a considerable quantity of porcelain, although this was probably intended more for practical use than strictly for a collection, given its dispersal throughout the rooms and apartments. Only three pieces of the grey-green Chinese celadon have survived: two large fourteenth-century vases, now in Palazzo Pitti (Museo degli Argenti, Inv. O.d.a. nos. 1335–1336) and a bowl, added to the collections in the nineteenth century, with an inscription showing it to be a gift from the Bey of Egypt[3] to Lorenzo il Magnifico (Museo degli Argenti, Inv. Bg. maioliche no. 102). These pieces were admired for their texture and brilliance which western potters did not yet know how to attain, though other oriental ceramics – the 'grey' and 'scarlet' about which little information has survived – were also used. From the inventories of Duke Alessandro and later of Cosimo I, it is obvious that celadon ware continued to be used and appreciated even after the appearance of white porcelain; during the mid-sixteenth century cases of bluish-white pieces, some of which can still be found in Florentine collections, began to arrive at the port of Livorno.

However, the collecting of exotic items by the Medici was not limited to practical considerations. In Lorenzo's inventory, for example, we find an ostrich egg located in the palace's chapel, while a second egg was kept in the chapel at Careggi. Yet another

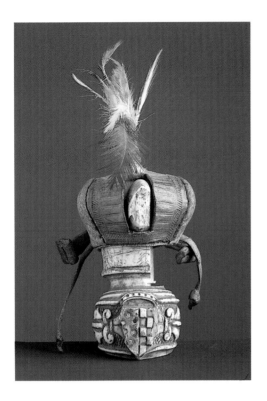

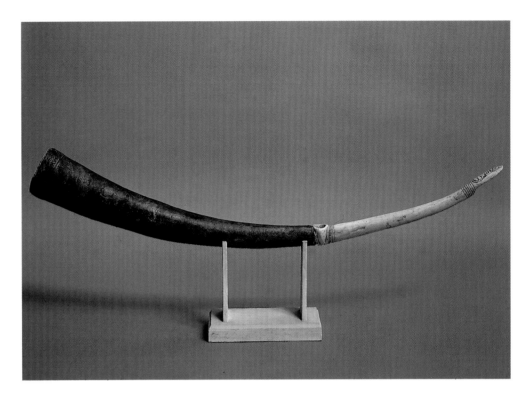

was in Lorenzo's own apartments,[4] indicating that these rare items were probably kept more for their symbolic value, with their references to conception and the Virgin Mary (as seen in Piero della Francesca's painting of Federico da Montefeltro, now in the Brera gallery), than anything else. The huge turtle shell,[5] hung like a shield over a fireplace in the villa of Careggi, must surely have had quite a different significance, but in this case too, the low value attributed to it – a single florin – does not encourage any highly imaginative interpretation. The tusk of an Arctic whale, believed to be the horn of a unicorn and owned by Cosimo I, has already been mentioned and it is not surprising that 'a dagger, a small knife and a fork with a handle of unicorn tipped and with a sheath of gold' was estimated at five hundred florins[6]. There were even elephant tusks and sharks' teeth which, in France, were believed to be the petrified tongues of dragons, widely held to be powerful talismans[7]. Pliny's *Historia Naturalis* was clearly of little help for, although it was the only credible classical source available for understanding such strange and fascinating *naturalia*, it was most probably interpreted in the light of the medieval bestiaries which had used it as a descriptive source for everything that could not be deduced from contemporary oriental texts. Consequently the horns of all kinds of exotic animals, often reaching Europe as containers for relics, were believed to be *meraviglie*, ranging from the claw of a griffin to the horn of a rhinoceros[8].

During the period of Cosimo I, the second duke and later the first grand duke of Florence, a considerable number of items from Central America and Africa were added to the collections. The central American cloaks of feathers, now in Florence's

Ivory stand with the Medici-Toledo arms *for a hawk's hood, Florence (?), c. 1550. Florence, Museo Nazionale del Bargello.*

African horn used as a bugle with the Medici-Toledo arms, *central Africa and Florence, c. 1539. Florence, Museo di Etnologia e Antropologia.*

Opposite page: Celadon plate and vase *probably owned by Lorenzo il Magnifico. China, 14th–15th centuries. Florence, Museo degli Argenti.*

anthropological museum, and the mask in the Museo Pigorini in Rome are among the victims of the unfortunate dispersal of many of the artistic items in the grand ducal collections which occurred under the Habsburg-Lorraine, the Savoy and even more recently[9]. However, objects no less important than the curios in semi-precious stones or bone, now housed in the museums of Florence's university, such as the Minerological and Lithological or the Anthropological Museums, are displayed in Palazzo Pitti, their rightful and more natural home. In the past, especially during the seventeenth-century, some of these items were kept in the private chambers of individual members of the Medici family instead of being 'officially' displayed in the rooms around the Tribune in the Uffizi.

Occasionally the owner had his coat of arms engraved on a rare item such as the African horn made from an elephant's tusk, now in the Museum of Anthropology and Ethnology in Florence (Inv. no. 22181),[10] which bears the arms of Cosimo I, thereby enabling us to identify with certainty the piece and the date when it entered the collection. In other cases, the ivory was used simply to make practical items, such as the stand for a falcon's hood with the Medici-Toledo arms in the Museo Nazionale del Bargello (Inv. Carrand no. 194) which was clearly one of the forty listed in the 1553 inventory of Palazzo Vecchio, along with various other exotic and 'Turkish' objects[11]. It is impossible to know exactly how many oriental weapons may have been housed in Palazzo Vecchio at the time, since the most private chambers, including Cosimo and Eleonora di Toledo's *tesoretto* where the most precious and rare items were kept, were not subject to the inventory, the keys being held by the servants who personally attended the dukes themselves. Exotic materials and objects were still therefore considered to be luxurious rarities intended purely for the pleasure of the sovereigns, an attitude and practice obviously shared by other members of the family.

Ferdinando owned a certain number of round shields made from rhinoceros hide and decorated with gold tooling,[12] one of which is most probably that preserved in the Museo Nazionale del Bargello (M 788). This Indo-persian item, not yet identified in the inventories earlier than 1631,[13] clearly inspired the black and gold decoration, occasionally also in relief, of many pieces of furniture listed within the palace, described as tooled 'in the Persian manner' and decorated with the Medici cardinal's coat of arms[14]. These are distinguished from the black and gold Venetian decorations which did not have hunting scenes or animal designs, the entire decoration consisting of plant motifs in the most orthodox Islamic style. The difference is quite clear when we compare this round shield to a black and gold bow, which had a fragment of Mameluk carpet around the grip at the time of its use, now displayed in the Museo Nazionale del Bargello (M 352). This is, most probably, one of the large quantity of bows the Grand Duke ordered from Venice in 1568, to be used on the galleys of the Knights of Saint Stephen[15].

The first Japanese weapons appear in the private chambers of Palazzo Pitti in 1597. Two of these, a *naginata* and a *nagamaki*[16] now housed in the Museo Nazionale

Dahl *(circular shield), Indo-persia, second half of the 16th century.*
Florence, Museo Nazionale del Bargello.

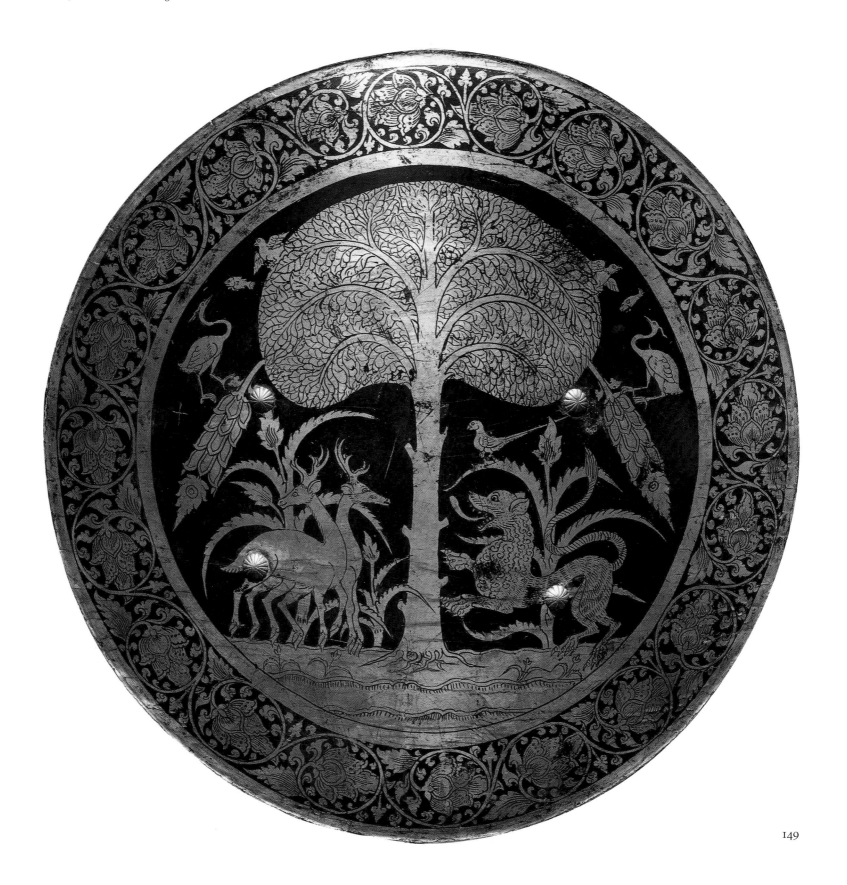

Bow with arrows, *Anatolia, earlier than 1568.*
Florence, Museo Nazionale del Bargello.

Naginata and Nagamaki, *Japan, earlier than 1585.*
Florence, Museo Nazionale del Bargello.

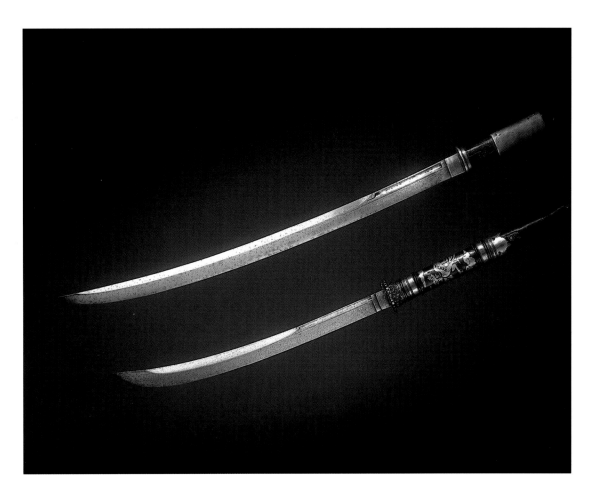

del Bargello (M 280, M 281), probably arrived in Florence in 1585 with the first European diplomatic mission of a Japanese daimyo[17]. In 1631, the first suit of armour from the Land of the Rising Sun was added to the armoury of the Uffizi. Oriental swords, sabres and daggers also arrived and the shining lacquer was at first thought to be polished horn since this technique of treating wood was unknown at the time in the west.[18]

The series of gifts presented by the Persian court in 1613 when Fakr-ed Din hoped to form an alliance with Cosimo II (1590–1609–1621) to fight the Turks, constituted another important influx of exotica. On this occasion, not only textiles and weapons such as the splendid shield, or *sipar,* encrusted with mother-of-pearl and almost certainly of Indian origin, now in the Museo Nazionale del Bargello (M 788),[19] but also a variety of other objects including two boxes, one of tortoiseshell, the other mother-of-pearl. The round tortoiseshell box was displayed together with one already in the Tribune of the Uffizi (Museo degli Argenti, Inv. Bg. Ambre no. 41 and Bg. V no. 17) where other similar pieces now lost to us, were kept. Such objects were an indication to the perceptive visitor of the erudition of the Medici court, its cosmopolitan outlook, international relations and opulence.

To some extent the concept of what constituted a precious possession was changing; the value of an object no longer derived purely from its rare or costly material but also from its evocative and allusive qualities. It was during this period that the *stanza delle meraviglie,* or Wunderkammer, housing natural and artistic objects which were considered to be inexplicable miracles of divine and human creativity, began to develop into the scientific museum on the one hand and the art gallery on the other, thus entirely transforming, albeit gradually, the arrangement of the Medici collections. The armoury, adjacent to Buontalenti's Tribune in the Uffizi, seemed almost like an intermediary between the two worlds, housing, for example, an equestrian figure in oriental dress – from the description almost certainly Persian – holding the famous round shield with Caravaggio's Medusa. This 'historicised' use of a contemporary painting, clearly reminiscent of the circular shield which Leonardo da Vinci is reputed to have painted with such a realistic dragon that, on seeing it in shadow, it frightened the client, also demonstrates the extent to which the Baroque concepts of illusionism and naturalism had affected not only the production of art but also its presentation to the public. It is therefore understandable that at the time of Cosimo II and Ferdinando II (1610–1621–1670), shells mounted as salt cellars or small jugs, coral, coconuts and so on were rearranged in the Casino di San Marco, while exotic knives and implements with handles of jade, gemstones, ivory and precious metals were housed in both the Tribune and the armoury.

It is quite clear that during the seventeenth century the Uffizi's new acquisitions consisted primarily of weapons and objects of Turkish, or at least Anatolian, origin. Indeed, these often so intrigued the court artists that they borrowed them to place in still life paintings, such as the quite fascinating work by Bimbi (Inv. 1890 no. 5793). So

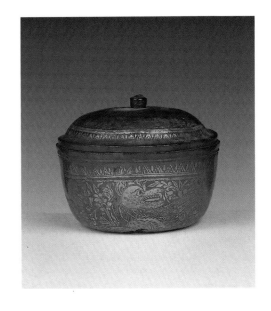

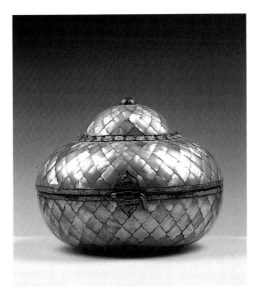

Tortoiseshell bowl embossed with gold, *Indo-persia (?), earlier than 1589. Florence, Museo degli Argenti.*

Round box *of gilded metal, mother-of-pearl and precious gems, Indo-persia (?), earlier than 1631. Florence, Museo degli Argenti.*

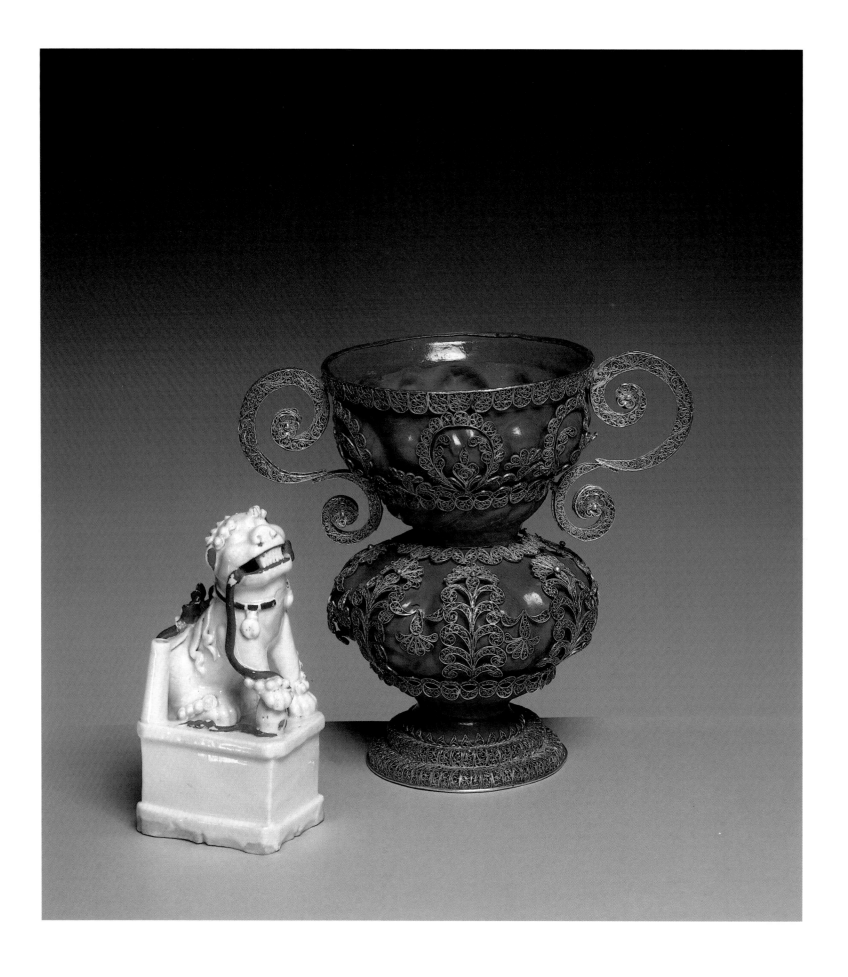

precise is his representation of the various objects that we can easily recognise among them a Persian steel club, known as a *gurz*, which can still be seen in the Museo Nazionale del Bargello (M 1228). Such weapons were probably trophies from the campaigns undertaken by the ships of the Order of the Knights of Saint Stephen, of which the grand duke was Grand Master, as well as representing the military successes of junior members of the dynasty. Here too, rather than forming a methodical collection, these items from different regions and countries were kept entirely as a political statement and it would be incorrect to believe there was any other intention or purpose attached to the programmatic and selective display of the contents of the private collections.

The eldest son of Cosimo III, Prince Ferdinando (1663–1713) had, however, a slightly different outlook. An enthusiastic traveller, he brought all manner of objects from northern European countries to further the learning and culture of the court and was a keen collector of curios, ranging from Chinese porcelain to black *bucchero* vases from Guadalajara, often painted or mounted with silver[20] (Museo degli Argenti, O.d.a. nos. 1121–1122 and Bg. Oreficerie profane no. 24). In true Baroque fashion these rarities were used as decorative pieces and were placed on tables, chests of drawers or shelves alongside English and German clocks, antique and modern Florentine bronzes, French carpets and fabrics of various origins, in a way which highlighted the cultural miscellany. Fascinated by mechanical and precision instruments, and a stylish hunter, this unfortunate heir to the throne, who died before his father thus bringing to an end all hope of perpetuating the dynasty, also collected a large number of experimental magazine hunting guns and most elegant dress swords which, though now dispersed among different collections in Florence and abroad, are still clear evidence of the new significance the word 'precious' had now acquired.

Opposite page: Dog from Fo, *China (Ch'ing), early 18th century.* Bucchero vase from Guadalajara *with silver filigree mount, Mexico and Florence, late 17th-early 18th century.* Florence, Museo degli Argenti.

Notes and references

1 ASF MAP 165, c. 5, c. 20.

2 Many carpets of this kind appear in the inventory of Lorenzo il Magnifico (ASF MAP 165) see M. Spallanzani, *Fonti archivistiche per lo studio dei rapporti fra l'Italia e l'Islam: le arti minori nei secoli XIV–XVI*, in *Venezia e l'Oriente vicino*, proceedings of the first international symposium on Venetian art and Islamic art, Venice 1986, pp. 83–92, and, for a most interesting, although fragmentary, piece of Mameluk carpet in the Bardini collection, G.Curatola, *Il commercio dei tappeti a Firenze nell'Ottocento, appunti sugli antiquari Bardini*, in *La conoscenza dell'Asia e dell'Africa in Italia nei secoli XVIII e XIX*, edited by A. Gallotta and U. Mazzini, Naples 1989 (Istituto Universitario Orientale, the 'Matteo Ripa' series) ibid. pp. 247–60.

3 M. Spallanzani, *Ceramiche alla corte dei Medici nel Cinquecento*, Modena 1994, p. 17, but see also other titles by the same author, in particular the articles of 1980; for the bowl, entry no. 328 in *Palazzo Vecchio committenza e collezionismo medicei*, pp. 178–9.

4 ASF MAP no. 165, c. 12b, c. 14b, c. 64b.

5 ASF MAP no. 165, c. 65.

6 ASF MAP no. 165, c. 26; as for all other quotations from this inventory, I refer to the transcription published by Marco Spallanzani and Giovanna Gaeta Bertelà, 1992, S.P.E.S., Florence.

7 M. Scalini, 'Naturalia e arte orafa. Dai tesori medioevali alle raccolte medicee', in *Di natura e d'invenzione, fantasie orafe dal Rinascimento al Barocco*, catalogue edited by K. Aschengreen Piacenti and M. Scalini, Arezzo 1993, pp. 53–63.

8 The first unfortunate animal of this kind to arrive in Europe died during a storm while being transported from Portugal to Rome in 1515. Consequently, for a long time after, the only reference available concerning its appearance, also somewhat imaginative, was Dürer's drawing, on which the form of Duke Alessandro de' Medici's emblem is based.

9 See the section on the exotic items in *Palazzo Vecchio 1980*, pp. 161–72, entries by E. Bassani, L. Laurencich Minelli, A. Guarnotta; the first and most thorough study of central American objects is still, however, D. Heikamp, *Mexico and the Medici*, Florence 1972; on the African objects, E. Bassani, W. B. Fagg, *Africa and the Renaissance: Art in Ivory*, Munich 1988, ill. p. 46, p. 200.204, entries p. 241, p. 247, but see also p. 45 for a carved horn, documented in Florence in 1643 and now in the Musée de Cluny, Paris (Inv. no. 88).

10 E. Bassani, entry no. 299 in *Palazzo Vecchio 1980*, p. 162, where there are other descriptions of exotic items; see also Bassani-Fagg 1988, p. 47 where it is suggested the piece may have originated from Zaire in central Africa, circa 1539.

11 ASG GM no. 28, c. 24: '...four pairs of Moorish slippers / II pairs of red Turkish reins / 6 pairs of Turkish stirrups without buckles / the uniform of a Turkish Janissary all in red silk with tassels, head-dress and spurs decorated with silver gilt and niello.../ 12 new falconers' gloves / a box with 40 falcons' hoods inside / 12 Syrian bows of various sizes / 20 Turkish-style quivers, some with arrows and some without / ...one large undecorated horn / 4 small horns of oxen / a large Moorish horn for blowing covered with black leather / a long black horn /...'.

12 ASF GM no. 79 [1571–1588], c. 193a: 'Four round shields painted with gold from India...'.

13 For a description of the piece see M. Scalini, 'Oggetti rari e curiosi nelle collezioni medicee: esotica e naturalia', in *Antichità viva XXXV*, 2–3, 1996, pp. 59–67.

14 Ferdinando never, in fact, renounced the status of cardinal, conferred on him in 1563.

15 Scalini 1996, p. 62, p. 66, no. 21.

16 Scalini 1996, ill. p. 59.

17 R. W. Lightbrown, 'Oriental Art and the Orient in Late Renaissance and Baroque Italy', in *Journal of the Warburg and Courtauld Institutes*, XXXII, 1969, pp. 228–79, mentions other gifts presented to various courts. G. Berchet, 'Le antiche ambasciate giapponesi in Italia', in *Archivio Veneto*, XIII, 1877, pp. 150–203, recounts that the Doge of Venice was presented with a *katana* with a sheath encrusted with mother-of-pearl and a *wakizaschi*. In 1615 (ibid. pp. 188–9) the ambassadors of the king of Ossu brought gifts of *Cattane*, described as similar to scimitars.

18 M. Scalini, 'Il gusto internazionale ed esotico nelle armi della nuova Europa', in *Armi e armati. Arte e cultura delle armi nella Toscana e nell'Italia del tardo Rinascimento*, catalogue edited by F. Scalia, Cracow – Florence 1989, pp. 95–105, especially pp. 104–5.

19 Scalini 1996, p. 61, fig. 9, and bibliography.

20 Among those in Prince Ferdinando's apartments in Palazzo Pitti (ASF GM no. 1222, c. 102), divided into groups of red and black were, 'Two small *bucchero* vases, with a tall base and rounded body, each with four small handles, ⅓ of a *braccio* in height … a similar one with embossments and 2 handles, ⅓ of a *braccio* … Three similar, about 1 *braccio* each, decorated with gold, one of which is broken … Four similar round vases, with white fillets and handles' etc. In addition to Heikamp's work of 1972 on the *buccheri*, for two Ginori vases believed to have been decorated by 'Moors' see A. Gonzáles Palacios, *Il tempio del gusto*, Turin 1986.

BAROQUE MAGNIFICENCE

The fifty years of stable government which characterised the Florentine political scene in the mid-seventeenth century proved also to be one of the most coherent of the time as regards both the taste and public commitment of the grand ducan dynasty. Years of cultural advances had coincided with the social ascent of the family, which was now one of the most important in the peninsula and had gained the respect of the Emperor and of other European rulers through both their single-minded artistic patronage and their shrewdly-arranged political marriages. When Cosimo II (1590–1609–1621) died prematurely, his wife, Maria Maddalena of Austria (1589–1631), daughter of the archduke Charles of Austria, became regent of the state of Tuscany. Cosimo II's sister, Claudia (1604–48) married Leopold V, archduke of Austria, in 1626

Private Treasures at the Time of Ferdinando II

and some twenty years later Ferdinando's sister, Anna (1616–76), was married to the archduke's son, Ferdinand Charles.

Mario Scalini

The Habsburgs and the Medici were therefore closely related and when Ferdinando visited the court at Innsbruck in 1628, Archduke Leopold presented him with a gift of quite outstanding prestige and craftsmanship,[1] acquired not long before for the sum of 6000 thalers[2]. In the *Guardaroba* the piece became known as the *Stipo di Alemagna* (the German cabinet) (Museo degli Argenti, M.P.P. no. 1541), an evocative and almost romantic name which distinguished it from the 'old' and the 'new' cabinets previously commissioned by Francesco I and Ferdinando I for the Tribune. Like the earlier ones made in Florence,[3] this grand and impressive cabinet was mainly of ebony, though it had several quite unusual distinguishing features.

Firstly, as Philipp Heinhofer (1578–1647), the art dealer from Augsburg who designed the cabinet and oversaw its construction, explained to his Austrian client in a series of letters, he had, as far as possible, avoided using metals as they require maintenance, and particularly silver which needs frequent polishing to keep its bright gleam. The carved part, attributed to Ulrich Baumgarten, was entirely of ebony, while the coloured panels of semi-precious stones were not of *commesso* but, more unusually, were painted with eighty-two stories from the Bible and twenty from the life of Christ[4]. *Commesso* had been used instead to decorate some of the internal drawers and doors arranged on one of the sides of a cylinder (concealed behind a pair of doors) which revolved, revealing the different sides one by one[5]. On the back and at various heights, a series of distorting mirrors was gradually revealed, perhaps for amusement or simply as an optical curiosity, leading progressively upwards to an image of the Pietà on copper. Intended to stand on a table like the stipo di Pomerania

Ulrich Baumgarten, Johann König
or Anton Moratz and others
(designed by Philipp Heinhofer),
the Stipo di Alemagna
(the German Cabinet), Augsburg,
1619–1625. Florence, Museo degli
Argenti.

Distorting Mirror (detail),
mounted at rear.

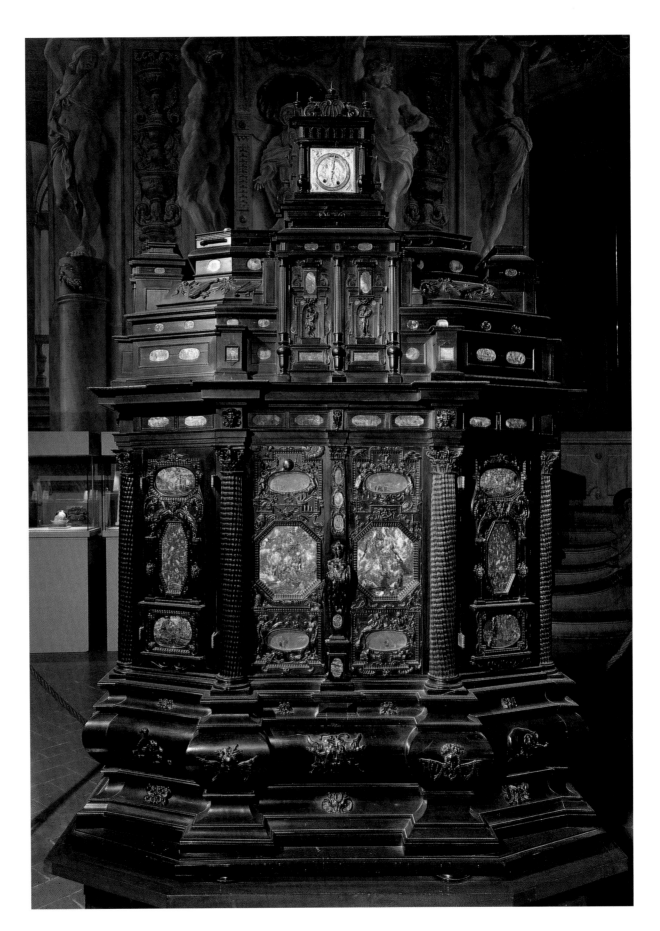

(the Pomeranian cabinet) acquired shortly before, and the two Italian pieces already mentioned, this ingenious masterpiece embraced all the artistic skills in its craftmanship. It was, in fact, the first piece to demonstrate fully the decorative possibilities of the guillochet technique of working wood with such precision that it cannot have failed to impress the artists and craftsmen of the Florentine court. Furthermore, this amazing piece also contained a mechanical organ which played music by the Augsburg composer Christian Erbach. This was a reminder of celestial harmony which, together with the sequence of religious images, synthesised the functions of the soul and human activity as related to both nature and artifice, transforming the object into a kind of stimulus to meditation. Clearly, when the cabinet was housed in the Tribune of the Uffizi, it completely altered the secular aspect of the chamber which Ferdinando II's predecessors had created and adorned to house their treasures and wonders.

At a time in when war was raging between Catholics and Protestants, the sumptuous gift which the young ruler of Tuscany brought back from his educational tour of the Austrian Empire's German territories could hardly have had a more pointed diplomatic significance. However, Ferdinando's own personal tastes, those he was free to express only in the privacy of his apartments in Palazzo Pitti, did not always conform to his rather solemn public image, evident in his official portraits for which, even more than his predecessors … he liked to pose in military regalia.

Some idea of his personal preferences and of his relationships with his wife and closest friends can be gained from several entries in the inventory of his personal *guardaroba*. This private collection was situated in some of the mezzanine rooms of the palace's summer apartments, where a section of the Museo degli Argenti now is, and access to it was permitted only after his death in 1670. The rooms were furnished with a series of cupboards, the height of which is still clearly indicated by the presence of a bracket – left undecorated and therefore not intended to be seen – around the walls at the level of the springer of the vaults. The ceiling was painted with subjects which clearly referred to the content of the rooms themselves,[6] systematically arranged and ordered almost as if they were open to visitors like the rooms of the Armoury in the Uffizi. Twenty years ago Kirsten Aschengreen Piacenti[7] carried out the first analysis of the items recorded in the inventory made on the death of the grand duke and identified two shell-shaped dishes made of rhinoceros horn (Inv. Bg. IV nos. 18–19) as part of the grand duke's private possessions. These, after many vicissitudes, are now displayed in the Museo degli Argenti in the same rooms where they were once originally housed. This first analysis also revealed the presence of the amber fountain 'which serves wine' (Museo degli Argenti, Inv. Bg. Ambre no. 95)[8], 78 cm, in height and probably made in Augsburg in the early seventeenth century. The identification of the ivories, however, is more problematic. The author of the study was, I believe, referring to the only statuette of Cleopatra housed in the Museo degli Argenti (Inv. Bg. Avori no. 100) when she maintained that the figure was easily

Amber fountain 'which pours wine', *Germany, c. 1610. Florence, Museo degli Argenti.*

Following page: detail

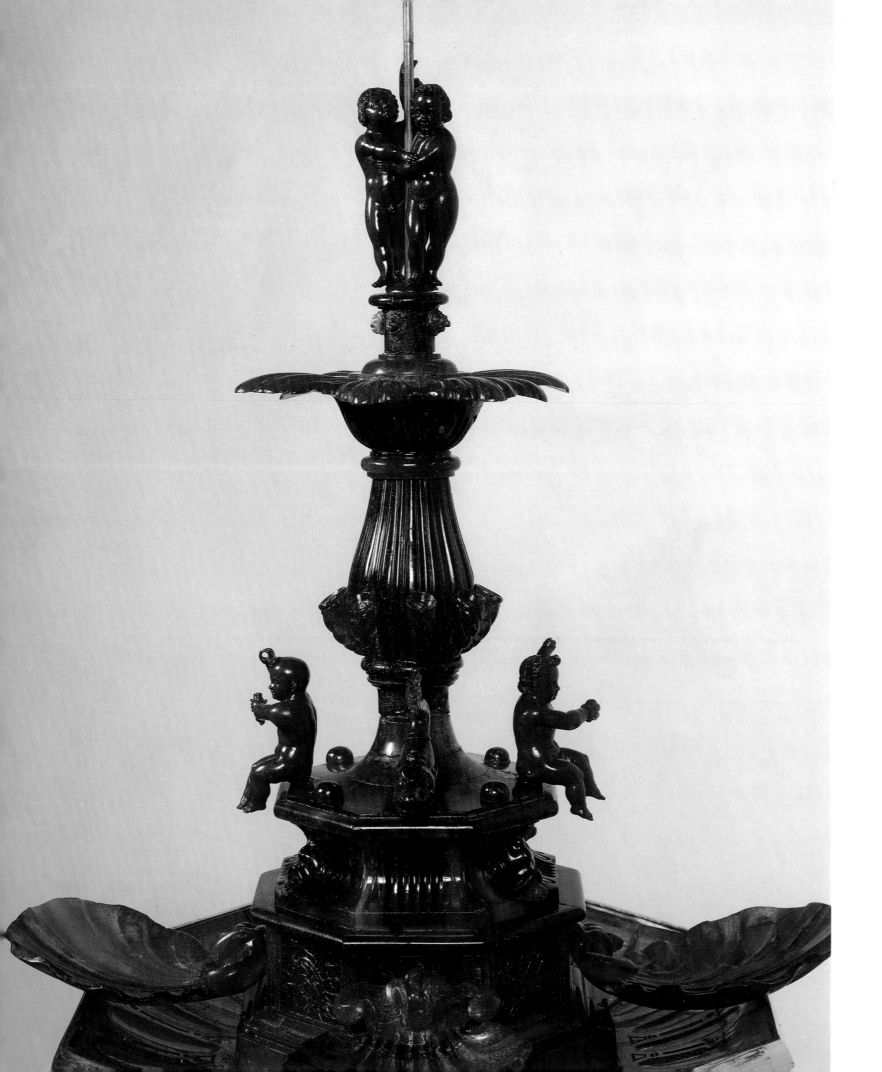

identifiable in the collection and that, like the two cherub archers,[9] it was not of excellent workmanship[10]. Most probably the 'ivory Venus with a cherub, engraved in relief, on a base painted black' (ASF GM 750, c. 177b) has been lost, unless it is to be identified as the only existing Venus (Inv. Bg. Avori no. 30), other than that attributed to Balthasar Stockamer by Piacenti, mentioned in Cardinal Leopoldo's inventory (1617–75)[11]. Clearly recognisable, instead, are both the small sculpture of a 'resting spaniel' in ivory, previously recorded in the *Inventario della Guardaroba segreta della Serenissima Archiduchessa*, compiled in 1625,[12] and the turned globe with portraits of Ferdinando and his father, Cosimo II (Museo degli Argenti, Inv. Bg. Avori no. 136) made by the master craftsman Filippo[13]. Also noteworthy among the ivories and other items studied by Piacenti, is the beautiful Indian gunpowder casket (Inv. Bg. Armi no. 1202)[14] dated to the early fifteenth century, though there is no record of how and when it was acquired. Continuing to examine this revealing document, we come across 'a marble bust of Cardinal Leopoldo wearing his biretta', possibly identifiable as the attractive marble sculpture attributed to Antonio Novelli, now in the Museo degli Argenti (Inv. O.d.A. no. 181); more recent research has shown, however, that the portrait is probably of Giovancarlo[15]. The list also includes 'Two matching terracotta groups of men and horses, about 1 *braccio* high', which it is tempting to identify with the famous pieces by Rustici representing skirmishes between horsemen. Inevitably a large number of arms and weapons are also listed and described[16]. Clearly recognisable is a Turkish baton made of 'granadilla' wood, inlaid with small crescents of bone, one of the many exotic items so frequently found in all of the Medici residences.

Despite the accuracy of so many of the descriptions it has not been possible to identify amongst the weapons the magnificent harquebus made in Munich by Daniel Sadler and Hieronimus Borsthoffer the Elder around 1628 and now in the Museo Nazionale del Bargello (M 233). The fact that the piece, with its lock, is first recorded in 1639 in the Armoury of the Uffizi[17] is evidence that it was a diplomatic gift, probably, as Boccia has suggested, presented to Cosimo during his visit to his uncle, the Emperor Ferdinand ii (1578–1619–1637), in Prague. However, the most illustrious piece, listed together with some rather mediocre bowls of rock crystal, is without doubt the following: 'An oval bowl of red agatine chalcedony with a pedestal of the same material, ⅓ of a *braccio* high, with a lid of the same, crowned by an enamelled gold figure, leaning on a lance and holding in the other hand a golden shield with the arms of Saxony enamelled on it, with small diamonds on the armour and the base on which the figure is standing, decorated with two ribbons and two bows of enamelled gold with small diamonds on them, inside a case of red satin, embroidered with gold thread and studded with pearls on the outside'[18] (Museo degli Argenti, Inv. Gemme no. 624). Brought to the Tribune in the Uffizi only in 1753,[19] already lacking its shield with the arms of Saxony, this valuable piece was most probably a present from the Elector of Saxony, together with an oriental bowl of semi-precious stone with

Cleopatra, *owned by Ferdinando II de' Medici, southern Germany, first quarter of the 17th century. Florence, Museo degli Argenti.*

Sleeping spaniel, *owned by Maria Maddalena d'Austria. Florence, Museo degli Argenti.*

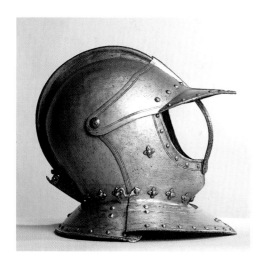

Daniel Sadler and Hieronimus Borsthoffer the Elder,
Harquebus *owned by Ferdinando II de' Medici, Munich, 1628.*
Florence, Museo Nazionale del Bargello.

The armoured helmet *of Mattias de' Medici, southern*
Germany or Flanders, c. 1630. Florence, Museo Nazionale del
Bargello.

diamonds, gold and enamel (Museo degli Argenti, Inv. Gemme no. 745)[20]. Originally believed to have been made in Saxony, Piacenti has recently re-evaluated the bowl,[21] preferring to identify it as the work of a French goldsmith.

Clearly Saxony, heavily involved in the Thirty Years War, was suffering such a crisis that it was quite unlikely to produce any item so sumptuous or luxurious. Moreover, a third piece in the Museo degli Argenti, a quite lovely cameo representing a Pietà (Inv. Gemme no. 103) and made in Paris in the early fifteenth century, has a similar mount with black and white volutes. Comparison with the mount of a portrait of Cardinal Mazzarino in painted enamels by Jean I Petitot shows quite clearly that it was also made at the French court;[22] both the mount and the parts in metal are attributed to Gilles Légare[23].

The precious items which Grand Duke Ferdinando II kept for his private enjoyment were quite international, although his tastes clearly tended towards a Germanic style which was also favoured by the younger members of the family. Except for the cabinets, the most spectacular of which is, in fact, Ferdinando II's, designed by Matteo Nigetti, made in the grand ducal workshops between 1642 and 1646 and still in the Tribune of the Uffizi (Inv. O.d.A. no. 912) today, many of the most valuable ornaments and furnishings were undoubtedly Germanic in style.

Gilles Légare (mount) and unknown glyptic artist, Jasper vase, with gold, enamel and diamonds, originally owned by the Duke of Saxony and later by Ferdinando II de' Medici. France, c. 1650-1660. Florence, Museo degli Argenti.

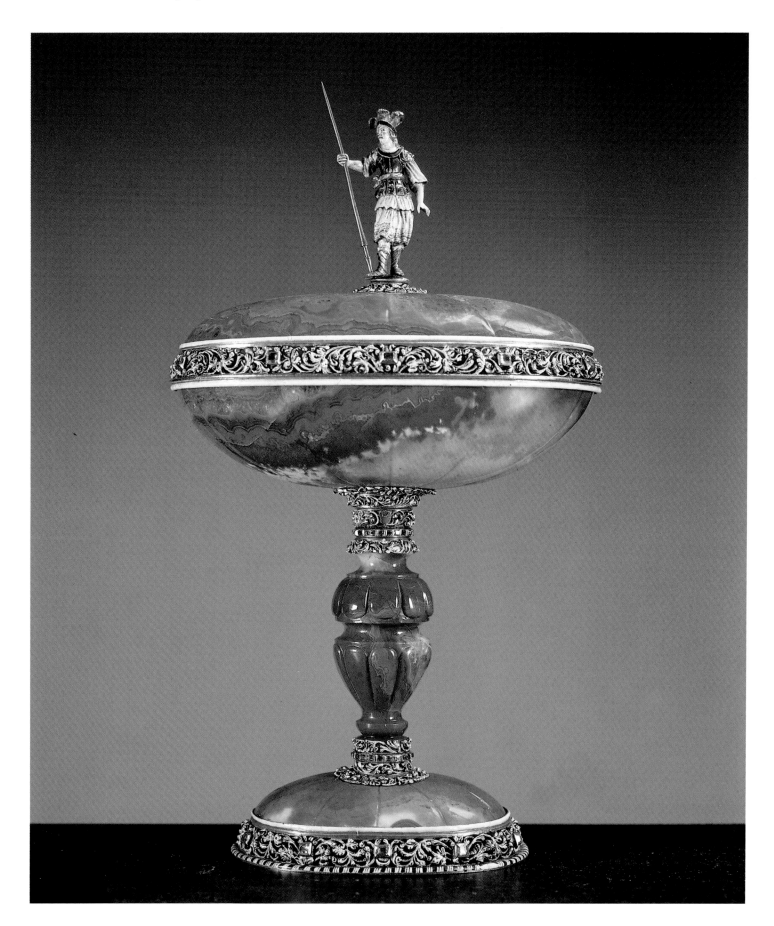

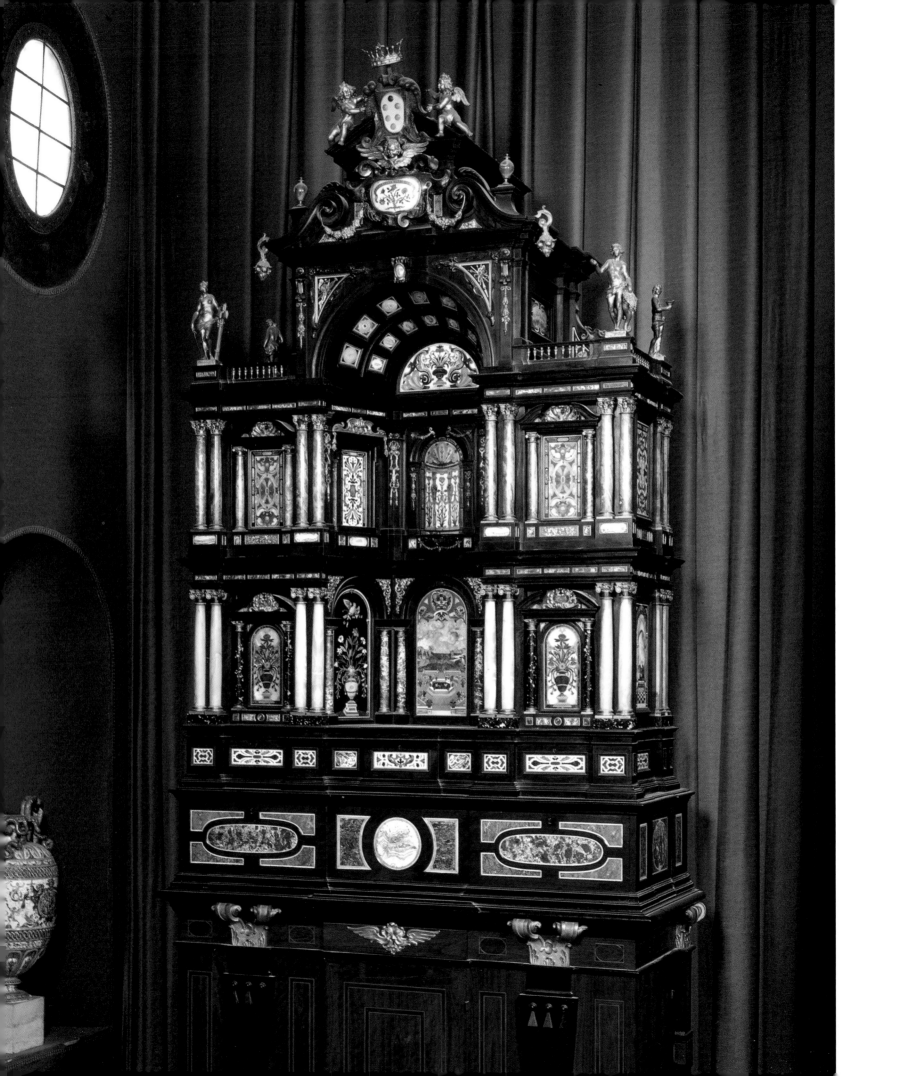

The part played in the Thirty Years War by some members of the dynasty must have considerably influenced this tendency. Instead of, for example, the trinkets and jewels reflecting sixteenth century tastes listed in the inventories compiled on Cosimo II's death, or the exotic curiosities such as the jade mask, possibly of Mesoamerican origin, set in a heraldic case glorifying the Rovere family which died out with Ferdinando II's wife, Vittoria (1623–94), (Museo degli Argenti),[24] the young Mattias (1613–67) preferred carved ivories. The prince, Ferdinando's third son, fought in the Imperial army from 1632 and participated in the battle of Nordlingen in 1639; he certainly enjoyed better fortune than his younger brother, Francesco (1614–34) who died of the plague after only two years of service. Mattias, however, distinguished himself when the city of Coburg was sacked on 28 September 1632 and was rewarded with a series of thirty ivory 'towers', turned in the form of vases and carved with facets, grooves and concentric spirals by Marcus Heiden and his pupil, Johann Eisenberg, for Johann Casimir, duke of Saxony, and Julich von Cleve und Berg, prince of Coburg, between 1618 and 1631.[25]

Twenty-seven of these eccentrically-shaped vases remain, some evocative of the Far East, some directly inspired by the geometric designs of the Italian Renaissance, yet together constituting a rare example of an entirely Nordic concept of magnificent, princely furnishings during the early Baroque period. Greatly admired on their arrival, they were placed in the Tribune of the Uffizi as evidence of the prowess of a family member. Exhibited nearby, in the rooms of the Armoury, was the battledress of Bernard of Saxony Weimar (1603–39), a defeated general of the Protestant forces, another prestigious piece of booty won by Mattias who, even in his later years as governor of Siena, frequently had himself portrayed as a warrior. Thus even these military trophies were considered 'precious', as is confirmed by the fact that the helmet Mattias is seen wearing in a portrait of him as a young man still remains in the collections today (Museo Nazionale del Bargello, M 233), having survived even the Habsburg-Lorraine purge of 1773, when it was obviously recognised as an important memento of a hero of the empire.[26]

The history of the collections belonging to other, secondary, members of the dynasty, such as those who were destined for the church rather than a military career, is quite different. The largest and most consistently excellent collection of artistic items is, without doubt, that of Cardinal Leopoldo. A man of some intelligence and a knowledgeable connoisseur of paintings, while still resident in Rome he was the patron of Balthasar Stockamer, already mentioned as one of the greatest masters of ivory carving.[27] A number of large statues based on classical sculptures or on contemporary pieces are now housed in the Museo degli Argenti: David with the head of Goliath (Bg. Avori no. 150),[28] also copied in bronze by Giovan Francesco Susini; Hercules and the Hydra (Bg. Avori no. 151), based on a model by Algardi[29] and frequently copied on the same scale in bronze; an Apollo (Bg. Avori no. 31) modelled on the *Apollino* in the Uffizi[30] which was at the Villa Medici in Rome until 1704.

Jade mask with a mount of gold, enamel and diamonds, *probably owned by Vittoria della Rovere, Central America and France, c. 1650-1660. Florence, Museo degli Argenti.*

Opposite page: Grand ducal workshops (designed by Matteo Nigetti), Ferdinando II's Cabinet, Florence, 1642-1646. Florence, Uffizi Gallery.

Johann Eisenberg and Marcus Heiden, 3 Ivory 'tower' vases, originally in the collection of the Duke of Saxony, brought to Florence by Mattias de' Medici, Coburg, 1627-1628. Florence, Museo degli Argenti.

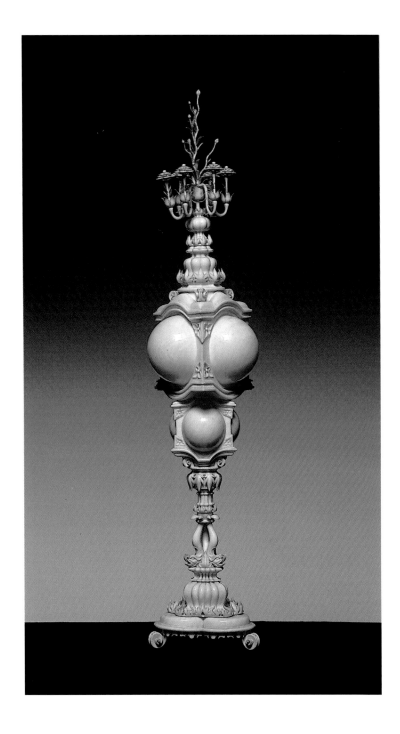

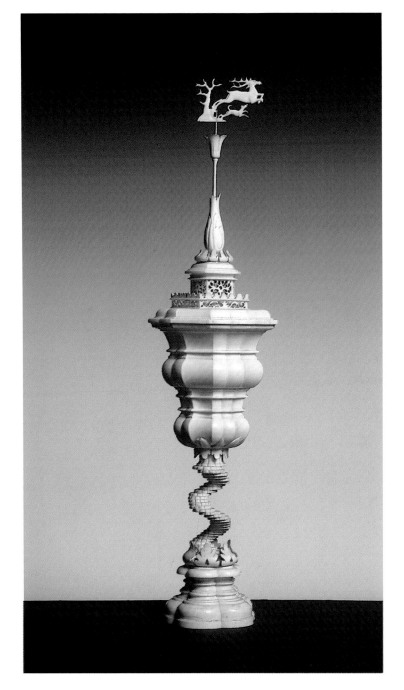

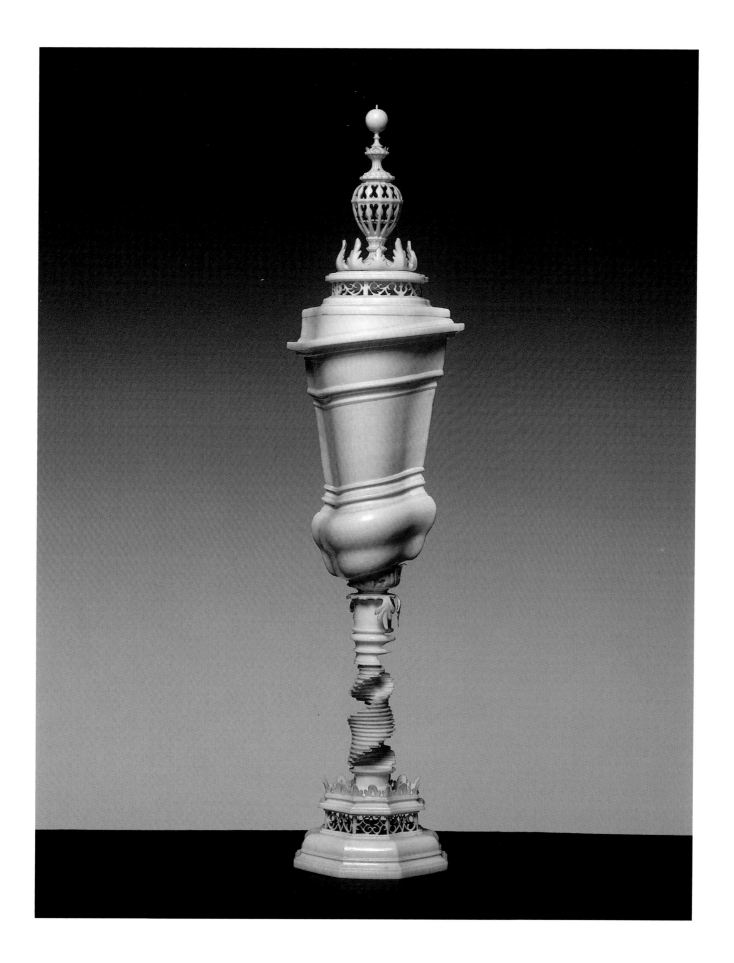

Balthasar Stockamer, Justice and Peace,
made in Rome for Cardinal Leopoldo de' Medici, 1665.
Florence, Museo degli Argenti.

Particularly handsome is the pair of female figures representing an allegory of Justice and Peace (Inv. Bg. Avori no. 143)[31]. We do not know which statues the artist used as a model here,[32] but he clearly executed the pieces with the care and precision which his patron so particularly appreciated.

Bronzes inspired by classical statues, or often exact copies of them, began in fact to be produced during the latter part of Ferdinando's rule and enjoyed a real upsurge in popularity at the time of Cosimo III with artists such as Giovan Battista Foggini and Massimiliano Soldini. Interest in collecting this kind of small classical figure began during the fifteenth century, and in Florence they had been used mainly as the crowning or decorative elements of cabinets. Artists such as Wilhelm von Tetrode[33] and Giambologna[34] had worked on scale reductions of the rare classical statues kept in the Gallery in Florence or at the Villa Medici in Rome, which were some of the dynasty's most renowned and valued possessions. To what extent the diffusion of classical iconography was due to the successors of Tetrode, from Pietro and Ferdinando Tacca onwards, can be judged for oneself, bearing in mind that its expansion became more widespread just when the Medici collections began to be more frequently visited by foreigners who wanted to take home some reminder of their visit to Florence.

The same phenomenon was evident with items made of semi-precious stone, mainly *commesso* work or the less expensive *scagliola*, worthy surrogates of the superlative pieces made for European monarchs. The expansion of this class of artistic craftsman within the city is confirmed by the large cabinet, finished in 1677,[35] which Vittoria della Rovere had made partly by workshops outside those of the court. Although this large cabinet is to some extent influenced by the furniture of Leonard van der Vinne,[36] using rare woods as inlay, it is a perfect example of the restrained, not to say austere, style of a court convinced of the value of noble local traditions.

Notes and references

1 K. Aschengreen Piacenti, *Il Museo degli Argenti*, Milan 1967, no. 797, p. 174.

2 D. Alfter, *Die Geschichte des Augsburger Kabinettschranks,* Augsburg 1986; see in particular pp. 50–53, figs. 37–38. An entry giving the inventory description of the piece in 1635 is contained in E. Colle, A. Gonzáles Palacios, *I mobili di Palazzo Pitti: Il periodo dei Medici, 1537-1737,* Florence 1977, pp. 186-90, with bibliography.

3 According to the account books of income and expenditure, in 1566 (ASF Depositeria Generale 773, c. 43 no. 277) two hundred and thirty *libbre* of ebony were ordered from Cologne.

4 Attributed to either Johann König or Anton Moratz, see Alfter 1986, p. 51, no. 245.

5 The other three sides are decorated with images of the twelve apostles, the Crucifixion and the Deposition.

6 For information on the attribution of the decorations and their relationship with other contemporary fresco cycles, see the paper by Elsa Acanfora (in preparation).

7 K. Aschengreen Piacenti in 'Collectors and Princes', *Apollo,* September 1977, pp. 202–7, identified some of the items from an analysis of the manuscript in the Florentine State Archive, GM 750, c. 167.

8 K. Aschengreen Piacenti, *Il Museo degli Argenti,* Milan 1967, p. 160, no. 565; ASF GM 750, c. 172; the fountain was entrusted to the keeper of the Gallery, Giovanni Bianchi, so that it could be kept in the Uffizi.

9 Described as follows in the inventory (ASF GM 750, c. 177), 'Three ivory cherubs ⅓ in height with bow and quiver, each with a base of black ebony on small ivory feet', two of which are, without doubt, Bg. Avori no. 8 and no. 9, clearly smaller than the 'Cleopatra in ivory ⅓ in height, poisoning herself with the serpent in her hand, on a base of turned wood' (clearly the item mentioned in the text, photo GFS neg. no. 101237). A third cherub, now without the bow and the base, may have been the item described in Inv. Bg. Avori no. 21 which, like the others, I consider to be a German piece dating from the first quarter of the seventeenth century.

10 Given the historical period, however, the two cherubs which still have their bases and the Cleopatra have a delicacy of style worthy of closer study. Although it is not clear which is the piece representing Saint Sebastian with a cherub holding the palm of martyrdom, it could, I believe, be Inv. Bg. Avori no. 138, attributed to Sebastian Leonhard Kern and dated mid-seventeenth century. However, I am unable to identify the engraved glass mentioned in the inventory.

11 K. Aschengreen Piacenti, 'Le opere di Baltasar Stockamer durante i suoi anni romani', in *Bollettino d'arte,* January–June 1963, pp. 99-109, fig. 5; it seems more probable that the author was referring to the mid-seventeenth century German piece, Inv. Bg. Avori no. 30, GFS neg. no. 101215, rather than to Stockamer's statuette.

12 ASF GM 423, c. 37, no. 235 (1625): A sleeping dog on top of an ebony base which contains a drawer; (A.s.e. no. 187) see also *Natura viva in casa Medici,* exh. cat. edited by M. Mosco, Florence 1985, p. 92.

13 ASF GM 750, c. 177b, mentions Filippo Tre[xler?], meaning Drechsler, or a turner, though I believe the reference is more probably to Johann Philip Treffler (1625–98) who, in fact, served Ferdinando II as a turner and watchmaker, continuing his career under Cosimo III; see W. Prinz, *Deutsche Kunstdrechsler am Florentiner Hof,* in 'Mitteilungen des Kunsthistorischen Institutes in Florenz', I–II, 1967, p. 173–84; the piece is also mentioned in K. Aschengreen Piacenti, *Il Museo degli Argenti,* Milan, 1967, p. 155, no. 482.

14 ASF GM 750 c. 179, 'An antique ivory horn, entirely decorated with bas-reliefs of hunting scenes, with a panther attached to the horn by a rope of white silk'. See also L.G. Boccia, entry number A146 in *La caccia e le arti,* exh. cat., Florence 1960, p. 35.

15 It is quite easy to distinguish between the two as Giovancarlo had a birthmark with hairs on the left of his throat, which is quite clearly visible on the marble bust. Moreover, the unusual style of the moustache was that normally worn by Cardinal Carlo: see C. Morandi, *Ritratti medicei del Seicento,* Florence 1995.

16 ASF GM 750, 'A model of an artillery gun in black stamped leather with its wooden cart. No 1 / Four double breast plates of iron which were probably used as armour. No 4 / A long, narrow gun barrel with a breech of heavy brass, a key, and other parts in brass being some sort of invention of unknown use about 2 1/3 *br.* long. No 1 / A gun barrel : 3/4 *br.* long without the casing. No 1 / A Turkish gun barrel with the sight made of silver. No. 1 / An antique carbine which is wheel-loaded from behind. No 1 / A very old harquebus without its wheel case, wheel and gun which are rear-loaded. No 1 / c. 180 v. On the day of 31 August 1670 / A harquebus with the stock inlaid with ivory, with a German barrel, lacking the mechanism. No 1 / A small harquebus, the stock decorated with mother-of-pearl, with barrel and wheel case. No 1 / Two blunderbusses in a wooden case with keys and other appurtenances. No 2 / A stick shaped like a harquebus with a false wheel case. No 1 / Three short barrelled pistols. No 3 / Two small pistols with old-fashioned mechanisms. No 2 / A short pistol with fixed wheel case of engraved steel. No 1 / Short pistol with normal wheel case. No 1 / Two small antique pistols without wheel case. No 2 / A cover for a large gun in red

velvet, decorated with gold thread, with brass buckles and brass tips and gilded brass handle decorated with a mask. No 1 / Seven Florentine guns made by Michelangelo. No 7 / A pair of pistol-type guns. No 2 / Another Florentine gun. No. 1 / Three Roman guns with decorated springs, one of which is smaller. No 3 / Three more ordinary Roman guns, one of which is black, the others partly engraved. No 3 / Two French guns, one ordinary, the other with the invention of a lid...[sic.] powder. No 2 / A German wheel case, broken. No 1 / Six pairs of iron moulds for making bullets. No 6 / Two ordinary scimitars, with normal iron fittings and wooden handles covered with leather, with green taffeta covers. No 2 / A scimitar with steel handle and hilt with a chain attached to the pommel and hilt with a black leather sheath. No 1 / A scimitar with a cap hilt and a silver gilt ferrule, with handle of white bone and Turkish leather sheath. No 1 / c.181 / A spring-released sabre with engraved silver gilt ferrule and guard, the handle decorated with gold. No 1 / A knife alla Turchesa with a handle of black bone and Turkish leather sheath, with silver hilt and ferrule. No 1 / Four painted lances one of which with a gilded head. No. 4 / Four white lances. No 4 / Four spears with wooden handles, one being of bamboo, with their cases of stamped leather. No 4 / A club made from granadilla or some dark iron-grey wood. No. 1 / Four bamboo spears each 4 1/2 br. long. No 4 / Two wooden lances painted black, each 4 br. long. No 2 / A wooden club, painted with Indian colours, 3 1/3 br. long. No 1 / A blowgun with ivory ferrule, 4 1/4 br. long with green taffeta cover, No 1 / A blowgun made of black wood 3 1/6 br. long. No 1 / A linstock with a pointed hammer and sword inside, which is used as a walking stick, 1 1/3 br. long. No 1 / A harquebus to be used as a stick with the mechanism and iron bullet, with a spike at the end 2 1/6 br. long. No 1 / A lance with a cloth banner with the arms of the Barberini, the original being in the Gallery or in the guardaroba. No 1 / A spiked cudgel of damascened steel, worked and decorated on the sides, with a sage-green cloth cover. No 1 / A baton of Turkish granadilla with small rings of white ivory. No. 1 [Museo Nazionale di Antropologia e Etnologia, Florence] / A stamped leather sheath, partly decorated with gold in the Turkish style. No 1 / c.181v. / Two steel flasks, one plain and the other decorated, with a steel chain. No 2 / A large steel bow for a crossbow 1 1/4 br. in height. No 1 / A walnut crossbow with steel bow and a gadget in the carrier of the arrow. No 1 / An iron anchor with two prongs, about 1 br. in height. No. 1 / Two crossbows with arrows, the casing of the bow completely inlaid, 2 1/2 br. No 2 / Another crossbow with bow and casing made of pear wood. No 1 / Three crossbows with lead bolts, pearwood casing and steel bows, one of which can be pulled backwards and forwards. No 3 / A crossbow of jujube wood, with a steel bow, with a decoration of a harpy and two small lions and the tip adorned with a

small mask. No 1 / A crossbow with steel bow, branded with a crown. No 1 / The following is all consigned to Anton Francesco Tofani, Keeper of the Armoury...[a further list of items follows] / c.182v. / These things were in the room of S.A.S.: / Twelve bows for firing Turkish arrows, two of which are Persian. No 12 / Five sheaths, two of sumac and three of wood, filled with arrows of various sizes, about 200 in all. No 5 / Five wooden sheaths, empty. No 5 / Two wooden sheaths, empty. No 2 / Twelve arrows with ivory tips. No 12 / Four hundred Venetian arrows in a box. No 400 /.../ From Clemente Rinieri, footman of the G.M. of the Serenissimo G.D. Ferdinando 2° / in...178 A crossbow of jujube wood, with steel bow and decorated with a carving of a harpy. No 1 / .../ c. 202 /.../ [April 1671] On the seventh day of the month / Di[ary]... / 102 A harquebus for hunting, with a long barrel the third quarter of which is faceted, with a casing of maplewood, iron fitments and wheel case. No 1 / A harquebus for hunting with the barrel tipped with silver and a maplewood casing, with no mechanism and the arms of the Medici on the butt, and at ° / 5 an arabesque of silver. No 1 / A harquebus for hunting with a barrel 2 1/3 long which at ° / 5 has four facets, with a Brescian mechanism and walnut casing with iron fitments. No 1 / A harquebus approximately 3 d[enari] 30 long, with a barrel made by Maestro Cristoforo Leoni, with local-made mechanism and half walnut casing with brass fittings. No 1 / A pair of pistols with faceted barrels and pearwood casings and iron fittings with a French wheel case. No 1 / A harquebus for hunting with a Brescian barrel about 2 1/3 long, with maplewood casing and no mechanism. No 1 / Di[ary] 173.201 To Anton Francesco Tofani, keeper of the Armoury'.

17 L.G. Boccia, 'Gli archibugi a ruota del Bargello', in L'uomo, le armi, le mura, in 'L'illustrazione italiana' I, no. 2, 1974, pp. 84–110 and idem, entry no. 264 in Palazzo Vecchio, committenza e collezionismo medicei, exh. cat., Florence 1980, pp. 139–40; the accompanying collection of knives also exists, in the Museo Nazionale del Bargello M 286/290, L.G. Boccia, Nove secoli di armi da caccia, Florence 1967, pp. 92–3.

18 ASF GM 750, c.171.

19 A.M. Massinelli, entry O.A. no. 09/00225473, Soprintendenza per i Beni Artistici e Storici, Florence, Pistoia and Prato.

20 K. Aschengreen Piacenti, in 'Note su due vasi del Museo degli Argenti', in Scritti in onore di Ugo Procacci, Florence 1978, pp. 567–70. The serpentine piece was identified as Central Asian by E.J. Grube, in L'eredità dell'Islam, exh. cat., Venice 1993, p. 359. It has been dated mid-fifteenth century except, of course, for the mount which is clearly seventeenth century.

21 K. Aschengreen Piacenti, 'Quattro secoli di oreficeria al Museo degli Argenti', in Ori e tesori d'Europa, proceedings of the conference held in the Castello di Udine, 3–5 December 1991, pp. 71–8.

22 See R. Kahsnitz, pp. 242–4; to summarise the history of the piece: Chateau de Pau during the sixteenth century, the property of Antoine de Bourbon and Jeanne d'Albret; later known to be in the possession of Henry IV of France; brought to Florence following the marriage of Cosimo III to Marguerite-Louise d'Orleans (1661).

23 Musée d'Art et d'Histoire de Genève. inv. no. AD 2261, see M. Gauthey, *Imaux peints de Genève, XVII-XVIII siècles,* Geneva 1975, p. 25, no. 1. In this case too the mount is decorated with diamonds. Similar, but by another craftsman, possibly the Swiss jeweller, Jean I Petitot, is the mount of the enamel portrait of Louis XIV, sent to Carlo Cesare Malvasia in 1678, after he had dedicated the *Felsina pittrice* to the sovereign, surrounded by 68 diamonds and now in the Arciconfraternità della Madonna della Salute, Bologna.

24 D. Heikamp, *Mexico and the Medici,* Florence 1972, fig. 43; the style of the base, decorated with white, black and red enamel, is late seventeenth century French. K. Aschengreen Piacenti, *Il Museo degli Argenti,* Milan 1967, p. 192, no. 1298.

25 K. Aschengreen Piacenti, 'Tours d'ivoire', in *FMR* (French edition), no. 23, V, December 1989, pp. 68–96.

26 The Armoury of the Uffizi was dispersed between 1773 and 1780; see B. Thomas in *Mostra delle armi storiche restaurate dall'aiuto austriaco dopo l'alluvione,* exh. cat., Florence 1971, pp. 13–29.

27 See note 11.

28 J. D. Draper, entry no. 42 in *Liechtenstein, the Princely Collection,* exh. cat., New York 1985, p. 72; the terracotta model is in the Biblioteca Nazionale, Florence.

29 J. Montague, *Alessandro Algardi,* New Haven 1985, p. 202 for the bronze in the Wadsworth Atheneum, Hartford; there is also a wax model in Doccia, see K. Lankheit, *Die Modellensammlung der Porzellanmanufaktur Doccia,* Munich 1982, fig. 126, 22:15.

30 K. Aschengreen Piacenti, 'Le opere di Balthasar Stockamer durante i suoi anni romani', in *Bollettino d'arte,* January–June 1963, pp. 99–110, and especially pp. 101–2, no. 23.

31 For this and other ivories see K. Aschengreen Piacenti, 'Intagliatori nordici di avorio e di legno alla corte granducale nel Seicento', in *Gazzetta antiquaria,* 1991, no. 11, pp. 46–53.

32 A useful general reference is provided by the relief of the same subject but of quite different composition made by Massimiliano Soldani Benzi, see O. Raggio, in *Liechtenstein, the Princely Collection,* exh. cat., New York, 1985, pp. 84-6, a terracotta previously in the Daniel Katz collection, in *A Catalogue Celebrating Twenty-five Years of Dealing in European Sculpture and Works of Art,* London 1992, p. 34.

33 A.M. Massinelli, 'I bronzi dello stipo di Cosimo I de' Medici', in *Antichità viva,* 1, 1987, pp. 36–45, and, by the same author, 'Magnificenze medicee: gli stipi della Tribuna', in *Antologia di Belle Arti,* II, 1990, pp. 111–34.

34 In fact this craftsman made many statuettes which, rather than exact reproductions of the existing piece, may well be, as I have frequently pointed out, examples for the proposed restoration of broken classical statuary.

35 E. Colle, *I mobili di Palazzo Pitti, il periodo dei Medici, 1537–1737,* Florence 1997, pp. 206–9, inv. O.d.A. no. 729.

36 Such as, for example, the table (Inv. I.M.A. no. 753) and the cabinet (Inv. O.d.A. no. 1521), both now in the Museo degli Argenti, Palazzo Pitti.

After a lengthy period of rule Ferdinando II was succeeded by his son Cosimo III who became grand duke in 1670 at the age of twenty-eight and governed Tuscany for over half a century until his death in 1723. Such longevity was not, unfortunately, to be enjoyed by Cosimo's eldest son, the *Gran Principe* Ferdinando, whose character and intelligence might have offered some ray of hope for the future of a state now facing steady decline; he died, however, before his father in 1713, the succession therefore passing to his brother Gian Gastone and leading to the demise of the Medici dynasty.

While it is quite true to say that the Tuscan grand duchy was in a state of decline both politically and administratively during its latter period, the same could not be said of the artistic output of the court which continued to be inventive and abundant for the

Golden Twilight: the Reign of Cosimo III

entire duration of Cosimo III's reign; consequently Florence, though no longer an international power, became one of the undisputed capitals of decorative arts in Europe.

Annamaria Giusti

Alvar Gonzáles Palacios has done much to improve our knowledge and appreciation of the arts under the Medici during this period and has frequently pointed out that 'the success of Florentine Baroque was quite incredible', representing one of the most splendid moments in the history of European decoration[1]. Certainly court and city life were not as brilliant as that of Louis VIX's Paris, so sorely missed by Marguerite d'Orléans that, after thirteen years of unhappy marriage to Cosimo III, she returned to France, abandoning Palazzo Pitti and her bed inlaid with semi-precious stones, as well as her increasingly devout husband, whose religious tendencies were encouraged by his beloved mother, the grand duchess Vittoria della Rovere. The *Galleria dei Lavori* however, represented a unique resource for the Florentine court and, despite its rather complex organisation it had run smoothly and efficiently producing masterpieces of decorative arts, since the time of Ferdinando I. Colbert himself not only used the Gallery as an example when he created the royal Gobelins workshops which opened in France in 1667, but also drew directly from the ranks of the grand duke's craftsmen to take to Paris the typically Florentine arts of mosaic and semi-precious stone carving which fascinated the Sun King as greatly as they had his mentor, Cardinal Mazzarino[2].

The international fame and prestige of the Gallery and its production were already well established at the time of Ferdinando I and Cosimo III seems to have intended to emulate his great-grandfather, investing both time and money to ensure their success, and almost surpassing Ferdinando with the extravagance of the generous gifts he

presented to the monarchs and potentates of Europe, especially during the latter part of his reign. Perhaps such magnificence, so abundantly bestowed, was merely a show of false grandeur, though it is perhaps more fascinating to see it as a reaction to the encroaching atmosphere of *Götterdämmerung* – a desire to leave a glittering trail across the firmament of fine arts which the Medici had so loved.

While Cosimo III was determined that the work of his gallery should be internationally recognised, he was also concerned that it should be receptive to craftsmen of different talents and origins, skilled in working rare materials and using sophisticated techniques, so that Florence might avoid the risk of provincial stagnation. Ferdinando II had also been aware of the possibility, and foreign artists, many of whom would remain in Florence for long periods producing their most brilliant work under Cosimo, had already begun work during the latter years of his reign. He was still the hereditary prince in 1668, however, when his portrait, now in the Museo dell'Opificio delle Pietre Dure, was engraved on rock crystal by Gerard Walder and set in a frame carved by the Dutch artist Vittorio Crosten. This twining, leafy garland is one of the earliest pieces produced by Crosten during his lengthy period of activity in Florence[3]. In the following year the same two artists collaborated once more on a portrait of the reigning grand duke, Ferdinando II. On this occasion Crosten succeeded in modelling the hard boxwood into delicate forms worthy of an ivory turner (his other speciality), weaving the roses and motto of the grand duke's emblem into a magnificently-executed flourish. Prudently, it was decided to protect such a delicate item in an ebony case,[4] a restrained piece by a carver capable of much greater sophistication, Leonard van der Vinne, whose wood inlay decorations are considered masterpieces of European Baroque furniture.

Of Flemish origin, Van der Vinne was already working in Florence in 1659 and died there in 1713, the same year as the *Gran Principe* Ferdinando for whom he made countless pieces, including a frame for a portrait of himself as a child in the late 1660s entirely decorated with flowers inlaid with wood, ivory and tortoiseshell[5]. A gradual reconstruction of the production of 'Tarsia', as Van der Vinne was often known,[6] has enabled us to attribute some extremely elaborate furnishings to him, not only those still housed in Florentine museums but also in other locations, such as the chest of drawers now in the Kunstgewerbe Museum in Berlin[7]. This latter piece combines the attractive use of semi-precious stones in the external decoration (a distinctive feature of the production of the *Galleria dei Lavori*), with Van der Vinne's floral inlay which unexpectedly enhances the interior.

It has been suggested that before his arrival in Florence, the Flemish artist must have developed his 'flamboyant' style during a period spent in Paris where, teeming with Baroque inventiveness during the second quarter of the century, this style of inlay became fashionable, its popularity extending also to England and Germany. Clearly, however, in Florence the precedent of Ligozzi's naturalism, which had for so long provided a creative model, offered Van der Vinne the perfect artistic setting in

Gerard Walder and Vittorio Crosten,
Portrait of Cosimo de' Medici, 1660.
Florence, Opificio delle Pietre Dure.

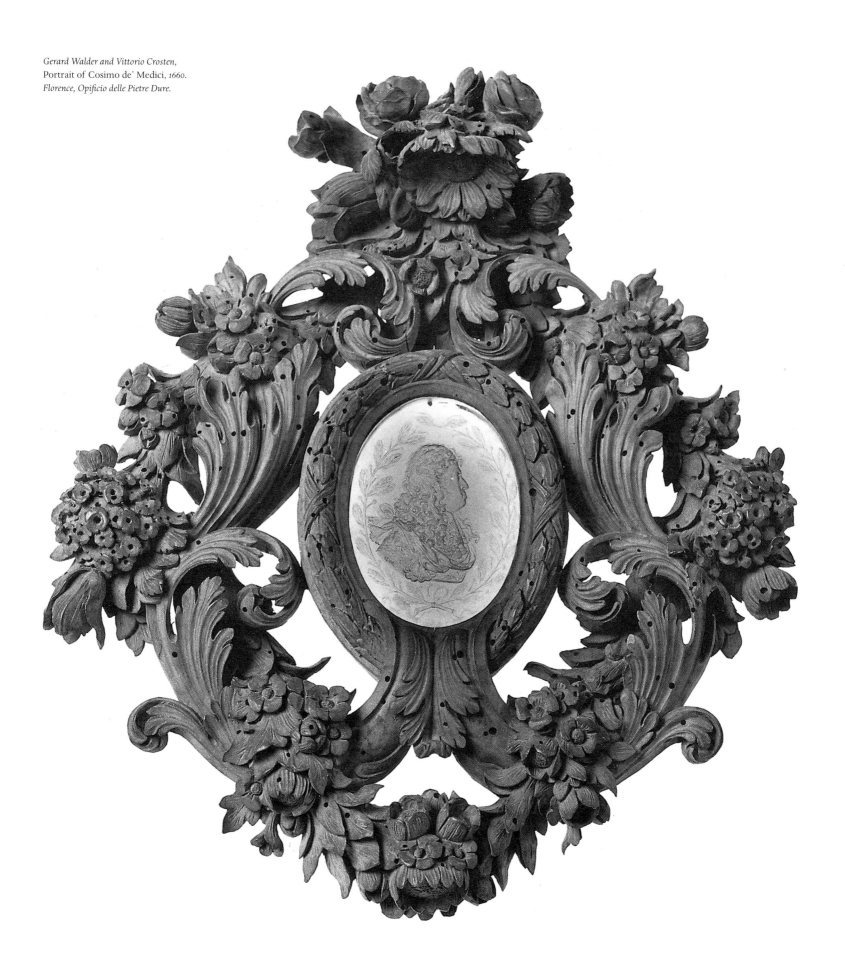

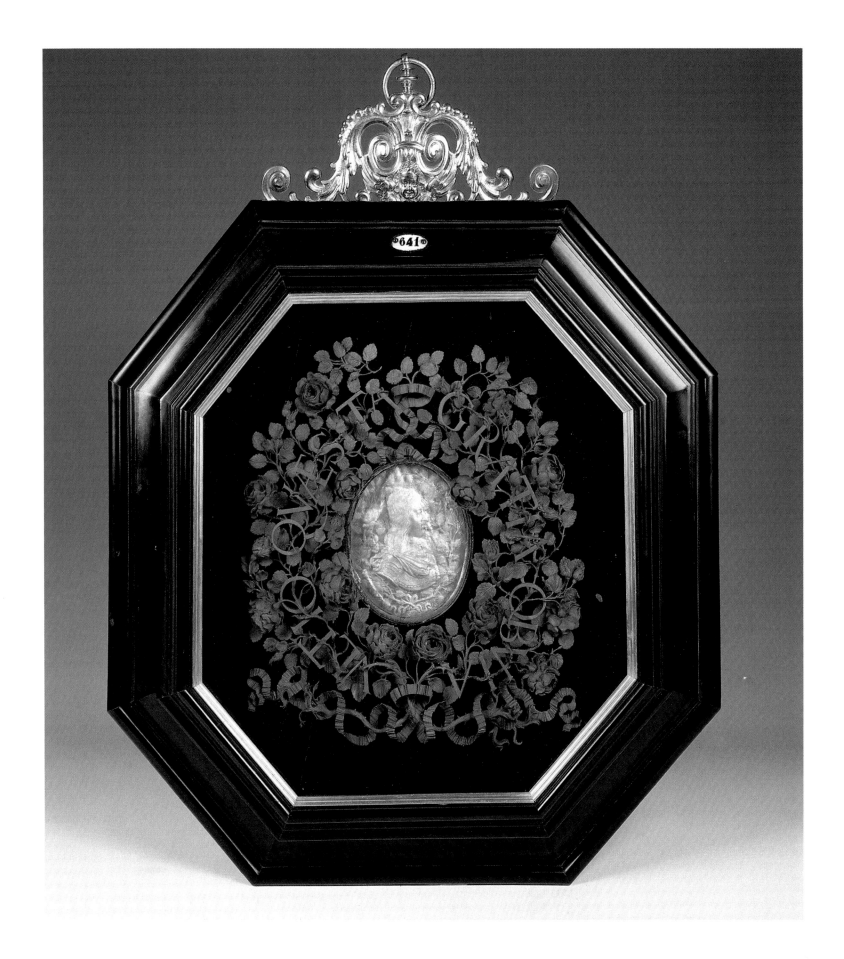

which to give full expression to his luxuriant floral inlays. His work succeeds in combining a range of rare woods, tastefully blending the delicate yet luminous shades of their varying tones not only with other rare materials such as ivory and tortoiseshell, but also with the rather more modest mother-of-pearl or bone tinted with green, all equally enhanced by the artist's prodigious creative flair and extrordinary technical skill. In 1677 van der Vinne was appointed *primo ebanista* (first cabinet-maker) of the Medici Gallery where, during the same period, other inlayers were also employed. Many clearly remained subordinate to the superior artistic ability of Van der Vinne, such as the anonymous author of the inlays framing mythological scenes made in Florentine mosiac which decorate a cabinet now in Palazzo Vecchio[8]. Of a standard almost equal to that of the resident master of Baroque inlay was the French craftsman Riccardo Bruni, who in 1686 was working on the decoration of Prince Ferdinando's private chamber in Palazzo Pitti, of which all that remains is a door inlaid with the wood of the exotic jacaranda tree[9].

The cosmopolitan artistic circles which developed around the Florentine court during the latter part of the seventeenth century even experimented successfully with the art of ivory carving; the skill had for some time been a specialisation of German craftsmen in particular and (true to family tradition) was admired by both Cosimo and his son Ferdinando, who himself tried his hand at ivory turning under the guidance of the Bavarian artist Filippo Sengher. Sengher came to Florence in 1675 and gained such international repute that in 1712 Cosimo III who, when it came to broadcasting Florence's artistic prestige throughout Europe, was as generous with his craftsmen as he was with the items made in his gallery, sent him to the court of the Tsar where he died in 1723. Three pieces made by Sengher are housed in the Museo degli Argenti: two vases which are masterly reproductions of early seventeenth-century pieces, and a double medallion linked by a chain with a portrait of Cosimo III and his monogram, an impressive and skilful *tour de force* carved in bas-relief on a single piece of ivory.

One of the most important figures of European Baroque, the sculptor Balthasar Permoser (1651–1732), spent a brief but highly productive period at the Medici court. Several times between 1676 and 1690 he was commissioned to make pieces in ivory, including the fine portrait of Violante of Bavaria, a bas-relief oval engraved in 1688 for her marriage to Prince Ferdinando, and a set of knife handles made for the prince himself and probably almost immediately made into small sculptures set on plinths of ebony and ivory. The Dutch artist Crosten was as skilled in ivory as in wood inlay, and his greatest masterpiece must surely be the panels decorating the grandiose ebony cabinet completed in 1704 and now in Palazzo Pitti[10]. The vigorous decorative features of the piece, designed by Giovan Battista Foggini, are superbly complemented by the supple ivory forms, highlighted by the velvety darkness of the ebony background. Foggini had designed this apparently austere cabinet 'in the form of a temple', and it subtly represents an intentional juxtaposition of a stately, classical form and a restless

Florentine miniaturist and Leonard van der Vinne, Portrait of Prince Ferdinando, *c. 1670. Florence, Opificio delle Pietre Dure.*

Opposite page: Gerard Walder, Vittorio Crosten and Leonard van der Vinne, Portrait of Ferdinando II de' Medici, *1669. Florence, Opificio delle Pietre Dure.*

177

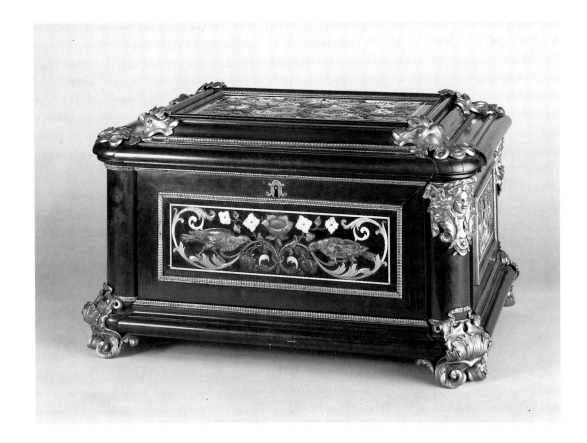

Opposite page: Leonard van der Vinne and the Grand ducal workshops, Cabinet of wood with ivory, mother-of-pearl coloured woods and bronze, *1667. Florence, Opificio delle Pietre Dure.*

Opposite page: detail.

Grand ducal workshops and Leonard van der Vinne, Ebony chest of drawers with semi-precious stones and bronze gilt, *inlayed in the interior, second half of the 17th century. Berlin, Kunstgewerbe Museum.*

energy which pervades the crisp precision of the ivory foliage and the wooden elements, curvaceously sculpted with volutes and garlands by Adamo Suster[11].

Another rare material which nature so generously provided for the fanciful Baroque wonders produced in the grand ducal Gallery was tortoiseshell. A restrained element amidst the feast of rare woods used in decorations by Van der Vinne and his followers, it was also occasionally used as the principal element, for example in the pair of tables 'with ivory arabesques' which belonged to Vittoria della Rovere,[12] or the two cabinets in Palazzo Vecchio, with tortoiseshell veneer edged with ebony and finished with bronze gilt, also inherited from the grand duchess[13]. Recorded in the apartments of Prince Ferdinando in 1698 was, moreover, a table with an opalescent alabaster top originally combined with the amber gleam of tortoiseshell used for the pyramid-shaped legs[14]. Fully expressive of Foggini's inventiveness, the supports were decorated with three tritons bearing shells studded with pearls arranged in an imaginative variation of the Medici arms.

The vogue for such sophisticated combinations of materials is also evident in the pair of vases dated 1689, carved from Flanders touchstone. They are decorated with silver and bronze gilt ornamental sculptures which seem almost to evolve out of the stone itself and are attributed to Massimiliano Soldani Benzi who specialised in metals

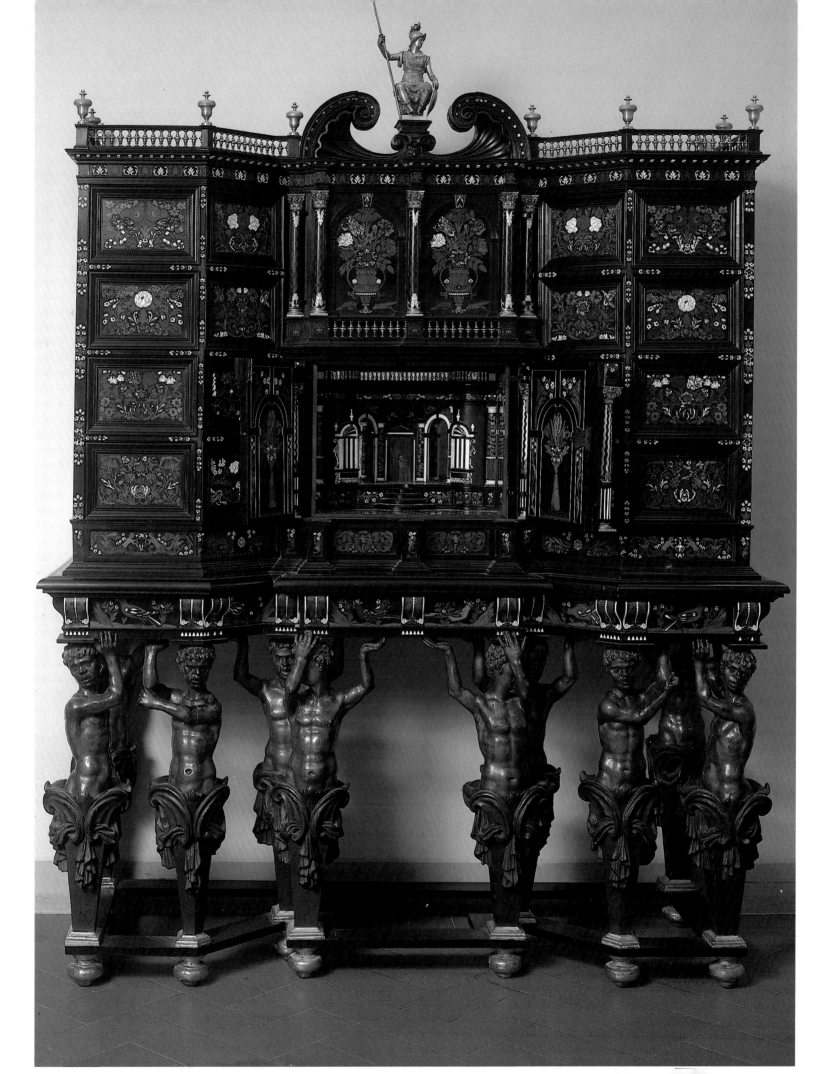

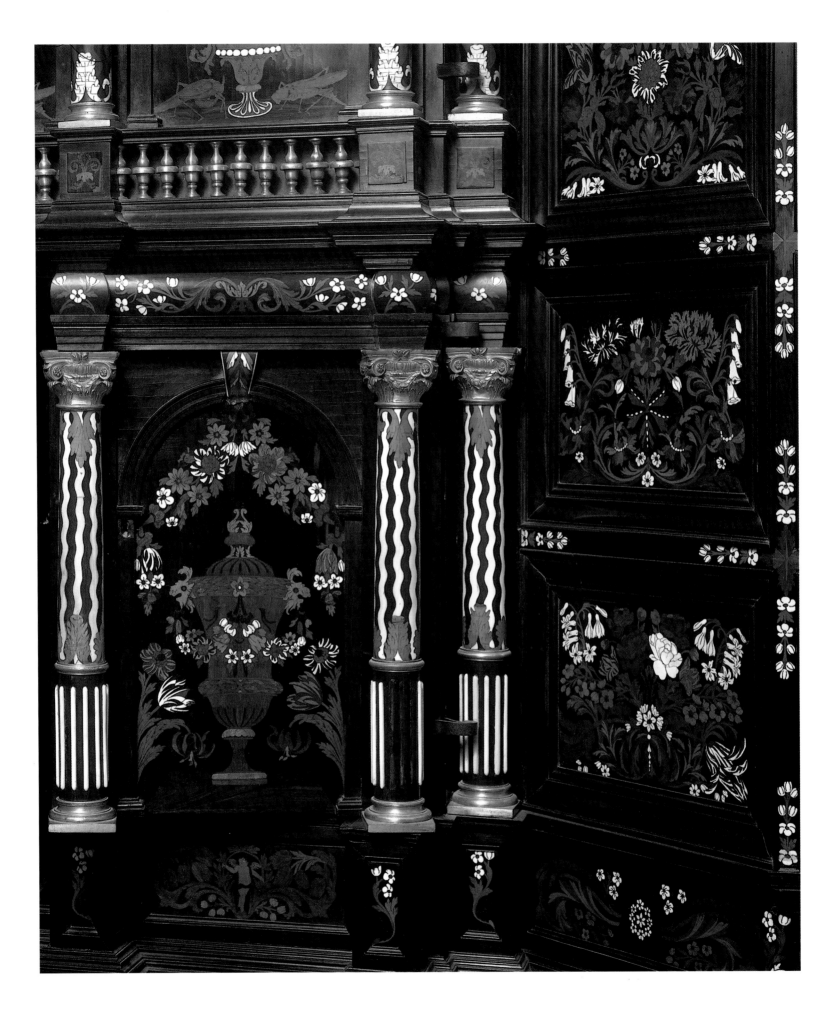

Filippo Sengher, Double medallion in ivory, *1675–80. Florence, Museo degli Argenti.*

Opposite page: Vittorio Crosten and Adamo Suster (designed by Giovan Battista Foggini), Cabinet of ebony, ivory, alabaster and bronze gilt, 1704. Florence, Pitti Palace, Queen's Drawing Room.

and, like Foggini, was one of the foremost sculptors of Florentine Baroque. Originally part of a set of four,[15] these vases also belonged to Ferdinando. By comparison with to his father, who specialised in the family passion for semi-precious stone, the prince had a lively and intelligent understanding of many aspects of artistic production and creativity. Indeed, a work of art not originally intended for, but acquired by, him provides an intriguing image of his cultural education: the surreal painting by the Flemish artist, Domenico Remps, now in the Museo dell'Opificio, represents a lively and capricious *trompe-l'œil* of a *cabinet d'amateur* in which the miscellany of paintings, engravings, medals, sculptures, ivories and natural curiosities displayed to the amazed viewer is somehow pervaded by a subtle aura of *vanitas* not at all displeasing, one imagines, to a prince so in harmony with the spirit of his age[16].

Yet so many of the magnificent Medici furnishings were destined to be lost, first and foremost the gold and silver items, almost all of which were melted down during the period of Lorraine rule or were plundered by Napoleon's French troops. Such was the fate of the silverware, the ornaments and the most fanciful curios (including two bird cages owned by the prince, one of silver wire, the other silver plate), as well as solid silver furnishings which Cosimo and his sons had had copied from examples seen in the great European courts. Some pieces of silverware commissioned by the devout grand duke for relgious purposes were saved from the destruction which befell the secular items. These are now the only remaining examples of the gold and silver work so superbly produced by the Medici Gallery from the time of the first grand dukes. An excellent direct comparison can be made between one of these earlier pieces, the silver panel donated to the chapel of Santissima Annunziata by Ferdinando I in 1600, and the altar frontal made for the same church between 1680 and 1682 by Arrigo Brunich, a silversmith from Lübeck. The latter was designed by Giovan Battista Foggini, still strongly influenced by his recent Roman sojurn, as is evident from the style of the bas-reliefs and decorations, described in the relevant documents as 'arabesques in the new Roman manner'[17].

Foggini subsequently collaborated with the most talented court jewellers, Bernardo Holzmann and Cosimo Merlini,[18] in making the furnishings for the chapel of the Virgin Mary commissioned by Cosimo III for the church of Santa Maria in Impruneta. The elaborate decoration in silver with inserts of semi-precious stone, designed by Foggini for the altar to the Virgin, was installed in two separate stages. In 1698, after six years' work, the altar shelf and the ciborium made by Holzmann were completed and in 1714 the chased silver altar frontal, made by both Holzmann and Cosimo Merlini, was installed. This was to be the last piece of Florentine religious silverware produced before the decline of the Medici and the consequent artistic crisis,[19] though there was certainly no sign of this in the irrepressible vitality of Foggini's figurative and decorative design and the superb craftsmanship of the two artists. Although the reason for the votive offering to the Virgin was, in fact, the poor health of the heir to the throne it expresses no sense of foreboding but on the contrary

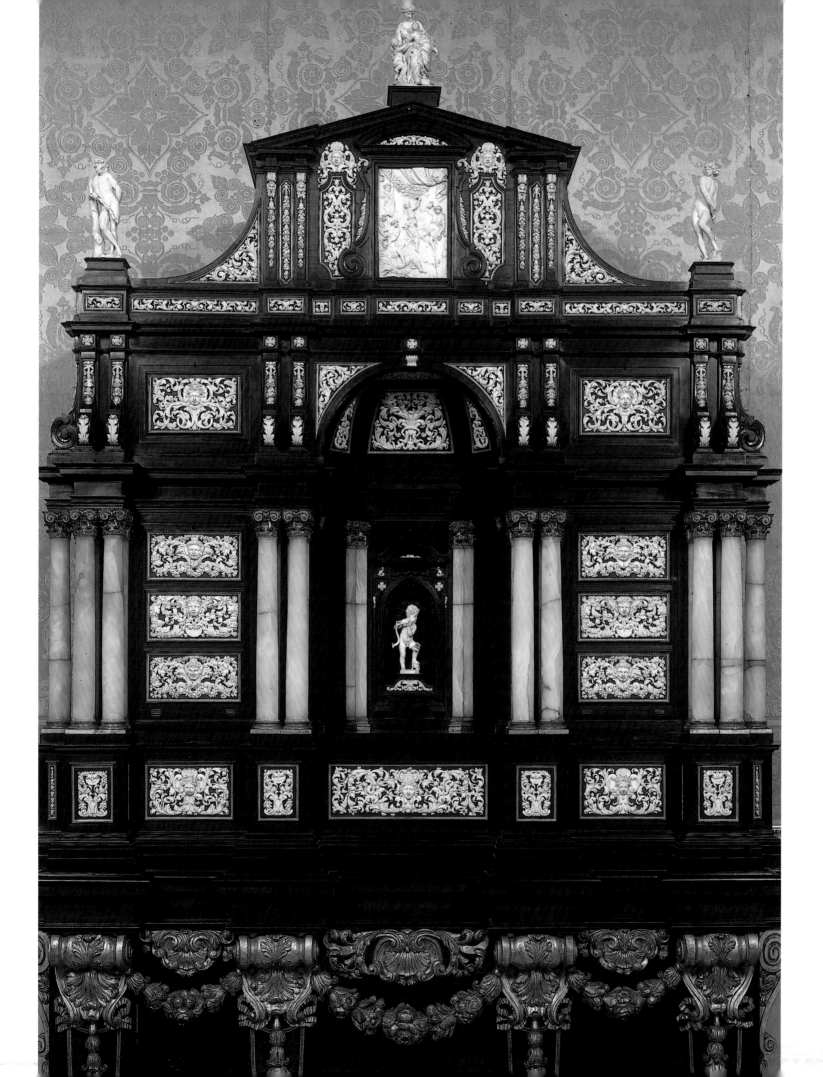

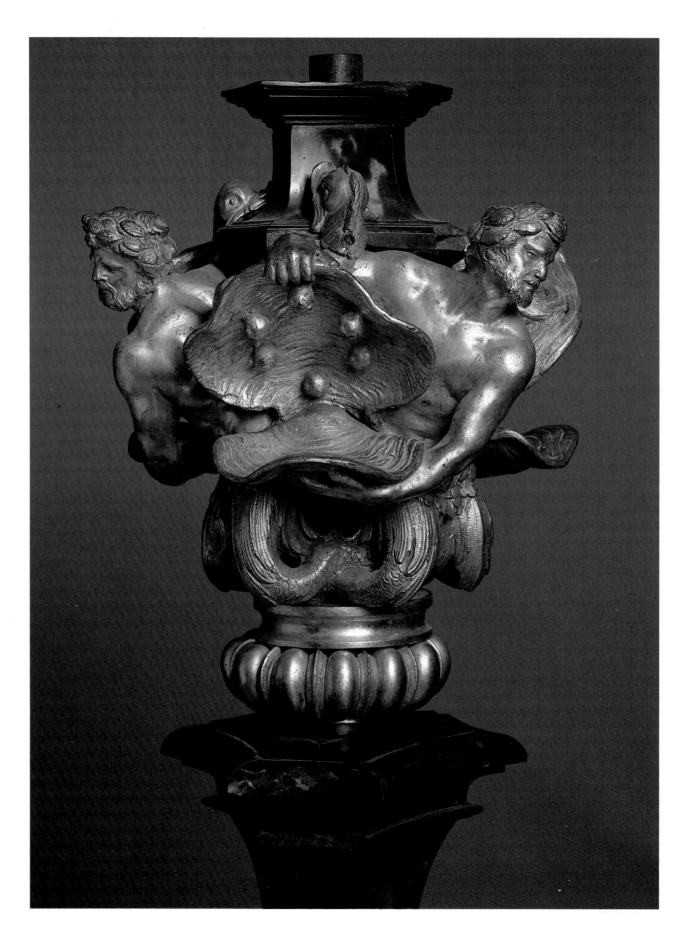

Giovan Battista Foggini and Grand ducal workshops, Tritons, originally the base of a table, bronze and tortoiseshell, late 17th century. Florence, Pitti Palace, Loggetta dell'Allori.

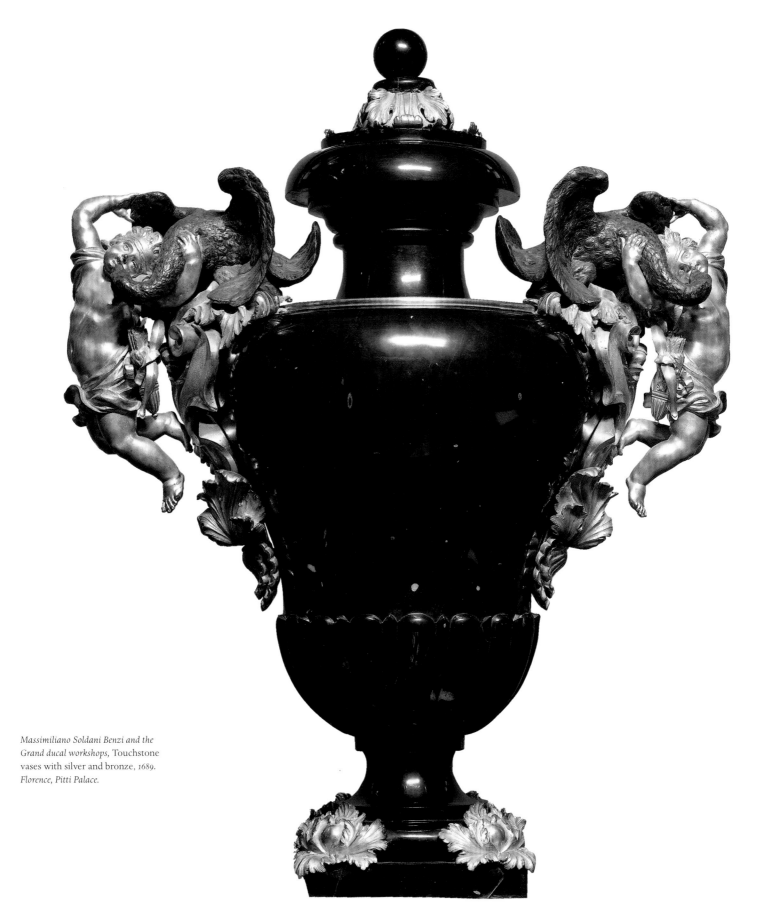

Massimiliano Soldani Benzi and the Grand ducal workshops, Touchstone vases with silver and bronze, *1689. Florence, Pitti Palace.*

is a proud statement of continuity. Indeed, portrayed in the centre is Cosimo III, kneeling in the same pose as his forefather, Cosimo II, in the semi-precious stone panel made a century earlier in Florence for the altar to Saint Charles Borromeo, on which another Cosimo Merlini had worked – the first of three generations of jewellers active in the Medici Galler[20].

Cosimo did not, however, leave munificent signs of his devotion only in the churches of his own city. In 1696 the church of Bom Jesus in Goa, in the distant East Indies, received from the grand duke of Florence a magnificent catafalque of rare marbles decorated with bronzes to provide a splendid base for the silver urn containing the remains of Saint Francesco Saverio. This grandiose monument, which the Gallery took five years to complete, was sent by Cosimo to the Jesuits of Goa in gratitude for the gift of a pillow which had belonged to the saint. Enclosed in forty-five cases, it reached its destination after almost a year's voyage, in 1697, accompanied by an 'engineer' and a craftsman from the grand ducal workshops who assembled it in two weeks, to the admiration and wonder of the Portuguese colony[21]. It was not, however, the first time that the Medici and their remarkable craftsmen had turned their attention towards the East. At the beginning of the seventeenth century, Ferdinando I had equipped a ship to seek supplies of the precious transparent chalcedony as well as other rare stones from the East, while only a few years later undeniable proof of the extent of the diffusion of Florentine mosaics to areas distant both geographically and culturally distant was to be found in the panels of semi-precious stone *commesso* decorating the Throne Hall of the Red Fort in Delhi; conspicuous amidst the predominant naturalistic subjects of flowers and birds is an image of Orpheus the musician, intent on entrancing the Moghul court with the unfamiliar melodies of the West[22].

In addition to impressive public works, Cosimo also commissioned religious items for his own private devotions which were certainly no less sumptuous, such as the splendid series of reliquaries intended for the chapels of Palazzo Pitti, now almost all in the Treasury of San Lorenzo[23]. These reliquaries, of various shapes and made of different, though always precious, materials were almost all made in the period between 1690 and 1715, coinciding not only with the grand duke's increasing religious fervour, but also with the final phase of the *Galleria dei Lavori*. The sculptor Massimiliano Soldani Benzi (1656–1740), one of the most talented Florentine artists of the day, worked on these reliquaries. Skilled in the technique of metal sculpture, Soldani had learned his art at the Florentine Academy established in Rome in 1673 by the grand duke. Such were the European connections of Cosimo III's court that in 1682 the young Soldani was despatched to Paris to learn the skill of medallion making and must have impressed even Louis XIV, who agreed to pose for this young Florentine protégé. On returning to Florence, Soldani revived the prestige of the Medici mint, which he directed between 1688 and 1728, producing a series of more than fifty coins celebrating the glories of the ruling family[24]. He also worked on many

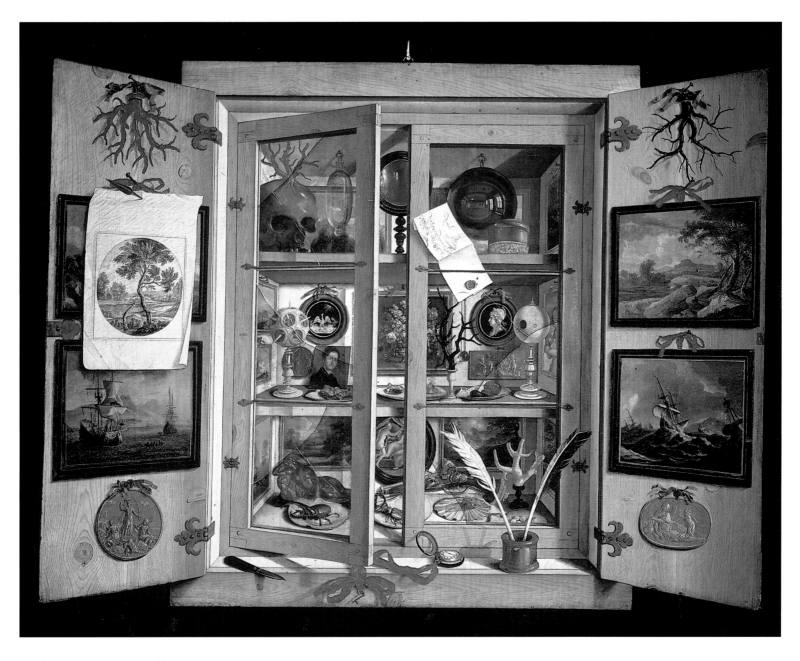

Domenico Remps, Trompe l'œil still life, *oil on canvas,*
17th century. Florence, Opificio delle Pietre Dure.

quite excellent bronze miniatures of classical statues as well as some magnificent silverware including, of course, the series of reliquaries. Despite the fact that both the grand duke and in particular Foggini, director of the Gallery from 1694 on, favoured exuberant decorative compositions and sumptuous combinations of different materials, Soldani generally succeeded in respecting the purely sculptural nature of his art and exploiting the quality of the metals with which he worked. A perfect example of his artistry can be seen in the reliquary of Saint Casimir of Lithuania,[25] one of his masterpieces – majestic, yet lightened by the silky gleam of the silver softly illuminated by inserts of gold. The leafy volutes of the supports and the vigorous stance of the lilies demonstrate that Soldani was not only one of the greatest sculptors, but also had fine qualities as a designer.

Throughout Cosimo III's reign, however, semi-precious stones still predominated amidst the innumerable precious materials handled by the skilled and tireless craftsmen of the grand ducal workshops. Cut and composed into mosaics whose luxuriant composition was matched by an astonishing precision of workmanship, or sculpted into modulated, sensual figures and reliefs in pure Baroque style, they were perhaps favoured even more than in the past.

Two centuries after the art of semi-precious stone working had been introduced to Florence, the workshops of the declining Medici grand duchy enjoyed a final, lively period of activity under the guidance of Giovan Battista Foggini (1652–1725), who directed the entire production of the court workshops from 1694 until his death, distinguishing it with his own brilliant and sophisticated decorative style. A versatile *genius loci*, Foggini frequently intervened personally in the Gallery's sculptures and metal ornamentation, and above all produced a wide variety of artistic designs, documented in his sketchbooks in the period between 1713–18. These designs range from drawings for mosaics, which were then 'mandati a colorire' ('sent to be coloured') by various painters working for the Gallery, to wax models for sculptural elements, or to designs for complete items of furnishing or decoration, including the choice of materials, combined and composed in various ways, but always subtly and expertly used to create a sensual and tactile effect.

With unique flair Foggini's creative imagination combined the decorative style of Roman Baroque, which he had experienced firsthand during his period in Rome as a young man, with a reinterpretation of the inventive *bizarrerie* of late Florentine Mannerism. These two elements inspired, for example, the frothy circlet of dolphins on a magnificent table top dated 1716,[26] and the mocking grins of the bronze masks peering whimsically from the garlands decorating the semi-precious stone caskets which the workshops were producing in great quantities at this time[27]. Typical of Florentine arts, and also of convenient size, the little boxes were, in fact, the perfect gift for high-ranking international personages, some of whom received another refined 'souvenir' of Florence from the generous grand duke – a relief or mosaic reproduction of the revered fresco of the Annunciation in the church of the

Opposite page: Bernardo Holzmann and Cosimo Merlini (designed by Giovan Battista Foggini), Altar frontal in silver and semi-precious stone, 1714. Impruneta (FI), Church of Santa Maria.

Opposite page: Massimiliano Soldani Benzi, Saint Casimir Reliquary, silver and silver gilt, 1680-90. Florence, Treasury of the Church of San Lorenzo.

Santissima Annunziata. The subject of the Annunciation had appeared in the repertory of Florentine mosaics at the time of Ferdinando I and became a leitmotiv of Cosimo III's devotion to the cult of the Virgin Mary, perfectly combining the 'sacred' and the 'regal' whether it decorated the elaborate holy water stops in the apartments of the palace[28] or adorned wall panels such as that presented to Pope Innocent XII for the jubilee of 1700,[29] magnificently framed in bronze.

In this latter phase of production, figurative art was restricted to religious or commemorative pieces, the latter generally reproduced in glyptic form. The art of semi-precious stone was still dominated by flowers, fruit and birds, dazzling colours shining from the background of black touchstone, transforming Ligozzi's naturalistic style into vivacious graphic forms which seem almost to verge on the Rococo. A new and successful development in the use of naturalistic subjects was now to be seen in the proliferation of bronze garlands laden with semi-precious stone fruits. Obsessive in their perfectionism, the workshops even established the specialisation of *fruttista,* who were experts in creating the various forms required, ranging from tiny draped garlands on reliquaries, caskets and clocks to the allusive sensuality of the ornate frame made for the wedding of Gian Gastone de' Medici in 1697,[30] or the striking prie-dieu of the Electress Palatine. Designed by Foggini and sent in 1706 as a gift to Cosimo III's daughter on her marriage to the Elector Palatine in Dusseldorf, one of the most attractive features of this magnificent piece[31] are the three angels' heads quite outstandingly sculpted in full relief. This unusual example of glyptics was carved in *carnicino* chalcedony from Volterra by Giuseppe Antonio Torricelli (1662–1719) an expert unequalled in the art of sculpting semi-precious stone.

This genre had been neglected by the workshops after the first admirable mosaic sculptures made at the time of Ferdinando I, but returned to favour with the pliant Baroque style preferred by the Medici court and Foggini. In Torricelli Foggini found an artist capable of supple moulding of the tough materials and transforming sculptural designs into figures as delicate and soft as wax. Although Torricelli considered the almost full-sized bust of Vittoria della Rovere to be his greatest work,[32] the delicate forms he achieved with the hard chalcedony in the graceful reliquary of the cradle of the Baby Jesus,[33] or the nebulous shadings in the theatrical Saint Emeric reliquary[34] have a subtly sensual fascination.

An expert in sculpting semi-precious stone, Torricelli also excelled in mosaic inlay, such as the Adoration of the Magi on the tabernacle in the Palatine chapel,[35] and in carving cameos, a skill which other *maestri di rilievo* active in the Gallery also practised successfully. Francesco Ghinghi, for example, later became director of the semi-precious stone workshop created in Naples by Charles of Bourbon, while at the end of the seventeenth century the Landgrave Carl of Hesse-Kassel requested the services of Francesco Mugnai, who stayed to work for him until his death in 1710[36]. Without doubt Torricelli, who preferred to work on unusually large pieces, was responsible for the chalcedony cameo now in the Museo dell'Opificio, though in 1748 it was still recorded

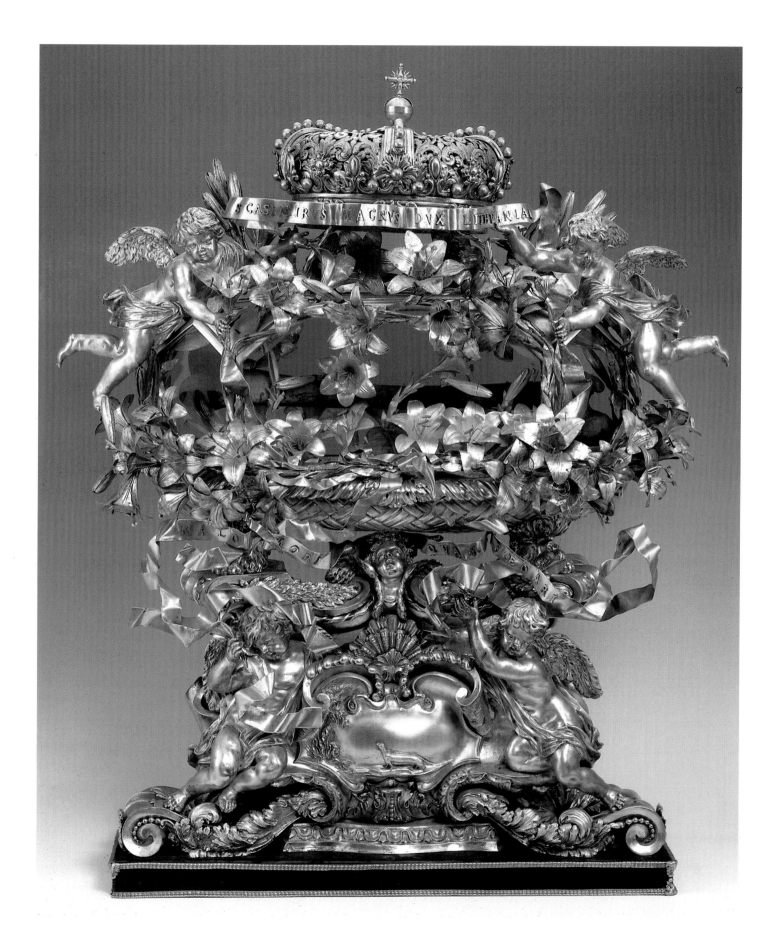

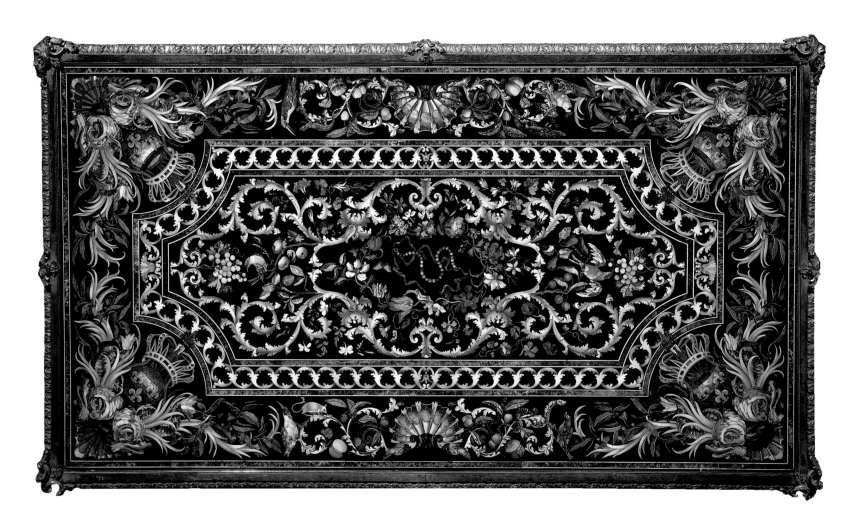

Grand ducal workshops (designed by Giovan Battista Foggini),
Table with arabesques and animals, *1716. Florence, Palatine
Gallery.*

in the workshop of his son, also employed by the Gallery which had now passed to the Lorraine[37]. His too is the cameo representing Cosimo III and Tuscany in front of the Temple of Peace, inspired by a medal made by Soldani and dated 1684.

The celebratory cabinet of the Elector Palatine[38] marks a dynastic occasion. Sent to Düsseldorf in 1709 as a gift from the grand duke to his son-in-law, Johan Wilhelm, the widowed Anna Maria Luisa brought it back to Florence in 1717 together with other magnificent gifts she had received from her father. Together with the contemporary prié-dieu belonging to the Electress, the cabinet represents one of the most spectacular examples of Foggini's creativity; the theatrical structure and the profusion of decoration in bronze and semi-precious stone produce an effect of Baroque splendour, in keeping with the intrinsic theme of the glorification of the prince.

The imposing sculpture in the central niche, portraying him in vigorous and expressive pose, was the result of close collaboration between Foggini, responsible for the elements in bronze, and Torricelli who carved the parts in chalcedony and Egyptian *cailloux* with his usual mastery.

Perhaps encouraged by its success and by the desire for apotheosis to the Olympus of monarchs, Cosimo III seems to have planned another cabinet for himself. Among the unfinished works left in the Opificio the single elements of a similar chalcedony statue of the grand duke would indeed seem to suggest the project. The time for such ostentation had passed, however: with no heir, the aged grand duke, who in his youth had chosen the motto 'Certa fulgent sidera' (A sure, bright star), could now only watch the splendour of the Medici fade irrevocably.

Giuseppe Antonio Torricelli, Chalcedony cameo representing Cosimo and Tuscany, *17th century. Florence, Opificio delle Pietre Dure.*

193

Notes and references

1 An important, concise summary of A. Gonzáles Palacios' studies and comments on this matter may be found in 'Trionfi barocchi a Firenze', in *I mobili di Palazzo Pitti. Il periodo dei Medici 1537–1737*, edited by E. Colle, Florence 1997, pp. 15–44.

2 In 1668, not long after the Gobelins workshops had opened, Colbert obtained permission from Ferdinando II de' Medici for Ferdinando Migliorini to move to France. The artist had worked in the *Galleria dei Lavori* and was head of a small group of semi-precious stone workers, all of whom remained in Gobelins until the last member of the group died during the first decade of the eighteenth century. See A. Giusti, *Il laboratorio dei Gobelins e la tradizione degli arredi di pietre dure in Francia, in Pietre Dure. L'arte europea del mosaico negli arredi e nelle decorazioni*, London-Turin 1992, pp. 195–221 and bibliography.

3 Crosten, an expert in carving both ivory and wood, was active and is documented at the Florentine court from 1663 to 1704. A. Gonzáles Palacios and E. Colle have successfully traced his production. See the entry dedicated to Crosten by Colle and its relative bibliography in *I mobili di Palazzo Pitti* op. cit., 1997, pp. 279–80, where all the surviving Medici furnishings for which Crosten was wholly or partly responsible are published.

4 The case is also in the Museo dell'Opificio delle Pietre Dure; the documents relative to both this and Cosimo's portrait were published by E. Colle in *Arredi dalle dimore medicee*, Florence 1993, pp. 11, 26. It is interesting to learn from a document traced by Colle (*I mobili* op. cit. 1997, p. 280) that despite such precautions the fragile 'boxwood ornament engraved with letters...was completely broken' (the result of a fall, perhaps?), as early as 1670 and was returned to Crosten himself to be repaired.

5 Given the age at which Ferdinando, who was born in 1663, is portrayed, the little portrait may be dated around 1668–9. The piece is now in the Museo dell'Opificio. See A. Giusti, *Il Museo dell'Opificio delle Pietre Dure a Firenze*, Milan 1978, cat. 579, and E. Colle in *La cornice italiana dal Rinascimento al Neoclassico*, Milan 1992, p. 347, no. 142.

6 A. Gonzáles Palacios in particular has described van der Vinne's character and art in his study, 'Limiti e contesto di Leonardo van der Vinne' in *Paragone* 1977, 3, pp. 37-68.

7 See A. Gonzáles Palacios, *Cassette e orologi*, in *Il Tempio del Gusto*, Milan 1986, I pp. 41–7.

8 Published by A. Giusti in *La Cappella dei Principi e le pietre dure a Firenze*, Milan 1979, pp. 292–3; for a more recent bibliography see E. Colle, *I mobili* op. cit. 1997, pp. 211–12.

9 See E. Colle *I mobili* cit., 1997, p. 235 and bibliography.

10 The cabinet, now in the *Salotto della Regina* (Queen's Drawing Room), was first published by K. Lankheit, *Florentinische Barockplastik: Die Kunst am Hofe der letzten Medici 1670-1743*, Munich 1962, p. 65; it has subsequently been more closely studied and the stages of its construction by various craftsmen have been documented. For a summary and the complete bibliography see E. Colle, *I mobili* op. cit. 1997, pp. 220–22.

11 The cabinet-maker, Adamo Suster, is known to have worked at the Medici court from 1680 to 1718. The documents concerning him, first notified by A. Gonzáles Palacios, *Il Tempio* cit., 1986, pp. 29-30, no. 13 and later by E. Colle, *I mobili* op. cit. 1997, p. 303, show he only worked on ebony, unlike his probable *maestro*, Cosimo Maures, in whose workshop he first appears as an assistant in February 1680. In a period of over fifty years from 1646 to 1698, Maures worked with both ivory and ebony, as had his father, Marchionne 'the German', documented as active in Florence in 1601. For documents relevant to their lengthy employment in the Gallery, see E. Colle, *ibid.*, pp. 292–3.

12 Now in the Villa of Poggio Imperiale, they are mentioned for the first time in the inventory of the grand duchess Vittoria's personal possessions drawn up in 1692; see E. Colle, *Arredi* op. cit. 1993, p. 19, and the same author in *I mobili* op. cit. 1997, p. 161.

13 See E. Colle, *I mobili* op. cit. 1997, pp. 218–9, and bibliography.

14 The table top, described in the 1698 inventory of the prince's apartment as 'made of Montauto alabaster', has been lost. Now housed in Palazzo Pitti and Palazzo Medici Riccardi, the four supports of tortoiseshell and bronze were made into candelabra with the addition of a wooden base in the late 19th century. See K. Aschengreen Piacenti, A. Gonzáles Palacios in *Gli Ultimi Medici*, exh. cat., Florence 1974 p. 374, no. 213, and E. Colle, *I mobili* op. cit. 1997, p. 160.

15 In *Gli Ultimi Medici* cit., 1974, p. 362, it was suggested that a payment made in 1689 to Soldani for the metal decorations on a touchstone vase refers, in fact, to these two pieces.

16 In 'I quadri della collezione del Principe Ferdinando di Toscana', in *Paragone*, 1975, 301, pp. 57-98, M. Chiarini established that the painting belonged to the collection of Prince Ferdinando, identifying it in the inventory of Ferdinando's personal possessions in Palazzo Pitti at the time of his death in 1713. Perhaps originally intended for the Marquis Francesco Riccardi whose name is signed on a *trompe-l'œil* letter attached to a door of the cupboard, the *scarbattolo*, as it is described in the inventory, is attributed to Domenico Remps, a specialist in illusionistic still lifes, by A. Giusti in *Il Museo dell'Opificio* cit., 1978, pp. 335–6.

17 For the Santissima Annunziata silver altar frontal, and the gold and silver work produced during this period in general, see the detailed study by E. Nardinocchi, *Laboratori in Galleria e botteghe sul Ponte Vecchio. Sviluppi e vicende dell'oreficeria nella Firenze del Seicento, in Argenti fiorentini*, Florence 1993, pp. 102–68. See also A. Mazzanti, *Ascesa delle botteghe fiorentine fra Tardobarocco e Reggenza. Il declino dei laboratori granducale 1700-1765*, ibid., pp. 169-228.

18 For further information on the work of these craftsmen, the last to represent the great tradition of working precious metals in the Medici workshops, see the relevant entries in *Argenti* op. cit. 1993, pp. 418 and 426; see also the references to Brunich on p. 398. Further documentary information is found in E. Colle, *I mobili* op. cit. 1997, pp. 286 and 294.

19 See *Argenti* op. cit. 1993, vol II, pp. 345–7.

20 The golden altar frontal with the portrait of Cosimo II in the centre remained in Florence due to his unexpected death and was later melted down. The famous semi-precious stone panel with the image of the grand duke survived and is in the Museo degli Argenti. See the exhaustive description and history by M. Sframeli in *Splendori di pietre dure. Arte di corte nella Firenze dei Granduchi*, exh. cat., Florence 1988, pp. 158–60, and bibliography.

21 See C. Sodini, *I Medici e le Indie. Il diario di viaggio di Placido Ramponi emissario in India per conto di Cosimo III*, Florence 1996.

22 See E. Koch, *Shah Jahan and Orpheus: the Pietre Dure Decoration and the Programme of the Throne Hall of Public Audiences at the Red Fort of Delhi*, Graz 1988; also eadem, *Le pietre dure e altre affinità artistiche tra le corti dei Moghul e dei Medici, in Lo specchio del principe. mecenatismi paralleli: Medici e Moghul*, Rome 1991, pp. 17-36; A. Giusti, *Pietre dure tra Occidente a Oriente*, ibid., pp. 37-46.

23 See L. Bertani, E. Nardinocchi, *I tesori di San Lorenzo: 100 capolavori di oreficeria sacra*, Livorno 1995, and bibliography.

24 See K. Langedijk, *Medaglie di Cosimo III*, Florence 1991.

25 Housed in the Treasury of San Lorenzo; see L. Bertani, E. Nardinocchi, *I tesori* op. cit. 1995.

26 Recorded in the *Giornale di Galleria* in 1716 and now in the Galleria Palatina, the table top still has its original ebony support, decorated with bronze gilt applications and semi-precious stone. The mosaic 'fantasia' of natural and heraldic subjects is similar to several designs recorded in Foggini's sketchbook and I have therefore attributed the table to him. For a bibliography of this piece, see the entry by E. Colle in *Splendori* op. cit. 1988, p. 186.

27 A large number of caskets have been located in various European collections and published by A. Gonzáles Palacios in *Cassette* op. cit. 1986.

28 Two identical pieces, with busts of the Angel and the Virgin in semi-precious stone mosaic, are in the Apartments of Palazzo Pitti and the Museo dell'Opificio: see A. Giusti in *Splendori* op. cit. 1988, p. 170, and bibliography. A third and more elaborate holy water stop with mosaic Annunciation was made in 1704 for Anna Maria Luisa de' Medici and is now in Palazzo Pitti; see A. Giusti in *La Cappella* op. cit. 1979, pp. 278–9, and bibliography.

29 See the entry by A. M. Massinelli in *Splendori* op. cit. 1988, and bibliography.

30 The documents concerning the frame, now in the Royal Apartments of Palazzo Pitti, were published by K. Lankheit, *Florentinische* op. cit. 1962, p. 64–65.

31 For a critical summary and bibliography of the piece see E. Colle, *I mobili* op. cit. 1997, pp. 233–4.

32 The bust, previously in the Conservatorio delle Montalve alla Quiete, is now stored in the Museo degli Argenti; the complex process involved in the making of this piece is described by Torricelli himself in his *Trattato delle gioie e pietre dure e tenere*. See the entry by A. Giusti in *Splendori* op. cit. 1988, p. 174, and bibliography.

33 See M. Sframeli in *Splendori* op. cit. 1988, p. 172, and bibliography.

34 Today in the Treasury of San Lorenzo: see L. Bertani, E. Nardinocchi, *I tesori* op. cit. 1995.

35 See A. Giusti in *La Cappella* op. cit. 1979, p. 303.

36 One of the few remaining pieces made by Mugnai while in Germany is the large mosaic cameo with a half-length portrait of the Landgrave, now in the castle of Rosenborg in Denmark. See A. Giusti in *Pietre Dure* op. cit. 1992, p. 193, fig. 65.

37 Until recently the cameo had generally been only tentatively attributed to Torricelli, but I believe the document showing it to have been possessively housed in his son's workshop is clear evidence that it was his work, as indeed I have always maintained. In a brusque letter written on 30.1.1748 the *Guardarobiere Maggiore*, Vincenzo Riccardi, wrote, 'Thinking of the decoration of the *Cesarea Galleria delle Maestranze* and knowing to what extent one has abused the considerable patience of S.M.C., I therefore order the removal from Torricelli's workshop of the famous cameo which he has claimed to be perfecting after many years of study...' (ASF, IRCL, Filza 2374, c. 16).

38 For an extensive bibliography of the cabinet, including the most recent documents, see E. Colle, *Mobili* op. cit. 1997, pp. 225–7.

THE "GALANTERIE GIOIELLATE" — JEWELLED FAVOURS

On the death of the Electress Palatine, Anna Maria Luisa de' Medici, in February 1743, the jewels she had so jealously safeguarded for many years were still kept in her private apartments; the exquisite workmanship and the precious stones constituted a priceless treasure which even the cold descriptions provided by the 150 entries of the inventory cannot disguise. There are rings set with diamonds of high quality, crosses with rubies, emeralds and diamonds, sacred images, brooches, clasps made of most rare stones, diamond necklaces, framed miniature portraits, and even buttons, handles and a small crown made of coconut shell, all of which were encrusted with diamonds and precious gems, not to mention the unset pearls and stones. In two *scarabattole* (small cabinets) some 789 items made of gold and gemstones were found,

The Gems of Anna Maria Luisa de' Medici, Electress Palantine

which the inventory describes memorably and delightfully as *galanterie gioiellate* (jewelled favours). These included small bowls made from semi-precious stone, mounted in gold, enamels and precious gems, snuff-boxes, seals, scent bottles and flower vases.[1]

Anna Maria Luisa, the last of the Medici dynasty, was born in 1667, daughter of the unhappy marriage between Cosimo III and Marguerite Louise d'Orléans, cousin of Louis XIV of France. At the height of its glory, the Tuscan dynasty was soundly linked to all the greatest ruling families of Europe, including that of the Empire. Anna Maria was betrothed to one of the most powerful German princes, Johann Wilhelm, the Elector Palatine, and spent twenty-five most happy years at the court of Düsseldorf. The marriage took place in the cathedral of Florence on 29 April 1691 by proxy, and for the occasion Anna Maria, who had received gifts of valuable jewellery from her father Cosimo III, was 'dressed entirely in a most beautiful white brocade adorned with many gems of immense value'.

Anna Maria loved precious objects and jewellery and she appears bedecked with gems and jewels in all her portraits. Sutterman's portrait, now in the Stibbert Museum in Florence, shows her barely three years old, adorned with a cross-shaped pendant with diamonds and rubies on a ribbon, and a bracelet in enamelled gold, also with rubies and diamonds; while in an engraving on copper by Jan Frans Douven, showing her as a young girl, she is wearing a chain of enamelled gold set with gems. In a much later portrait dated 1685 by Anton Domenico Gabbiani, now in the Villa of Poggio Imperiale, Anna Maria proudly wears a clasp with a large octagonal stone in the centre, one of those mentioned in the inventory, and a lovely brooch pinned to her sleeve, while another portrait by the same artist shows her rather older with an even

Maria Sframeli

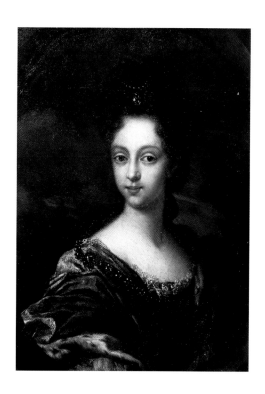

Jan Frans Douven, Anna Maria Luisa de' Medici. *Florence, Depots of the Florentine Galleries.*

199

Flemish goldsmith, Peacock, 17th century.
Florence, Museo degli Argenti.

Flemish goldsmith, Ostrich , late 17th century.
Florence, Museo degli Argenti.

more precious clasp consisting of two large sapphires, one oval and the other drop-shaped, with an ornate mounting.

Research by Hermine Kühn-Steinhausen, published in her fascinating biography of Anna Maria, a close examination of the Karlsruhe archives by Yvonne Hackenbroch, and the more recent study by Stefano Casciu[2] have all revealed that the Electress received many unique ornaments and jewels from her husband while at the court of Düsseldorf. In the letters which she wrote to her beloved uncle, Cardinal Francesco Maria, from her German home, she frequently described at some length the presents received from her husband. Thus during her first year of marriage she related not only that the Elector, on his return from a journey to Holland, had brought her gifts of drop-shaped diamonds and other jewels, but also that every time he had to go on a trip he sent precious gifts with his letters and, moreover, that for every festivity held at the court of Düsseldorf Wilhelm gave his wife jewels or rare ornaments.

The gems now housed in the Museo degli Argenti are only a tiny part of the valuables once owned by the Electress.[3] They date from the sixteenth century to the beginning of the eighteenth century, but despite much meticulous research in the Florentine and German archives in recent years, many doubts still exist regarding their origins and various periods.[4]

The Elector also gave her some antique jewels which belonged to the Palatine dynasty, identifiable in the 1691 Düsseldorf inventory by the entries marked *Churfürstin* (Electress) in the margin. It is possible, however, that some of the pieces may have been inherited by Anna Maria before her German marriage.

This may well be the case of the series of tiny animals now in the Museo degli Argenti. These include a butterfly enamelled in blue and yellow and decorated with rubies, diamonds and a baroque pearl; a frog with a pearl for the body, diamonds for eyes and feet and a green enamel head; a spider made from a baroque pearl and a diamond; a gold lizard enamelled in green, with a pearl back and diamond eyes and tail; a crouching dragon gnashing its teeth, made from a long baroque pearl to which the limbs are attached, with diamonds for eyes and a long straight tail of gold enamelled in green. Many similar items were, in fact, in the magnificent cabinet which Cardinal Ferdinando de' Medici had given to his niece, Eleonora, on the occasion of her marriage to Vincenzo Gonzaga, Duke of Mantova: '1 lizard', '2 frogs', '2 small butterflies with 16 gems', '2 spiders', '1 dragon'.⁵ These had been made by Leonardo Zaerles, a jeweller of Flemish origin who had moved to Rome and worked for Ferdinando de' Medici between 1582 and 1584, in whose inventories he is frequently mentioned. Reading the list of Eleonora's jewels it is quite clear that his work consisted predominantly of such plant and animal subjects. Entirely Flemish in style and origin, the jeweller developed this theme of natural motifs in quite unusual ways such as describing a jewel as '1 leaf with a spider on it'. Although it is not entirely certain that these are the items now in the Museo degli Argenti, it is clearly quite possible that some of Eleonora's gems were brought back to Florence after her death in 1611. Their description at least shows that such pieces were commissioned by the Medici from Flemish jewellers employed by the grand ducal workshops.

In trying to establish the origin of these pieces, we should not forget that a sequence of reciprocal exchanges had resulted in an 'international court style' and in Florence the most famous jewellers working for the Medici grand dukes were often Flemish, French and even Swedish.

An example of the mobility of goldsmiths at the end of the sixteenth century, in this case moving from Italy to northern Europe, is the pendant 'of Pantalone and Zanni serenading two lovers' made, probably in Munich, by an Italian craftsman, Giovan Battista Scolari, a native of Trento. The gondola, made from a large baroque pearl with an unusual crescent shape, has a prow decorated with an eagle's head and floats over a sea of waves from which the heads of two fish emerge. The jewel may originally have been made to celebrate the first performance of *a commedia improvvisa all'italiana* in northern Europe which took place in 1568 at the court of Albert V of Bavaria as part of the festivities for the marriage of his son, the future William V, to Renate of Lorraine. A similar pendant was owned by Maria of Bavaria, Albert's daughter and the sister of William, in 1577. The artist is recognised as being Giovan Battista Scolari, a court jeweller who interpreted the part of Zanni when one of the

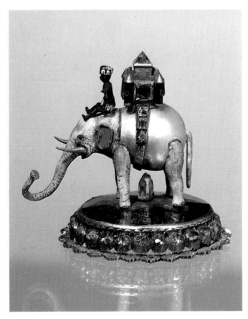

German goldsmith, Camel, *late 17th century. Florence, Museo degli Argenti.*

Dutch goldsmith, Elephant, *late 17th century. Florence, Museo degli Argenti.*

German goldsmith (Munich), Gondola pendant, c. 1570. Florence, Museo degli Argenti.

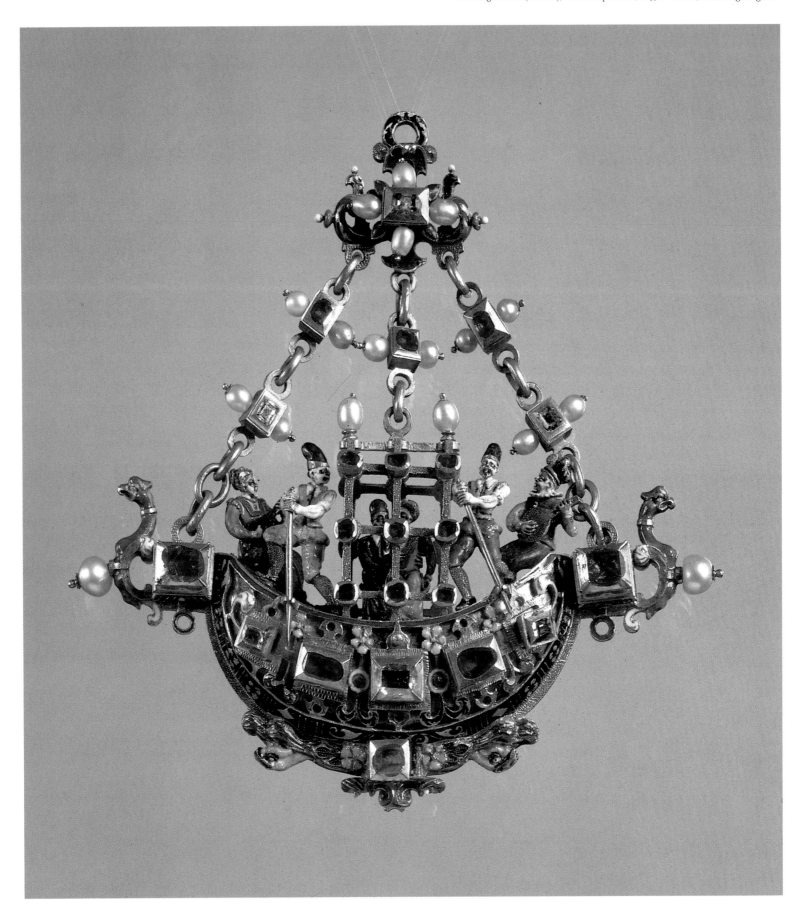

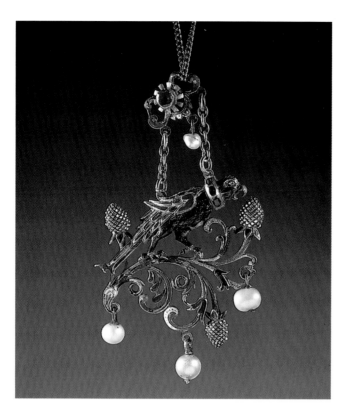

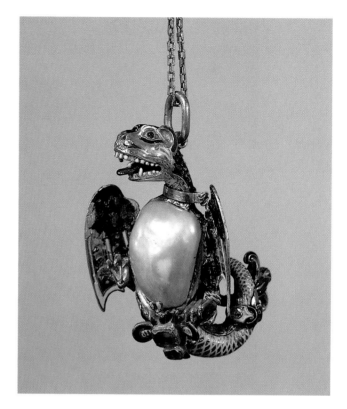

actors died violently in a duel. Another pendant in the form of a gondola with two lovers seated under a canopy is stylistically similar; the elaborate decoration and technique used would suggest, however, that this piece is of German workmanship. It is, in fact, almost certainly from Munich since it would seem to be the jewel worn by the Bavarian princess Maria Anna, daughter of William V and Renate of Lorraine, in the portrait painted in 1589 on the occasion of her marriage to Ferdinand of Austria. 1589 was indeed important for the Medici's dynastic connections as in the same year Renate of Lorraine's niece, Christina, married Grand Duke Ferdinando I of Tuscany.

The 'parrot pendant', representing the bird perched on a branch with strawberries, pecking at one of the three fruits, is of late sixteenth-century Flemish craftsmanship. A German print of a pair of earrings with parrots, dated around 1600 and now in the Victoria and Albert Museum, London, suggests that the jewel was based on this or a similar design.

The pendant of a 'Dragon attacked by a bee' is also late sixteenth-century Flemish. The body of the dragon is made from a baroque pearl and, stung by the bee, its jaws open in a roar of pain, showing the sharp teeth of white enamel and the pointed red tongue. A golden chain around its neck and clawed left paw prevents the dragon from fighting. Symbolically the bee often represents the leniency of a ruler; it may perhaps be only coincidence, but in Florence the bee was the emblem adopted by Ferdinando I. In 1588 Michele Mazzafirri made a medallion with his image on one side

Flemish goldsmith. Parrot pendant, late 16th century. Florence, Museo degli Argenti.

Flemish goldsmith, Pendant with a dragon stung by a bee, c. 1580. Florence, Museo degli Argenti.

Following pages: Flemish goldsmith, Mermaid pendant, 1570-80 and Triton pendant, 1580-90. Florence, Museo degli Argenti.

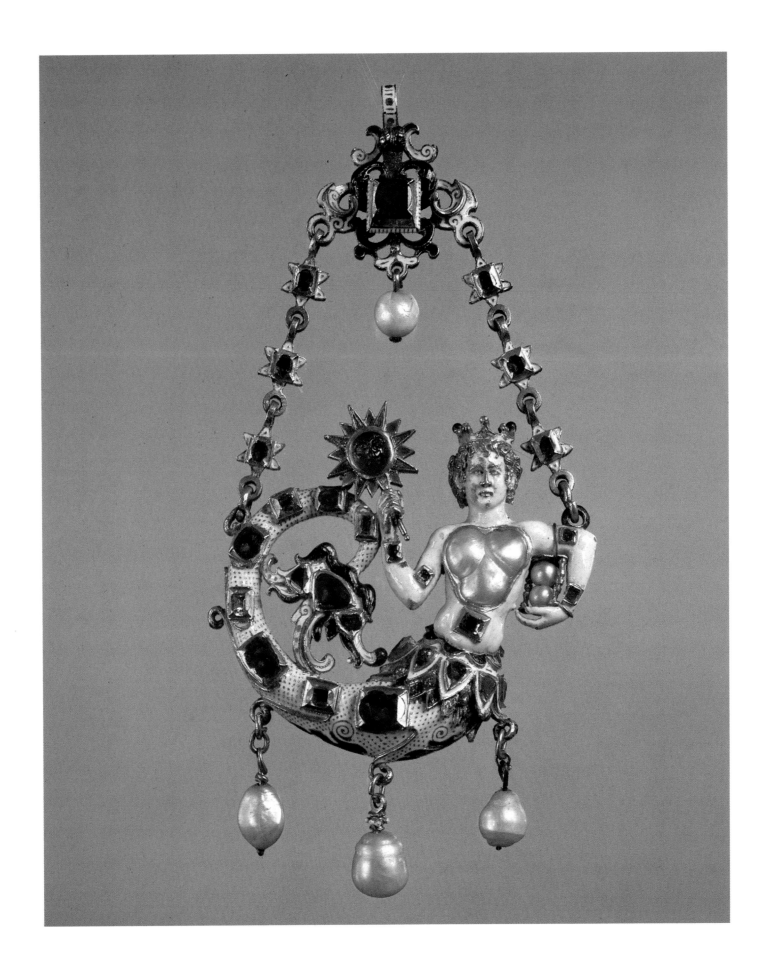

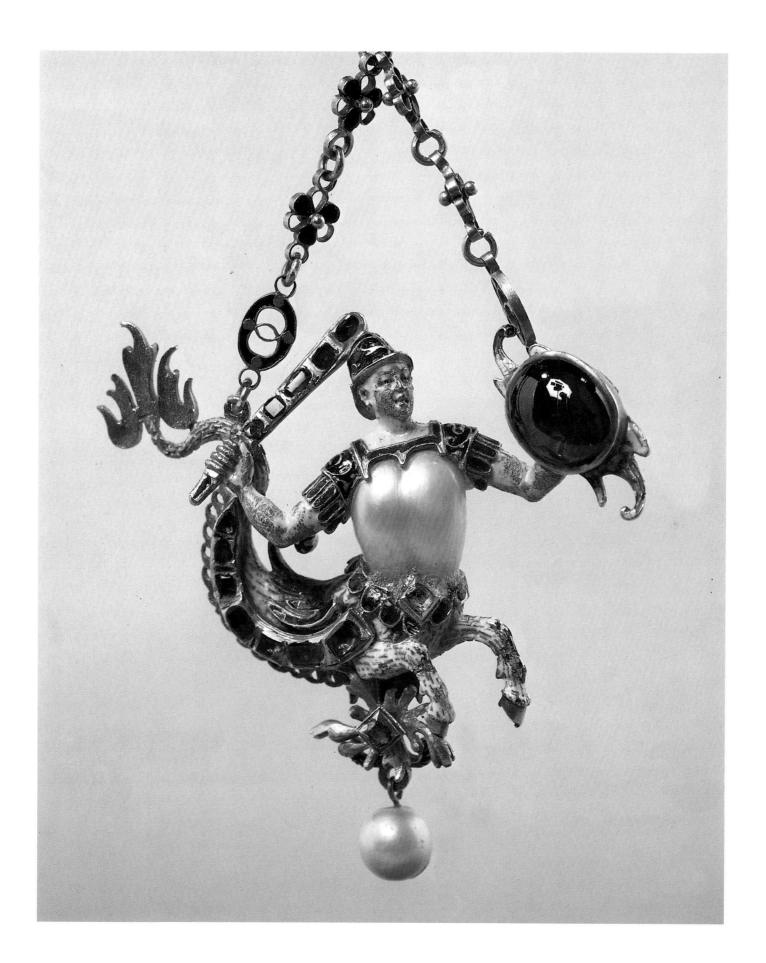

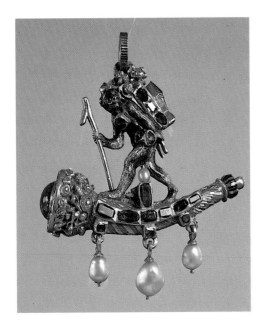

Flemish goldsmith, Pendant with a monkey on a barrel, *1580-90. Florence, Museo degli Argenti.*

Dutch goldsmith, Pearl flask, *late 16th century, Florence, Museo degli Argenti.*

while on the reverse was the emblem of a queen bee surrounded by a swarm and accompanied by the motto *Maiestate tantum* referring to the virtues of the prince. It is therefore quite possible that the pendant was made in the Medici workshops.

A subject particularly popular amongst goldsmiths was that of the mermaid; the Museo degli Argenti has three pendants dedicated to this mythical sea-dweller. The most valuable of the three is the 'Mermaid with a sceptre and hourglass'. In this rare example the mermaid is represented crowned like the mistress of the sea, Fortune, displaying her attributes: a sceptre in the form of the sun and an hourglass. On the reverse side of the sun-sceptre is a crescent moon on a dark blue background indicating control over the ebb and flow of water and alluding to alternating good and bad fortune. The hourglass, symbolic of time inexorably passing, refers to transience, while the beauty of the mermaid, whose tail is curved into a crescent, is perhaps intended to represent the temptations of ephemeral pleasure, destined to vanish as the sand falls through the hourglass or as the tide breaks on the shore.

Another creature of the sea is the 'Triton', armed with helmet, club and an oval shield made from a large garnet, represented in the act of fighting. The body is a baroque pearl, while the face, arms, forelegs and the scaly tail are enamelled in white.

The most unusual pendant of a 'Monkey dressed as a pedlar', on a whistle also belongs to this set of Flemish-style jewels. The monkey is dressed in green and is carrying a pannier filled with fruit. The pendant, identifiable in the 1691 Düsseldorf inventory, was probably taken from a series of twelve engravings of similar subjects by Pieter van der Borcht (1545–1608), published in Antwerp by Jan Baptist Vrints. The light-hearted theme suggests that the jewel was intended for a child, as does its function as a whistle. Moreover, it has been pointed out that, in the portrait of Eleonora Gonzaga as a child from the Kunsthistorisches Museum, Vienna, a jewel with a monkey can be seen on the sleeve of her dress.

A baroque pearl was also used to make a miniature flask with a screw top and gold neck enamelled in green and blue. It is believed to be of Dutch manufacture, dated to the late sixteenth century and, although there are several differences, it is similar in style to the famous pearl owned by Johann Wilhelm, the Elector, and known as the *Pfälzische Perle* or Palatine Pearl, bought in Amsterdam.

The nine buttons with military figures in gold, enamelled in various colours, belonged to the ancestral collection of the Palatine state. These military figures – a foot soldier, two officers, a harquebusier, a swordsman, a piper, a drummer boy, a gunner and a swordsman – together with a tenth figure known to be in Ulm from 1743, are mentioned in the inventory of the Elector Palatine's possessions compiled on 31 August 1691, where twelve similar figures are also recorded. As Yvonne Hackenbroch has pointed out, these figures are based on the creations of Hendrick Goltzius, who made a series of military figures in the Flamboyant style between 1582 and 1587, as well as on two illustrated volumes: a work by Abraham de Bruyn, *Die Waffen unde kleydung der burgerey zu antorff*, published in Antwerp in 1581 and one by Theodore Bry, *Stem und*

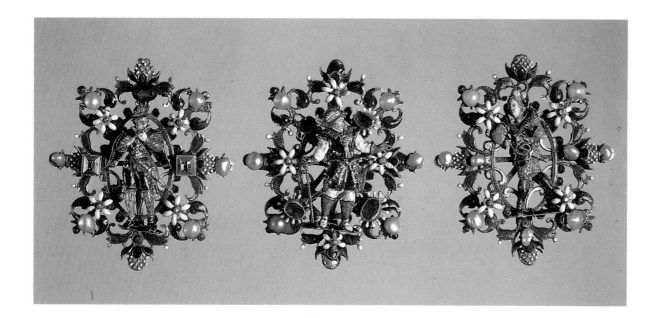

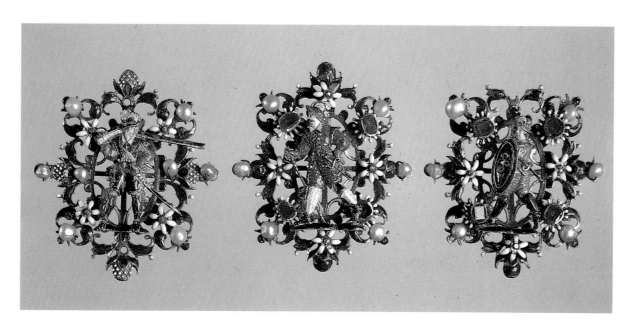

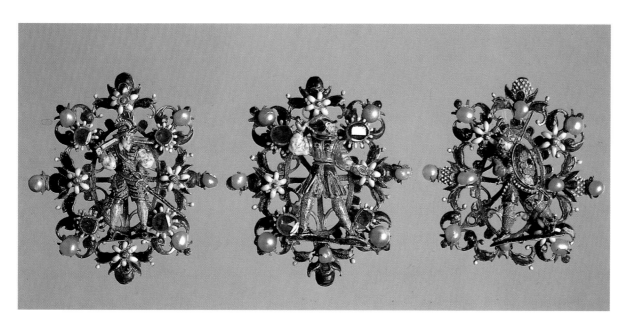

Flemish goldsmith, Nine
'buttons' with military figures,
*late 16th century. Florence, Museo
degli Argenti.*

Flemish goldsmith, Pendant with wounded lion, *c. 1580. Florence, Museo degli Argenti.*

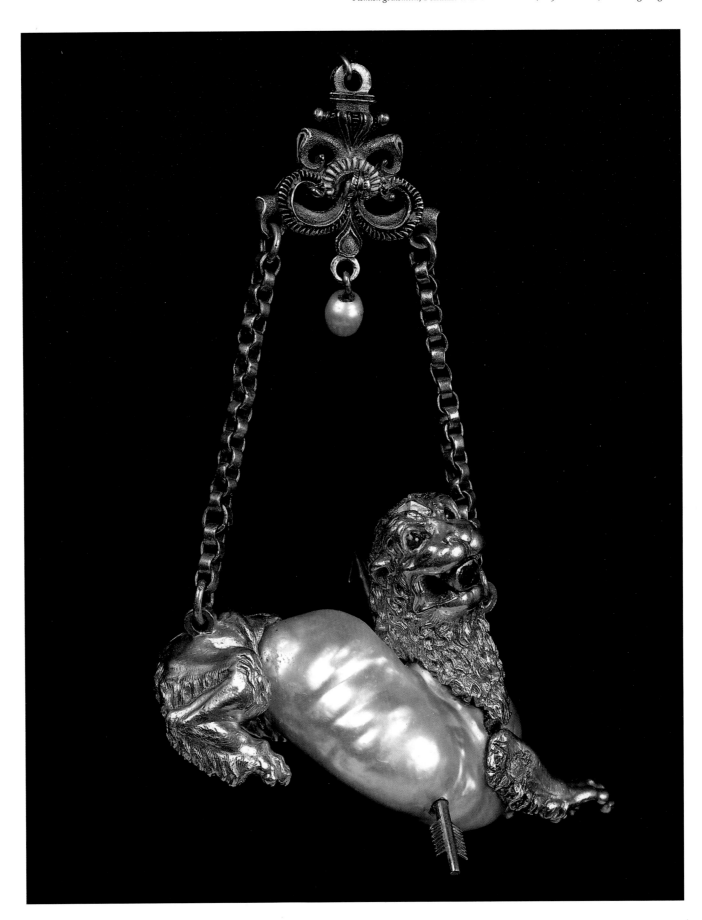

German goldsmith, Bacchus, *late 17th century. Florence, Museo degli Argenti.*

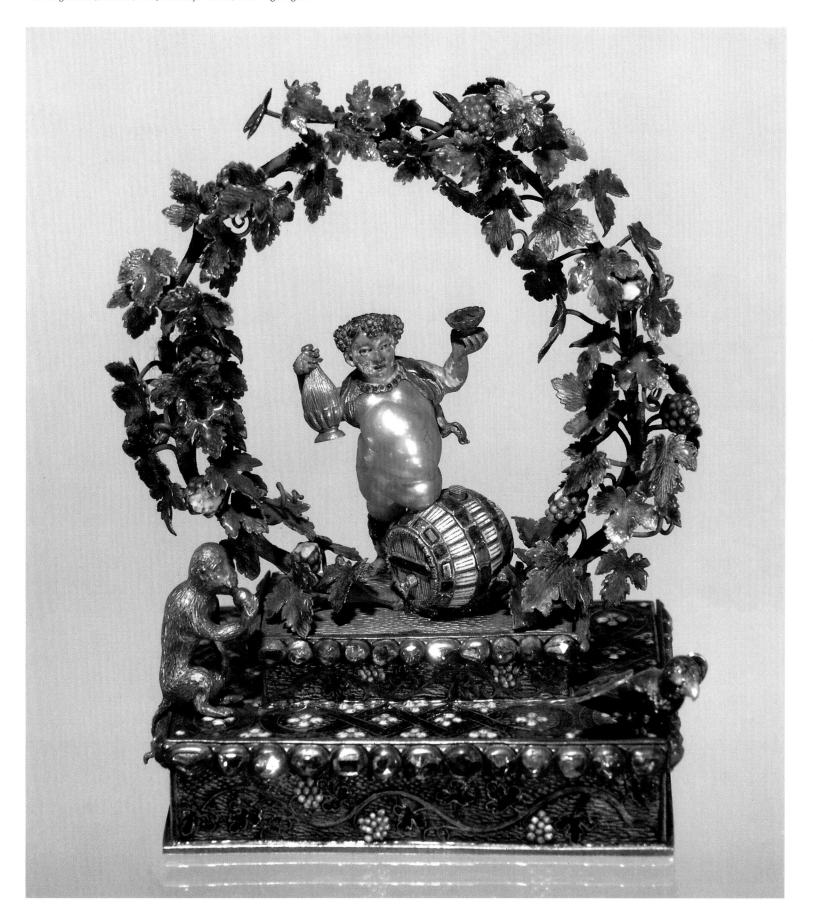

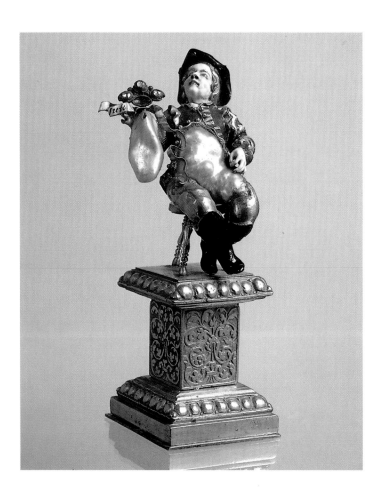

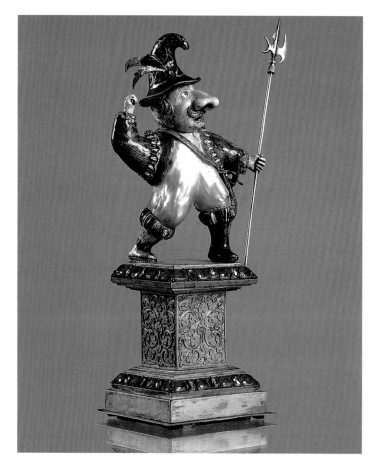

German jeweller, Cobbler, late 17th century.
Florence, Museo degli Argenti.

German goldsmith, Swiss soldier, late 17th century.
Florence, Museo degli Argenti.

Wapen buchlein Emblemata, published in Frankfurt in 1592 with a second edition in 1593. In an account book of the Elector Palatine Frederick IV, covering the period from June 1599 to June 1600, a payment is recorded on 28 July for a soldier, almost certainly the work of Hercule van der Vink who had come to Heidelberg in 1579 and died there ten years later. The buttons were originally stitched onto a black velvet ribbon around a hat and a note in the margin of the 1691 inventory states that the jewels had been handed over to the Electress Palatine and they are, in fact, duly registered in her inventory of 1743 and again in the Viennese inventory of 1768.

A group of small ivory statues with gold enamel may be attributed to German court circles, and dated around 1700. These were clearly either bought by the Electors Palatine themselves, or were presents received from other German princes on the occasion of court festivities or anniversaries. One such piece is the 'Shoemaker', a tiny figure, seated on a golden three-legged stool, made from a baroque pearl with enamel holding the form of a shoe, also a pearl. The 'Swiss soldier', a dwarf in military uniform, has a base identical to that of the shoemaker. Other similar pieces are in the Grünes Gewolbe in Dresden and since 1725 have been attributed to a goldsmith and

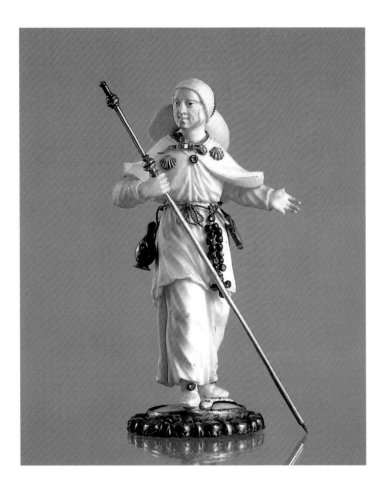

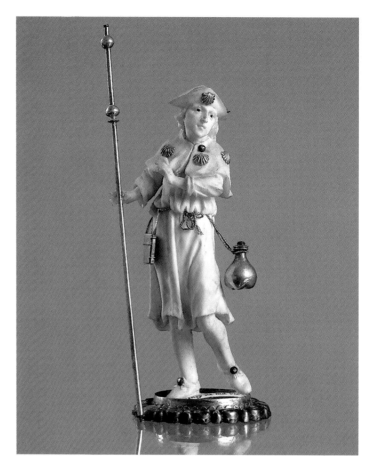

dealer called Verbecq, a native of Frankfurt. Two pairs of 'Pilgrims' and 'Pedlars' are made from ivory. The male pilgrim has a cape and hat with golden scallop shells, his pilgrim's staff and a water jar attached to his belt, while the woman has a hat, staff and a rosary attached to her girdle; both have enamelled bands around their feet inscribed in French *Ainsy va ma vie* and *A sa fin* – doleful meditations on the human lot.

More cheerful are the two little figures of pedlars. The man is bent under the weight of the tray with his merchandise on show – toiletry items, medical instruments, glasses and three phials with *Jas, Ros* and *Eu* written on them. The woman, looking almost like a direct descendant of the classical allegories of Abundance, carries a wicker basket filled with fruit and flowers on her head. Two series of engravings, *Le Arti di Bologna* by Annibale Carracci published in 1646, and *L'arte per via*, by Giovanni Maria Mitelli dated 1660, provided a wealth of inspiration for artists with their street scenes and sketches of pedlars. The fruit seller in particular seems to be a copy, albeit a century later, of the famous engraving of the same subject by Jacques Bellange. Other small sculpted groups, more complex and elaborate, represent, for example, a 'Knife grinder' with his cart and dog, or 'Two

German goldsmith, Female pilgrim, *late 17th century. Florence, Museo degli Argenti.*

German goldsmith, Male pilgrim, *late 17th century. Florence, Museo degli Argenti.*

Following pages: German goldsmith, Pedlar and Fruit and flower seller, *late 17th century. Florence, Museo degli Argenti.*

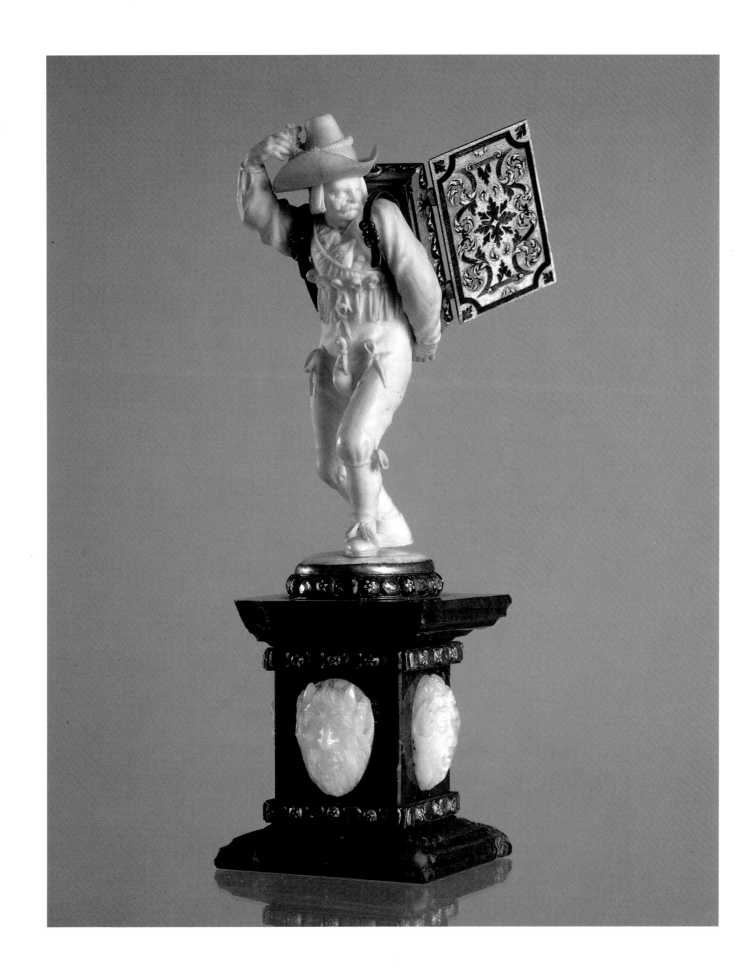

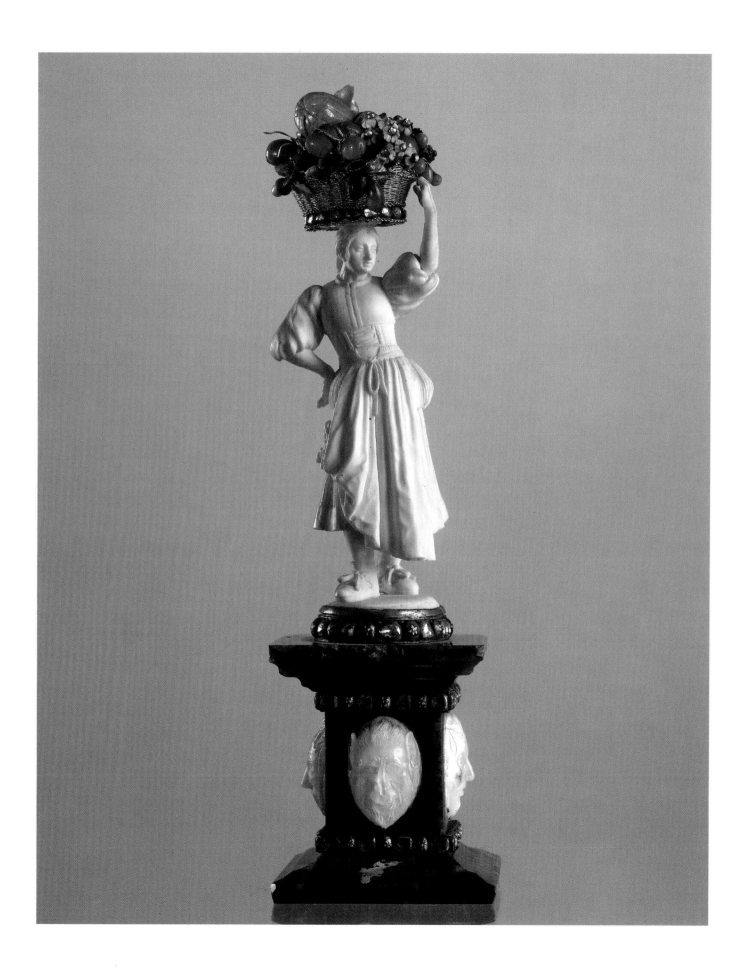

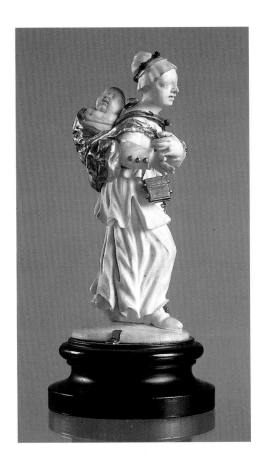

German goldsmith, Mother and child, *late 17th century. Florence, Museo degli Argenti.*

mules carrying baskets' with perfume bottles, ridden by a monkey and led by a muleteer.

Research carried out by Yvonne Hackenbroch has shown that these little figures were made for 'theme' entertainments at the court or costume balls known as *Hotelleries allemandes* or *Wirtschaften*, when the castle became a hostelry, the lord and his lady became the landlords and the guests the customers. Dressed up in popular costume, the members of the aristocracy could forget rigid court etiquette for the duration of the party and enjoy the freedom permitted only to the more humble classes of society. At the end of the party guests were given valuable 'souvenirs' and, in keeping with their temporary roles, pretended to buy them from counters set up in the park. On 9 January 1690 the 'knife grinder's' party – *Die Scherenschleifer* – took place at the Berlin court of the Elector of Chur-Brandenburg, Frederick III, and his wife Sophia Charlotte, the future rulers of Prussia. For the occasion the poet Johann von Besser, master of ceremonies, was commissioned to write some verses. Sophia Charlotte was a close friend of the philosopher Leibniz and, influenced by the resulting cultural atmosphere of the court, the poet interpreted the knife grinder symbolically as a forger of men and strongly emphasised the freedom of those who are not concerned with the affairs of state.

The gem of the 'Baby in a crib' is a poignantly significant piece in the life of Anna Maria Luisa. The crib is of gold filigree, trimmed with braid, fitted with four handles decorated with pearls, and crowned at the top with a half pearl. It is supported by two feet from which it rocks. The cover which warms the new-born baby is a large baroque pearl, and the head is a similar smaller pearl, engraved with facial features. The blue silk quilting is dotted with minute pearls. The motto, Auguror eveniet, alludes to the hope, never fulfilled, for the birth of a prince and an heir. The year was 1695 and the crib can, in fact, be identified as the one André Joseph van der Cruyce referred to in a letter addressed to Johann Wilhelm, assuring him that as soon as was possible he would send him the 'perle orientale figurant un enfant emmailloté et le berceau'. Another jeweller who made an interesting little item for the Electors has also been identified. A perfume spray in enamelled gold was made by Peter Boy the Elder, originally from Frankfurt and active at the court of Düsseldorf during 1712 and 1713. One side of the bottle is decorated with the combined arms of the Elector Palatine and Anna Maria Luisa, enclosed within the chain of the Order of the Golden Fleece with the crown of the Palatinate at the top. Under the crown on the other side is the monogram AMLCPR (Anna Maria Luisa Countess Palatine of the Rhine); on a red enamelled background beneath this, two white doves are depicted on a branch with a green leaf, holding in their beaks green ribbons which form a figure 3. The presence of the Imperial globe in the coat of arms enables us to date the piece to the period 1708–14, the only years during which the Elector could have made use of this device. Most probably it was a gift from the Elector to Anna Maria and may have been commissioned in 1711, the year in which Johann Wilhelm went to Frankfurt to assist at

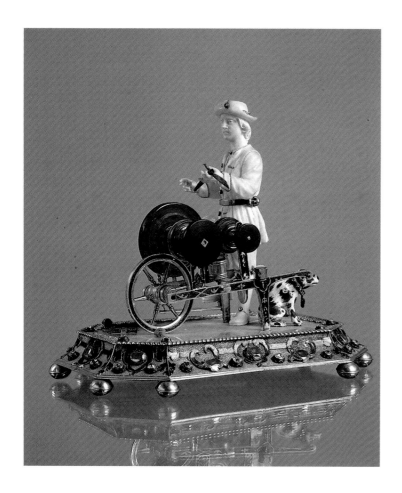

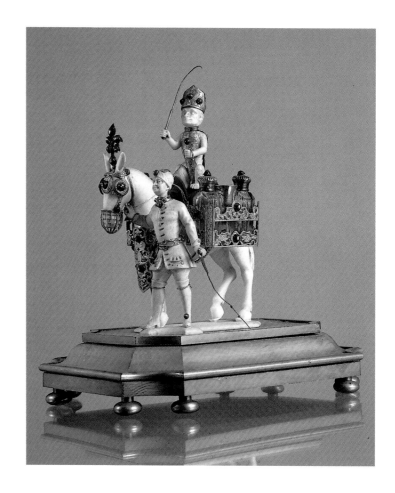

the election of the future Emperor Charles VI. This was followed by his coronation on 22 December which Anna Maria also attended. The piece was therefore clearly made either in 1711 or 1712–13 when the jeweller moved to Düsseldorf to work for the Elector.

In 1719, after the death of her husband, Anna Maria returned to Florence bringing her jewels and treaures with her. The heir to the throne of Tuscany, Prince Ferdinando, had died in 1713 and Cosimo III was to die in 1721. Gian Gastone was without heir and died in 1737, the last Medici grand duke. The major European powers had already decreed that on the demise of the Medici dynasty, Tuscany would be ruled by Francis Stephen of Lorraine, husband of Maria Theresa of Habsburg and Emperor of the Holy Roman Empire since 1745. After the death of her brother, Anna Maria remained the ultimate heir to the family possessions and was particularly concerned as to the destiny of the gems and jewels, both personal and those belonging to the state. With obstinate determination she succeeded in obtaining agreement to the 'Family Pact' drawn up in Vienna on 31 October 1737 defining the transfer of authority from the last Medici to the new grand dukes. With quite providential foresight she insisted on the inclusion of

German goldsmith, Knife-grinder, late 17th century.
Florence, Museo degli Argenti.

German goldsmith, Muleteer, late 17th century.
Florence, Museo degli Argenti.

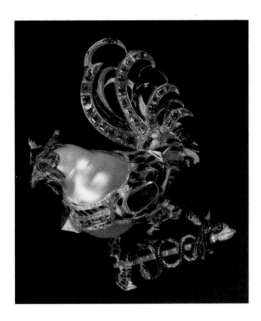

Flemish goldsmith, Cockerel pendant, *1570-80. Florence, Museo degli Argenti.*

Opposite page: Dutch goldsmith, Cradle and baby, *c. 1695. Florence, Museo degli Argenti.*

Article III which determined that the collections of paintings, sculptures, jewels and artistic ornaments – the wealth of objects which now form the core of the Florentine museums – should be bequeathed to the state of Tuscany and should never leave it: 'At this moment the most Serene Electrice cedes, gives and transfers to His Royal Highness for himself and his successors as grand dukes, all the furniture, effects and rare treasures of the inheritance of her brother, being galleries, paintings, statues, libraries, jewels and other precious things that His Royal Highness pledges himself to preserve on the express condition that these things, being for the ornament of the state, for the benefit of the people, and for an inducement to the curiosity of foreigners, nothing shall be alienated or taken away from the capital or from the territories of the grand duchy.'

In order to safeguard the bequest, on 18 February 1738 Anna Maria had sent an inventory to Vienna of 'the gems of her family in the keeping of the state of Tuscany', which consisted of thirty-five pieces. Francis Stephen had used pressure to obtain the gems of the House of Medici and had tried to interpret the treaty to his advantage, attempting to claim ownership of the treasures and not simply their use 'pro tempore'. Thus, when Francis Stephen, his consort Maria Theresa and the Prince Charles came to visit Florence, they could adorn themselves with the crown jewels for official ceremonies, but on their departure they were obliged to return them to Anna Maria who took care personally to oversee their restitution.

Probably wishing that her personal jewels – family heirlooms and gifts from her beloved husband – should be disposed of in fit manner after her death, on 5 April 1739 she ordered that all the jewels left at her death should be added to the state collection. It was an impressive challenge and Francis Stephen neither retracted nor lessened his claims. On 14 January 1741 the Florentine marquis and senator Carlo Ginori was entrusted with a letter to the Electress from the new grand duke who, quite ignoring the terms laid down by the Family Pact, insisted that the gems should be handed over on the pretext that in the event of invasion he would defend the state of Tuscany. In her firmly negative reply, the Electress reminded Francis Stephen that only a few years earlier he himself had made the agreement with her that the Medici family jewels, 'were destined to become state jewels for the use and ornament of the duchesses when they will have taken up residence here and as they have been the source of so much pleasure to me, I have also added many of my own gems of considerable value'.

Her most meaningful reply, however, was the compilation dated 10 March 1741 of a new inventory of the state jewels, 'to which her Highness has added many of her own having had various of them set in the latest fashion'. It is easy to identify the pieces added at that time by comparing this inventory with the previous one of 1738. Some of the most important pieces in her possession were added, mainly large and rare gems of considerable value which had belonged to the Medici for centuries.

The Electress died in 1743. The Compte de Richecourt, one of Francis Stephen's agents, immediately undertook the compilation of a new inventory, completed on 27

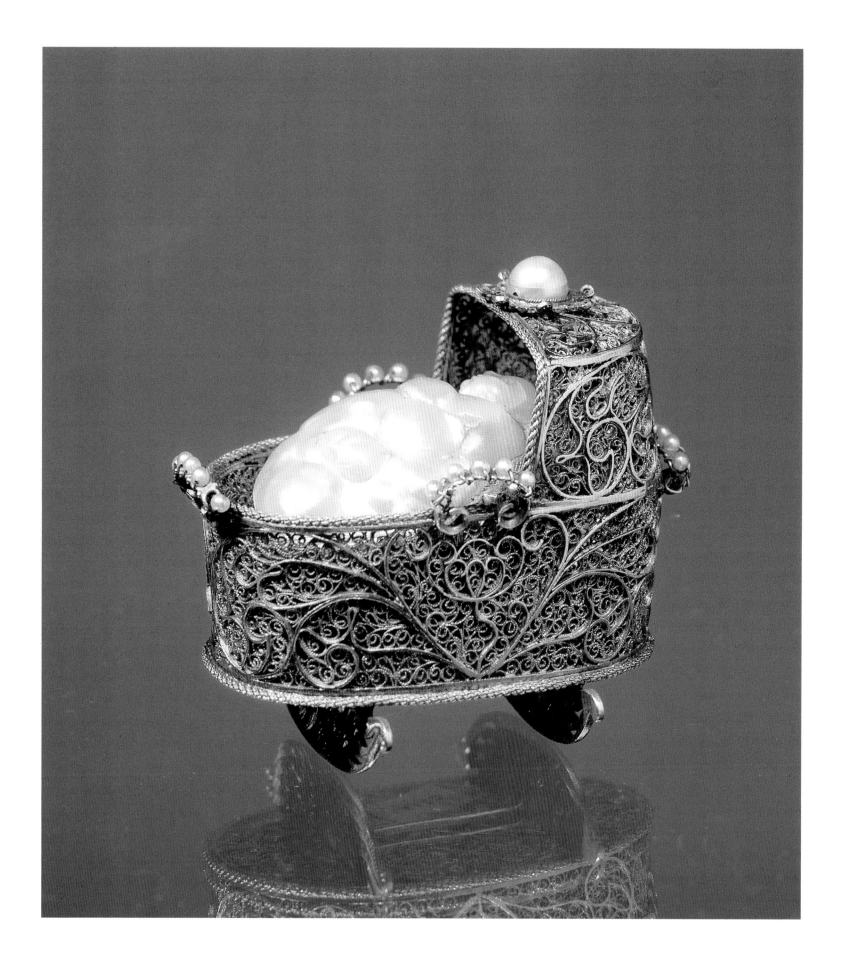

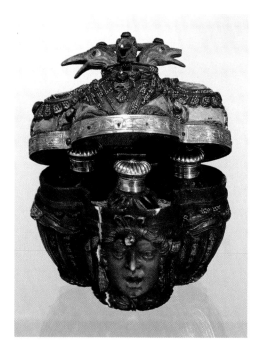

German goldsmith, Casket, *late 17th century.*
Florence, Museo degli Argenti.

Opposite page: Peter Boy the Elder, Whistle, *1708–14.*
Florence, Museo degli Argenti.

May, which included the gems owned personally by the Electress and in her private apartments at her death: their total value amounted to 4 278 574 *scudi*. The inventory is divided into two parts: the first covers the 'gems found in the room where the most Serene Electress Palatine died', and includes valuable jewels which had probably been given to her by Johann Wilhelm as many were bequeathed to members of the Elector's family; the second part covered the *galanterie gioiellate* (jewelled favours).

The notes 'broken up' or 'sent to Vienna' frequently appear in the margin alongside the individual entries of the inventory. Francis was in need of money to finance the Austrian War of Secession and, after having failed to gain possession of the Medici jewels while Anna Maria was still alive, he lost no time as soon as she had died. The state jewels were removed from the 'secret archive' by Richecourt and sent to Vienna under cover where they were then sold or broken up and, in any case, rendered totally unrecognisable, apart from the three most distinctive pieces: the large diamond known as the 'Fiorentino', the topaz and the strings of pearls.

In August of 1747 Francis Stephen decided to sell the remaining precious gems in the eastern empire and thus lengthy inventories divided by kind and all dated 9 October list the objects from which the gems had been removed for export to Constantinople.

On 4 April 1750 a decision was made that all the jewels and medals which had been left in Florence were to be sold in Germany, where the style of the pieces was still fashionable and higher prices could therefore be obtained. A synthetic account of the fate of the Medici jewels was written on the inventory of 18 August 1743: 'Of all the jewels described in the above-mentioned inventory some have been given as bequests as can be seen from the receipts, some have been sent to Vienna at different times ... some have been sold and broken up for sale ... of the *galanterie gioiellate* which were in the two cabinets some have been broken up for sale, some sold, and the rest sent to Vienna.'

The surviving pieces were absorbed into the inventories of the Viennese court; included in that of 1765, drawn up on the death of Francis Stephen, are almost all of the *galanterie* now in Florence except for six pieces (the shoemaker, the spider, the winged dragon, the cradle and baby, the dove and the lion).

In the early 1920s, after the First World War, it was in fact a comparison between these two inventories which facilitated the return to Italy of part of the jewels illicitly transferred to Vienna. The terms agreed in the treaty of Saint-Germain, signed on 10 September 1919, as well as a special convention between Italy and Austria concerning works of art, signed on 4 May 1920, and the commitment and efforts of the Italian delegation at the Peace Conference, which included Ettore Modigliani, all made this possible. However, it was due first and foremost to the iron will of Anna Maria Luisa who had foreseen the sad fate of all the rare and antique items so lovingly collected over the centuries by her family and who had tried to save them with the Family Pact which, even at a distance of two centuries, demanded respect.

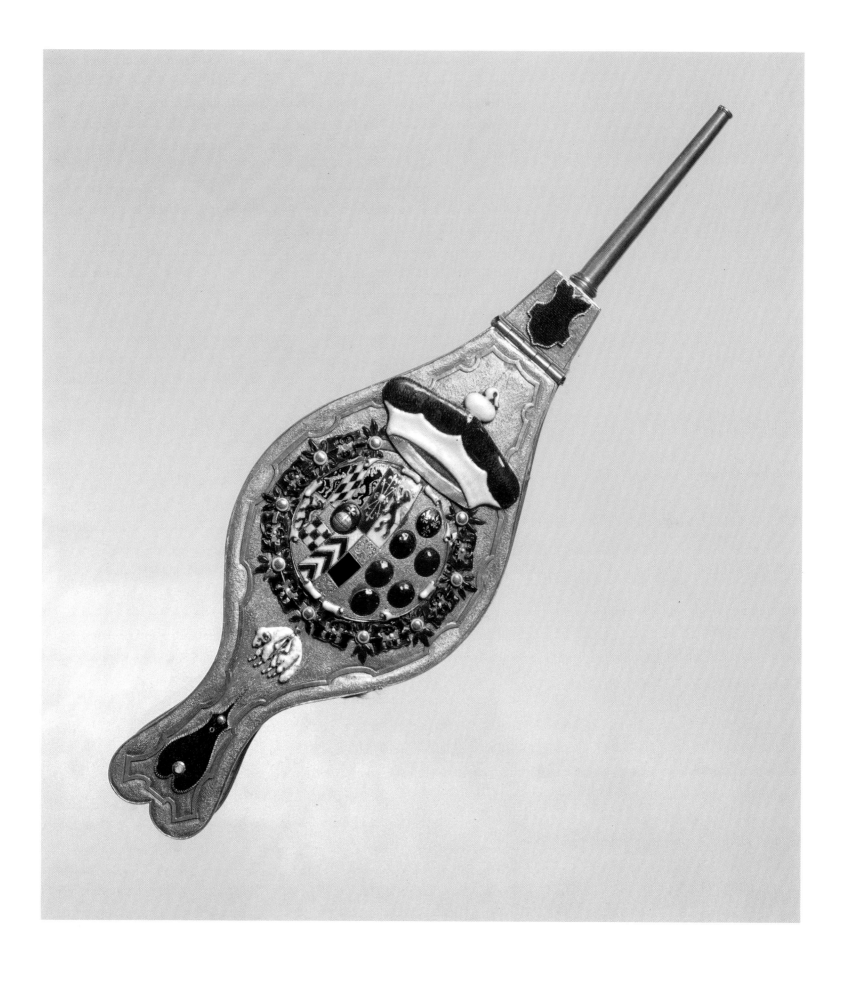

Notes and references

1 The inventory has been completely transcribed by Maria Sframeli and published in Y. Hackenbroch, M. Sframeli, *I gioielli dell'Elettrice Palatina al Museo degli Argenti*, Florence 1988.

2 H. Kühn-Steinhausen, *Die Letze Medicäerin — eine deutsche Kurfürstin*, Düsseldorf 1939, ed. it. Florence 1967; Hackenbroch, in Hackenbroch–Sframeli, cit.; S. Casciu, *Anna Maria Luisa de' Medici Elettrice Palatine (1667–1743)*, Florence 1993.

3 K. Aschengreen Piacenti, *Il Museo deli Argenti*, Milan 1967; K. Aschengreen Piacenti, 'The Jewels of the Electress Palative,' in *Apollo* 103, September 1974, pp. 230-33.

4 Hackenbroch, Sframeli, cit.

5 A.M. Massinelli, 'Eleonora e i suoi gioielli', in MCM *La Storia delle Cose*, no. 3, 1986, pp. 17–21; A.M. Massinelli, F. Tuena, *Il Tesoro dei Medici*, Novara 1920.

APPENDIX

The Treasures of Medici: from Objects of Wonder to the Organization of Knowledge

The Formation of the Fifteenth-Century Collection, its Dispersion and the Return to Florence of the Medici Treasures

The Medici Collections at the Time of Cosimo I and Francesco I

54 *Athena,* Etruscan bronze, Hellenistic period. Florence, Museo Archeologico.

55 *Chimera,* Etruscan bronze, late 5th century BC. Florence, Museo Archeologico.

56 *Wild boar,* marble, mid 1st century BC. Florence, Uffizi Gallery.

57 Niccolò Tribolo and other Florentine sculptors, *The Animal Grotto,* detail of the right side, mid 16th century. Granite, marble and coloured stone. Castello, Villa Medicea.

59 Willem Tetrode, scale reduction in bronze of the *Belvedere Apollo,* c. 1560. Florence, Museo Nazionale del Bargello.

60 Workshop of Agnolo Bronzino, *Series of portraits* representing famous members of the Medici family, 1555–65. Oil on copper plate. Florence, Uffizi Gallery.

61 Giovanni Antonio Maggiore, *Turned sphere of ebony and ivory containing miniatures,* c. 1580. German artist. Florence, Museo degli Argenti.

62 Grand ducal workshops and Giovanni Battista Cervi, *Lapis lazuli bowl in the shape of a shell* with a handle of enamelled gold shaped like a snake, 1576. Florence, Museo degli Argenti.

63 Giovan Battista Metellino, *Bowl with dolphin base,* rock crystal and silver gilt. Milan, late 16th century. Florence, Museo degli Argenti.

64 Milanese artist, *Flask engraved with Orpheus with the Muses and the Judgement of Midas,* rock crystal with gold mounts, c. 1580. Florence, Museo degli Argenti.
 Milanese artist, Flask shaped like a fish, rock crystal and enamelled gold, c. 1580. Florence, Museo degli Argenti.

65 Sarachi workshop, *Chalice in the form of a bird,* engraved with scenes of boar and wolf hunting, rock crystal with enamelled gold mounts, c. 1580. Florence, Museo degli Argenti.

66 Flemish artist, *Double nautilus pitcher with a mount of silver gilt,* rubies and turquoise, second half of 16th century. Florence, Museo degli Argenti.

68 Flemish artist, *Double nautilus pitcher with a mount of silver gilt,* second half of 16th century. Florence, Museo degli Argenti.

69 *Engraved double nautilus cup with silver-gilt mounts,* China, 16th century. Florence, Museo degli Argenti.

70 Properzia de' Rossi (attr.), *Engraved cherry nut with silver-gilt mount,* mid 16th century. Florence, Museo degli Argenti.

71 *Anthropomorphical pendant in jade,* Mayan, 600–900 AD.

Florence, Museo degli Argenti.
Small jade statue of a forefather, Central Mexico, post-classic period (900–1520?). Florence, Museo degli Argenti.
Head of a dog in onyx, Aztec, late post-classic period (1430–1520). Florence, Museo di Mineralogia.
Head of a dog in amethyst, Aztec, late post-classic period (1430–1520). Florence, Museo di Mineralogia.

The Medici Collection of Gems during the Fifteenth and Sixteenth Centuries

74 Cameo, shell, *Portrait of Cosimo the Elder.* Florence, Museo degli Argenti.

75 Pyrgoteles (attr.), chalcedony cameo, *Athena and Poseidon.* Naples, Museo Archeologico.

76 *The Farnese Bowl,* chalcedony cameo. Naples, Museo Archeologico.

77 Engraving, cornelian, Apollo, *Marsyas and Olympus,* or 'Nero's seal'. Naples, Museo Archeologico.

78 Sostratos, chalcedony cameo, *Nike with two galloping horses.* Naples, Museo Archeologico.

79 Giovanni delle Opere, known as 'Delle Corniole', engraving on cornelian, *Portrait of Girolamo Savonarola.* Florence, Museo degli Argenti.

80 Domenico di Polo, engraving on emerald plasma, *Hercules.* Florence, Museo degli Argenti.
 Domenico di Polo, chalcedony cameo, *Portrait of Alessandro dei Medici.* Florence, Museo degli Argenti.

81 Chalcedony cameo, *Sacrificial scene.* Gold frame with coloured enamel, late 16th century. Florence, Museo degli Argenti.

82 Valerio Belli, *Casket,* silver gilt, enamel and rock crystal engraved with scenes from the Passion, 1532. Florence, Museo degli Argenti.

83 Chalcedony cameo, *Portrait of Catherine dei Medici.* Frame set with rubies. Florence, Museo degli Argenti.
 Engraving on rock crystal, *Portrait of Cosimo I dei Medici.* Florence, Museo degli Argenti.

84 Tryphon, cameo, *The marriage of Cupid and Psyche.* Boston, Museum of Fine Arts.

85 Giovanni Antonio de' Rossi, chalcedony cameo, *Portrait of Cosimo I dei Medici, Eleonora di Toledo and their children.* Florence, Museo degli Argenti.

86 Engraving on amethyst, *Hercules.* Florence, Museo Archeologico.

87 Domenico Romano, chalcedony cameo, *Triumph of Philip II of Spain,* c. 1550. Florence, Museo degli Argenti.

88 Cameo in 'sapphire' chalcedony, *Portrait of Philip II.* Gold

stone commesso, silver and garnets, early 17th century. Florence, Museo degli Argenti.

133 Grand ducal workshops (designed by Bernardino Poccetti and Jacopo Ligozzi), *Table with vases and flowers*, 1610. Florence, Palatine Gallery.

135 Grand ducal workshops, *Table with fruit, flowers and birds*, semi-precious stone commesso, first quarter of 17th century. Castle of Rosenborg, Denmark.

136 Grand ducal workshops and Giovanni Bilivert, *Cabinet with a view of Villa La Petraia*, second decade of 17th century. Florence, Palazzo Vecchio.

137 Jacopo del Monnicca, designed by Bernardino Poccetti, Jacopo Ligozzi and Baccio del Bianco, *Table for the wedding of Ferdinando II de' Medici*, 1649. Florence, Uffizi Gallery, Tribune.

139 Grand ducal workshops, *Ex-voto of Cosimo II*, semi-precious stone, enamel and diamonds, 1624. Florence, Museo degli Argenti.

Curios and Exotica in the Medici Collections

146 *Celadon plate and vase*, probably owned by Lorenzo il Magnifico. China, 14th–15th centuries. Florence, Museo degli Argenti.

147 *Ivory stand with the Medici-Toledo arms* for a hawk's hood, Florence (?), c. 1550. Florence, Museo Nazionale del Bargello.
African horn used as a bugle with the Medici-Toledo arms, central Africa and Florence, c. 1539. Florence, Museo di Etnologia e Antropologia.

149 *Dahl* (circular shield), Indo-persia, second half of the 16th century. Florence, Museo Nazionale del Bargello.

150 *Bow with arrows*, Anatolia, earlier than 1568. Florence, Museo Nazionale del Bargello.
Naginata and Nagamaki, Japan, earlier than 1585. Florence, Museo Nazionale del Bargello.

151 *Tortoiseshell bowl*, embossed with gold, Indo-persia (?), earlier than 1589. Florence, Museo degli Argenti.
Round box of gilded metal, mother-of-pearl and precious gems, Indo-persia (?), earlier than 1631. Florence, Museo degli Argenti.

152 *Dog from Fo*, China (Ch'ing), early 18th century. *Bucchero vase from Guadalajara* with silver filigree mount, Mexico and Florence, late 17th-early 18th century. Florence, Museo degli Argenti.

Private Treasures at the Time of Ferdinando II

158 Ulrich Baumgarten, Johann König or Anton Moratz and others (designed by Philipp Heinhofer), the *Stipo di Alemagna* (the German Cabinet), Augsburg, 1619–1625. Florence, Museo degli Argenti.

159 *Amber fountain 'which pours wine'*, Germany, c. 1610. Florence, Museo degli Argenti.

161 *Cleopatra*, owned by Ferdinando II de' Medici, southern Germany, first quarter of the 17th century. Florence, Museo degli Argenti.
Sleeping spaniel, owned by Maria Maddalena d'Austria. Florence, Museo degli Argenti.

162 Daniel Sadler and Hieronimus Borsthoffer the Elder, *Harquebus* owned by Ferdinando II de' Medici, Munich, 1628. Florence, Museo Nazionale del Bargello.
The armoured helmet of Mattias de' Medici, southern Germany or Flanders, c. 1630. Florence, Museo Nazionale del Bargello.

163 Gilles Légare (mount) and unknown glyptic artist, *Jasper vase*, with gold, enamel and diamonds, originally owned by the Duke of Saxony and later by Ferdinando II de' Medici. France, c. 1650–1660. Florence, Museo degli Argenti.

164 Grand ducal workshops (designed by Matteo Nigetti), *Ferdinando II's cabinet*, Florence, 1642–1646. Florence, Uffizi Gallery.

165 *Jade mask* with a mount of gold, enamel and diamonds, probably owned by Vittoria della Rovere, Central America and France, c. 1650–1660. Florence, Museo degli Argenti.

166 Johann Eisenberg and Marcus Heiden, *3 Ivory 'tower' vases*, originally in the collection of the Duke of Saxony, brought to Florence by Mattias de' Medici, Coburg, 1627–1628. Florence, Museo degli Argenti.

168 Balthasar Stockamer, *Justice and Peace*, made in Rome for Cardinal Leopoldo de' Medici, 1665. Florence, Museo degli Argenti.

Golden Twilight: the Reign of Cosimo III

175 Gerard Walder and Vittorio Crosten, *Portrait of Cosimo de' Medici*, 1660. Florence, Opificio delle Pietre Dure.

176 Florentine miniaturist and Leonard van der Vinne, *Portrait of Prince Ferdinando*, c. 1670. Florence, Opificio delle Pietre Dure.

177 Gerard Walder, Vittorio Crosten and Leonard van der Vinne, *Portrait of Ferdinando II de' Medici*, 1669. Florence, Opificio delle Pietre Dure.

The Gems of Anna Maria Luisa de' Medici, Electress Palatine

All photographs in this volume are the property of Antonio
Quattrone with the exception of the following: